THE HUNTER GRACCHUS

THE HUNTER GRACCHUS

And Other Papers
on Literature and Art

GUY DAVENPORT

COUNTERPOINT

Washington, D.C.

Previous publications of these essays are listed on page 341.

Library of Congress Cataloging-in-Publication Data
Davenport, Guy.
The Hunter Gracchus and other papers on literature and art / Guy Davenport.
1. Arts. I. Title.
NX60.D38 1996
700—dc20 96-43090

ISBN 1-887178-24-4 (alk. paper)

FIRST PRINTING
Book and jacket design by Wesley B. Tanner/Passim Editions
Composition by Wilsted & Taylor

Printed in the United States of America on acid-free paper that meets the
American National Standards Institute z39-48 Standard.

COUNTERPOINT
P.O. Box 65793
Washington, D.C. 20035-5793

Distributed by Publishers Group West

Contents

Introductory Note

Like *The Geography of the Imagination* (1981) and *Every Force Evolves a Form* (1987), this third gathering of studies, reviews, essays, and commentaries has for a semblance of unity only their being written on the same typewriter. And as with the previous two collections, most of these pieces were commissioned by editors or written for occasions. There is even a lecture, given at a symposium on revolutions at Transylvania University here in Lexington, Kentucky. A miscellany of this sort has at least the merit of placing in one book pieces that came out in a great diversity of magazines, newspapers, and books.

A recent vogue among editors asked writers to transcribe entries from their journals and notebooks, so I have included some of these for their tangential interest, and one of them out of unseemly stubbornness as it was excluded from the book version of one literary magazine's "writers' notebooks" issue for reasons of political correctness. We live in strange times.

The way I write about texts and works of art has been shaped by forty years of explaining them to students in a classroom. I am not writing for scholars or fellow critics, but for people who like to read, to look at pictures, and to know things.

The Hunter Gracchus

ON APRIL 6, 1917, in a dwarfishly small house rented by his sister Ottla in the medieval quarter of Prague (22 Alchimisten-gasse—Alchemists Alley), Franz Kafka wrote in his diary:

> Today, in the tiny harbor where save for fishing boats only two ocean-going passenger steamers used to call, a strange boat lay at anchor. A clumsy old craft, rather low and very broad, filthy, as if bilge water had been poured over it, it still seemed to be dripping down the yellowish sides; the masts disproportionately tall, the upper third of the main-mast split; wrinkled, coarse, yellowish-brown sails stretched every which way between the yards, patched, too weak to stand against the slightest gust of wind.
>
> I gazed in astonishment at it for a time, waited for someone to show himself on deck; no one appeared. A workman sat down beside me on the harbor wall. "Whose ship is that?" I asked; "this is the first time I've seen it."
>
> "It puts in every two or three years," the man said, "and belongs to the Hunter Gracchus."

Gracchus, the name of a noble Roman family from the third to the first centuries B.C., is synonymous with Roman virtue at its sternest. It is useful to Kafka not only for its antiquity and tone of incorruptible rectitude (a portrait bust on a classroom shelf, at odds and yet in harmony with the periodic table of the elements

behind it) but also for its meaning, grackle or blackbird; in Czech, *kavka*. Kafka's father had a blackbird on his business letterhead.

The description of Gracchus's old ship is remarkably like Melville's of the *Pequod*, whose "venerable bows looked bearded" and whose "ancient decks were worn and wrinkled." From Noah's ark to Jonah's storm-tossed boat out of Joppa to the Roman ships in which Saint Paul sailed perilously, the ship in history has always been a sign of fate itself.

THE FIRST HUNTER GRACCHUS

A first draft, or fragment, of "The Hunter Gracchus" (the title of both the fragment and the story were supplied by Kafka's literary executor, Max Brod) is a dialogue between Gracchus and a visitor to his boat. Gracchus imagines himself known and important. His fate is special and unique. The dialogue is one of cross-purposes. Gracchus says that he is "the most ancient of seafarers," patron saint of sailors. He offers wine: "The master does me proud." Who the master is is a mystery: Gracchus doesn't even understand his language. He died, in fact, "today" in Hamburg, while Gracchus is "down south here." The effect of this fragment is of an Ancient Mariner trying to tell his story to and impress his importance upon a reluctant listener, who concludes that life is too short to hear this old bore out. In the achieved story the interlocutor is the mayor of Riva, who must be diplomatically attentive. The authority of myth engages with the authority of skeptical reason, so that when the mayor asks "*Sind Sie tot?*" (Are you dead?) the metaphysical locale shivers like the confused needle of a compass in "*Ja, sagte der Jäger, wie Sie sehen*" (Yes, said the hunter, as you see).

A VICTORIAN PENTIMENTO

Between writing the two texts now known as "The Hunter Gracchus: A Fragment" and "The Hunter Gracchus," Kafka read Wilkie Collins's novel *Armadale*, which ran serially in *The Cornhill*

Magazine from 1864 to 1866, when it was published with great success and popularity. A German translation by Marie Scott (Leipzig, 1866) went through three editions before 1878.

Along with *The Woman in White* (1860) and *The Moonstone* (1868), *Armadale* is one of the three masterpieces of intricately plotted melodrama, suspense, and detection that made Collins as famous as, and for a while more famous than, his friend Dickens.

Although its plot contains a ship that has taken a wrong course and turns up later as a ghostly wreck, a sudden impulse that dictates the fate of two innocent people (both named Allen Armadale), it is the novel's opening scene that Kafka found interesting enough to appropriate and transmute. Collins furnished Kafka with the ominous arrival of an invalid with a ghastly face and matted hair who is carried on a stretcher past the everyday street life of a village, including "flying detachments of plump white-headed children" and a mother with a child at her breast, to be met by the mayor.

Collins's scene is set at a spa in the Black Forest (home of the Hunter Gracchus in the fragment). He has a band playing the waltz from Weber's *Der Freischütz*, which must have struck Kafka as a fortuitous correspondence. Among the archetypes of the Hunter Gracchus is the enchanted marksman of that opera.

In Collins it is a guilty past that cannot be buried. The dead past persists. Kafka makes a crystalline abstract of Collins's plot, concentrating its essence into the figure of Gracchus, his wandering ship, his fate, and the enigmatic sense that the dead, having lived and acted, are alive.

Collins's elderly, dying invalid is a murderer. He has come to the spa at Wildbad with a young wife and child. In his last moments he writes a confession intended to avert retribution for his crime from being passed on to his son. *Armadale* is the working out of the futility of that hope.

Kafka, having written a dialogue between Gracchus and an un-

identified interlocutor, found in Collins a staging. Gracchus must have an arrival, a procession to a room, an interlocutor with an identity, and a more focused role as man the wanderer, fated by an inexplicable past in which a wrong turn was taken that can never be corrected.

DE CHIRICO

The first paragraph of "The Hunter Gracchus" displays the quiet, melancholy stillness of Italian piazze that Nietzsche admired, leading Giorgio de Chirico to translate Nietzsche's feeling for Italian light, architecture, and street life into those paintings that art history calls metaphysical. The enigmatic tone of de Chirico comes equally from Arnold Böcklin (whose painting *Isle of the Dead* is a scene further down the lake from Riva). Böcklin's romanticization of mystery, of dark funereal beauty, is in the idiom of the Décadence, "the moment of Nietzsche." Kafka, like de Chirico, was aware of and influenced by this new melancholy that informed European art and writing from Scandinavia to Rome, from London to Prague.

Kafka's distinction is that he stripped it of those elements that would quickly soften into kitsch.*

"Zwei Knaben sassen auf der Quaimauer und spielen Würfel." Two boys were sitting on the harbor wall playing with dice. They touch, lightly, the theme of hazard, of chance, that will vibrate throughout. "History is a child building a sandcastle by the sea," said Heraclitus two and a half millennia earlier, "and that child is the whole majesty of man's power in the world." Mallarmé's *Un coup de dés jamais n'abolira le hasard*, with its imagery of shipwreck and pathless seas, was published in 1897 when Kafka was fourteen. "God does not play at dice," said Einstein (whom Kafka may have

*For *nicceismo* in Böcklin and de Chirico, see Alberto Savinio's "Arnold Böcklin" in *Operatic Lives* (1942, translated by John Shepley, 1988) and de Chirico's *Memoirs* (1962, translated by Margaret Crosland, 1971). Savinio is de Chirico's brother.

met at a Prague salon they are both known to have attended). Kafka was not certain that He didn't.

There is a monument on this quay, a *säbelschwingende Held*, a sword-flourishing hero, in whose shadow a man is reading a newspaper. History in two tempi, and Kafka made the statue up, much as he placed a sword-bearing Statue of Liberty in *Amerika*.

A girl is filling her jug at the public fountain. (Joyce, having a Gemini in the boys, an Aquarius in the water jug, and a Sagittarius in the monument, would have gone ahead and tucked in the full zodiac, however furtively; signs and symbols have no claim on Kafka, who wrecks tradition rather than trust any part of it.)

A fruit seller lies beside his scales (more zodiac, Libra!) staring out to sea.

Then a fleeting Cézanne: through the door and windows of the café we can see two men drinking wine at a table *in der Tiefe*, all the way at the back. The patron is out front, asleep at one of his own tables.

Into this de Chirico high noon comes a ship, *eine Barke*, "silently making for the little harbor." The sailor who secures the boat with a rope through a ring wears a blue blouse, a French touch that makes us note that two French words have already turned up (*quai* and *barque*). It's the late, hard spare style of Flaubert, as in the opening paragraphs of *Bouvard et Pécuchet*, that Kafka is taking for a model and improving upon.

Gracchus, like Wilkie Collins's Armadale, is brought across the quay on a bier, covered by a large Victorian shawl, "a great flower-patterned tasselled silk cloth" perhaps taken from Collins's carpet speckled with "flowers in all the colours of the rainbow," and like Armadale he seems to be more dead than alive.

Gracchus's arrival is strangely ignored by the people in the square, as if he were invisible. A new set of characters—a committee of innocents—takes over: a mother with a nursing child, a little boy who opens and closes a window, and a flock of biblical

doves, whose associations with fated ships fit Kafka's diction of imagery, Noah's dove from the ark, and Jonah's name ("dove" in Hebrew).

The mayor of Riva arrives as soon as Gracchus has been carried inside a yellow house with an oaken door. He is dressed in black, with a funereal band on his top hat.

FIFTY LITTLE BOYS

These *fünfzig kleine Knaben* who line up in two rows and bow to the Bürgermeister of Riva when he arrives at the house where the Hunter Gracchus has been carried remind us of Max Ernst's *collages* or Paul Delvaux's paintings; that is, they enact the surrealist strategy of being from the dream world, like Rudyard Kipling's hovering ghost children in "They" or Pavel Tchelitchew's children in his painting *Hide-and-Seek*.

Another horde of children, girls this time, crowd the stairs to the court painter Titorelli's studio in *The Trial*. Their presence is almost as inexplicable as that of the boys. They live in the mazelike tenement where Titorelli paints judges and where brokers gossip about cases in process. They are silly, provocative, brazen pests. Like the boys, they line up on either side of the stairway, "squeezing against the walls to leave room for K. to pass." They form, like the boys, a kind of gauntlet through which the mayor of Riva and K. have to pass to their strange and unsettling encounters.

In December 1911 Kafka, having witnessed the circumcision of a nephew, noted that in Russia the period between birth and circumcision was thought to be particularly vulnerable to devils for both the mother and the son.

> For seven days after the birth, except on Friday, also in order to ward off evil spirits, ten to fifteen children, always different ones, led by the *belfer* (assistant teacher), are admitted to the bedside of the mother, there repeat *Shema Israel*, and are then given candy. These innocent, five- to

eight-year-old children are supposed to be especially effective in driving back the evil spirits, who press forward most strongly toward evening.

At the beginning of *Armadale*, the Bürgermeister of Wildbad in the Black Forest, awaiting the arrival of the elder Armadale ("who lay helpless on a mattress supported by a stretcher; his hair long and disordered under a black skull-cap; his eyes wide open, rolling to and fro ceaselessly anxious; the rest of his face as void of all expression . . . as if he had been dead"), is surrounded by "flying detachments of plump white-headed children careered in perpetual motion."

In 1917 Kafka wrote in his Blue Notebook (as some of his journals have come to be called): "They were given the choice of becoming kings or the king's messengers. As is the way with children, they all wanted to be messengers. That is why there are only messengers, racing through the world and, since there are no kings, calling out to each other the messages that have now become meaningless." (There is another sentence—"They would gladly put an end to their miserable life, but they do not dare to do so because of their oath of loyalty"—that starts another thought superfluous to the perfect image of messenger children making a botch of all messages.)

All messages in Kafka are incoherent, misleading, enigmatic. The most irresponsible and childish messengers are the assistants to K. in *The Castle*. (They probably entered Kafka's imagination as two silent Swedish boys Kafka kept seeing at a nudist spa in Austria in 1912, always together, uncommunicative, politely nodding in passing, traversing Kafka's path with comic regularity.)

THE NEW MYTH

Despite Kafka's counting on myths and folktales about hunters, enchanted ships, the Wandering Jew, ships for the souls of the

dead, and all the other cultural furniture to stir in the back of our minds as we read "The Hunter Gracchus," he does not, like Joyce, specify them. He treats them like groundwater that his taproot can reach. Even when he selects something from the midden of myth, he estranges it. His Don Quixote, his Tower of Babel, his Bucephalus are transmutations.

Hermann Broch placed Kafka's relation to myth accurately: beyond it as an exhausted resource. Broch was one of the earliest sensibilities to see James Joyce's greatness and uniqueness. His art, however, was an end and a culmination. Broch's own *The Death of Virgil* (1945) may be the final elegy closing the long duration of a European literature from Homer to Joyce. In Kafka he saw a new beginning, a fiercely bright sun burning through the opaque mists of a dawn.

> The striking relationship between the arts on the basis of their common abstractism [Broch wrote], their common style of old age, this hallmark of our epoch is the cause of the inner relationship between artists like Picasso, Stravinsky and Joyce. This relationship is not only striking in itself but also by reason of the parallelism through which the style of old age was imposed on these men, even in their rather early years.
>
> Nevertheless, abstractism forms no *Gesamtkunstwerk* — the ideal of the late romantic; the arts remain separate. Literature especially can never become completely abstract and "musicalized": therefore the style of old age relies here much more on another symptomatic attitude, namely on the trend toward myth. It is highly significant that Joyce goes back to the *Odyssey*. And although this return to myth — already anticipated in Wagner — is nowhere so elaborated as in Joyce's work, it is for all that a general attitude of modern literature: the revival of Biblical themes, as, for instance, in the novels of Thomas Mann, is an evidence of the impetuosity with which myth surges to the forefront of poetry. However, this is only a return — a return to myth in its an-

cient forms (even when they are so modernized as in Joyce), and so far it is not a new myth, not *the* new myth. Yet, we may assume that at least the first realization of such a new myth is already evident, namely in Franz Kafka's writing.

In Joyce one may still detect neo-romantic trends, a concern with the complications of the human soul, which derives directly from nineteenth-century literature, from Stendhal, and even from Ibsen. Nothing of this kind can be said about Kafka. Here the personal problem no longer exists, and what seems still personal is, at the very moment it is uttered, dissolved in a super-personal atmosphere. The prophecy of myth is suddenly at hand. [Broch, introduction to Rachel Bespaloff's *De l'Iliade* (1943, English translation as *On the Iliad*, 1947)]

Prophecy. All of Kafka is about history that had not yet happened. His sister Ottla would die in the camps, along with all of his kin. The German word for *insect* (*Ungeziefer*, "vermin") that Kafka used for Gregor Samsa is the same word the Nazis used for Jews, and *insect extermination* was one of their obscene euphemisms, as George Steiner has pointed out.

Quite soon after the Second World War it was evident that with *The Castle* and *The Trial*, and especially with "In the Penal Colony," Kafka was accurately describing the mechanics of totalitarian barbarity.

PERPETUAL OSCILLATION

Kafka, Broch says, had "reached the point of the Either-Or: either poetry is able to proceed to myth, or it goes bankrupt."

Kafka, in his presentiment of the new cosmogony, the new theogony that he had to achieve, struggling with his love of literature, his disgust for literature, feeling the ultimate insufficiency of any artistic approach, decided (as did Tolstoy, faced with a similar decision) to quit

the realm of literature, and ask that his work be destroyed; he asked this
for the sake of the universe whose new mythical concept had been be-
stowed upon him.

In the Blue Notebooks Kafka wrote: "To what indifference
people may come, to what profound conviction of having lost the
right track forever."

And: "Our salvation is death, but not this one."

Kafka's prose is a hard surface, as of polished steel, without res-
onance or exact reflection. It is, as Broch remarked, abstract ("of
bare essentials and unconditional abstractness"). It is, as many
critics have said, a pure German, the austere German in which the
Austro-Hungarian empire conducted its administrative affairs, an
efficient, spartan idiom admitting of neither ornament nor poetic
tones. Its grace was that of abrupt information and naked utility.

Christopher Middleton speaks (in a letter) of "the transparent,
ever-inquiring, tenderly comical, ferociously paradoxical narra-
tive voice that came to Kafka for his Great Wall of China and Jose-
phine the Singer: Kafka's *last* voice."

The paradox everywhere in Kafka is that this efficient prose is
graphing images and events forever alien to the administration of
a bureaucracy. Middleton's remark comes in a discussion of the
spiritual dance of language.

> I'm reading about Abraham Abulafia, his "mystical experience," theo-
> ries of music and of symbolic words. There was a wonderful old Sephar-
> dic Rabbi in Smyrna, Isaak ha-Kohen, who borrowed and developed a
> theory, in turn adopted and cherished by Abulafia, about melody, a the-
> ory with obviously ancient origins, but traceable to Byzantium, mel-
> ody as a rehearsal, with its undulatory ups and downs, of the soul's
> dancing toward ecstatic union with God: to rehearse the soul, bid your
> instrumentalists play... so melody is a breathing, a veil of breath which
> flows and undulates, a veiling of the Ruach (spirit). When you listen to
> recent re-creations of Byzantine music, the theory seems more and

more childish, but the facts it enwraps become more and more audible—even the *touching* of flute-notes and harp strings enacts the vertiginous conspiracy, the "letting go," out of any succession of instants into an imaginable *nunc stans*, an ingression into "the perfect and complete simultaneous possession of unlimited life" (as dear old Boethius put it). Oddly enough, this (what's "this"?) is the clue to the narrative voice (I conjecture) . . . that came to Kafka for his Great Wall of China.

What Kafka had to be so clear and simple about was that nothing is clear and simple. On his deathbed he said of a vase of flowers that they were like him: simultaneously alive and dead. All demarcations are shimmeringly blurred. Some powerful sets of opposites absolutely do not, as Heraclitus said, cooperate. They fight. They tip over the balance of every certainty. We can, Kafka said, easily believe any truth and its negative at the same time.

LUSTRON UND KASTRON

Gracchus's *Lebensproblem*, as the Germans say, is that he cannot encounter his opposite and be resolved (or not) into Being or Nonbeing, as the outcome may be.

Opposites do not cooperate; they obliterate each other.

In 1912, at a nudist spa in Austria, Kafka dreamed that two contingents of nudists were facing each other. One contingent was shouting at the other the insult "Lustron und Kastron!"

The insult was considered so objectionable that they fought. They obliterated each other like the Calico Cat and the Gingham Dog, or like subatomic particles colliding into nonexistence.

The dream interested Kafka; he recorded it. He did not analyze it, at least not on paper. He knew his Freud. There are no such words as *lustron* and *kastron* in Greek, though the dream made them Greek. If we transpose them into Greek loan words in Latin, we get *castrum* (castle) and *lustrum* (the five-year-recurring spiri-

tual cleansing of Roman religion). Both words are antonyms, containing their own opposites (like *altus*, deep or high). *Lustrum*, a washing clean, also means filthy; the *cast-* root gives us *chaste* and *castrate*. And *lust* and *chaste* play around in their juxtaposition.

At the spa Kafka records, with wry wit, the presence of the two silent Swedish boys whose handsome nudity reminded him of Castor and Pollux, whose names strangely mean Clean and Dirty (our *chaste* and *polluted*). These archetypal twins, the sons of Leda, Helen's brothers, noble heroes, duplicates of Damon and Pythias in friendship, existed alternately. One lived while the other was dead, capable of swapping these states of being. They are in the zodiac as Gemini, and figure in much folklore, merging with Jesus and James.

When Gracchus claims in the fragment that he is the patron saint of sailors, he is lying. Castor and Pollux are the patron saints of sailors, the corposants that play like bright fire in the rigging.

Pollux in Greek has a euphemism for a name: Polydeukes (the Sweet One). When the Greeks felt they needed to propitiate, they avoided a real name (as in calling the avenging Fates the Eumenides). Pollux was a boxer when all fights were to the death.

Dirty and clean, then, tref and kosher, motivated Kafka's dream. The insult was that one group of nudists were both. Kafka was a nudist who wore bathing drawers, a nonobservant Jew, a Czech who wrote in German, a man who was habitually engaged to be married and died a bachelor. He could imagine "a curious animal, half kitten, half lamb" (derived from a photograph of himself, age five, with a prop stuffed lamb whose hindquarters look remarkably like those of a cat). He could imagine "an Odradek," the identity of which has so far eluded all the scholars.

We live, Kafka seems to imply, in all matters suspended between belief and doubt, knowing and ignorance, law and chance. Gracchus is both prehistoric man, a hunter and gatherer, and man

at his most civilized. He thinks that his fate is due to a fall in a primeval forest, as well as to his death ship's being off course.

Kafka could see the human predicament from various angles. We live by many codes of law written hundreds or thousands of years ago for people whose circumstances were not ours. This is not exclusively a Jewish or Muslim problem; the United States Constitution has its scandals and headaches. Hence lawyers, of whom Kafka was one. He dealt daily with workmen's accidents and their claims for compensation. What is the value of a hand?

His mind was pre–pre-Socratic. His physics teacher had studied under Ernst Mach, whose extreme skepticism about atoms and cause and effect activated Einstein in quite a different direction.

Walter Benjamin, Kafka's first interpreter, said that a strong prehistoric wind blows across Kafka from the past. There is that picture on the wall that Gracchus can see from his bed, of a Bushman "who is aiming his spear at me and taking cover as best he can behind a beautifully painted shield." A Bushman who has not yet fallen off a cliff and broken his neck.

"Mein Kahn ist ohne Steuer, er fährt mit dem Wind, der in den untersten Regionen des Todes bläst." (My boat is rudderless, it is driven by the wind that blows in the deepest regions of death.)

This is the voice of the twentieth century, from the ovens of Buchenwald, from the bombarded trenches of the Marne, from Hiroshima.

It was words that started the annihilating fight in Kafka's dream, meaningless words invented by Kafka's dreaming mind. They seem to designate opposite things, things clean and things unclean. Yet they encode their opposite meanings. The relation of word to thing is the lawyer's, the philosopher's, the ruler's constant anguish. The word *Jew* (which occurs nowhere in Kafka's fiction) designates not an anthropological race but a culture, and

yet both Hitler and the Jews used it as if it specified a race. "The Hunter Gracchus" inquires into the meaning of the word *death*. If there is an afterlife in an eternal state, then it does not mean death; it means transition, and death as a word is meaningless. It annihilates either of its meanings if you bring them together.

The language of the law, of talking dogs and apes, of singing field mice, of ogres and bridges that can talk—everything has its *logos* for Kafka. (Max Brod recounts a conversation in Paris between Kafka and a donkey.) Words are tyrants more powerful than any Caesar. When they are lies, they are devils.

The purity of Kafka's style assures us of its trustworthiness as a witness. It is this purity, as of a child's innocence or an angel's prerogative, that allows Kafka into metaphysical realities where a rhetorical or bogus style would flounder. Try to imagine "The Hunter Gracchus" by the late Tolstoy, or by Poe. The one would have moralized, the other would have tried to scare us. Kafka says, "Here is what it feels like to be lost."

As Auden noted, *as if* in Kafka is treated as *is*. To bring *is* to bear on Kafka's *as if* will only annihilate them both.

FIFTY CHILDREN IN TWO ROWS

We cannot read "The Hunter Gracchus" without being reminded of all the refugee ships loaded to the gunwales with Jews trying to escape the even more packed cattle cars to Auschwitz, turned away from harbor after harbor.

One of the arrangers of some of these ships was Ada Sereni, an Italian Jewish noblewoman whose family can be traced back to Rome in the first century. In September of 1947 she was involved in secret flights of Jewish children from Italy to Palestine. A twin-engine plane flown by two Americans was to land at night outside Salerno. Ada Sereni and the twenty-year-old Motti Fein (later to command the Israeli Air Force in the Six-Day War) were waiting

with fifty children to be taken to a kibbutz. As the plane approached, the fifty were placed in two rows of twenty-five each, holding candles as landing lights in a Sicilian meadow. The operation took only a few minutes and was successful. The children were in orange groves the next morning. *"An der Stubentür klopfte er an, gleichzeitig nahm er den Zylinderhut in seine schwarzbehandschuhte Rechte. Gleich wurde geöffnet, wohl fünfzig kleine Knaben bildeten ein Spaller in langen Flurgang und verbeugten sich."* (He knocked at the door, meanwhile removing his top hat with his black-gloved right hand. As soon as it was opened, fifty little boys stood in formation along the hallway and bowed.)

The SS wore black gloves.

DEATH SHIPS

Kafka does not decode. He is not referring us to Wagner's *Flying Dutchman* or the myth of the Wandering Jew, or to the pharaonic death ships that had harbors built for them in the empty desert, or to the treasure ships in which Viking lords were laid in all their finery, or to the Polynesian death ships that glided from island to island collecting the dead, or to American Indian canoe burials, or to Coleridge's Ancient Mariner, or to any of the ghost ships of legend and folktale. There is a ghostly hunter in the Black Forest. Kafka's ability to write "The Hunter Gracchus" is evidence of what Broch meant when he said that Kafka is the inventor of a new mythology.

SIND SIE TOT?

At Auschwitz it was difficult to tell the living from the dead.

RAVEN AND BLACKBIRD

Poe's mind was round, fat, and white; Kafka's cubical, lean, and transparent.

RIVA

When Max Brod and Kafka visited Riva in September of 1909 it was an Austrian town where eight thousand Italians lived. It sits on the northwest end of Lake Garda. Baedeker's *Northern Italy* for 1909 calls it "charming" and says that "the water is generally azure blue."

AION

Time in Kafka is dream time, Zenonian and interminable. The bridegroom will never get to his wedding in the country, the charges against Joseph K. will never be known, the death ship of the Hunter Gracchus will never find its bearings.

CIRCADIAN RHYTHM

The opening of "The Hunter Gracchus" is a picture of urban infinity. There is always another throw of the dice. Another newspaper is being printed while today's is being read; a jug of water must soon be refilled; the fruit seller is engaged in "the eternal exchange of money and goods" (Heraclitus on the shore shaping the sea, the sea shaping the shore); the men in the café will be there again tomorrow; the sleeping patron is in one cycle of his circadian rhythm. Play, reading, housekeeping, business, rest: it is against these ordinary peaceful things that Kafka puts the long duration of Gracchus's thousand years of wandering, a cosmic infinity.

A KIND OF PARADOX

Reality is the most effective mask of reality. Our fondest wish, attained, ceases to be our fondest wish. Success is the greatest of disappointments. The spirit is most alive when it is lost. Anxiety was Kafka's composure, as despair was Kierkegaard's happiness. Kafka

said impatience is our greatest fault. The man at the gate of the Law waited there all of his life.

THE HUNTER

Nimrod is the biblical archetype, "a mighty hunter before the Lord" (Genesis 10:9), but the Targum, as Milton knew, records the tradition that he hunted men ("sinful hunting of the sons of men") as well as animals. Kafka was a vegetarian.

MOTION

Gracchus explains to the mayor of Riva that he is always in motion, despite his lying as still as a corpse. On the great stair "infinitely wide and spacious" that leads to "the other world" he clambers up and down, sideways to the left, sideways to the right, "always in motion." He says that he is a hunter turned into a butterfly. There is a gate (presumably heaven) toward which he flutters, but when he gets near he wakes to find himself back on his bier in the cabin of his ship, "still stranded forlornly in some earthly sea or other." The motion is in his mind (his *psyche*, Greek for "butterfly" as well as for "soul"). These imaginings (or dreams) are a mockery of his former nimbleness as a hunter. The butterfly is one of the most dramatic of metamorphic creatures, its transformations seemingly more divergent than any other. A caterpillar does not die; it becomes a wholly different being.

Gracchus when he tripped and fell in the Black Forest was glad to die; he sang joyfully his first night on the death ship. "I slipped into my winding sheet like a girl into her marriage dress. I lay and waited. Then came the mishap."

The mistake that caused Gracchus's long wandering happened *after* his death. Behind every enigma in Kafka there is another.

"The Hunter Gracchus" can be placed among Kafka's parables. Are we, the living, already dead? How are we to know if we are on course or lost? We talk about loss of life in accidents and war

as if we possessed life rather than life us. Is it that we are never wholly alive, if life is an engagement with the world as far as our talents go? Or does Kafka mean that we can exist but not be?

It is worthwhile, for perspective's sake, to keep the lively Kafka in mind, the delightful friend and traveling companion, the witty ironist, his fascinations with the Yiddish folk theater, with a wide scope of reading, his overlapping and giddy love affairs. He undoubtedly was "as lonely as Franz Kafka" (a remark made, surely, with a wicked smile).

And some genius of a critic will one day show us how comic a writer Kafka is, how a sense of the ridiculous very kin to that of Sterne and Beckett informs all of his work. Like Kierkegaard, he saw the absurdity of life as the most meaningful clue to its elusive vitality. His humor authenticates his seriousness. "Only Maimonides may say there is no God; he's entitled."

On Reading

To MY AUNT MAE — Mary Elizabeth Davenport Morrow (1881–
1964), whose diary when I saw it after her death turned out to be a
list of places, with dates, she and Uncle Buzzie (Julius Allen Mor-
row, 1885–1970) had visited over the years, never driving over
thirty miles an hour, places like Toccoa Falls, Georgia, and Antre-
ville, South Carolina, as well as random sentences athwart the
page, two of which face down indifference, "My father was a horse
doctor, but not a common horse doctor" and "Nobody has ever
loved me as much as I have loved them"—and a Mrs. Cora Shiflett,
a neighbor on East Franklin Street, Anderson, South Carolina, I
owe my love of reading.

Mrs. Shiflett, one of that extensive clan of the name, all re-
taining to this day the crofter mentality of the Scots Lowlands
from which they come, a mixture of rapacity and despair (Faulk-
ner called them Snopes), had rented a house across the street from
us formerly occupied, as long as I could remember, by another
widow, Mrs. Spoone ("with an *e*"), she and her son, whom we never
saw, as he was doing ten years "in the penitencher." But before
Mrs. Shiflett's son, "as good a boy to his mother as ever was," fell
into some snare of the law, he had been a great reader. And one
fateful day Mrs. Shiflett, who wore a bonnet and apron to authen-
ticate her respectability as a good countrywoman, brought with
her, on one of her many visits to "set a spell" with my mother, a

volume of the Tarzan series, one in which Tarzan saves himself from perishing of thirst in the Sahara by braining a vulture and drinking its blood. She lent it to me. "Hit were one of the books Clyde loved in particular."

I do not have an ordered memory, but I know that this work of Edgar Rice Burroughs was the first book I read. I was thought to be retarded as a child, and all the evidence indicates that I was. I have no memory of the first grade, to which I was not admitted until I was seven, except that of peeing my pants and having to be sent home whenever I was spoken to by our hapless teacher. I have even forgotten her appearance and her name, and I call her hapless because there was a classmate, now a psychiatrist, who fainted when he was called on, and another who stiffened into petit mal. I managed to control my bladder by the third grade, but the fainter and the sufferer from fits, both classmates of mine through the ninth grade, when I quit school, kept teachers edgy until graduation.

No teacher in grammar or high school ever so much as hinted that reading was a normal activity, and I had to accept it, as my family did, was part of my affliction as a retarded person. The winter afternoon on which I discovered that I could follow Tarzan and Simba and some evil Arab slave traders was the first in a series of by now fifty years of sessions in chairs with books. I read very slowly, and do not read a great deal as I would much rather spend my leisure painting and drawing, or writing, and I do not have all that much leisure. And as a teacher of literature I tend to read the same books over and over, year after year, to have them fresh in my mind for lectures.

From *Tarzan*, which I did not read efficiently (and Burroughs's vocabulary runs to the exotic), I moved on to available books. My father had a small library of a hundred or so, from which I tried a *Collected Writings of Victor Hugo*, mysteriously inscribed in my father's hand, "G. M. Davenport, Apr. 24, 1934, Havana, Cuba," where I am positive my father never set foot. Under this inscrip-

tion, he (or somebody) drew a cube, in ink that bled through to appear on the other surface of the page, on Victor Hugo's forehead in a frontispiece engraving. But Hugo is not Edgar Rice Burroughs, and I could make nothing of him.

Aunt Mae had inherited, with pride, the small library of my uncle Eugene, a soldier in World War I, buried in France a decade before my birth. This contained a complete Robert Louis Stevenson and James Fenimore Cooper, both of whom proved to be over my head. But there was a picture book of Pompeii and Herculaneum, which opened a door of a different sort, giving me my first wondering gaze into history and art. Aunt Mae was herself addicted to the novels of Zane Grey, whom I lumped in with Victor Hugo as a writer unable to get on with what he had to say, as bad at dawdling as Cooper.

And then I made the discovery that what I liked in reading was to learn things I didn't know. Aunt Mae's next-door neighbor, Mrs. McNinch, belonged to the Book-of-the-Month Club, which in 1938—I was eleven—sent its subscribers Antonina Vallentin's *Leonardo da Vinci*. Mrs. McNinch, a woman of fervent piety and a Presbyterian, had chosen this book because of *The Last Supper*. She lent it to me. I had not known until the wholly magic hours I spent reading it, all of a wet spring, that such a man as Leonardo was possible, and I was hearing of the Renaissance for the first time. I read this difficult book in a way I can no longer imagine. I pretended, I think, that I was following the plot and the historical digressions. I have not reread this book and yet I can in lectures cite details of Leonardo's career from it. Or think I can. I have read some forty studies of Leonardo since, and many books about his epoch, and may be fooling myself as to which source I'm remembering. But I can still see all the illustrations, the codex pages in sepia, the paintings in color.

When I returned the biography of Leonardo, the generous Mrs. McNinch lent me Carl Van Doren's *Benjamin Franklin*, also

published in 1938 and a Book-of-the-Month Club selection. This was harder going, with phrases like "minister plenipotentiary," which I would mutter secretly to myself. It is a truism that reading educates. What it does most powerfully is introduce the world outside us, negating the obstructions of time and place. When, much later, I ran across the word *opsimathy* in Walter Pater, I could appreciate the tragic implications of late learning. All experience is synergetic: Bucky Fuller should have written, and probably did, about the phenomenon of Synergetic Surprise. We cannot guess what potential lies in wait for the imagination through momentum alone. The earlier Leonardo and Franklin enter one's mind, the greater the possibility of their bonding and interacting with ongoing experience and information.

My childhood was far from bookish. I spent a lot of it hunting and fishing, searching Georgia and South Carolina fields for arrowheads, longing to work on the Blue Ridge Railroad, playing softball in the street, building tree houses. The hunting was done with my Uncle Broadus Dewey on Saturdays with a bird dog named Joe. Joe was gun-shy and had conniption fits with pitiful howls when we took a shot at game. Many lives were spared, of squirrels and partridges and rabbits, to spare Joe's nerves. I myself never managed to shoot anything. What I liked was the outing and the comradeship and pretending to have Leonardo's eyes in looking at plants, rocks, the landscape. Back from hunting, I would try to imitate a page of the notebooks. On manila construction paper from Woolworth's I would draw in brown ink leaves in clusters, and rocks, and insects, hoping that the page resembled one by Leonardo.

When the first American paperbacks came along, they, too, opened other worlds: Sherlock Holmes and other detective fiction, leading me to read people in the Holmesian manner at the barbershop and on the street.

I now have ample evidence for tracing synergies in reading. A

few summers ago I spent a beautiful day in Auvers-sur-Oise, standing by the graves of Vincent and Theo. The wheat field is still unmistakably there, across the road from where they are buried against the cemetery wall, the Protestant place; and Gachet's house and garden. This day began with Irving Stone's trashy and irresponsible biography and the hilariously vulgar film based on it, but one must begin somewhere. Opsimathy differs from early learning in that there are no taproots, no years of crossbreeding, no naturalization in a climate.

After I had taught myself to read, without reading friends or family, I kept at it, more or less unaware of what hunger I was feeding. I can remember when I read any book, as the act of reading adheres to the room, the chair, the season. Doughty's *Arabia Deserta* I read under the hundred-year-old fig tree in our backyard in South Carolina, a summer vacation from teaching at Washington University, having lucked onto the two volumes (minus the map that ought to have been in a pocket in vol. II) at a St. Louis rummage sale. (The missing map was given me fifteen years later by Issam Safady, the Jordanian scholar.)

I read most of Willa Cather and Mann's Joseph tetralogy in the post library at Fort Bragg. The ordnance repair shop was on one side, the stockade on the other, and I was "keeping up my education" on orders from the adjutant general of the XVIIIth Airborne Corps, who kindly gave me Wednesday afternoons off specifically to read.

Proust I began among the spring blossoms of the Sarah P. Duke gardens in Durham, North Carolina, and finished forty years later by my fireplace in Lexington, Kentucky, convalescing from a very difficult operation to remove an embedded kidney stone. These settings are not merely sentimental; they are real interrelations. The moment of reading is integral to the process. My knowledge of Griaule's *Le renard pâle* is interwoven with my reading a large part of it in the Greenville, South Carolina, Trailways bus station.

Yeats's *A Vision* belongs to the Hôtel Monsieur-le-Prince, once on the street of that name, as does *Nightwood* and *Black Spring. The Seven Pillars*, an Oxford room; *Fanny Hill*, the Haverford cricket field. And not all readings are nostalgic: the conditions under which I made my way through the *Iliad* in Greek were the violence and paralyzing misery of a disintegrating marriage, for which abrasion, nevertheless, the meaning of the poem was the more tragic. There are texts I can never willingly return to because of the misery adhering to them.

Students often tell me that an author was ruined for them by a high-school English class; we all know what they mean. Shakespeare was almost closed to me by the world's dullest teacher, and there are many writers whom I would probably enjoy reading except that they were recommended to me by suspect enthusiasts. I wish I knew how to rectify these aversions. I tell bright students, in conference, how I had to find certain authors on my own who were ruined for me by bad teachers or inept critics. Scott, Kipling, Wells will do to illustrate that only an idiot will take a critic's word without seeing for oneself. I think I learned quite early that the judgments of my teachers were probably a report of their ignorance. In truth, my education was a systematic misleading. Ruskin was dismissed as a dull, preacherly old fart who wrote purple prose. In a decent society the teacher who led me to believe this would be tried, found guilty, and hanged by the thumbs while being pelted with old eggs and cabbage stalks. I heard in a class at Duke that Joyce's *Ulysses* was a tedious account of the death of Molly Bloom. An Oxford don assured me that Edmund Wilson is an astute critic. Around what barriers did I have to force my way to get to Pound, to Joyce, to William Carlos Williams?

All of this points to our having a society that reads badly and communicates execrably about what we read. The idea persists that writing is an activity of thoughtful, idealistic, moral people called authors and that they are committed to protecting certain

values vital to a well-ordered society. Books mold character, enforce patriotism, and provide a healthy way to pass the leisurely hour. To this assumption there has been added in our day the image of the author as a celebrity, someone worth hearing at a reading or lecture even if you have no intention of parting with a dime for one of the author's books.

There is little room in this popular concept of writing for the apprehension and appreciation of style. I had all along, I would like to think, been responding to style in my earliest attempts to read. I knew that the books I failed to enjoy—Scott's *The Black Dwarf* was the worst of these—were texts that remained foggy and indeterminate, like a moving picture experienced through bad eyesight and defective hearing. Style is radically cultural both linguistically and psychologically. I couldn't read Scott, Stevenson, and Cooper because I had not developed the imaginative agility needed to close the distance between me and the style of their texts. I could read, with excitement and a kind of enchantment, the biographies I encountered so early of Leonardo and Franklin not only because my curiosity about them was great, but because these biographies were in a contemporary, if academic, English.

My discovery of style came about through various humble books. Hendrik Van Loon's whimsical history of the world (a Pocket Book from Woolworth's) alerted me to the fact that tone makes all the difference. It was this book that began to make something of an aesthete of me, for I progressed to Van Loon's biography of Rembrandt (conflating the rich experience of the Leonardo biography with the pleasure of reading for style), a book I kept reading for the pleasure of the prose, despite my ignorance of his historical setting. In it, however, I saw the name Spinoza, which led me to dear old Will Durant, who led me to Spinoza's texts, and all fellow readers who have ever taken a book along to a humble restaurant will understand my saying that life has few enjoyments as stoical and pure as reading Spinoza's *Ethics*, evening

after evening, in a strange city—St. Louis, before I made friends there. The restaurant was Greek, cozy, comfortable, and for the neighborhood. The food was cheap, tasty, and filling.

Over white beans with chopped onions, veal cutlet with a savory dressing, and eventually a fruit cobbler and coffee, I read the *De Ethica* in its Everyman edition, Draftech pen at the ready to underline passages I might want to refind easily later. Soul and mind were being fed together. I have not eaten alone in a restaurant in many years, but I see others doing it and envy them.

At some time, as a freshman in college I would guess, my pleasure in style came together with the inevitable duty of having to read for content. I became increasingly annoyed with inept styles, like James Michener's, or styles that did violence to the language (and thus knew nothing of sociology until I could read it in French), with the turkey gobble of politicians and the rev. clergy. I began to search out writers whose style, as I was learning to see, was an indication that what they had to say was worth knowing. This was by no means an efficient or intellectually respectable procedure. I found Eric Gill's writing (all of which has evaporated from my mind), Spengler (all retained), Faulkner (then unknown to my English profs), Joyce (whose name I found in Thomas Wolfe), Dostoyevsky.

A memory: I was desperately poor as an undergraduate at Duke, did not belong to a fraternity, and except for a few like-minded friends (Dan Patterson, who was to become the great student of Shaker music; Bob Loomis, the Random House editor; Clarence Brown, the translator and biographer of Osip Mandelstam) was romantically and self-indulgently lonely. I was already learning the philosophical simpleness that would get me through life, and I remember a Saturday when I was the only person in the library. I took out Faulkner's *Absalom, Absalom!* (buff paper, good typography) and went back to my room. I felt, somehow, with everybody else out partying (Dan Patterson was practicing the pi-

ano in the basement of Duke chapel), Faulkner deserved my best. I showered, washed my hair, put on fresh clothes, and with one of Bob Loomis's wooden-tipped cigars, for the wickedness of it, made myself comfortable and opened the Faulkner to hear Miss Rosa Coldfield telling Quentin Compson about Thomas Sutpen.

So it went with my education. God knows what I learned from classes; very little. I read Santayana instead of my philosophy text (the style of which sucked), I read *Finnegans Wake* instead of doing botany (in which I made an F, and sweet Professor Anderson, that great name in photosynthesis, wrote on the postcard that conveyed the F, "You have a neat and attractive handwriting"). Instead of paying attention to psychology I made a wide study of Klee and Goya.

On a grander scale I got the same kind of education at Oxford and Harvard, where I read on my own while satisfying course requirements. I can therefore report that the nine years of elementary schooling, four of undergraduate, and eight of graduate study were technically games of futility. If, now, I had at my disposal as a teacher only what I learned from the formalities of education, I could not possibly be a university professor. I wouldn't know anything. I am at least still trying. I've kept most of my textbooks and still read them (and am getting pretty good at botany).

Wendell Berry, that thoughtful man, once remarked that teachers are like a farmer dropping an acorn into the ground. Some years will pass before the oak comes to maturity. We give grades, and lecture, and do the best we can. But we cannot see what we have done for many years to come. In setting out to write about the pleasure of reading, I find that I have equated my private, venturesome reading with my education, such as it is. There's much to be learned from this. All useful knowledge is perhaps subversive, innocently and ignorantly so at first. I assumed, with the wisdom of children, that it was best not to mention to my fourth- and fifth-grade teachers, Miss Taylor (who made us all take a Pledge of Life-

long Abstinence from Alcohol) and Miss Divver, that I had read
Antonina Vallentin's *Leonardo* and Van Doren's *Franklin*, and
wanted very much, if I could find them, to read *Frankenstein* and
Dracula.

I also read in those grammar-school years the nine volumes of
Alexander Dumas's *Celebrated Crimes*, a dozen or so volumes of
E. Phillips Oppenheim, and the three-volume *Century Dictionary*
(I have always accepted dictionaries and encyclopedias as good
reading matter).

Last year I met a young man in his twenties who is illiterate;
there are more illiterates in Kentucky than anywhere else, with the
possible exception of the Philippines and Haiti. The horror of his
predicament struck me first of all because it prevents his getting a
job, and secondly because of the blindness it imposes on his imagi-
nation. I also realized more fully than ever before what a text is and
how it can only be realized in the imagination, how mere words,
used over and over for other purposes and in other contexts, can be
so ordered by, say, Jules Verne, as to be deciphered as a narrative of
intricate texture and splendid color, of precise meanings and val-
ues. At the time of the illiterate's importuning visits (I was trying
to help him find a job) I was reading Verne's *Les enfants du capitaine
Grant*, a geography book cunningly disguised as an adventure
story, for French children, a hefty two-volume work. I had never
before felt how lucky and privileged I am, not so much for being
literate, a state of grace that might in different circumstances be
squandered on tax forms or law books, but for being able, regu-
larly, to get out of myself completely, to be somewhere else, among
other minds, and return (by laying my book aside) renewed and re-
freshed.

For the real use of imaginative reading is precisely to suspend
one's mind in the workings of another sensibility, quite literally to
give oneself over to Henry James or Conrad or Ausonius, to Yuri
Olyesha, Bashō, and Plutarch.

The mind is a self-consuming organ and preys on itself. It is an organ for taking the outside in. A wasp has a very simple ganglion of nerves for a brain, a receptor of color, smell, and distances. It probably doesn't think at all, and if it could write, all it would have to say would concern the delicious smell of female wasps and fermenting pears, hexagonalities in various material (wood fiber, paper) in the architecture of nests, with maybe some remarks on azimuths (for the young). Angels, to move to the other pole of being, write history and indictments only, and if Satan has written his memoirs they would read like Frank Harris, and who would want to read them?

Music is as close as we will get to angelic discourse. Literature comes next, with a greater measure than music can claim of the fully human. I am on slippery ground here, as the two arts can share natures. *Don Giovanni* and the *Mass in B Minor* are both music and literature; all of what we now call poetry was for many centuries song. Even if we had all of Sappho's texts, we would still be without the tunes to which they were sung—like having only the libretto of *The Magic Flute*.

Shakespeare's sonnets and the *Duino Elegies* are a kind of music in themselves.

By "fully human" I mean *The Miller's Tale* and the *Quixote*, Surtees and *Humphry Clinker*, Rabelais and Queneau. The fully human is suspect in our society; Kentucky high schools keep banning *As I Lay Dying*. We do not read enough to have seen that literature itself is not interested in the transcendental role society has assumed for it. The pleasure of reading has turned out not to be what our culture calls pleasure at all. The most imperceptive psychologist or even evangelist can understand that television idiotizes and blinds while reading makes for intelligence and perception.

Why? How? I wish I knew. I also wish I knew why millions of bright American children turn overnight into teenage nerds. The substitution of the automobile for the natural body, which our cul-

ture has effected in the most evil perversion of humanity since
chivalry, is one cause; narcosis by drugs and Dionysian music is an-
other. I cannot say that an indifference to literature is another
cause; it isn't. It's a symptom, and one of our trivializing culture's
great losses. We can evince any number of undeniable beliefs—an
informed society cannot be enslaved by ideologies and fanaticism,
a cooperative pluralistic society must necessarily be conversant
with the human record in books of all kinds, and so on—but we
will always return to the private and inviolable act of reading as
our culture's way of developing an individual.

Aunt Mae didn't read the books she inherited from Uncle Eu-
gene, slain in France fighting for my and your right to read what
we want to. She read *Cosmopolitan* and *Collier's* and "the *Grit*." And
Zane Grey. She knew, however, that books are important, to be
kept right-side up on a shelf in the living room near her plaster-of-
Paris life-size statue of Rin Tin Tin.

The world is a labyrinth in which we keep traversing familiar
crossroads we had thought were miles away, but to which we are
doomed to backtrack. Every book I have read is in a Borgesian se-
ries that began with the orange, black, and mimosa-green cloth-
bound *Tarzan* brought to me as a kindly gift by Mrs. Shiflett in
her apron and bonnet. And the name Shiflett, I know because of
books, is the one Faulkner transmuted to Snopes.

And Aunt Mae, whose father was a horse doctor but not a com-
mon horse doctor, looked down her nose at the Shifletts of this
world as common white trash (she was an accomplished snob, Aunt
Mae). A few years ago, exploring the Cimitière des Chiens et
Chats in Paris, I came upon the grave of Rin Tin Tin, Grande Ve-
dette du Cinema, and felt the ghost of Aunt Mae, who had always
intended "to visit the old country," very much with me, for I'm old
enough to know that all things are a matter of roots and branches,
of spiritual seeds and spiritual growth, and that I would not have
been in Paris at all, not, anyway, as a scholar buying books and

tracking down historical sites and going to museums with edu-cated eyes rather than eyes blank with ignorance, if, in the accident of things, Aunt Mae and Mrs. Shiflett had not taken the responsi-bility of being custodians of the modest libraries of a brother and a son, so that I could teach myself to read.

Tom and Gene

RALPH EUGENE MEATYARD met Thomas Merton on January 17, 1967, at the Trappist monastery of Our Lady of Gethsemani near Bardstown, Kentucky. The day was bright and cold. The next day Merton wrote his friend Bob Lax that he had been visited by "three kings from Lexington," as Michael Mott records in his biography. Tom's letters to Lax were always madcap and full of private jokes, so that why we were cast as the Magi must remain a mystery. We brought no gifts, we came in Gene's car, and we were decidedly remote in religion: Gene, I think, was a lapsed Methodist; Jonathan Williams a very lapsed Episcopalian; and I a Baptist who would figure in Tom's judgment as the only real pagan he had ever met.

Tom was grateful that we weren't pious. His life was bedeviled by people who had read a third of *The Seven Storey Mountain* and wanted to say they had met him. Just why we made our visit I'm not certain. Jonathan Williams was well into his ongoing enterprise of meeting every person worth knowing on the face of the earth, and had remarked that he "had no sense of Merton the man" and wanted to look in on him. Jonathan was at the time on a weeklong visit at my house, showing slides and giving readings at the University of Kentucky. Some years before he had introduced me to Gene Meatyard, optometrist and photographer. Gene and I had become friends, and I had begun urging him to photograph

32

literary figures. Eventually he photographed Louis Zukofsky, Wendell Berry, James Baker Hall, Jonathan Greene, and Hugh Kenner, among others. It was therefore as a portraitist that he was along. I was there because Tom had read my poem *Flowers and Leaves* (to his fellow monks, at table, moreover; the silent Trappists may hear secular writing while they eat, and it was one of Tom's chores to read to them).

This frosty January day has become magic in my memory. Merton met us at the lodge. He was dressed in dungarees, sweater, and hooded jacket. He looked like a cross between Picasso and Jean Genet. He got into Gene's car to guide us to his cement-block one-room cabin in the woods in back of the abbey. Tom had just before this become a desert father, the first in a thousand years. He remarked wryly that the abbot suspected him of having orgies there. (Joan Baez had been a visitor a short time before, against all rules: two signs along the approach to Gethsemani warned away the female sex—the first read NO LADIES PERMITTED, the second NO WOMEN.) Tom and the abbot had had disagreements about the rules for a desert father, especially about Tom's growing predilection for visiting people in Louisville and Lexington. "Who's to say," Tom countered, "if Saint Anthony didn't take the streetcar into Alexandria when he'd had it with his loneliness?"

The hermit's cabin had its bed zoned from the rest of the inside by a Mexican blanket. We got to see the bed—spartan to be sure when Tom reached under it to bring out a half bottle of the local bourbon. There was an oil stove for heat as well as a handsome fireplace. A few sacred icons, all folk art, were on the walls. The books were largely poetry. I noted letters on his desk from Marguerite Yourcenar and Nicanor Parra. Tom Merton knew no strangers; we settled in to good talk as if we had known each other for years.

Gene had begun the conversation as we got out of the car. His incredibly sharp eyes had seen a rock by a pine tree near the cabin

porch, and he remarked casually that it had been photographed by someone and used on the cover of a New Directions book. Tom had taken the picture. So Gene and Tom first met as fellow photographers. And it is not every day you meet someone who can identify from a phenomenal visual memory a rock among rocks and a pine among pines. (I once needed Gene to identify a man in his thirties of whom I had only a photograph at age ten. This was at an airport; Gene identified him as he emerged from the plane.)

My notes say that at some point Tom did a dance, which he said was Chilean, though I now cannot remember any music or Tom dancing. He made drawings for us by dipping weeds in ink and slapping them onto a sheet of typing paper. He drew a horse, very Zen in its strokes. We had arrived at eleven, having been lost for an hour on Kentucky back roads; the matter of lunch arose. Tom served us goat cheese made at the abbey, packets of salted peanuts, and jiggers of bourbon. Jonathan asked at this epicurean meal what Tom was writing. He was writing what came to be Section 35 of *Cables to the Ace* (1968). Would we like to hear some of it?

He read: "C'est l'heure des chars fondus dans le noir de la cité. Dans les caves, les voix sourdes des taureaux mal rêvés! l'océan monte dans les couloirs de l'oeil jusqu'à la lumière des matins: et ils sont là, tous les deux: le Soleil et le Franc-Tireur."

My notes say: Gene photographed as we talked. For the rest of their friendship, up until Tom's departure for the East, Gene photographed.

Tom's bladder needed frequent relief. The outhouse was the home of a black snake. Tom instructed us, if we wanted to use this amenity, to kick the door first and shout, "Get out, you bastard!" In the afternoon we walked up the hill to the reservoir—the Monk's Pond of Tom's magazine—and it was on this walk that he talked about *Flowers and Leaves* and suggested that Jonathan consider becoming a Trappist. In the summer, he said, there was nude bathing in the pond for those so minded, and he remembered swimming there with the Stephen Spenders.

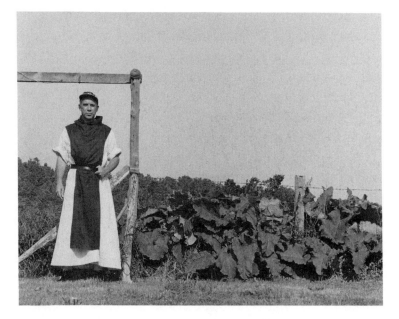

My notes say: A warm, generous, frank, and utterly friendly man.

We left at four, having been given bread from the refectory and having been introduced to Brother Richard, who, clerking in the abbey's cheese shop, was allowed to talk.

When Bonnie Jean Cox later met Tom, she whispered to me, "This is not the man who wrote *The Seven Storey Mountain*," as indeed he wasn't. It was Bonnie's observation, when we heard of Tom's death in Bangkok, that he had held out his hand to God on his arrival in heaven and hooted, "Hello you old son of a bitch!"

Tom's reputation was already myth in these last two years of his life when Gene Meatyard was one of his closest friends. Gene, merriest of men and with a wicked sense of humor, delighted in my telling him that I had been to an English Department cocktail party where some visiting scholar was impressing us with his inside dope about Father Marie Louis, Order of the Cistercians of the Strict Observance. Did we know—few did—this English prof asked us in awed tones, that Merton had retreated from the monas-

tery, incredibly disciplined as it was (sign language only, vigils at the altar through the night, incessant prayer and unremitting study), for a bare hut in a Kentucky forest, where he'd grown a long beard, and where absolutely no one saw him. He communicated only with God.

This professor was enjoying himself immensely, imparting privileged information to the ignorant.

At an opportune moment, I said, watching the ghastly look that grew on his face: "Tom Merton was by the house day before yesterday, turning up on my porch after a phone call from the bus station. He was in mufti: tobacco-farmer field clothes, with a tractor cap. He made quite a dent in my bottle of Jack Daniels, and was excited to find that I had a text of Bernardus Silvestris's *De Mundi Universitate*, about which we had a lively discussion. We also talked about Buster Keaton and the superiority in comic genius of the silent film over the talkies, Charles Babbage, French painting, and Lord knows what else, including Catalan, a dictionary of which he'd hoped I could lend him."

It was quite clear that the professor took me to be not only a fool but a jackanapes, and soon after this I was told that one of my department who listened to this drivel reported me to the administration as a fraud. (I had just come to the university, and was suspect for various other reasons.)

I am sorry that I could not have recounted a later appearance of Tom in Lexington, when he, Gene, an editor of *Fortune* and Columbia classmate of Tom's, and I went to lunch at the Ramada Inn. The editor of *Fortune* had rented a car at the airport, wrecked it, and had minor cuts and bruises, enough to have bloodied his clothes. He sported a bandage around his head and invited second looks. Gene was in a neat business suit. Tom was, as before, dressed as a tobacco farmer. The four of us were served with the utmost courtesy, beginning with martinis, which Tom downed four of. One of Tom's topics at this meal was the architecture of Buddhist temples.

It is my guess that Tom was, like Saint Paul, all things to all men. The pious monk of the professor at the cocktail party certainly existed. He was indeed the vigilant before the altar in the cold watches of a winter's night. He was also the man who asked Joan Baez to take off her shoes, as he hadn't seen a woman's foot in years. He showed me where she'd danced in the wheat field for him, barefoot and singing. He had a healthy distrust of the trendy and velleitous in religion. He winced when pious visitors from the world hunted him down. One Sunday afternoon he, Gene, Bonnie, and I walked to the remotest part of a field, in hiding from the inevitable elbow swingers. "Even so," he said, "it was here that a car stopped, and a family got out, and before I could get away they held up their infant son dressed in a Trappist habit." It was this same afternoon that we learned that Tom gave lectures to the abbey on Eastern religions. He'd looked at his watch, said, "Damn! I have to jackrabbit over to the big house and do the Sufis," and trotted off at a lively pace, shouting that he'd be back in fifty minutes.

Gene Meatyard was at this time deep into Zen, which he saw as a philosophy relevant to his art as well as to his life. Zen was, however, but one of many of Gene's concerns. He was, when he met Tom Merton, one of the most distinguished of American photographers, all the more distinguished and typically American for being invisibly in a Kentucky university town. He was known to the members of the Lexington Camera Club, which was, with Van Deren Coke, Guy Mendes, James Baker Hall, and Robert C. May among its members, one of the epicenters of American photography. He had a large circle, or circles, of friends. Born in 1925 in Normal, Illinois (he treasured that name), he invented himself. He was deeply, eclectically educated, despite a typical high school and Williams College. When he met Tom Merton he was married to the charming and beautiful Madeleine ("Mattie") and had three children, Mike, Chris, and Melissa. Their home, which Tom visited frequently, was as friendly and comfortable a place as a home can be. While bearing the stamp of all the Meatyards' hobbies, it

was Gene's hand that one saw traces of everywhere—his *objet-trouvé* sculptures, his collection of rare recordings of jazz, his books and photographs.

The laughable was Gene's passion. He had a notebook full of peculiar names which led, in time, to the idea of Lucybelle Crater and her daughter Lucybelle Crater (a misremembering of Flannery O'Connor's Lucynelle Crater and her daughter Lucynelle Crater). One of Lexington's citizens at the time was Carlos Toadvine, whose stage name was Little Enis. Gene was fascinated with his own name, Meatyard, and was delighted when I pointed out that it is the Middle English *meteyeard*, or yardstick, cognate with *Dreyfus*. And that his first name is properly pronounced *Rafe*. He approved of Edward Muggeridge's changing his name to Eadweard Muybridge.

My first response to Gene's photographs was to see them as images parallel to Henry James's evocation of hallucinations—the blurred, half-recognizable face in the shadows. I did not know at the time that Gene had worked in many styles, that he had made documentary studies as brilliant as Margaret Bourke-White's and had begun as a fairly traditional modernist, echoing Minor White and Charles Sheeler. All the Merton portraits belong to a period of experimentation in which Gene was exploring his own mastery of the camera. He would take pictures seemingly offhandedly, without looking in the viewer. There was an afternoon of talk with Tom at Gene's house in which he took some amazing photographs all but secretly. I was aware that the camera was there on its tripod and that Gene fiddled with it from time to time.

There were also elaborate stagings and poses. There was an afternoon when Gene took Tom and me to an abandoned farm, standing us under a clothesline, having us peer into a rain barrel, posing us back to back like duelists. This was at the time that the Anglican Bishop Pike had wandered off into a desert in the southwest, and the papers were full of speculation as to his whereabouts. "All bishops are mad," Tom offered.

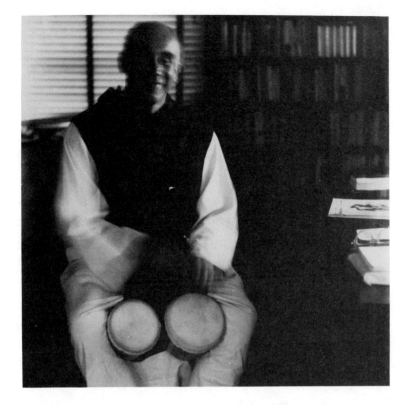

When Edward Rice's *The Man in the Sycamore Tree: The Good Times and Hard Life of Thomas Merton* was published in 1970, Gene read it with care and a great deal of skepticism. This was the first exposure of Merton as a thoroughly human, frequently confused complex of personalities. The Merton who emerges from Michael Mott's sensitive, thorough, and uncompromisingly honest biography of 1984, *The Seven Mountains of Thomas Merton*, is a turbulence of conflicting directions. He was a hermit committed to silence, meditation, and solitude who was one of the most gregarious of human beings. His vow of chastity had to contend with an uncontrollable desire to be in love and to be loved. In the 1960s he was very much like an adolescent just discovering sex. In religion he sometimes seemed to be more of a Sufi and Buddhist than a Christian. His poetry at this time made a quantum leap into a

highly charged style derived from Nicanor Parra and a new vision of absurdity.

Gene Meatyard certainly contributed to this existentialist view of the world. Gene had made a kind of surreal poetry of the visual.

Gene's Lucybelle Crater series—couples wearing the same masks in every picture, one a transparent mask that aged the subject, the other a grotesque Halloween witch's face—is contemporary with *Cables to the Ace* and *The Geography of Lograire*. Gene was interested in what happens to the rest of the body when the face is masked. A mask, like an expression, changes the way we see feet and hands, stance and personality. These photographs are both satiric and comic; their insight, however, is deep. We are all masked by convention and pretense. Merton would have said that we are masked by illusion. He was, as Gene perceived, a man of costumes (masks for the whole person). His proper costume was a Cistercian robe, in which he looked like a figure out of El Greco or Zurbarán. He liked wearing this in the wrong place—a picnic, for instance, of which Gene made a set of photographs. This was one of Gene's favorite modes: the candid shot of families and groups, a use of the camera as old as photography but in Gene's masterly hands a psychological sketchbook and a comedy of manners.

The breakthrough in Tom's poetry came from a convergence of forces: reading Flannery O'Connor (whose stories are Christian mimes in a comic vernacular), *Mad* magazine, and the ads in *The New Yorker*, and a vision from the cargo cults of New Guinea. *The New Yorker* ads seemed to Tom to disclose the true sickness of our time. They are *chic* and unobjectionable, and yet they are as vivid a temptation of Saint Anthony as any painted by Bosch or Brueghel. They present, masked, what *Mad* openly and jeeringly exposed. And the New Guinea cargo cults: expectations by primitive people that the American army would someday return with the same kind of wonderments (airplanes, canned food, whiskey, recorded music, magic medicine and skilled surgeons,

bombs and rifles, boots and metal hats) they had brought in the Second World War.

Is not modern Christianity, Tom asked in his poetry and in his inmost meditations, our cargo cult? Physical desire, as any Buddhist knows, is insatiable. It has no plateau of satisfaction; it offers no rest. The family with one automobile wants two; the family with two, three. Wealth has become not advantage and pleasure in the world but a hunger for more wealth. Thus all sense of measure, of inner peace, becomes impossible.

Both Gene and Tom had evolved a personal discipline that they associated with Zen—self-mastery as well as mastery over adversity. Tom at this time was in correspondence with hundreds, and was maintaining friendships of varying intensity (from deep love to the casually interesting); he was reading in the literatures of both sides of the world; he was practicing the severe discipline of being a desert father. He wrote a phenomenal number of pages in these years: a *Lives of the Saints* that still lies in the vaults of the Vatican, unpublished; *Confessions of a Guilty Bystander* (1966); his journals, letters, poems. (Each monk in a Trappist community has his work; Tom's was writing.) Each friend—psychiatrist, publisher (James Laughlin of New Directions, who was worldly confessor for Tom's very worldly sins, literary adviser, and emissary between Tom and the literary establishment), typists, devoted conspirators and runners of errands, even suppliers of money for phone calls and drink (this kitty was known as the Mars Bar Fund, all contributions welcome), Islamic theologians, and on and on—interacted with a different element of Thomas Merton's complicated roundness.

In Gene Meatyard he must have seen, at first, a photographer and a quiet ironist. Later he saw something like his opposite: a man happily married, with children, a profession, and an art. Such complementarity is rare. Gene, whether making chocolate for Christmas gifts—chocolate as eaten by archangels, dominions, and powers—or violet jam, did everything in the best way possible. He

had combined the two ways of making people see better, optometry and photography. He had perfect manners; he was intelligent, responsive, and good-natured. And, like Tom, he could deplore and delight in the absurdity of things. Gene, who normally drove and read at the same time, could rejoice in coming upon a Lexington driver who was technically blind, with a license from the police that restricted his driving to less-traveled streets. *Mais bien sûr!* was Tom's approval of both these apparent absurdities.

The relationship of artist and model is one that has taken its place as a subject in art at least since Vermeer. Picasso meditated on it in many suites of drawings and etchings; it is implicit throughout Rembrandt. In our time, artist and subject have an equal claim on our attention. When Henri Cartier-Bresson photographed the old Matisse, the result is "a Cartier-Bresson," the subject of which is Matisse. All of Gene's photographs of Tom Merton are "Ralph Eugene Meatyards," subject: Thomas Merton.

Gene's studies of the Zukofskys, Louis and Celia, done in their New York apartment, are also very much "Meatyards." They had met Gene at my house in Lexington, Kentucky, and knew his work and what they were in for. Gene liked to say that he photographed essence, not fact. Gene read Zukofsky before he photographed him; Zukofsky's layered text turns up as double exposures in the portraits, as oblique tilts of the head, as blurred outlines. The "innocent eye" of Monet and Wallace Stevens was not for Gene: he needed to know all he could about his subjects. He did not, for example, know enough about Parker Tyler, who sat for him and came out as a complacent Southern gentleman on a sofa; the photograph is neither Parker Tyler nor a Meatyard.

The first thing we notice about Gene's portraits of Tom is the wild diversity. Here's Tom playing drums, and Tom the monk, and Tom the tobacco farmer, and Tom the poet (holding Jonathan Williams's thyrsus). Many were taken when Tom could not have been aware that he was being photographed. Many are posed in a collaboration between artist and subject.

Gene had agreed with me that Tom could look eerily like Jean Genet—Gene Jennet, as Gene pronounced the name with typical Meatyardian intrepidity. This was within the psychological game of belying appearances, one of Gene's games. For Tom resembled the French outlaw and prose stylist only when he was in his farmer's clothes; that is, in a mask for the body. (Gene had no interest in the nude, and I know of only one such photograph, made for a show of the naked body; Gene predictably photographed his subject in a bathroom, where nudity is normal and necessary, and chose for his model the shyest and most modest of his friends, the poet Jonathan Greene.)

One of Gene's unachieved projects was to make photographs to illustrate William Carlos Williams's *Paterson*, a work he found endlessly interesting. By this time Gene had already started going wide afield to photograph portrait subjects, and I assumed that he was off to Paterson, New Jersey. "Oh no," Gene said, "I'll do the photographs here, in Lexington." This is worth knowing, and Williams would have gasped at the originality of the perception, at a fellow artist who saw the truth of his poem as a universal myth. A Dutch madonna of the sixteenth century is a Dutch girl with a Dutch baby on her lap. What Williams wrote about Paterson must be true of Lexington, and Gene's pictures would have been a commentary on *Paterson* at the highest critical level: parallel creation.

Tom Merton has been, and will be, written about extensively. He was photographed as much as the Pope. We will always be reinterpreting Merton the man, with all his divergent energies, along with Merton the theologian, moralist, and philosopher. A photographic record is so obviously prime material for the biographer and commentator that we forget its importance because of its usualness in our time. Try to imagine an image of Jesus, drawn or painted from the life, and the kind of writing it would generate. Consider the mythic charisma Lincoln's photographs have contributed to our sense of him. We are all healthily aware that photographs lie, deceive, and misrepresent, and yet we go right on

reading them as if they are expert witnesses. Richard Nixon's unfortunate face seems to spell out his lack of character, his villainy, his deviousness. "The body," said Wittgenstein, "is a picture of the soul."

Another distinguished American photographer, Douglas Haynes of Arkansas, photographs children only and has a thousand tricks of gesture and voice for beguiling his subjects into the maskless natural innocence he's a master at capturing. A photographer of animals has the same problem, for a photograph is a stage, the subject an actor, and the moment of exposure a cue. Gene had no studio, never directed his subjects, and usually looked away as if uninterested before he triggered the shutter. I have spent several days being photographed by Gene and never knew when he was photographing. We kept a conversation going, usually an exchange of anecdotes. I knew, however, where Gene's eyes were: they were on light, on shadows. A Meatyard photograph is always primarily an intricate symmetry of light and shadow. He liked deep shadows of considerable weight, and he liked light that was decisive and clean.

He liked resistant structures. Many of Gene's photographs are of buildings, especially interiors, in the process of demolition, or of buildings holding up under time. Time itself may have been his ultimate subject—what it does to people and the world. The Lucybelle Crater sequence is of people momentarily aged forty years by masks. His own triumphant portrait by Guy Mendes is of him waving good-bye with his hat, as if being seen off on a train.

Gene was, at least after a year of knowing Merton, conscious of photographing a figure who was undergoing a transition. There were rumors that Merton was going to live in the east, probably as a Zen monk in Japan. ("Not Tom!" Gene said. "Not him!") There was the sense that something had to give: that Tom was being torn by the world and the church, by his genuine desire for total solitude and his equally genuine passion for people, for talk. He wanted Christianity to be refound, and the church was edgily

afraid of him. He was a new thing in Catholicism: a truly ecumeni-
cal spirit. When he wrote about the Shakers, he was a Shaker. He
read with perfect empathy: he was Rilke for hours, Camus, Faulk-
ner. I remember an afternoon when he turned into Heraclitus and
through this mask savaged Martin Heidegger. "Heidegger under-
stood nothing of Being." Psellos said that the mind could take any
form, but I wonder if there has ever been as protean an imagina-
tion as Thomas Merton's? He could, of an afternoon, dance to a
Louisville jukebox to Bob Dylan, argue an hour later with James
Laughlin about surrealism in Latin American poetry, say his of-
fices in an automobile headed back to Gethsemani, and spend the
evening writing a mullah in Pakistan about techniques of medi-
tation.

Gene photographed Tom with a firm realization that he was
photographing a Kierkegaard who was a fan of *Mad*; a Zen adept
and hermit who drooled over the hospital nurse with a cute behind
and well-turned ankle, and who could moreover sweep such a
nurse off her feet; a man of accomplished self-discipline who some-
times acted like a ten-year-old with an unlimited charge account
at a candy store.

It must be put on record that both Gene and Tom were as stub-
born as mules. They knew their minds, as genius always does, and
when they went headstrong into an enterprise nothing could stop
them. Both were stoically indifferent to their ailing bodies. They
enjoyed having difficult and untenable prejudices. Gene hated
television and the movies, color photography ("just some chemi-
cals in the emulsion, nothing to do with photography"), and espe-
cially color slides of paintings. I had lots of these, both as teaching
aids and for my delight. Gene would sit patiently through a new
box of slides if he turned up when Bonnie Jean and I were having an
evening of projecting.

"Oh Lord!" Gene would say. "This man can't draw worth a
damn."

"Gene, this is Rembrandt." (Or Caravaggio, or Degas.)

"I don't care who he is. The human leg can't bend that way."

When he brought his photographs over to show, always mounted, he was modestly silent. We did the talking, not he. He only talked about others' photographs. I like to think that Gene's final suite of photographs—of Kentucky trees winter-bare, made Cézanne-like by kicking the tripod—were a continuation of the Merton photographs, for they were Tom's favorite place, the Kentucky woods. Merton's cabin was remoter than Thoreau's, and he was there for twenty-seven years more than Thoreau lived at Walden. They were both men suspicious of man's wisdom but in awe of and in search of God's.

The last time Gene and I were present with Tom was with Tom's spirit only. We were in Louisville, at dinner at Tommie O'Callaghan's, Tom's devoted patron, typist, and go-between with the world. John Howard Griffin was there also. Tommie was one of the few people who had demanded and been allowed to see Tom's body in its U.S. Air Force coffin. She had not been able to recognize him, so severe was the facial distortion. Tom, who noticed everything and knew more about the world than forty other people together, had not noticed a frayed electrical cord to his fan in Bangkok, and had not known that the east has direct current rather than alternating. In *Cables to the Ace* he had written:

> *Oh the blue electric palaces of polar night*
> *Where the radiograms of hymnody*
> *Get lost in the fan!*

And Gene called me one Sunday morning to say that he'd had a dream about Tom. Tom was getting off an old-fashioned electric trolley in some eastern city (turbans, robes) and its trolley pole had fallen and hurt him. A few days later he called to say that he'd heard of Tom's death by electrocution in Bangkok.

Taking Up Serpents

THERE ARE ANCIENT MANUSCRIPTS in which the Gospel of Mark ends "Then they went out and ran away from the tomb, beside themselves with terror. They said nothing to anybody, for they were afraid." Beyond this eloquently abrupt stop, which any master of narrative must stand in awe of, other equally ancient manuscripts add various scenes of Jesus' resurrected presence to his women friends and to his disciples. The Oxford Revised Standard Bible (1962)—the King James Version of 1611 tidied up and corrected in the light of current scholarship and English usage—relegates these additions to a footnote and says that they are of dubious authority.

These verses have Jesus instructing his disciples thus (in the 1611 text):

> Goe yee into all the world, and preach the Gospel to every creature. He
> that beleeveth and is baptized, shalbe saved, but he that beleeveth not,
> shall be damned. And these signes shal follow them that beleeve, In my
> Name shall they cast out devils, they shall speake with new tongues,
> they shall take up serpents, and if they drinke any deadly thing, it shall
> not hurt them, they shall lay hands on the sicke, and they shall recover.

The Jacobean committee of translators were following William Tyndale's version of 1534 sneakily and without attribution. But in these verses they changed his "and shall kill serpents" to

"shall take up serpents"—correctly, if you follow the Greek, which in one text has *kai en tais khersin opheis arousin* (in their hands shall lift up snakes) and in another simply *opheis arousin* (shall lift up snakes). Saint Jerome translated the Greek as *serpentes tollent* (they shall raise up snakes).

Of these "following signs" as they are acted out by contemporary Christians, speaking "with new tongues" has been ignorantly misunderstood to be not the gift of speaking foreign languages that was given the disciples at Pentecost but gibberish called the Unknown Tongue. Prudent Christians down the centuries have taken the snakes and poison to be the same kind of hyperbole as moving mountains by faith (Matthew 17:20). By the middle of the second century the philosopher Celsus was talking about the chuckleheadedness of Christians (their *kouphotes*, thinness of intellect).

As you read this there are Christians in Alabama, Kentucky, North Carolina, and Tennessee allowing themselves to be bitten by rattlesnakes (*Crotalus horridus*), swilling strychnine from Mason jars, and babbling in the Unknown Tongue. Dennis Covington has made himself uncomfortably familiar with The Church of Jesus with Signs Following (Scottsboro, Alabama) as well as the snake-chunking congregation in Jolo, West Virginia. In *Salvation on Sand Mountain: Snake Handling and Redemption in Southern Appalachia* (1995), he explores their ecstatic orgies, their theology, their psychology, their history and sociology.

He got onto the handlers of serpents after a stint as a reporter in El Salvador, where he seems to have become familiar enough with human cruelty and violence that suicidal fanatics playing with deadly snakes was by comparison a benign idiocy. As a stringer for the *New York Times* he was sent to cover the trial, in Scottsboro, Alabama, of the Reverend Glenn Summerford, pastor of The Church of Jesus with Signs Following, now doing a stretch of ninety-nine years for attempted murder. The victim was his

wife, whose hand he held at gunpoint in a box of rattlers. She was twice bitten and would be dead except that the Reverend Summerford passed out with drink afterward, and she called for help and crawled to the highway where an ambulance found her.

These Christians who risk death twice weekly with snakes and poison are Flannery O'Connor people, Faulkner's Snopeses, Erskine Caldwell's sharecroppers. To southerners they are white trash. Historically, they come out of northern England and Scotland, as their names attest. They came to the United States, poorest of the poor, and settled in Appalachia. They are farmers, coal miners, unskilled workers, drifters. Their plaintive music is the very voice of defeat and despair: "If it weren't for bad luck I'd have no luck at all." Close up, they are just people, congenial, witty, friendly; in the mass they display a distinctive group psychology of half-witted intransigence in civilized behavior. They are suspicious, mean, lethal, backward.

They are sentimental. Crossbred with the Welsh, who will believe anything sufficiently incredible, they are capable of deep feeling and ecstasy. They have no self-control whatsoever.

When Covington became interested in them after the Reverend Summerford's trial, he visited their church and saw the snakes and the jars of strychnine. For music they have amplified guitars and tambourines. They sing and dance. They go into trances. They are fixated on one part of the Bible only, Mark 16. Their theology is simplicity itself. Jesus is Lord, and He wants us to be bitten by rattlesnakes, which if we have faith cannot harm us, and to drink strychnine and not die. There are virtuosi who also hold their hands to blowtorches and take handfuls of live coals from the stove, but these are show-offs, *kouphotikoi*.

Once bitten, they of course refuse medical treatment, though there are backsliders who howl in pain for an ambulance. There are champions like George Went Hensley who was bitten 116 times before dying of rattler venom. A cynic might remark how a

gene pool purifies itself, but what we have in the snake handlers, as Covington makes so vivid, is an anthropological cult as distinct as any totem clan in Australia, Burkina Faso, or British Columbia. Covington is more interested in the pathos and human strangeness of it all. I wonder, however, if the chunkers aren't an atavistic coven of snake worshipers for whom Jesus *is* the rattler?

As far as I can make out from Covington's account and from Thomas Burton's *Serpent-Handling Believers* (1993 — scary and revolting photographs on every other page), these extreme literalists have no interest in the rest of the gospels. They do not observe Christmas or Easter. They do have communion, with grape juice and flat bread, doctrinally pedantic about what's going on. They are *not* partaking of Christ's body or drinking His blood. ("We ain't cannibals! We ain't vampires!") They cast out devils and consider other religions as devil worship.

Covington, who was raised as an Alabama Methodist and later joined the Baptists, thought at first that he was seeing in the Church of Jesus with Signs Following an authentic and very rich Christianity. These people washed each other's feet, kissed and hugged, and shared the Mason jar of strychnine.

Covington parted with them when he gave his first sermon. (He had already become one of them by holding a snake, unbitten, and by joining in the orgies of singing and dancing.) He took as his text more of Mark 16, which begins with Jesus' postmortem appearance to Mary Magdalene, the first to see Him on the first Easter. Covington interpreted this as an argument for women preachers (forbidden among snake chunkers). A few years ago Edward Schillebeeckx, the Dutch Christologist, used this same argument for women in the priesthood; The Church of Jesus with Signs Following and the Vatican were both outraged.

Dennis Covington is a fine prose stylist, always spare, always sharply focused. There are no photographs and yet his book is more visual than Thomas Burton's. From Melville forward, Amer-

ican writing has specialized in technologies that also involve techniques of the spirit: Hemingway and the *corrida*, Mark Twain and piloting. Covington says, but does not show, that his quest was through the snake people to his own roots in their common ancestors. If he wants to show that literacy, a breaking out of the parochial, and an intelligent liberalism can free the Appalachian from centuries of bondage to ignorance and superstition, I suppose he's right. But such an emergence is at the edge of an enormous cultural identity that shows every sign of persisting. Snake handling began ninety years ago and is growing rather than diminishing. Other techniques of these people—marijuana growing, bootlegging, cockfighting, brawling families, drunkenness, shiftlessness, and general mumpery—still flourish.

They do not fit into the new industrial South—who does?

Their taking up a suicidal religion, so gaudy and so exclusive, is a defiance of a world they cannot understand. One detail, of a hundred such muted but meaningful ones: when the Reverend Summerford had held a gun on his wife and made her be bitten by a rattler, and was trying to get her to write a fake suicide note, dying as she was, the TV set was on.

Shaker Light

A SHAKER ORDINANCE SPECIFIES that "when we clasp our hands, our right thumbs and fingers should be above our left, as uniformity is comely." This admonition and a thousand others the Shakers carried in their heads; only late in their history, and reluctantly, did they write them down. Nor did the Spartans commit their rules to writing. A rule should be alive in one's head. A Spartan rule was to keep silent until you had framed what you had to say in the fewest possible words. In *The War Rule of the Essenes at Qumran* we read that the swords (spiritual swords, like Blake's, that would not sleep in his hand "till we have built Jerusalem / In England's green & pleasant Land") to be brandished by the Children of Light against the Children of Darkness at Armageddon "shall be made of pure iron refined by the smelter and polished like a mirror, the work of a craftsman; toward the point of both sides of the blade shall be embossed figured ears of wheat in pure gold."

Sparta, Essenes, Shakers; and there are others who made their communities a disciplined harmony. The state, Lycurgus said, should be "a work of philosophy," like his own Sparta. Of all the American experiments in communal life—the Amish, Owenites, New Harmonians, Oneidans, Icarians, and many others—the Shakers stand out. Many of their beautiful farms still survive with their round barns and severely elegant meeting houses. Their cabinets and tables and chairs are indestructible. They achieved an

integrity of style comparable to and rivaling that of many great movements in the fine arts. One can say: Louis XVI, De Stijl, Art Nouveau, Shaker.

By hindsight we can see that the Shakers are architectural pioneers a good century and a half ahead of the times. Practically everything we call modern is implicit in Shaker design. Dutch and Danish simplicity has followed but never surpassed the Shakers. When the Bauhaus and its master Walter Gropius announced that art as ornament and adjunct must disappear by resolving into the total design of rooms and buildings (an idea the Bauhaus took from the Russian constructivists), the Shakers had been there before them. Indeed, Mother Ann Lee's rule that "every force evolves a form" was a text we are more familiar with in the theories of Le Corbusier and Mies van der Rohe.

It was on a winter day in Kentucky more than twenty years ago that I heard Thomas Merton say that "the peculiar grace of a Shaker chair is due to the fact that it was made by someone capable of believing that an angel might come and sit on it." He was at the time writing his introduction to *Religion in Wood* (1966), the last of an authoritative series of books on Shaker doctrine, history, and artifacts by Edward Deming Andrews and Faith Andrews. The remark was made about a Shaker chair that Tom had in his hermit's cabin in the woods around the Trappist monastery of Gethsemani.

That an angel might sit in a Shaker chair no Shaker ever doubted. They saw angels around deathbeds, they heard angels singing and wrote down the music and words. They shared the angels' freedom of movement. A Shaker reported rising from his rocking chair, spinning in the air "for the space of half an hour, like a top," zipping out over a nearby pond to spin some more, and returning to his chair, holier and happier. Two Shaker sisters once went to the moon, they said, in rocking chairs, and brought back two songs you can find in the Andrewses' *Gift to Be Simple*. This is a charming book, but the masterwork on Shaker music is Daniel

Patterson's *The Shaker Spiritual* (1979). It is also one of the best histories of Shaker life, as well as the best book ever written on American music of any sort.

There are many recordings of Shaker songs, but I have heard none with an authentic ring to them. The best-known Shaker tune is the one Aaron Copland worked into *Appalachian Spring* (1944). Modern singers are wrong to imitate his glossy bel canto reading. We have James Fenimore Cooper's word for it that Shakers sang through their noses, and their spelling is proof enough that Shaker diction was thoroughly "country" (*bile* for *boil*, *sartin* for *certain*, and so on). Ann Lee was illiterate, and her recorded witness to the reality of the Devil should stand as our guide to the Shaker voice: "I've seed him! He's big as a bar!"

They were Quakers at first. Ann Lees, or Leese, born in the factory slums of Manchester in 1736, spent her childhood working at the looms, eighteen hours a day for a few pennies. Looms are loud, cotton lint adheres in the lungs, and the work, which is mainly one of watching to see that thread has not broken from the spindles, is tedious and boring. What is a Shaker meeting house, with its majestic lines of tall windows, but a cotton mill with the looms removed? The Shakers invented space, beautifully long empty rooms full of light. And where looms might be, there were dancing Shakers, keeping time with clapping hands, dancing in complicated figures, dancing and shouting for hours and hours, singing songs such as:

> *Love the inward, new creation,*
> *Love the glory that it brings;*
> *Love to lay a good foundation*
> *In the line of outward things.*

(God, patting his and her foot—the Shaker god was both male and female—must have signaled the Angels of Architecture and Celestial Design to come and listen, and make notes.)

> *Love a life of true devotion,*
> *Love your lead in outward care;*
> *Love to see all hands in motion,*
> *Love to take your equal share.*

(Marx and Engels studied the Shakers.)

> *Love to love what is belovéd,*
> *Love to hate what is abhorr'd;*
> *Love all earnest souls that covet*
> *Lovely love and its reward.*
>
> *Love repays the lovely lover,*
> *And in lovely ranks above*
> *Lovely love shall live forever,*
> *Loving lovely lovéd love.*

Such seraphic ecstasy came from a woman who bore four children that died soon after birth. She was in a long labor with the fourth when she had the vision that spirit must renounce sex. She believed that she was a prophet who was to lead a few fervent souls toward God. She may well have come to believe that she was a reincarnation. Jesus had been masculine, a wanderer without a home, a teacher. Mother Ann would be the feminine, creative force. She would gather her followers onto farms and into a perfect life in harmony with the seasons and all the ineluctable human needs. Mother Ann did not live to see a Shaker community. She saw the beginning of one at Watervliet in New York. After her death in 1784, the communities proliferated from Maine to Kentucky, at first under the eldership of Joseph Meacham and then in their golden period under the long thirty-year leadership of Lucy Wright.

The tone and quaintness of Shaker life has attracted many historians. Dolores Hayden's *Seven American Utopias* (1976) is the best concise account. Priscilla J. Brewer's *Shaker Communities,*

Shaker Lives (1986) is a sociological study in depth, avoiding the usual awe of Shaker simplicity and near-perfection to take a realistic view of the often harsh actualities (one learns, for instance, that the odd Shaker infant found a way into their chaste world, and that there were many disillusioned defectors). Gerard C. Wertkin's *The Four Seasons of Shaker Life* (1986) is a study of the Sabbathday Lake community in Maine, with photographs by Ann Chwatsky. But the most prominent of recent attention to the Shakers was the exhibit in 1986 at the Whitney Museum of American Art, and its magnificent catalogue by June Sprigg. Any doubt remaining about the genius of Shaker design was evaporated by this show, the most extensive one ever devoted to all their arts.

Furniture and tools evolve just like living organisms; the caveman's sharpened stick became, in time, the fork. It was implicit in the cut of Shaker belief that a fork should be a fork and nothing else. They therefore rethought tools and furniture as strictly useful objects: what we perceive as character and dignity in Shaker design is their triumphant demonstration that form is good sense. They flattened the besom broom into a blade—a translation in the language of form and function. A pair of fingers, translated into wood, with the elastic strength of the wood for muscle, gives us the Shaker clothespin. The push and pull of a saw can be made a continuous force if they are translated into a circle, yielding another Shaker invention. Shaker windows were on pivots so that outside and inside were equally easy to clean.

The severe beauty of Shaker cabinets, with their cunning nests of drawers, derives from their genius for organizing space. Storage and retrieval, ease of accessibility, room to work—if work is redemption it is as much an act of worship as prayer or dancing in praise of the Lord. Every Shaker artifact can therefore be seen as the most useful form—say, for a wheelbarrow or chair or sewing table—and as proof that beauty and usefulness are the same thing.

They reinvented the world. They invented a new kind of light,

a new kind of space. One of the debates of the eighteenth century was what human nature might be, under its crust of civilization, under the varnish of culture and manners. Rousseau had an answer. Thomas Jefferson had an answer. One of the most intriguing answers was that of Charles Fourier, who was born in Besançon two years before the Shakers arrived in New York. He grew up to write twelve sturdy volumes designing a New Harmony for mankind, an experiment in radical sociology that began to run parallel to that of the Shakers. Fourierism (Horace Greeley founded the *New York Tribune* to promote Fourier's ideas) was Shakerism for intellectuals. Brook Farm was Fourierist, and such place-names as Phalanx, New Jersey, and New Harmony, Indiana, attest to the movement's history. Except for one detail, Fourier and Mother Ann Lee were of the same mind; they both saw that humankind must return to the tribe or extended family and that it was to exist on a farm. Everyone lived in one enormous dormitory. Everyone shared all work; everyone agreed, though with constant revisions and refinements, to a disciplined way of life that would be most harmonious for them, and lead to the greatest happiness. But when, of an evening, the Shakers danced or had "a union" (a conversational party), Fourier's Harmonians had an orgy of eating, dancing, and sexual high jinks, all planned by a Philosopher of the Passions.

There is a strange sense in which the Shakers' total abstinence from the flesh and Fourier's total indulgence serve the same purpose. Each creates a psychological medium in which frictionless cooperation reaches a maximum possibility. It is also wonderfully telling that the modern world has no place for either.

Freud and Marx stole ideas from Fourier by the handful, and all modern designers look to the Shakers as their forerunners. Both the Shakers and Fourier declined the Industrial Revolution just as it was beginning. Mother Ann knew her mind and heart when she fled Blake's "dark Satanic Mills" in Manchester for the green val-

leys of the Ohio and the Susquehanna. Fourier longed for the same geography. His constant vision was to found the first Harmonian Phalanx (that's a Spartan word, taken from Plutarch) in "Ohio" (which he seemed to understand was all of the frontier inland from the eastern seaboard). One has to follow Fourier in one's imagination, as no group has as yet tried his experiment. Fourier offered the founding of the first Harmony to Napoleon, at the time exiled on Elba. If the emperor would buy four hundred quaggas (now extinct—zebras with stripes on the neck only) and four hundred zebras, and have eight hundred three- and four-year-old orphans (no shortage of those in the Revolution and the Napoleonic Wars), Fourier (an accountant in a cloth firm in Lyons) would arrive and show Napoleon how to organize these citizens under a wholly new form of government, psychology, and postcivilization harmony. Every child would be a genius, would be wildly happy and totally fulfilled. Until puberty offered a wider scope for the emotions, food was to be the wee Harmonians' sensuality. Such as a bowl of raspberries in cream, heaped with a pound of refined Jamaican sugar, six times a day on breaks from working in the turnip patch, learning carpentry, typesetting, weaving and so on. Napoleon did not reply.

One Harmony would beget a second one through emulation by the envious. This is precisely the Shaker mode of reproduction; several of their hymns rejoice that the world will eventually all become Shakers by wanting to be as happy as they are.

And where they had business with the world—selling furniture, tools, livestock, cloth, oval boxes (much prized)—the world was indeed impressed. The one Shaker product that spread farthest was seeds. They were the first to offer garden and orchard seeds in colorful printed packets. Fourier, for whom the center of human life was the garden and whose Harmonies were to raise horticulture to the level of Paradise itself, would have approved of

the symbolism of a childless people (the Harmony offered chastity as one of the orgiastic modes) who were best known for their seeds.

Just around the corner from my house in Lexington, Kentucky, there stood for well over fifty years a pear tree and an apple tree that had grown around each other in a double spiral. In the twenty years I have walked past them daily, they have always got into my thoughts, and always benignly. They were a husband and wife, as in Ovid's poem in which an inseparable couple become trees side-by-side in an eternal existence. They generated in my imagination a curiosity about the myths our culture has told itself about apples and pears. Apple is the symbol of the Fall, pear of Redemption. Apple is the world, pear heaven. Apple is tragic. A golden one given first as a false wedding gift and later presented by a shepherd to a goddess began the Trojan War and all that Homer recorded in the *Iliad* and the *Odyssey*. The apple that fell at Newton's feet also fell on Hiroshima and Nagasaki and is right now embedded in thousands of bombs mounted in the heads of rockets, glowing with elemental fire that is, like Adam and Eve's apple, an innocent detail of creation if untouched and all the evil of which man is capable if plucked.

The day before yesterday this intertwined apple and pear were in full bloom. In every season these trees have been lovely, in autumn with their fruit, in winter a naked grace, in summer a round green puzzle of two kinds of leaves; but in spring they have always been a glory of white, something like what I expect an angel to look like when I see one. But I shall not see these trees again. Some developer has bought the property and cut down the embracing apple and pear, in full bloom, with a power saw, the whining growl of which is surely the language of devils at their business, which is to cancel creation.

Joyce the Reader

It is difficult to think of writers other than James Joyce the understanding of whose works is so dependent on knowing what they read. Once writers have achieved Joyce's status, curiosity alone might lead us to look into their reading. What we discover is that literature is a complex dialogue of books talking to books. We see significances generated by affinities and associations of great imaginative intensities. We are told that "the eyes of all them that were in the synagogue were fastened" on Jesus when, on a sabbath in Nazareth, he read aloud from Isaiah. A particular bond was thereby established between a reader and what he read: a bond of symbolic kinship, a reciprocity whereby Isaiah grows in our veneration because Jesus read him, and Jesus becomes that much more substantial in our sense of him because our eyes, too, can be fastened on him reading Isaiah in the synagogue.

It was Joyce's understanding of history that our future is in our past. The writer is the keeper of the past, and is therefore a guide to the future. Beside Joyce the master artificer of our time we can place Joyce the reader. He was one of the most imaginative and creative readers since William Blake, and like Blake he had an astounding ability to transform, penetrate, analyze, and interpret. Joyce was aware of (and put to good use in the library chapter of *Ulysses*) Georg Brandes's reading of Shakespeare, which was important to him because it was coming from Denmark where Joyce

began very early in his career to locate a web of significances. From Brandes, plausibly, he also learned of Kierkegaard. He already knew Ibsen and Jens Peter Jacobsen. Scandinavia became Joyce's "keen wind, a spirit of wayward boyish beauty" (as he calls the spirit of Ibsen in *A Portrait of the Artist as a Young Man*). Dublin was a Viking outpost, Joyce fancied that his blood was Norman, and there was a mystery to be solved in the historical divergence of Dublin and Copenhagen. Why was the one a paralyzed, stultifying mire of bigotry and the other a progressive, healthy experiment in tolerance, social justice, and intellectual excitement?

Both cities were in great need of spiritual housecleanings by the middle of the nineteenth century. The Scandinavians had their Grundtvig and Kierkegaard (who had Holberg to build on), their brothers Brandes and Nexø, Ibsen and Strindberg, and to all of these they listened, after much kicking and stubborn resistance. The Scandinavian pattern was to be scandalized by Jacobsen's Darwinism, by Kierkegaard's existentialism, by Brandes's strenuous liberalism, and then, after a face-saving interval, to decide that they were right and to act accordingly. The Scandinavian enlightenment was a matter of an educable, flexible people who listened to their prophets. Ireland's prophets, as Joyce noted bitterly, had quicklime thrown into their eyes.

In Ellsworth Mason and Richard Ellmann's *The Critical Writings of James Joyce* (1959; 2nd ed. 1989) we can see his attention to writers who were the consciences of their people, even such humble voices as James Lane Allen's in Kentucky or James Clarence Mangan's in Ireland.

Of the past Joyce made a synthesis that we are only now beginning to chart and understand. The genetic fission by which the arts proceed, and which happens organically and slowly in a Dickens or a Kafka, Joyce speeded up in the boldest experiment in the history of literature. He needed to know the past, to search it for those inexplicable correspondences that he saw Blake taking from

Swedenborg and Böhme, and which seemed to have such meaning for Baudelaire, Rimbaud, and others (Fourier, for instance, and at a different stratum of thought, Vico, Michelet, and Quinet). He needed to put himself back with Dante, for whom all of creation was legible as a symbol, back to the sense from which all art springs that everything fits into a unity, which Heraclitus called the logos, and for which many modern writers were searching (Yeats would be Joyce's immediate example) with various wild lunges and imaginative forays.

If the synthesis could be achieved, it would have to be universal, inclusive, tragic. What Joyce envisioned as a reader was more like an anthropology of the human imagination than a critical assessment. For all his saying that *Lady Chatterley's Lover* seemed to him to be the work of an Italian greengrocer, Joyce knew that it is as much a narrative told by the world's voice as *The Brothers Karamazov.* The past is a midden; it is the city dump at Oxyrhynchos outside Alexandria where we find shreds of papyrus with texts by Aristotle and Sappho on them. To mime Gerty MacDowell, Joyce needed Marie Corelli, not Flaubert. To create Bloom he needed to read *Ruby the Pride of the Ring.*

And in the system precipitated by correspondences one followed one's nose. Joyce's locale was Dublin; everything there came into his scheme. In 1863 a grandnephew of the resplendent Dubliner Richard Brinsley Sheridan, playwright and parliamentarian, published a novel, *The House by the Churchyard*, set in Chapelizod (where Mr. James Duffy lived in "A Painful Case"). Its author, Sheridan Le Fanu, is remembered as a master of Gothic thrillers like *Uncle Silas* (1864) and for a handful of first-rate ghost stories. *The House by the Churchyard* is as messy a "loose and baggy monster" (in Henry James's famous phrase) as a Victorian ever heaped together on the principle that too much is not quite enough. It is Hogarthian in its drawing of villagers, soldiers, duelists, blackmailers, frauds, quacks, and aging maidens. It is a confusion of

genres; the detective story, the Dickensian world-picture novel, the Gothic romance, the revenge tragedy, and Smollettian farce take their turns in trying to dominate.

Joyce the imaginative reader had several points of entry into this tangled novel: its setting in Chapelizod (Isolde's chapel), the locale of *Finnegans Wake*; its radical Irishness; the word *churchyard*, the Danish for which is *kirkegård* (old spelling, *kierkegaard*); and the lyric descriptions of the river Liffey, treated as a sprightly girl, dancing and sparkling but on her way to being a sewer in Dublin. But what Joyce focused on was a gruesome event in the twisted plot: namely, that a murder victim lingers on in a coma. If a brilliant drunk of a rakehell Dublin surgeon can trepan him successfully, the victim can be made conscious momentarily, can be asked who his murderer is, and will die, this time of the trepanning, which is certain to be fatal. Le Fanu concocted this as Grand Guignol to make Victorian flesh creep. Joyce saw in it an analogue of Finnegan coming alive at his wake. He saw in it his metaphysics of literature: every work of art is a witness to a murder; that is, to the past, which Joyce always saw as a crime against the present and the future. The writer is the irresponsible, virtuoso surgeon who can bring back the dead momentarily. "He lifts the lifewand and the dumb speak." The future cannot be born until the sins of the past are brought to the bar.

Joyce worked *The House by the Churchyard* into *Finnegans Wake*. By doing so he also rewrote "A Painful Case" without altering a word of it. He had already absorbed this story into *Ulysses* by having Bloom attend Mrs. Sinico's funeral. And *Ulysses* is subsumed, along with all of Joyce's work, by the *Wake*. Like Penelope, he wove and raveled his web (remember that it was a winding sheet for Laertes, her father-in-law), and each weaving was more elaborate than the previous one.

So all of Joyce's reading was woven into his writing. Many scholars have made studies of this process, the paradigm of which

is of course Joyce's reweaving of the *Odyssey* as *Ulysses*. A book of critical and occasional pieces by another writer is likely to be journalistic donkey work. Joyce's is a set of clues. The lecture on Blake alerts us to how Joyce thought about Blake as well as how he saw himself (and note Nora playing Catherine Blake for the evening).

In a wonderful sense Joyce rewrote the books he read. His Ibsen is a more heroic and wise playwright than the Ibsen we have. His Shakespeare is decidedly more Joyce than Shakespeare; or, as we might say without falling into nonsense, his Shakespeare is a Joycean Shakespeare. These colorings and fusions are what make Joyce the infinitely rich, infinitely imaginative and suggestive writer he is. He can be more Freudian than Freud. His cadenzas on themes by Lewis Carroll outshine their source.

Eventually some diligent scholar will collect all of Joyce's obiter dicta, from Frank Budgen and Arthur Power, from the Jolases and like witnesses, as well as from letters and from *Dubliners, A Portrait, Ulysses,* and the *Wake.* We will then be in a better position to understand why Joyce praised Yeats, D'Annunzio, and Kipling for imaginative powers he sometimes doubted that he himself had, and how his rebellious pride in his own genius was exactly counterbalanced by the humility of placing himself as simply another writer among all the rest.

II Timothy

*For wee wrestle not against flesh and blood, but against principalities, against powers,
against the rulers of the darknes of this world, against spirituall wickednes in high
places.*

<div align="right">

EPHESIANS 6:12 [1611]

</div>

THIS SENTENCE, in which we can see oiled athletes grappling in
the dust of a gymnasium at Tarsos, was first written down from
Paul's dictation by his secretary Tykhikos around the year 60. This
was when Nero was still sane and Plutarch, over in snowy Boeotia,
was an adolescent about to set out for Athens to study mathematics
and philosophy with Ammonius, who was a peripatetic teacher
like Paul and Jesus. What interested me in this strong sentence
when I came across it out of context—having previously paid more
attention to the sentences before and after, about putting on the
whole armor of God, or, as Samuel Butler's mother said, girding
one's loins with the breastplate of righteousness—was Paul's seem-
ing to have a good word to say about the flesh. The context was
Blake's *The Four Zoas*, where it serves as epigraph and is in Greek.
Blake was a congenial Christian and like Kierkegaard and Bunyan
had that gift of analogy and integrating vision that makes a
prophet a prophet.

"For our fight is not against human foes," *The New English Bible*
translates, "but against cosmic powers, against the authorities and
potentates of this dark world, against the superhuman forces of
evil in the heavens." No good word about the flesh here. The im-
agery of Paul's *haima kai sarka* (where *blood* had the sense of cour-
age, liveliness, strength, life itself; and *flesh* meant the whole body,

not a portion of it) is missing. When Jerome made his Latin translation in the fourth century (in Bethlehem, with his lion) he reversed the order: *carnem et sanguinem*, the "flesh and blood" of kinship, of being human.

The air around Jesus and Paul was full of devils. It is easy to see these for what they were: we call them viruses, bacteria, epilepsy, depression, phobias, obsessions, blindness, lameness, scleroses. And something subtler: meanness, cruelty, selfishness. We see Jesus healing both disease and the ungenerous heart, scarcely making a distinction between them, as if the wounded body and the wounded mind were the same kind of hurt crying out to Heaven to be healed.

What I at first found liberating in Paul's sentence is that he was saying the flesh is not in itself evil. Evil is in the mind, in the will. Evil is in the power one person has over another, in governments, and especially in official views of virtue that conceal ill will, jealousy, and a great fear of the flesh and the world.

My upbringing was Baptist. Aside from the holiday warmth of Christmas and Easter, what the church had to teach was the opposite of good news. It was bad news, dreary and dull all the way. With adolescence came a questioning of it all. To identify bigotry and narrowmindedness in a Southern Baptist congregation is no great feat. Our church was for white people only; some members of it belonged also to the Ku Klux Klan. Miss Lottie Estes told us in Sunday School that Jesus' nudity on the cross was far more painful to him than the nails in his hands and feet. I was already having trouble with the absurdity of the Christian proposition, namely that belief in a set of incredible events would get me to heaven post mortem. And it was true that I had no musical gift and so had come to hate all the hymns.

Meanwhile, I was actually being raised by my parents to believe that a moral life, polished manners, and an ambition to be moderately well off were the essence of acceptable behavior. Both my par-

ents tacitly agreed with Trollope that a strong interest in religion was a prelude to insanity. The good is the enemy of the better. The ancient code of middle-class propriety has stuck with me. Religion has yet to put down even a tentative root in my soul.

The Bible, however, I've read over and over across the years, not only because a literary scholar must know it well but because I find in it a spiritual resourcefulness, an imaginative engagement, an excitement of curiosity and wonder. I find Amos to be a wholly good man. Ruth and Naomi move me to tears. The only integral survival of the deep past is in the Bible, in Homer, in the archaic Greek poets. I see a Jesus in the gospels who is not quite like anybody else's (except perhaps Mikhail Bulgakov's) and who is decidedly different from the one of the Baptist sermons I have endured.

Paul I see as a figure in Plutarch's world, an intellectual with both a Jewish and a Greek education. He belongs to a renaissance of that moment in the fifth century when one could hear Aristarchus or Diogenes or Socrates in an Athenian gymnasium. He echoes them, sometimes literally. Diogenes said that the love of money is the marketplace for all evil; Paul changed *marketplace* to *root*. Paul, like his Greek predecessors, was a man of cities. Jesus preferred villages, hillsides, lakeshores. In my imagination I see Jesus as a man so attractive (eyes, gestures, a man whose genius was compassion) that people might easily drop what they were doing and follow him. Paul, however, I see as a bald and seriously bearded official, born to administrate.

He was something like an Eichmann when we first see him. He seems to have been present at the stoning of Stephen. He was a zealot, an authoritarian, a pedant in the law.

His conversion is a swerving of world history. Two renaissances suddenly flow together, like the Missouri flowing into the Mississippi. John had awakened the old tradition of the prophet—a new Elijah, Jonah, Amos—and Jesus had joined his revival. The turbu-

lence they introduced can be measured by John's and Jesus' executions, only a few years apart. Their converts took stock within a few years of the crucifixion. They kept the spirit of Jesus' teaching alive. Scholars posit collections of his sayings that found their way into the gospels. The oral tradition must have been extensive; how else can we account for such folklorish elements as walking on water and feeding thousands with a few fish and loaves?

An epic amplification had made Jesus' life a myth before a single gospel was written. Paul saw none of the gospels. What would he have thought of them? Did he have a hand in the first, the one written by Marcus in Rome? He mentions a Marcus in II Timothy, and deems him "a useful assistant." Why didn't Paul himself write a biography of Jesus?

I can remember, years ago, when it occurred to me that the very essence of the gospels is the fact that they are incredible, that these crucial accounts are, like everything else we have made, stained with human error and uncertainty. We see this as much in the canonical gospels as in the very moving Gospel of Thomas, and in the near-idiotic Gnostic gibberish from Nag Hammadi. Jesus spoke—in Aramaic? in common-market Greek?—and what he said was written down for us years afterward. Paul wrote: and we aren't all that certain about his texts.

The Tykhikos who took down Paul's letters to the Colossians and the Ephesians turns up in Beckett's *Waiting for Godot* to dramatize the Christian predicament. He has a rope around his neck and carries a heavy bag (Bunyanesque, this), a folding stool (Jesus when he comes will want a throne, the archaic English meaning of *stool*), a picnic basket (for the loaves and fishes, in case Jesus wants to do that again), and a greatcoat. He is haltered like a beast of burden and subject to the whip of one Pozzo. His name is Lucky, the Greek for which is Tykhikos. We see him go stark raving mad. Jesus, like Monsieur Godot, promised to return "soon." We Chris-

tians have been waiting, as of this writing, for nearly two thousand years. Soon! And what if He came some years back and was shut up in an insane asylum or lynched all over again or, as Dostoyevsky imagined, dragged before the Inquisition? Ruskin remarked that if an angel appeared in the English sky a sportsman would bring it down.

Waiting for Godot is but one of Beckett's statements about Christianity; *Endgame* is another, where the word *nail* in three languages gives us the names of the characters other than Ham, whose name provides the hammer. Christianity in Beckett's comedy (his designation "tragicomedy in 2 acts" is part of the joke) is an agony of waiting, a proposition vitiated by taunting uncertainty, a galling frustration. Joyce, Beckett's master, had seen Christianity as a myth that had displaced human nature itself. But the history of Christianity is not Christianity. It is a religion that can constantly return to its sources and renew itself, as with Milton and Blake, Kierkegaard and Luther. There are perhaps only Christianities.

I have a sharp feeling that Paul's Christianity is at great variance with Jesus'. Under house arrest in Rome, a city of moral philosophers all under the eye of Nero's police (Musonius Rufus, Apollonius of Tyana, Epictetus's school, all suspected of sedition and fleas), Paul was a religious philosopher who had assumed the role of a prophet, much as Muhammad was to do in Islam. His task was to explain, convert, spread the good word. Jesus had, in a paradoxical sense, removed the scaffolding of the law to show that the structure would stand by itself—by faith. The tribe was to be replaced by a new kind of community. Goodwill was to replace legality.

What Jesus had done was to cancel the classical idea of fate, to silence the oracles, to unify the human spirit under one dominion, which each of us is to find in our heart. The law and life itself would then be identical. Others were to be another self, treated as such.

The bond would be love, respect, loyalty, a kinship for which the metaphor would be that we are all children of one father. So redeemed, Cain would embrace Abel rather than kill him.

The awesome simplicity of this vision was what Paul had to implement. The authority Jesus constantly invoked—the origin of man in a natural unity that was not at war with itself, whose tribal deities and demons were all myths—Paul placed in Jesus himself, whom he understood to be the creator of all that is. Jesus strove to reconcile man with himself: to make a unity of the divided self and to make a unity of the brotherhood of man. Paul, striving to bring man and God together in a philosophical unity that he called *faith*, *redemption*, *salvation*, *worship*, inadvertently divided us all over again. Christ's return was the diffusion of his spirit through all humankind: the descent of the dove. Paul relocated this return in historical time and made Christianity a preparation for fullest life, rather than the fullest life itself. In the very act of spreading the good news of liberty under a new dispensation he imprisoned us in a corrosive anxiety, in mandates to persecute, to bind the good news in an obfuscation of fear and superstition.

We cannot blame Paul; we can only say that with the best will in the world he unwittingly returned our spiritual life to the bonds from which Jesus freed us.

Thus the strong sentence in Ephesians about the spirit of evil in things heavenly has become an irony central to those who try to be followers of the loving and gracious rabbi with the dusty feet, the agile mind, the loving heart, who healed and told vivid parables.

When some twenty years ago I began to write stories, I found that I was assuming that my subject was precisely this dialogue between Jesus and Paul, and that the student teaching what he had learned was a process that engaged my imagination and moral sense. In my first book of stories, *Tatlin!* (1974), I wrote about the Soviet artist and engineer Vladimir Tatlin (1885–1953), whose

creative genius had to be expressed under the eyes of Lenin and Stalin. Did I first become aware of this confrontation of power and liberty in a Baptist Sunday School, when the antagonists were Jesus standing manacled before Pontius Pilatus, and Paul in Rome?

The other stories in this book also explore themes essentially religious: Heraclitus's understanding of the unity of humankind and of the world; Kafka's encounter with a new machine, the airplane; the discovery of the prehistoric caves at Lascaux; Poe's spiritual discovery that he was an Orpheus in the nineteenth century; and the meditations of a Dutch philosopher in our time on a complex of observations derived from Samuel Butler and Charles Fourier, masters of happiness.

These early stories are all written out of the perception that the modern world is a renaissance generated by our new knowledge of civilization's archaic beginnings. Fourier took Jesus' "Unto Caesar, the things that are Caesar's; unto God, the things that are God's" as a mandate for us to redesign Caesar's things, that is, our political structures, to be in harmony (his great word) with the things that are God's. His new design is so eccentric, so radically a revision, that I imagined my Dutch philosopher seeing it in terms of Butler's Erewhonians who, while satirizing Victorian hypocrisies (or, as Paul would say, the spirit of evil in things heavenly), are also Butler's sly imagining of a secret utopia. (Modern writing has many secret Christians like Butler: Wittgenstein, Joyce, Beckett, Kafka.)

In "The Dawn in Erewhon" (the story about the Dutch philosopher) I quote Ephesians 6:12 along with a veritable subtext from the New Testament. Eventually these concerns would appear more openly in my stories. In *Eclogues* (1981) I bind the double tradition of Greek and Roman pastoral to the pastoral metaphor in the gospels. I make a story out of Acts 14:6–20, where Ovid's account of Baucis and Philemon coincides with Paul and Barnabas in Lystra, an event that Paul reminds Timothy of in his second letter

to him. (And Timothy was a native of Lystra.) Paul's relationship with Timothy is the pattern for most of the relationships in *Eclogues*: teacher and fond pupil, mature and young shepherd. I felt also that there should be a story that translates this relationship into modern terms; hence "The Death of Picasso," which is not so much about the redemption of a young man as the finding of his spirit inside squandered and misdirected energies.

In *Apples and Pears* (1984) I take up and expand my Dutch philosopher's fascination with Fourier in a novella that occupies most of the book. The other three stories, placed before the novella, are about Henri Gaudier-Brzeska, a spiritual forager of great genius crushed by the things that are Caesar's; Bashō, another spiritual forager; and Kafka, yet another.

The Jules Verne Steam Balloon (1987), nine stories, is more openly a meditation on religion. In three interlocked stories, "The Bicycle Rider," "The Jules Verne Steam Balloon," and "The Ringdove Sign," a young Danish theologian who is writing a doctoral thesis on certain Gnostic colorings in the gospels (finding traces in figures dressed in white linen—the Lazarus of Secret Mark [quoted by Clement], the naked young man in the garden at Gethsemane, the angel at the tomb—of a *daimon* who instructed Jesus). This theologian is thoroughly Danish and modern; his father is a Lutheran pastor of much charm and broadmindedness. The fate of the thesis I leave to your imagination. Ephesians 6:12 occurs in Danish in this text, for its flavor, and because translations always act as symbols of the incarnation in a linguistic world. *Et Deus erat verbum.*

I have written a story about Jonah, who was a favorite of Jesus'. I find a significance in the prophet who had a hard go of it, who spoke as if through thick plate glass to his audience. So there are stories about Robert Walser, about Leonardo, about Pyrrhon of Elis, about T. E. Hulme, about C. Musonius Rufus, about Victor Hugo (at a moment when no one would listen to him), about Paul.

Paul's letters, even when not addressed to congregations, are meant for public reading (or were they later made to be so?). The second letter to Timothy, scholars say, is probably not Paul's work at all. Its vocabulary and style differ from letters that are certainly Paul's. But this cannot be wholly true: it is too much like a real letter. There is a grouch against one Alexander, a coppersmith, warning Timothy away from him. "Bring the coat I left with Karpos at Troas, and the books, especially my notebook."

The great Pauline note is struck in his sports image about having run a good race, the whole course (is he thinking of the marathon?), and expects the Olympic crown of wild olive. Timothy's father was a Greek, his mother and grandmother Jews converted to Christianity. Timothy could not be very old. Images of wrestling, running, fighting in armor come so readily to Paul's stylus that we suspect he comes from a culture in which Jewish, Roman, and Greek elements harmonized. His name, Saul, is from the Old Testament (and was pronounced Shaul); Paulus is a Roman name, and he would probably have had a Gaius or Julius added on, to go with his being a Roman citizen.

Timotheos is "his son." He, like Titus and others, is to carry on Paul's teaching. So the letter is a short treatise on being a teacher, with much good advice.

It is also wonderfully prophetic. Paul sees things getting worse before they can get better. "Men will come to love nothing but money and self." (Spengler, who treats Paul as the real founder of Christianity, ends *The Decline of the West* on the same note, saying that all spiritual value was draining from moral splendor, breeding, and culture into money.) "They will be arrogant, boastful, and abusive; with no respect for parents, no gratitude, no piety, no natural affection; they will be implacable in their hatreds, scandalmongers, intemperate and fierce, strangers to all goodness, traitors, adventurers, swollen with self-importance." (The New English Bible, this.) Diogenes in full spate!

And, he continues to Timothy, there will be "men who preserve the outward form of religion, but are a standing denial of its reality." This was a theme of Jesus'. In his first letter to Timothy, Paul had described ideal bishops, deacons, and elders. We who live in an age of popes bent under the weight of diamonds and wrought gold, of evangelists as wealthy as gangsters, and of Christians far richer than Nero at his greediest can legitimately ask if Christianity exists in any form even resembling that of Paul, much less that of Jesus. Early Christianity was against a ground of Judaism of strictest moral rectitude and ritual piety. On classical ground it was in the midst of a thousand altars to generous gods, a belief in whom was thoroughly rational. The Eleusinian mysteries, the cult of Mithras, the temples of Asculepius, local deities in their groves (Castor and Pollux, Pan, Artemis)—both Romans and Greeks had made a lovely syncretic harmony of these (pious Romans *collected* religions). What perversity in Christianity balked at tolerating them until they, as indeed happened, could be absorbed into their mythos?

If my writing, involved as it is with allegiances and sensualities, with its animosity toward meanness and smallness, has any redeeming value, it will be in its small vision (and smaller talent) that Christianity is still a force of great strength, imagination, and moral beauty if you can find it despite the churches and dogma. I remember, years ago, walking with Thomas Merton in the woods back of Gethsemani on a frosty autumn day. I forget what occasioned his remark. "Oh, there's salvation all right," he said, grinning broadly, "but not in the Church." *The* church. (My capital may be gratuitous.) "All bishops are mad," he said on another occasion (we were talking about Bishop Pike). And: "Martin Heidegger had no notion what Being is." And it was Merton who came up with the translation of Heraclitus, the fragment variously translated as "religion is a falling disease" or something equally nonsensical: "Bigotry is the disease of religion."

I include these obiter dicta of the great Trappist because I think I saw in him a real Christian, as I see in Edward Schillebeeckx another; and have seen others in Christopher Smart and Blake and Wittgenstein; in Kierkegaard and the elder Grundtvig; in Elizabeth Gaskell and Mother Ann Lee; in Thoreau and Martin Luther King, Jr. I will make my peace someday with Jesus' terrifying death on the cross (every breath costing him unimaginable pain in lifting himself by his nailed hands). Meanwhile, the Jesus who moves me is the one whose feet were washed at Simon the Pharisee's house. (Paul was once a Pharisee.) Simon was scandalized to see Jesus allowing a woman ("which was a sinner" says the King James version) to wash his feet. And Jesus had "somewhat to say to Simon." He said: "I entred into thine house, thou gavest me no water for my feete: but shee hath washed my feete with teares, and wiped them with the haires of her head. Thou gavest me no kisse: but this woman, since the time I came in, hath not ceased to kisse my feet. Mine head with oile thou didst not anoint: but this woman hath anointed my feet with oyntment." Jesus forgave the woman her sins, and the Pharisee grumbled about that, too.

Civilization and Its Opposite
in the 1940s

IN JULY 1942 PAVEL TCHELITCHEW, a Russian exile who like hundreds of European artists, scholars, and scientists had found refuge in the United States, had just finished a large painting called *Hide-and-Seek*. It was a culmination of his work up to that time, and was exhibited in a retrospective show of his paintings and drawings at the Museum of Modern Art in 1942. James Thrall Soby's monograph *Tchelitchew*, of the same year, served both as the show's catalogue and as the first study of the artist.

Hide-and-Seek is a system of visual puns. Like *Finnegans Wake*, published in 1939, it is a pattern of such intricacy that the best interpretations—Parker Tyler's pioneering *The Divine Comedy of Pavel Tchelitchew* (1967), the lucid and authoritative *Tchelitchev* of Lincoln Kirstein (1994), and Benjamin Ivry's unpublished Johns Hopkins thesis—increase rather than satisfy our curiosity. Its dominant themes, however, are clear. Children playing hide-and-seek are deployed in the branches of an ancient tree, which is also a hand and a foot. In a cyclical progression of the seasons that alludes to Arcimboldo (in principle but not in technique), Tchelitchew has constructed a poetic statement that is at once beguilingly magical, Proustian, Rilkean, and boldly biological. Its vivid sexuality, in conjunction with a lyric innocence, has disturbed people. It has remained an enigma.

Once they are in the world, paintings have their destinies.

Looking back to the forties, we have the advantage of perspective. We can say that Max Ernst's *Europe after the Rain* (1940–42) is exact in its foresight and that Pablo Picasso's *Guernica* was not so much a response to a tragic event in 1937 as a preparation of our eyes for violence that is still raging. We can also see a history that was invisible at the time.

Within two weeks of Tchelitchew's finishing *Hide-and-Seek*, this happened: the murder of 192 children at Treblinka on August 6, 1942. These were orphans in the care of the brilliant Polish pediatrician and humanitarian Janusz Korczak and his chief administrator Stefa Wilczynska. The orphanage, in Warsaw, was "a children's republic," a successfully modern experiment in the upbringing and education of abandoned children. Korczak's theories are known all over the world, from American orphanages to kibbutzim. (The most recent, and best, account of his life and work is in Betty Jean Lifton's *The King of Children: A Biography of Janusz Korczak*, of 1988; Korczak's novel *King Matt the First*, of 1923, was translated by Richard Lourie in 1986.)

On the day of their death by asphyxiation at Treblinka, Korczak's orphans were ordered into the street while they were having breakfast. Korczak understood what was about to happen and asked permission to march the children in an orderly fashion to the cattle cars that would take them to Treblinka. Korczak carried the youngest child, five-year-old Romcia, in one arm, and led another small child, perhaps Szymonek Jakubowicz, by the hand. Stefa came behind with (in Lifton's words) "the tattered remnants of the generations of moral soldiers he had raised in his children's republic." King Matt's flag—the standard of the orphanage— brought up the rear, carried by the oldest boy, who was fifteen. They marched out of the ghetto to the railhead where the trains left twice daily, packed with wearers of the blue Star of David on white armbands. Up to this point there are witnesses to the event. We know that Poles along the way shouted, "Good rid-

dance, Jews!" There is hearsay that Korczak himself was offered his freedom by the SS as the train was being loaded. He was an officer in the Polish army and had a reputation as a pediatrician. He refused.

At Treblinka they were packed into sheds into which the exhaust pipes of three-quarter-ton army trucks emitted carbon monoxide. The corpses were bulldozed into pits.

Tchelitchew's tree crowded with happy phantom children is a hymn to innocence. Into the sheds at Treblinka 192 children were packed by jackboots. Francisco Goya could—and in effect did—depict the latter. What happened in the sheds at Treblinka on August 6, 1942, requires the art of Sophocles, Dante, or Shakespeare. We have no art that can speak for the Holocaust. Tchelitchew was speaking for what the Holocaust went a tragic long way toward obliterating. Among the many assaults of National Socialism on civilized art and thought was its insult to the imagination—its identification of whole schools of painting, music, and writing as decadent. Tchelitchew fell into that category. He was, in the parlance of fashion, a neoromantic.

His true fellow spirit was James Joyce (one can locate abundant similarities in their work, such as the giant whose head is the promontory at Howth and whose toes are tombstones on the other side of Dublin, and children at play figure throughout *Finnegans Wake*), but there is no influence either way. Joyce, another victim of the Nazis, was dying in Switzerland when *Hide-and-Seek* was being painted; and Tchelitchew's English was incompetent. A closer analogue is Jean Cocteau's Tchelitchevian *Léone* of 1942–44. It is contemporary with *Hide-and-Seek*, and is as enigmatic. Had Cocteau seen Tchelitchew's work when he wrote of a sleeping heroic figure who is also a landscape, with nesting birds, and whose genitals are a bird (referring to the Greek *pteros*, winged *phallos*, and the Italian *uccelli*—male genitalia with feet and wings—which Leonardo's mischievous assistants drew on his

manuscripts)? Not since the High Renaissance, when paintings were layered as allegories, symbols, myths, and political homilies, had European art been so avid and skillful in implicated meaning.

The imagery of heroic innocence in T. S. Eliot is thoroughly Tchelitchevian, as we see in *The Waste Land* (1922), part three, "The Fire Sermon":

> *But at my back from time to time I hear*
> *The sound of horns and motors, which shall bring*
> *Sweeney to Mrs. Porter in the spring.*
> *O the moon shone bright on Mrs. Porter*
> *And on her daughter*
> *They wash their feet in soda water*
> Et O ces voix d'enfants, chantant dans la coupole!

These lines are transparencies overlaid. Sorted out, they are Andrew Marvell's *To His Coy Mistress* (1650), John Day's *The Parliament of Bees* (1607?), a popular song ("Little Red Wing"), an obscene Australian marching song, and Paul Verlaine's *Parsifal* (1888). An image of Actaeon and Diana from Ovid, a favorite Renaissance subject, underlies modern vulgarities.

Verlaine's part in Eliot's montage alerts us to his curious kinship to Tchelitchew. The line that ends Verlaine's sonnet (*And O voices of boys from the choir*) is about the magic power of the knight Parsifal's virginity. Velaine's meditation on the theme of heroic innocence is broken in on by real voices.

In his *Four Quartets* (1943) Eliot symbolizes a sequestered but recoverable innocence with unseen children hidden in gardens and in trees, for example, in "Burnt Norton":

> *Other echoes*
> *Inhabit the garden. Shall we follow?*
> *Quick, said the bird, find them, find them,*

> *Round the corner. Through the first gate,*
> *Into our first world, shall we follow*
> *The deception of the thrush? Into our first world.*
> *There they were, dignified, invisible,*
> *Moving without pressure, over the dead leaves,*
> *In the autumn heat, through the vibrant air.*
> *And the bird called, in response to*
> *The unheard music hidden in the shrubbery. . . .*

Eliot made this passage out of Rudyard Kipling's story *They* (1904), in which ghost children live in an English country house and garden. This placing of children at a slight distance, or hidden in trees, belongs to the iconography of our time, and may be a resuscitation of angels and putti, or even of elves and daimons.

The *Four Quartets* are in one sense Eliot's emulation, and rivalry, of Rainer Maria Rilke's *Duino Elegies* (1921). Both are the greatest poems of our century about time, mortality, and our tragic incomprehension of existence. Both negate time for an eternal present containing the past and the future. The evocation of the existential (momentum, entropy, and a vitality unaccounted for by either) at the end of "Little Gidding," as throughout the *Four Quartets*, and as in Rilke, finds in children a symbol of fate:

> *At the source of the longest river*
> *The voice of the hidden waterfall*
> *And the children in the apple tree*
> *Not known, because not looked for*
> *But heard, half-heard, in the stillness*
> *Between two waves of the sea.*

In Ezra Pound's *Pisan Cantos*—a text of the forties—the figure of an Italian girl becomes the poem's image of Fortuna, or Fate. Thomas Mann and Hermann Hesse had placed daimons in the form of lovely children throughout their oeuvres, as had Hermann

Broch in *The Death of Virgil*—another forties text (translated beautifully by Jean Starr Untermeyer when Broch was in exile in the United States). The more we look at the child as a symbol of fate in our time—in *The Little Prince* (1943) of Antoine de Saint-Exupéry, in Korczak's *King Matt*, in Balthus's daydreaming adolescents (or his *Mitsou*, a novel-in-drawings, of 1921, instigated and provided with a preface by Rilke), in Eudora Welty and Carson McCullers—the more we see that these are symbols of vulnerability, of a frail and unprotected innocence. History and art have the same story to tell; their dialects are sometimes so different that it takes a while to see that Tchelitchew's *Hide-and-Seek* is, in a leap of intuition six thousand miles distant, about the afternoon of August 6, 1942, when Stefa Wilczynska, Janusz Korczak, and 192 orphans were killed by Germans and Poles at Treblinka.

On another sixth of August, three years later, an American airplane destroyed Hiroshima with an atomic bomb. It imploded with a blinding solar brightness. Above this thermonuclear hell rose a biblical pillar of fire and smoke the shape of which looked to a British observer like a titanic mushroom. His simile, quoted by the *New York Times*, entered the language.

This mushroom cloud, with streaks of fire that give it the appearance of a skull, can be seen in the upper right of another of Tchelitchew's paintings, the large *Phenomena*, completed in 1938. This crowded canvas is technically a Temptation of Saint Anthony by way of genre and is teratologically exact in its depiction of genetic mishaps. Its mushroom cloud is an illusion: Tchelitchew meant it for an apocalyptic image, much as Albrecht Dürer might have employed it. It is the same kind of coincidence as Jules Verne's rocket to the moon from "Tampa Town," only 120 miles west of the John F. Kennedy Space Center at Cape Canaveral in "southern" Florida. The arts are rich in lucky prophecies. But the atomic explosion seen on television in *Finnegans Wake* is deliberate prognostication:

Lok! A shaft of shivery in the act, anilancinant. Cold's sleuth! Vayuns!
Where did thots come from? It is infinitesimally fevers, resty fever, risy
fever, a coranto of aria, sleeper awakening . . . a flash from a future. . . .
 Tom.
 It is perfect degrees excelsius. A jaladaew still stilleth. Cloud lay but
mackeral are. Anemone activescent the torporature is returning to
mornal. . . . Telle whish.

Joyce combined, as part of the world's-end scenario in the last
chapter of the *Wake*, an inevitable atomic bomb and the inevitable
presence of television in Dublin pubs.

The Hiroshima bomb is the center of the decade. Before it, a war
that began in 1939; after it, a cold war.

New York in the early forties was an outpost of the war in Eu-
rope. We can now look at some of the symmetries. Jacques Lip-
chitz got to New York in 1941 with his wife and the clothes on his
back, and survived. Max Jacob did not, and died at Drancy. We are
talking about neighbors in Paris. Bertolt Brecht escaped; Walter
Benjamin almost escaped. He got as far as the Spanish border,
where he could only solve the dilemma he was in—he had given up
his passport to the French before he knew that a new Nazi
agreement with Franco did not allow him to enter Spain—by
shooting himself. Two legal systems had literally deprived him of a
space on which to stand. He was Franz Kafka's subtlest explicator,
and a philosopher who studied the psychology of tyranny.

No assessment of American civilization is possible without tak-
ing into constant account the steady immigration, since 1620, of
people and ideas. These donations from outside follow a pattern
that is by now practically a folklore motif. One of the greatest
American physiologists, Samuel James Meltzer (1851–1920) was
born in Panevėžys, Lithuania, and destined to be a Talmudist. He
arrived in New York in 1883 by way of a medical school in Berlin.

He was invited to join the faculty of Rockefeller Institute for Medical Research in 1902. Practically everything done to you in a hospital (insertion of nasal tube into stomach, injection, oxygen tent, insulin, and dialysis, to name a few) he invented, or opened the way to its future discovery.

Multiply Dr. Meltzer by many thousands to understand American culture. In the forties we can point to William Carlos Williams, whose mother was more comfortable speaking Spanish than English; to Louis Zukofsky, whose parents spoke very little English. If we drop back a hundred years, we can say the same thing about John James Audubon and James Joseph Sylvester; drop back fifty, Charles Proteus Steinmetz. In the New York of the forties, W. H. Auden was already thoroughly American while losing nothing of his Englishness. Constantin Brancusi, a visitor in 1939 on Long Island, refused to look at Manhattan ("so ugly, so ugly").

Before the Wehrmacht flattened Poland, many Europeans had already begun to arrive in America. The architect William Lescaze had arrived as early as 1920, bringing the International Style (and a knowledge of Arthur Rimbaud and Guillaume Apollinaire to the great profit of Hart Crane). Ludwig Mies van der Rohe, the last director of the Bauhaus, came in 1938, following Walter Gropius and Marcel Breuer. The family of architectural styles that we call modern, with its ramifications into machine and interior design, began in Europe as a spirit and all too often came to the United States as a fashion.

The Schröder House, which Gerrit Rietveld had designed and built in Utrecht in 1924, for example, was the expression of a social and political ideal. Its continuous space defined a frankness and honesty in family life that was a dimension of Dutch liberalization. It is a democratic house but in an extremely utopian sense. It asked of its inhabitants that they appreciate its Shaker clarity and Spartan—or Japanese—reduction, functionalism, and essentiality. It is a house for the neat-minded, the orderly, the idealistic. Its style,

De Stijl, one of the most influential of the twentieth century, is a Dutch shaping of a spirit that arose in Russia among some of the most inventive and original artists of our time: Vladimir Tatlin, Kasimir Malevich, El Lissitzky, Alexander Rodchenko, Varvara Stepanova, and many others. From these elate Russians, who were intimately cooperative with a brilliant generation of poets (Osip Mandelstam, Nikolai Gumilev, Vladimir Mayakovsky, Anna Akhmatova), theoreticians (Victor Shklovsky, Mikhail Bakhtin), architects (Konstantin Melnikov), filmmakers, playwrights, and avant-garde publishers, the Bauhaus and De Stijl took their central philosophical tenet: that art must disappear as an autonomous aesthetic and reappear as an integral part of all design. Art was to be a habitation, an icon of a new religion; it was to be everything made.

A work by Piet Mondrian is an example of the pure design that Plato allowed in his ideal republic. Dramatically balanced lines on a white field are a paradigm of moral virtue and a well-ordered mind. Stoicism, which taught a calm control of the self, had at last come full circle to join the expression of the self in art. So abstract painting is and isn't painting; it is part of a wall, which is part of a house, which is a machine for living.

The Spartans had decreed that the city-state was a work of philosophy. This beautiful idea has proved to be fatally attractive to many people, with wildly varying results. It worked splendidly for the Shakers and other religious communities; it proved to be disastrous in the hands of Lenin and Hitler. The most rigorous plan for communities of like-minded people to bring the art of living to perfection was that of Charles Fourier (1772–1837), whose ideas inspired Marx and Lenin, our own New England transcendentalists, and many American communities on the frontier. His radical idea was to retribalize humanity into small agricultural communities, or *harmonies*—pure little democracies in which everyone was friend (and lover) of everyone else.

Le Corbusier's Unité d'Habitation in Marseilles, begun in 1945, was designed with Fourier's harmony in mind. So was the Bauhaus and its American counterpart, Black Mountain College, near Asheville, North Carolina. The Bauhaus and Black Mountain must surely have had higher ratios of geniuses among their alumni and faculty to the short lifespan of each than any school in history. And both were dedicated to the Russian idea that all the arts are integral, none independent. Within practically all the arts of the forties was this armature of idealism as the inner structure of a progressive and healthy society. László Moholy-Nagy brought the idea to Chicago's Institute of Design, Gropius to Harvard, Buckminster Fuller and Charles Olson to Black Mountain. It was inherent in the founding of the Museum of Modern Art.

That a museum might be a community school was the invention of Charles Willson Peale of Philadelphia. In 1786 he expanded his portrait gallery of Revolutionary heroes into a natural history museum complete with a mammoth skeleton. With Jean-Jacques Rousseau as its tutelary genius, it was laid out as an orderly display of the world's flora and fauna for Democratic Man to learn from on a Sunday afternoon, together with his wife and children. From its inception the Museum of Modern Art set out to educate with its permanent holdings and by frequent shows of painting, sculpture, architecture, film, and photography. Never before had a museum been in a cooperative and reciprocal relationship with its subject, or able and willing to be both critic and importer, teacher and curator. In the forties the Museum of Modern Art came of age; it became a vital and vigorously influential part of modern art, doing for art what James Laughlin's publishing house New Directions was doing for contemporary writing.

Like many of the guiding principles of the modernist avant-garde, this concept of art as integral is thoroughly archaic. In the forties French thinkers were diligently exploring in two complementary spaces: anthropology and surrealism. Claude Lévi-

Strauss and his structuralist circle were reassessing a century of ethnological research, trying to find out what human nature is (and thus carrying on the quests of Rousseau and Fourier), how it came to culture from barbarity, how it tamed itself. Surrealism defies definition but is always recognizable, whether as a canvas by Giorgio de Chirico or a play by Eugène Ionesco. Since its tactics are to disclose the illogical and the absurd through imaginative juxtaposition, it is technically a satiric art. Yet it differs widely from satire in that it is essentially poetic. Surrealism is the metaphysical poetry of satire.

From its beginnings, surrealism has worked with anthropology in a common enterprise that we can regard as a critical commentary on civilization in our time. French anthropology, inspired to some extent by Guillaume Apollinaire's and Paul Guillaume's appreciation of African and South Seas sculpture as art of the highest order, worthy of being placed in the Louvre beside Donatello and Auguste Rodin, began to study so-called primitive art as the door to the primitive mind.

In a symmetrical balance of assertions, surrealism said that civilization in the twentieth century is absurd and self-destructive; anthropology, that humankind in its deep past and in surviving primitive societies is wise and has an orderly and wonderfully imaginative mind. Sigmund Freud had told us that we are neurotic. Psychiatry was one of the disciplines that arrived in the forties with the influx of European immigrant refugees. Kafka's books began to be known in English translation. Not until the sixties would the United States be in a position to read French thought of the forties or to realize who had been here among us. Lévi-Strauss was here; Max Ernst was here. There is a time lag of about half a century in Atlantic crossings for ideas, despite attempts to speed things up. The Museum of Modern Art had a show of facsimiles of prehistoric art collected by the German an-

thropologist Leo Frobenius in 1937. This was seminal, but it took years for the seed to germinate.

Both anthropology and modern art had prepared us for the significance of a discovery of the deep past in 1940. The autumn of 1940 was tragic, however, and we had to wait until after the war even to know about the event. On the twelfth of September, just outside Montignac in the Dordogne, when country roads and highways were bumper-to-bumper with automobiles fleeing from the Germans (Paris had capitulated in June), two boys, Jacques Marsal and Marcel Ravidat, were playing in the woods around the Lascaux estate. It was a Thursday, and Thursdays were then the day off during the week for French schools. Marsal's dog, Robot, disappeared in the woods; only his frantic barking could be heard.

Robot had fallen into a deep hole opened by the uprooting of a tree in a windstorm the winter before. The boys went down the hole to rescue Robot, and suspected, once they explored around in the dark, that they had discovered a cave of the kind they knew all about from school, for Montignac is at the heart of French prehistory and children had been discovering caves in the region since 1880. The Begouïn brothers had found Tuc d'Audubert and Trois Frères just before World War I. Many of the caves around Les Éyzies-de-Tayac were the discoveries of the curiosity of children. And it was a little girl who first noticed the painted ceiling at Altamira in northern Spain (her father had been studying its floor for years; she, on her first visit, looked up).

The cave into which Robot fell was Lascaux, on the walls of which were the most extensively painted Paleolithic murals to have survived. It had been sealed for seventeen thousand years. Its polychrome horses and bulls have become as familiar to us as the ceiling of the Sistine Chapel. By unlikely coincidence, Abbé Henri Breuil, the greatest of French archaeologists and prehistorians, was only a few miles away, as the boys' schoolteacher Léon Laval

happened to know, so that this momentous discovery was shared in a few days by the scholar most able to appreciate its significance.

Its significance had already been intuited by Picasso, who early in his career had seen the painted bulls at Altamira, and whose *Guernica*, with its bull and horse, is a continuation of a theme at Lascaux (which has a bison pierced by a spear, rhyming with Picasso's dying horse). Lascaux became a munitions cache for the Maquis until 1944.

Every epoch chooses its own past and cannot know how it will be remembered. The forties did not know that Joyce would emerge as the century's greatest writer, or that Eudora Welty and Samuel Beckett, just beginning their careers in the forties, would be the masters of English prose at the century's end. Many diligent figures were still largely unheard of: Jean-Paul Sartre, Albert Camus, Simone de Beauvoir, Balthus, Buckminster Fuller, Joseph Cornell, Mark Rothko. Later they would all be far better known.

Conversely, we now pay scant attention to Peter Blume, Paul Cadmus, John Steuart Curry, or to the sculpture portraits of Isamu Noguchi. Civilizations ripen into cultures; the process is very long and must be measured in thousands rather than hundreds of years. It can be argued that we have not yet reached anything like a civilization and are a very long way from having an American culture. We therefore have no use for a national memory. Foreigners know our history better than we do.

The way in which the art of a decade encodes the spirit of the age is rarely direct. In the art of the forties what strikes us first is the diversity of styles and subjects. In the second half of the decade abstraction took over, brought from several European avant-gardes (those of Robert Delaunay, Piet Mondrian, Wassily Kandinsky, František Kupka, and Francis Picabia), and yet Mark Rothko and Jackson Pollock at their best bear no resemblance to European models. Fernand Léger said that he'd never painted bet-

ter than in his exile here in the forties. His sense of accomplishment could as well belong to Mondrian, Stuart Davis, and Robert Motherwell. Form had accomplished again what it periodically longs for: it became a metaphor for its subject, and therefore the subject itself. Form did not displace its subject; it absorbed it. The verticals and horizontals of Jan Vermeer are discernible in a Mondrian, even though it was, variously, a tree and a ginger jar he was abstracting. Nature is full of Jackson Pollocks: autumn leaves, vegetable tangles, and random litter of all sorts. Magnifications of stone and even of colonies of bacilli all look like Pollocks. The same can be said of Motherwell's silhouetted boulders and slats; or of beltway advertising and Stuart Davis. These similarities need not be offered to rationalize abstractions. We will always come back around to the hieroglyphic deployment of paint. Claude Monet was getting wonderfully close to Pollock in the last lily-pond canvases at Giverny, and Paul Cézanne was as desirous of painting a landscape in which nothing could be discerned but the brushstrokes as Henry David Thoreau was of writing "a sentence which no intellect can understand."

From World War I onward popular feeling and intellect had been so manipulated, frequently violently, insultingly, and crudely, that the arts felt the need to redefine themselves. The forties experienced a crisis in all the arts. Orson Welles was saying with *Citizen Kane* and *The Magnificent Ambersons*, "*This* is how to make a film." Ionesco and Jean Dubuffet returned their arts to their most elemental expression, to the basic needs of the drama—actors saying something about anything—and to drawing as untutored as children's on a sidewalk.

Picasso turned sixty in 1941, the year his illustrations of Buffon's Natural History were published (deluxe reprints of classic texts were safer for French publishers under Nazi occupation); and he ended the decade with his lithograph *The Dove*, which became a universal symbol on posters and in communist propaganda. An

iconographic study of Picasso's animals will disclose a coherent vocabulary and grammar (bull and horse, goat and sheep). Into this symbolic family he introduced the owl in the forties, making it a major motif of his poetry and sculpture at Vallauris after the war: Athena's bird, daimon of the Acropolis.

Picasso was at Royan, near Bordeaux, at the beginning of the forties. He returned to Paris, to the studio at 7, rue des Grands-Augustins, where he had painted the *Guernica*. Picasso was not alone in barricading himself in a prodigiously creative solitude during the occupation. Georges Braque, too, found new energies and directions, achieving his finest canvases since the cubist period. Always strict and spare in composition and color, in the forties he evolved a classicism of his own devising, as did Béla Bartók and Igor Stravinsky. The decade is rich in examples of artists finding that true mastery of a form lies in doing variations on a set of rules. E. E. Cummings's sonnets in his two books of the forties, *50 Poems* and *1×1*, are the most inventive sonnets in English since Gerard Manley Hopkins and the most daring modernization of a traditional form since Stéphane Mallarmé's.

The still life is the sonnet of painters. The cubist still life, as Gertrude Stein saw (and imitated in prose), was the focus of the modernist moment in painting. If Braque and Picasso renewed their art in the forties by finding isolation an occasion to fulfill and perfect, the then eighty-year-old Henri Matisse experienced a miracle of creative energy. At the beginning of the occupation, he moved to Nice, ill with gastric problems requiring dangerous surgery. His wife and daughter, both in the Resistance, were in the hands of the Gestapo. One son was in New York (Matisse refused to join him, asking what would happen to France if all her artists and writers were to leave), one was in Paris, his fate unknown.

In Nice, and later in Vence, he lived in hotel suites that he filled with a jungle of plants and an aviary of doves. (Picasso's Dove of

Peace was actually one of Matisse's flock.) Too weak to paint, he began "sculpting" with paper, pasting up the collages of *Jazz*, the Vence chapel, and the murals. It is as if in the midst of the hell of war Matisse felt that his response should be to orchestrate all that he knew of color harmony and the beauty of lines and masses. With an art one learns in kindergarten Matisse brought the most sensually happy career of the century to a finale as unpredictable as it was triumphant.

Gertrude Stein died in 1946. It was through her writing and her salon that we first heard of Picasso, Braque, and Matisse. We owe the shaping of modernism as a movement to her charming intelligence and brave discoveries. She thought of the Museum of Modern Art as an oxymoron: How could art be modern if it was in a museum? She did not consider that there could be a museum that paralleled her salon. For her, modern painting had for its geography a few Parisian neighborhoods. She was known in the forties for *The Autobiography of Alice B. Toklas* (1933) and for her last, popular works, *Wars I Have Seen* (1945) and *Brewsie and Willie* (1946).

Paul Klee, the comic Mozart of modernism, died in 1940, in his sixty-first year. With an energy as unfailing as Picasso's and a philosophical wit as lively as Ernst's, he gave us an oeuvre of such skill and complexity that he will probably be fully appreciated only in the next century. Quite early in modernism there occurred an overflow of poetry into painting. There is a pressure of words just under the surface of a de Chirico, for example, as if a poem had had to abandon the verbal and redefine itself in paint. This is most evident in Ernst, a great deal of whose work began as illustrations to texts and kept the sense of being texts. To see this quality better, note that few of Picasso's works suggest or can generate a text, nor do Matisse's. Klee, however, is one of the great poets of the century, close to Marianne Moore and Wallace Stevens, to Christo-

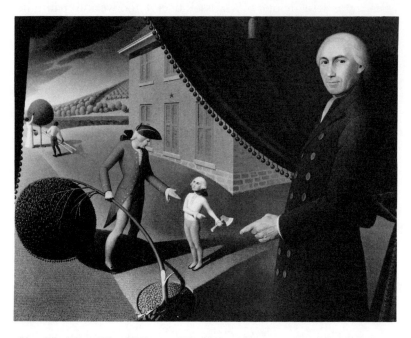

Grant Wood, *Parson Weems' Fable*, 1939. Oil on canvas, 38⅜ × 50⅛ inches. Amon Carter Museum, Fort Worth. 1970.43

pher Middleton and Jules Supervielle. Klee's titles, like Joseph Cornell's and Max Ernst's, are part of the work.

In André Malraux's imaginary "museum without walls" one might cause a considerable amount of cultural static by hanging a Grant Wood—*Parson Weems' Fable*, a work firmly located in a text (*The Life of George Washington with Curious Anecdotes Equally Honourable to Himself and Exemplary to His Young Countrymen*)—beside a Mark Rothko such as an untitled painting of circa 1948. *Parson Weems' Fable* was finished in 1939; Rothko's work was not yet, in the forties, what we think of when we hear his name: stacked rectangles of color. Wood died in 1942, after only a dozen years of painting in the style we know him by (and that not consistently). Rothko maintained his characteristic nonreferential style for thirty years.

Both Wood and Rothko (a Latvian Jew who came to the United States in 1913, at the age of ten) were American painters working in deep heritages from Europe. Aristotelian, dramatic, and ironic, Wood had to work in a society that missed his every subtlety. Platonic, contemplative, and lyric, Rothko worked above comment and beyond criticism. Abstract Expressionism was so obviously a matter of pure spirit that Americans, always eager for the transcendent and willing victims of the ineffable, embraced it.

Parson Weems' Fable is of its period: World War II awoke a cherishing of the American past that was variously vulgar, patriotic, and vernacular. We can separate Wood's painting from marketable nostalgia and calendar art easily enough. As his fellow hometown intellectual Garrison Keillor has sung, "His trees are perfectly round." That is, Malevich would have admired this painting. Little George Washington's head is a quotation from a three-cent postage stamp, a witticism from Dada. The composition is that of Charles Willson Peale's *The Artist in His Museum* in the Pennsylvania Academy of the Fine Arts. Wood's original title *Glad Am I, George* relates to a specific text: "I can't tell a lie, Pa." . . . /"Run to my arms, you dearest boy, . . . glad am I, George, that you killed my tree, for you have paid me for it a thousand fold." Wood's parson holds back the curtain to show us Squire Washington and little George. "Look!" say his eyes. He does not mind in the least that in the space he shows us we can also see two black slaves harvesting cherries. The *Mayflower's* next voyage, after the one that landed English protestants at Plymouth, was to Africa for a cargo of slaves. In the forties the bigotry of segregation was intact.

We can keep looking at Wood's painting, noting that the kind of historical rhyme it makes parallels the ideogrammatic method of Pound's *Cantos;* that the cherry was an ambiguous allusion (the cherry trees in Washington were a gift from Japan); that Wood's satire is civilized and gentle on the surface but resonantly troubling in its implications. The painting is a lie (myth, if you will)

about telling the truth. It is a slyly sincere painting about hypocrisy. It is rich in information (architecture, costume, horticulture), some of which is false (the cherry had not yet been introduced into the country).

It is Grant Wood's inability to remain mute that has cast him out of the modernist aesthetic. Charles Sheeler is mute, so that his elegant subjugation of matter to style moves him close enough to abstraction. He can be tolerated, like Charles Burchfield, whose muteness gives way to song from time to time.

What does this mean, our refuge in the wordless, our skittishness at anecdote, fable, sense? Is it our transcendental heritage? Through what naïveté was *Guernica* consistently denounced as ugly, enigmatic, politically wrong-sided, and technically inept on its tour of the United States before it hung for nearly fifty years in the Museum of Modern Art? Stubbornly, people refused to read it for what it was: civilization violated by brutality. The decade of the forties began an American awareness of this problem that is still crucial, still controversial. Forty years later American critics were still trying to dismiss Wood, still trying to criminalize Balthus as a painter of salacities. We cannot blame abstraction as a dominant style for this hostility toward the pictorial; we can, however, say that an abstract art devoid of ideas is also unthreatening and placid.

There was a public forties in the history of the arts, and there was a secret forties. If modern painting began with Picasso and Braque developing the implications in Cézanne's late work, it began again in St. Petersburg and Moscow with Tatlin and Malevich. Malevich died in 1935. Tatlin lived on until 1953, perilously camouflaged within the Soviet system, his painting banned, the movement in which he was such a force interdicted and largely dispersed. (Marc Chagall and Kandinsky escaped; Velimir Khlebnikov, Mandel-

stam, and Mayakovsky died.) Tatlin eked out his years teaching ceramics and designing an air bicycle. He never joined the Communist Party.

The Nazi concentration camps were not publicly acknowledged in the American press until the fall of Germany, when we saw their horrors in Margaret Bourke-White's photographs. French art went underground, or was unexhibited, or was maintained just beyond German focus, as with Sartre's plays. Gertrude Stein and Alice B. Toklas sat out the occupation at Bilignin, and once had to reply to a German officer that no, they did not know of two Jewish old maids rumored to be in the neighborhood.

Our century, ironically, will have to be listed with the most virulent in the pathology of bigotry. The United States banned Joyce's *Ulysses* (1922) for the first dozen years of its existence, and in the forties Henry Miller's works and D. H. Lawrence's *Lady Chatterley's Lover* (1928) were illegal. Tarzan in comic books was not allowed to have a navel. A list of proscribed artists and writers—Mircea Eliade in Rumania, Jean Genet in France, Alexander Solzhenitsyn in Russia—would almost coincide with a roster of genius.

By November 1945 Ezra Pound was serving the first of thirteen years in St. Elizabeths Hospital for the criminally insane in Washington, D.C. His case is symptomatic of the ambiguity inherent in constitutional liberty and in the liberal spirit as it was cultivated in the forties. Pound's crime was treason, "giving aid and comfort to the enemy in time of war." He was also the most influential, perhaps the greatest American poet of the twentieth century. His position at the center of English writing in our time is hard to contest, and Eliot, Joyce, William Butler Yeats, and many others have insisted on his primacy. He was the mentor of Eliot, William Carlos Williams, Louis Zukofsky, and Charles Olson, among others.

His crime was to broadcast violent and obscene opinions about the imminent war, damning international bankers, armaments manufacturers, and Roosevelt; praising Mussolini and fascist Italy; praising Hitler. As the broadcasts were all recorded months before their airing, the timing of Pound's alleged treason was ambiguous, and the case was never tried. And that was not the only ambiguity. Pound's mind had suffered a breakdown during his incarceration at Pisa, where he had surrendered to the American army in May 1945. It was here that he wrote *The Pisan Cantos* for which the Library of Congress awarded him the first Bollingen Prize in 1949. (The liberal outcry at this award was so strong that the Library was prohibited by Congress from giving out a poetry prize until 1990.) Pound was, even to the layman's eye, paranoid schizophrenic, a feature of which was an overt anti-Semitism. As with all schizophrenia, logic was not in the formula. Despite his obsessive bigotry, Pound had Jewish friends, many of long standing, such as Zukofsky (who, while deploring his anti-Semitism, bore him no resentment) or his psychiatrist Dr. Jerome Kavka. Pound's Jews were the imaginary ones of paranoia; Roosevelt was a Jew in his scheme.

At St. Elizabeths we can locate, in the forties, one of the strangest cultural activities of all history. In a ward for catatonics, or in good weather on the beautiful grounds of the prison hospital (St. Elizabeths began as an arboretum, hence the congeniality of the grounds), one could find the visitors T. S. Eliot (on one occasion lifting his legs to allow the imaginary vacuum cleaner of an inmate to do its work around his chair, Pound having demonstrated how this was to be done), Marianne Moore, H. L. Mencken, E. E. Cummings, or Archibald MacLeish. One could also find the young Hugh Kenner, then a graduate student at Yale, Herbert Marshall McLuhan, Charles Olson, and James Laughlin. There were young painters and poets, scholars and translators; and in with them were the half-baked and the fanatic. Pound and his wife

Dorothy (née Shakespear, daughter of Yeats's mistress Olivia) welcomed them all, for these visits were limited to four hours a day; the rest of Pound's time was spent among the mindless.

From Pound at St. Elizabeths came such a spray of energies that we have not yet charted them all. Olson, rector at Black Mountain College and a student of Pound, taught Robert Creeley, Robert Duncan, Jonathan Williams, Denise Levertov, Fielding Dawson, and many another, who were thus Pound's pupils at one remove. Pound, appalled at American ignorance, was a diligent teacher. On the grounds at St. Elizabeths one learned about Louis Agassiz, Leo Frobenius, Alexander Del Mar, Basil Bunting, Arthur Rimbaud, Guido Cavalcanti, Confucius, Mencius, Raphael Pumpelly, and on and on. He was making up for the periodic and convulsive self-erasure of the American mind.

One of the themes of Pound's later poetry is precisely this discontinuity of culture. He saw it as a desensitization of the spirit, and paranoidly saw it as deliberate. It was worse than deliberate: it was simple dullness. Or, to say this another way, it was the absence of a culture. How do you appreciate Grant Wood when you are unaware of the necessity of the fine arts to any culture?

A friend and agemate of mine was dared by her circle in a college dormitory to do an outrageously brave thing: to call St. Elizabeths (this is *res gestae*, forties) one evening and ask to speak to Ezra Pound. She called. An attendant answered and said he would fetch the patient to the phone. After a while, she heard the voice of Ezra Pound. "Start a renaissance!" it said, and hung up.

Renaissance: a re-beginning, a finding of lost things, a taking up of dropped continuities. Pound's *Cantos* begin with the word *And*. William Carlos Williams's *Paterson* (the very title implies *pater*, father in Latin, plus the English *son*) begins with a colon, a punctuation mark indicating that what follows is a logical derivation from what precedes. One of the axioms in Buckminster Fuller's *Synergetics: Explorations in the Geometry of Thinking* (1975) is

that we instinctively take a step back when we want to take a step forward.

How long will the United States be re-beginning? It has become a habit by this time, with corporate amnesia gaining ground. It is clear that we must reinvent the city (and perhaps we are, in malls). Neighborhoods and city streets are gone. Our renaissances tend to bleed to death. The late forties brought us a new kind of urban housing: freestanding high-rise structures set at a distance from one another to provide light and air, after such Corbusian models as Ville Radieuse (1930). Like the tenement housing they were intended to replace, these proved to be instant slums and places of terror, danger, and loneliness: anti-neighborhoods. At the same time Mies van der Rohe gave us a new vocabulary of glass and steel, but his most revolutionary built house—all glass— turned out to be elegant but uninhabitable, and now belongs to an Englishman who, helped by electric fans and open doors, lives in it for one week in the year. There are regular complaints that the modern in design and architecture is inhuman, without coziness, without comfort. A number of Le Corbusier's dwellings have been betrayed by their inhabitants. Two of his buildings were used for years as cow sheds. Today, many professors of architecture teaching modernist or postmodernist styles themselves live in comfortable Victorian houses.

The forties were undeniably a renaissance, of sorts. Our universities were again enriched (as before in the 1840s) with European scholars of the first rank. (The index to Laura Fermi's *Illustrious Immigrants: The Intellectual Migration from Europe, 1930/1941* runs to 1,400 names.) We were a new Netherlands, traditional refuge of the persecuted. (In all candor, however, it ought to be said that we refused many—Nijinsky for one, because he was insane—interned some, and erected barriers against others.) Even so, we had the makings of a renaissance in both the sciences and the arts.

Prehistoric painting is without regard for the horizontal or the vertical: one of the horses in Lascaux is jauntily upside down, drawn by some remote ancestor of Marc Chagall. With history came uprights on horizons. The Greek and Roman love of long rectangles enclosing bas-reliefs decided for Western painting that its finiteness would be concise and rational, bounded like property, like walls and floors. This convention is still a kind of law. The old Picasso superstitiously crammed his figures into rectangles. In modern painting there are two artists for whom the frame was the basis and essence of their work. One was a native of New York, Joseph Cornell, of Utopia Parkway, Flushing, Queens; the other Piet Mondrian, who came to New York in 1940 for the last four years of his life. He died in Murray Hill Hospital, of pneumonia, in 1944, even more than Lipchitz or Bartók the archetypal refugee. He was Dutch, had been trapped in the Netherlands by World War I, and had a great fear of bombs. He lived in Paris for twenty-one years and was sixty-six when he fled it for London in 1938, a very wrong choice as it turned out. Where he lived little mattered to a man whose life was contemplative, unmarried, philosophically quiet. To achieve the perfect arrangement of the horizontals and verticals and spare areas of the primary colors to which the most severe reductionism in the history of art limited his canvases, he sat for hours, occasionally rising to move a line (tape thumbtacked to the stretcher) a smidgin of a centimeter left or right. When the composition was correct, he painted it in. Only in art books are these Platonic visions elegantly neat; the originals are dirty whites and messy lines; any sign painter could have been neater. But the material realization does not matter; these are pure ideas. Brancusi said of Mondrian, "Ah! That great realist!" What Mondrian saw out of his studio window in Paris were train tracks, straight lines crossing their ties at right angles. He grew up in the Netherlands, where the horizon is a spirit level in all directions.

It is charming that New York mellowed Mondrian into a last

development something like Matisse's at Vence, allowing color and a giddy liveliness. Mondrian had always loved dancing, and shared with Ludwig Wittgenstein a connoisseurship of gaudily emphatic femininity; for Mondrian, Mae West; for Wittgenstein, Carmen Miranda and Betty Hutton. Someday a scholar will give us a treatise on music and painting (Burchfield and Sibelius, Klee and Mozart, Chagall and the joyful processional music of the Hasidim). Mondrian's *Broadway Boogie Woogie* is contemporary with Matisse's *Jazz* suite.

If Mondrian ended in the realm of pure essence, Joseph Cornell worked in a space explored by Picasso and Tatlin in 1913 that has had other occupants: Kurt Schwitters, for instance, and many folk artists; and in nature, the magpie and the bowerbird.

He called his works shadow boxes and montages. Their ancestry involves many influences. In 1911 two high-spirited Englishmen, Edward Verrall Lucas and George Morrow, cut up a mail-order catalogue, pasted it in various whimsical combinations, wrote captions in the style of schoolboy humor, and all unknowingly invented Dada, Max Ernst, and René Magritte. Ernst saw in *What a Life!*—Lucas's and Morrow's ur-text of surrealism—that the deliciously absurd is not the only effect of absurdly combined commercial illustrations. All advertising ages into sinister indictments of our culture. So Ernst made two of the most eerily Freudian collage novels out of Victorian illustrations to fiction, *La Femme 100 têtes* (1929) and *Une Semaine de bonté* (1934).

Joseph Cornell developed this method of quotation into a theater of lyric magic. He was as much a scavenger as the folk artists who decorate a wastebasket with magazine pages, or the makers of patchwork quilts. He accumulated a garage full of boxes containing celluloid parrots, stationery letterheads, broken dolls, handbills, watch springs, clay pipes, marbles, window screens, candy wrappers, wine glasses—the vernacular artifacts of our cul-

ture. Like Schwitters, the anticipatory archaeologist, he saw in trash the signature of our nature.

Cornell was an erudite man. One might guess that he was an eccentric out of Beckett, a grazer of garbage heaps. He had a poetic sensibility and a metaphysical wit the equal, often the rival, of de Chirico and Ernst. He is still considered a peripheral figure in American art, as his complex allusiveness can be dismissed as childish trivia. He therefore belongs to the secret history of the forties. He was a genius with an imagination as vigorous as Emily Dickinson's. Like her, he was a recluse, and like her he could transform the quotidian and the overlooked into beguiling mysteries. One quality in Cornell rare in modern art is his domesticity: his boxes are friendly, strangely familiar when first seen, as if we had known them before. They remind us of old museum displays, of drawers in which we have irrationally kept party favors, photographs, our favorite spinning top, an envelope with foreign postage stamps.

With Mondrian and Cornell we come back to the crisis in interpretation that so troubles modernist painting and writing. The new, which arrived with such promise and excitement in the forties, has remained enigmatic, a kingdom of the imagination that amounts to the riddle of a generation. What does *Hide-and-Seek* mean? Who can accurately read Joyce and Mallarmé? What is the difference between a Pollock and spilled paint?

A cliché we hear often enough is that modern art is a breakup, a disintegration, and cubism and abstract painting are offered as evidence. Exactly the opposite is true: the modern is an integration, a new beginning. It is in part a renaissance that reaches back to the archaic and that brought together some of the most creative minds of the century, disseminating energies and ideas that are still enriching the world. In another fifty years we will know more about

the forties; it takes the perspective of one century to know an-
other. We are just now seeing the significance of Zukofsky, who
was writing *"A"* in the forties but was unknown except to a few; of
Olson and the Black Mountain poets; of the real political history
of the time as archives are opened. We will have new readings of
Hide-and-Seek and of Cornell. Yet in a century the violence of the
forties will still not have lost its pain and ugliness, and it will still
seem wonderful that out of the human spirit so much art could be
made in a world where the artist was far more often the victim
rather than the honored benefactor of the people.

Style as Protagonist
in Donald Barthelme

HEMINGWAY'S "THE UNDEFEATED" (in *Men without Women*, 1927) begins with its protagonist Manuel Garcia knocking on the office door of one Retana, a manager of bullfights. Retana does not want to see Manuel, who has identified himself through the closed door, and only reluctantly agrees to talk with him. "Something in the door clicked several times," we are told, "and it swung open." Manuel enters. Retana is seated at his desk "at the far side of the room." If he opened the door, he was very agile in leaping back to this desk all the way across the room. Did someone else, beneath Hemingway's notice, open the door? Is the clicking in the door an electric catch release, in 1918 and in Spain? Not only a catch release but an electrical device that also swings doors open?

Electricity exists in this world: the fight Manuel is signed up for is "nocturnal." (We are supposed to savor that Latinate word as Spanish, and not think it the wrong diction.) But something is being slipped past us with this magic door. Did Hemingway the vaunted realist nod, or is he simply not interested in a technological device that would have engaged the full attention of Tolstoy? I suspect that it is one-upmanship, Hemingway's constant reminding his readers that they are excluded from the privileged space he has zoned off, story by story. We may watch, at our distance, but we may not enter. He will tell us the story, laconically and grudgingly, but what do we know of training camps for boxers,

of Chicago gangsters, of he-men and their women, of killing for the joy of killing, of amateur abortions and shit and pain? And electric doors? Don't worry yourself about electric doors; we have the disemboweling of defenseless horses coming up in this story, and buckets of blood, and sharp knives, and courage and death. But before the death, pain. Lots of pain, and how professional torturers of animals grunt and bear it.

For such writing Hemingway won the Nobel Prize, of which the givers deemed James Joyce, Marcel Proust, Ezra Pound, and Eudora Welty unworthy.

After Hemingway, Donald Barthelme. It was Hemingway's intent to come after Kipling, who he said was the world's worst writer. Now Kipling is a strong candidate for being the best writer of the short story in English, as well as an innovator in the form's architecture, narrative pace, and richness of tone. Like Flaubert and Henry James, Kipling moved the short story in one of its fated and characteristic directions, the miniaturization of the novel. He was equally skillful, and successful, in exploring the possibilities of the short story's being a wholly new form, one that could take the merest anecdote for a plot and build around it a structure more native to the poem or essay.

At the beginning of the twentieth century the short story became the most versatile of narrative forms. It was Joyce's basic form; it has been noticed that the chapters of *Ulysses* and *Finnegans Wake* operate as independent cooperative units. One could do anything with the short story: it had a genius and energy all its own. Tolstoy and Chekhov exercised its flexibility, as had Poe and Hawthorne half a century before.

When Donald Barthelme took up the short story he had a sense that it was a form that had proved its eligibility for responding to radical innovation. It was a form that had periodically collapsed under overuse and just as periodically renovated itself. It answered

to style in the hands of a master. Like the poem, it demanded style. All else would follow. Poe established this principle; John O'Hara and William Saroyan proved it. So did Eudora Welty and Flannery O'Connor.

Donald Barthelme remained, story after story, the master of a style that he invented. Hemingway quite early became the prisoner of a style that he appropriated and refined. Faulkner invented a family of styles that had various, largely successful fates. There are authors who, like Thomas Wolfe, drown in their styles; and authors who, like Saroyan, invent brilliant styles with the life span of a dandelion. The other master of a new style in American writing in our time, Welty, is so different from Barthelme that we can imagine them as the extremes between which we can locate all other styles with control, beauty, and distinction. Welty is the heir of Chekhov, Flaubert, and Joyce, whose stylistic strategies and energies she has emulated without a single trace of verbal imitation.

Innovation begins with finding. Barthelme had to find an unoccupied space where narrative had not previously been. The visual arts had preceded him; he followed. He would be the Max Ernst of writing. His subject matter would be versions of reality posited by the world—its language, its images, its tacit assumptions, its public being—that he would then inspect with an irony and wit as diligent as Ernst's.

The opening sentence of the entry on menstruation (*Règles*) in Diderot and d'Alembert's *Encyclopédie* is purest Donald Barthelme. "*Les Groenlandoises,*" it says, "*n'ont point de règles.*" The voice is disembodied, oracular, in full assurance of its authority, and unembarrassed that it is speaking nonsense. For Flaubert, connoisseur of such idiocies, this sentence would have been simple evidence that the Enlightenment frequently talked through its hat. The historian of science sees in this bogus assertion the stubborn persistence of medieval credulity. Now that we have Barthelme's de-

ployment of such sentences, one after another, as if intoned through a surrealist megaphone, we can see in it one of the surest strategies of his art.

Look at this sentence from the story "Paraguay" (1968):

> The great wall space would provide an opportunity for a gesture of thanks to the people of Paraguay; a stone would be placed in front of it, and, instead of standing in the shadows, the Stele of the Measures would be brought there also.

By the time we reach this sentence, we are prepared for anything. The story begins with a description of boulders in a pass in Tibet (by the traveler Jane E. Duncan, in 1906), not Paraguay. Foreign scenery was wanted, and a bit of Tibet was at hand, much as Henri Rousseau's "Mexico" is the tropical hothouse at the Jardin des Plantes, and Chateaubriand's snowy mountains of Florida are from a confusion of geography books or the cool assurance that his readers won't know the difference.

The Stele of the Measures; well, that's in the agora in Athens. Everybody knows that. But this one is going to be in a Paraguay that "is not," Barthelme tells us, "the Paraguay that exists on our maps. It is not to be found on the continent, South America; it is not a political subdivision of that continent, with a population of 2,161,000 and a capital named Asunción. This Paraguay exists elsewhere." Here a placard is held up beside the surrealist megaphone: it says *We have both read Borges, haven't we?*

But the sentence about the wall and the Stele of the Measures is a collage element from another text, in French, and by Le Corbusier. It's on page 142 of *The Modulor* (1968 [not 1954, as in Barthelme's note]):

> The great wall space would provide an opportunity for a gesture of thanks to the "Modulor": the stone of which I have just spoken would be placed in front of it; and, instead of standing in the shadows, the Stele of the Measures would be brought there also.

At least we know where we are in Corbusier. We are under the great apartment complex in Marseilles, the Unité d'Habitation, and the Stele of the Measures is Le Corbusier's trademark, a standing male figure with raised hand, the proportions of which demonstrate the Fibonacci module by which Le Corbusier designed the building. His prime inspiration was the Harmonian phalanx of Charles Fourier, who was in turn inspired by the organization of Jesuit colonies in Paraguay. Paraguay!

At this point do we hear Barthelme, with his kindliest smile, saying, "You're going too far. You're seeing *symbolism*, and symbolism numbs humor. Go back to the fun." Is the fun in the characters, who seem to have wandered into the story from another narrative, French or Scandinavian? And the opening through which they came let in fragments of encyclopedia articles. Kafka and Borges were allowed to be presiding muses in the making of the story. Barthelme chose this story for an anthology edited by Rust Hills called *Writer's Choice* (1974), and he added an introduction. "What I like about 'Paraguay,'" he says, "is the misuse of language and tone." He notes that "the flat, almost 'dead' tone paradoxically makes possible an almost-lyricism."

Exactly. Had not Ernst made a full lyricism out of woodcut illustrations to nineteenth-century novels combined with ads for shoes and plumbing? Barthelme, trained in art history, would have known that Ernst springs from one of the happiest flukes in modern aesthetics, E. V. Lucas and George Morrow's *What a Life! An Autobiography* (1911), where cuts from Whitely's mail-order catalogue, deliciously deficient in their purpose, are enlisted as illustrations to a text that they generate—"Dr. Bodley's School" is a fireplace, where one of the sports is leapfrog (a coathanger with trouser grip). An animal in the zoo is a steam iron on its four-legged rest.

Thus Corbusier's *Modulor* on page 142 becomes Barthelme's Whiteley's General Catalogue. Corbusier's subheading THE WALL

is taken over as is. Corbusier's first sentence is stopped at ". . . *in situ* concrete.*" The eloquence of the poetry must not be bled off. "The lift tower" is a mysterious phrase, partly because American publishers can't be bothered to transpose British translations into American. "Elevator shaft" would probably not have caught Barthelme's eye, and it would not have added to the effect of the Paraguay that is not *the* Paraguay, because layers of cultural discourse beneath which there is a radical preconception is what this story is about.

Barthelme changes one word in Corbusier's next sentence: "There was thus a danger [the danger, Barthelme] of having a dreary expanse of blankness in that immensely important part of the building." The next sentence is taken over whole: "A solution had to be found." And then the pen is added to scissors and paste.

Corbusier: "The great wall space would provide an opportunity for a gesture of thanks to the 'Modulor': the stone of which I have just spoken would be placed in front of it; and, instead of standing in the shadows, the Stele of the Measures would be brought there also."

Barthelme: "The great wall space would provide an opportunity for a gesture of thanks to the people of Paraguay; a stone would be placed in front of it, and, instead of standing in the shadows, the Stele of the Measures would be brought there also."

The rest of Barthelme's paragraph is a pastiche of phrases from Corbusier, out of sequence and context. An architect's solution to humanizing empty space beneath an enormous building becomes a mysterious taming of threatening space into congeniality ("softly worn paths, into doors").

Barthelme carefully guards Corbusier's innocence, his ridiculously vulnerable idealism. This story was written in Houston or Manhattan, where the space in question would be a parking lot or a lethal wasteland. Hence the final sentence: "Long lines or tracks would run from the doors into the roaring public spaces."

Barthelme's genius was in such layering. Sometimes we can lo-
cate all the layers, sometimes not; Barthelme clearly wanted us to
remain in the interstices: that's where his poetry is. He does not
mind (in fact, has alerted us) that phrases like "vast blind wall" and
"vast expanse of blankness" can be identified as prose by an archi-
tect who cannot control the echoes these phrases contain from
Kafka, Mandelstam, Piranesi, and from history.

Resonant quotation belongs to modernism as one of its major
devices. Eliot made *The Waste Land* and Pound *The Cantos*, Ives
much of his music, and Ernst his images from resonant quotations.
Barthelme's quotations are sometimes as exact as if for a scholarly
article. "Engineer-Private Paul Klee Misplaces an Aircraft be-
tween Milbertshofen and Cambrai, March 1916" begins "Paul
Klee said:". What follows is a plausible pastiche of Klee's diary
(*The Diaries of Paul Klee 1898–1918*, edited, with an introduction,
by Felix Klee, translated by Robert Y. Zachary and Max Knight,
1964). Barthelme provides two perspectives for this story, that of
the Secret Police (derived from a detective in Klee's diary, who
mistakes Klee for someone else) and that of Klee himself.

Klee was in the air force because he was a painter, and airplanes
need numbers, insignia, and varnish. The airplanes of 1916—
structures of sticks, canvas, wheels, motor—could be dismantled
for shipment on railway flatcars. A shipment for which Klee was
responsible turned up one plane short, its flatcar having been
switched to another train. This is the "losing" of an airplane.

The theme of loss, however, is not of an airplane, but of time,
by one of the century's greatest painters and the one whose work is
most kin to Barthelme's. The two were masters of whimsical iro-
nies as well as of arts that aspire to poetry while keeping to their
own forms.

In Barthelme's universe, which is never quite *the* universe, all
processes function interestingly, fascinatingly, but are never free
of static, abrasion, turbulence. Scientists sight a soul on its way to

heaven while discovering that they are in an adulterous triangle. Keepers of an ICBM silo are driving each other crazy. Eckermann gets on Goethe's nerves. Love, art, and civilization itself move from one frustration to another in Barthelme, but always with a perfect grace.

The tensions in Barthelme are between the density of his splendidly mimetic prose and the gratuitous nature of his subject matter. They grip each other, style and stuff. The stuff is hard to control, for Barthelme gives it chaotic reign. Anything at all might happen in *The Dead Father* (1975), for instance; the rules allow it. And yet what does happen, from the first tightening of the hawsers to the bulldozers, is made to seem inevitable. In his last book of all, *The King* (1990), this tension keeps threatening to relax. Only an idea holds it together: that war is stupid whether under the rules of chivalry or those of Hitler and Churchill. It is interesting that the last of Barthelme's Fathers (a true archetype in modern writing, to be placed with Mann's Artist, Walser's Servant, Kafka's Victim) should be Arthur, a difficult puppet to breathe life into—you might as well try to invigorate Santa Claus.

But fatherhood was Barthelme's obsession and big subject. In fatherhood he saw the succession of everything, the despair of necessity, authority, and tyranny. The best fathers are artists, whose offspring are works of art, and even these are problematical. The city and God and civilization are kinds of fathers. We need all these, but our freedom and identity are in escaping them, burying them decently. The best escape from a father is to become one: the cycle is perhaps comic. The father of fathers, however, is the past itself, which we destroy to our peril, and with which we live uneasily and insanely. That's what *The King* is about: the present bound as uncomfortably to the past as to a Siamese twin, life bound to war (that is, to death and the constant destruction of the means for civilization).

We live in a stupor, babbling, says Barthelme. Our minds are

addled by real estate and religion (Christian motorcycle gangs), platitudes and traffic. We are Moon-Dog shuffling along the streets of Manhattan. Barthelme may have predicted every tic and trendy vacuity of the yuppie. Like Mark Twain, he achieved what few writers of any time have achieved, a vantage point outside his world from which to regard it with impassioned irony and outrage. This vantage point can be talked about as a perfect mimicry, a mastery of idiom, a psychological tracking of received ideas and Pavlovian responses. Barthelme invented a new kind of narrative of which he was (so far) the sole practitioner.

Stanley Spencer and David Jones

ROGER FRY'S INSISTENCE, during the years when Bloomsbury was establishing its hegemony over British critical opinion, that the subject of a work of art is always secondary to technique calcified into a dogma: the subject of a work of art is negligible. Further mischief followed, which Fry did not intend. A perverse logic developed his dogma into the more insidious one that subject matter is merely a pretext for the artist to demonstrate a style of painting. The artist, we were to understand, is not primarily interested in the meadow, or nude, or bowl of apples before him. He is only interested in the aesthetics (Fry's great word) of their form. The British, notoriously suspicious of art, subverted Fry's noble attempts to redress an attention that he deemed too literal and too lacking in aesthetic appreciation into an excuse to ignore subject matter altogether.

The barricades on which Fry stood were those of a necessary revolution. He was trying to wean the British away from painting that he felt had become a very glossy and accomplished set of illustrations to literature, and little more. In planning the Postimpressionist exhibit of 1910 he was importing a sensibility. He wanted the British to see and feel and understand painting that had no text except nature, an art that was all "plastic significance," "significant form"—Picasso, Cézanne, Gauguin, van Gogh. He was thereby rendering two great schools of continental painting, Impression-

ism and Postimpressionism, iconographically sterile, a false step that is only now beginning to be corrected.

The greater loss caused by Fry's unfortunate teaching is that important British painters and poets, whose work was appearing toward the end of his life and in the generation after his death, could be easily dismissed. Although Walter Sickert could speak of Stanley Spencer's "fateful strangeness," Fry placed Spencer among the "pure illustrators" (that is, with Burne-Jones and Augustus Egg):

> Why is it that our *litterateurs* of the brush are so palpably inferior to their *confrères* of the pen? I may cite as an exception the case of Mr. Stanley Spencer, who is also a pure illustrator, indifferent to plastic significance, but whose psychological creations are at least original, curious, and vividly apprehended. They at least never sink to the deplorable level of stereotyped sentimentality which rules in the Royal Academy.
> [Roger Fry, "Some Questions in Esthetics," in *Transformations: Critical and Speculative Essays on Art* (1926), 27.]

These are strange words indeed to hear about Stanley Spencer, one of the century's greatest and most original painters. His perceived indifference to plastic significance was but half of the resistance the British put in his way. There was a dinner held at the Royal Academy in the late 1940s, when the Tate's acquisition of *The Resurrection, Cookham* had made a scandal in the press. At this dinner Sir Alfred Munnings and his distinguished guest Winston Churchill (amateur painter in the Impressionist manner Fry worked so hard to import, an irony to savor) noted that Spencer could not paint arms, that indeed he put them on backwards. Further, the fellow painted as badly as Picasso (pronounced with the short *a* Churchill also used for Nazi, *nazzy*). Sir Alfred agreed with Sir Winston. The painting was a farce and an outrage, Spencer an impostor. And the port and the walnuts went around the table again. We might note that Sir Winston's assessment of Spencer's

draftsmanship is precisely analogous to saying that Blake drew as maladroitly as Michelangelo.

More was implicit in Churchill's intended insult than Sir Winston could know; Spencer, like Picasso, was master of several styles, each with its own technique and iconography. Picasso's styles were a matter of periods in which he achieved, with Faustian éclat, another painter's work of a lifetime. A whimsically metaphysical writer (like Borges) could construct a science-fiction fantasy in which future critics might (after, say, a holocaust in which Picasso's paintings but no records about them survive) assign the Blue and Rose periods to one painter, cubism to another, the neoclassical to yet another, and so on, ending up with ten or fifteen factitious painters.

Spencer used three styles. The first is academic, derived from seventeenth-century Dutch work modified by French realism (Courbet, for instance). This style lasted his lifetime. From 1917 there is the self-portrait, now in the Tate, so wonderfully allusive in pose and rendering to Samuel Palmer's at the same age. (A parallel study of Spencer and Palmer would discover many similarities of religious temperament and iconography: flowering trees, symbolic roadways, humble truths suffused with ecstasy and vision.) In 1958 Spencer did a portrait of Dame Mary Cartwright, Mistress of Girton College, Cambridge, in this academic style (and a final self-portrait the following year). In between, Spencer used this style for Cookham landscapes, still lifes, various portraits, and the erotic paintings that were intended for a cycle of religious subjects.

The second style is the first medievalized, that is to say, brought close to the styles of Giotto and Cimabue. Many British artists followed this trend: we can see it in Eric Gill (inspired by medieval illuminations and stained glass), in David Jones, Clare Leighton, and others. This is Spencer's greatest style. In it he did the Burghclere murals, the series of resurrections, the village and

domestic genre scenes, and the final, unfinished major work, *Christ Preaching at Cookham Regatta.*

The third style was personal, sketchy, annotative, and unplanned. This is the style (always involving caricature and much humor) in which he painted The Beatitudes, The Temptations, and the autobiographical canvases, such as *Love Letters* and *The Dustbin, Cookham,* and all the strange paintings in which one needs to know how what Jacques Lacan calls an *hommelette* functions in Spencer's private psychology. An *hommelette* (egg broken and dispersed, treated as an object of desire: that is how the pun works) is what Freud named a fetish. In Lacan's schema it is anything that signals, or arouses, desire. Love, said Lacan, involves another, an Other, and this Other is a person. But human desire is sneaky, inventive, and highly talented. So Lacan recognizes another that is not a person but a dropped handkerchief, a snippet of hair from the beloved's head, or whatever "object-of-desire-with-a-little-o" (*"objet-petit-a"*). The first scholar of fetishes was Krafft-Ebing, in whose *Psychopathia Sexualis* we can find an English gentleman who ate guardsmen's socks that had been worn for a month. Spencer is the first major artist to study the *objet-petit-a.* His paintings of garbage, of dogs (his symbol for sexual energy), of barnyards of strong odor, are parallel to Joyce's reintroduction of the *inaccrochable* into art. We can see a similar claiming of tabooed subjects in David Jones, where there is an Augustinian insistence on the spirituality of matter however humble. The age-old tension between Gnostic, Manichaean rejection of (or indifference to) the world and Christian acceptance of creation as revelation and extension of God keeps cropping up in the oddest places. It is mildly entertaining to detect it in Roger Fry's Quakerish iconoclasm and in the artists whom Fry made it so difficult for the British to understand: David Jones's inclusion of the pagan in Catholic theology, Spencer's connoisseurship of the malodorous, the sexually eclectic, the total fusion of sacred and profane.

David Jones (1895–1974) and Stanley Spencer (1891–1959) are, for all their differences, spiritual twins, and together constitute a thoroughly British phenomenon: nonmodernist modernists. The semantics of this can be made clear. Modernism kept penetrating England all of this century without including the British in the concerns of the great movement, as England had been wholly involved in the previous international style (Beardsley, Rennie Mackintosh, Whistler, Wilde). English-speaking modernists tend not to have been born on English soil: Joyce, Pound, Eliot, Yeats, Beckett, Wyndham Lewis, Gaudier-Brzeska, Jacob Epstein. Where modernism was imported into England, the influence was timidly imitative, as with Ben Nicholson's cubism or the toe-in-the-water concessions to modernism of Paul Nash and John Piper.

Jones—poet, prose writer, painter, engraver, calligrapher—was, like Spencer, a common infantryman in the worst gore of World War I. The response of each to the war was a masterpiece of British art: Spencer's murals in the chapel at Burghclere, almost the exact equivalent of Jones's *In Parenthesis* (1937), sharing a concern for the quotidian chores of military life, for the suffering of the enlisted man, for the ritualistic aspect of army routine. Neither knows anything of the heroic in official versions of the war, or of the romanticism of T. E. Lawrence's *Seven Pillars of Wisdom*, or even of the sentiment of Wilfred Owen, Siegfried Sassoon, or Rupert Brooke. Jones's favorite tone of the misery of the war is in an anecdote he treasured and frequently told. A mud-caked sergeant in a trench learns that Lord Kitchener had been drowned in the North Sea. " 'E 'as, 'as 'e?" replied the sergeant. "Well, roll on, fuckin' duration!"

What Jones was hearing was a *legionarius* in some Gaulish *castrum* hearing of Caesar's assassination, and genially damning all generals and emperors. He was hearing a trooper in Joshua's army whose feet hurt, who was weary of mule trains and camp grub and

the hard desert ground at night. Both Jones and Spencer had their genius centered in an imaginative transparency of history and of ideas. They could collapse time where it suited their aesthetic ends to combine events and essences. Regard the opening of Jones's "The Roman Quarry":

> *There she blows, there she goes*
> *the old tin tube rings clear*
> > *Back to kip for section six*
> > *The monkey's knackers for section seven.* *

The diction of this reaches into the parlance of sailors and soldiers, and is grounded in Jones's perception that language encodes every nuance of culture. We are hearing reveille on a bugle, in 1917, in the first century B.C. (Roman soldier in Britain), cockcrow with all its symbolism (Peter's denial, Paul's "last trump"), Spartan trumpets, Roman trumpets at the Feast of the Cleansing of the Weapons on the Field of Mars in Rome (described by Plutarch), Joshua's trumpets, and on and on. We are also looking at a long tradition that flows in its own channel through European art. From the High Middle Ages through the Renaissance, antiquity was helplessly modernized. Shakespeare's Caesar wore trunk hose and doublet, felt hat with feather. There is no visual dimension to Gibbon; his readers would have been dependent on Poussin and the brothers Adam for imagery. With Scott the historical imagination begins to demand authenticities, a taste that reached its fulfillment in Kipling in England and Flaubert in France.

Spencer located the gospels in Cookham-upon-Thames, and symmetrically clothed Old Testament angels in Edwardian and twentieth-century clothes. Before thinking that we can appreciate (or be offended by) this calculated anachronism, let us notice that the mythologizing of the gospels began quite early and is by now

*David Jones, *The Roman Quarry and Other Sequences*, ed. Harman Grisewood and René Hague (London: Agenda Editions, 1981), 3.

undetected by most of us. No ox or ass stands in the stable at Christ's birth in the gospels; we put them there. The number of the Magi is not in Scripture; we made them three. And so on. Far from leaving tradition, Spencer is deep within many traditions of Christian iconography such as the Dutch tradition of localizing events of the Bible in finely detailed realism (the Annunciation in a Dutch room).

In Parenthesis fuses Malory and World War I battlefields, and discovers the sacramental in the ordinary. *The Anathémata*, a meditation throughout on the Mass, is concerned to find in all art and ritual, from the dawn of time, activities identical with those of the Catholic liturgy. "This thing other" is the phrase Jones uses for man's earliest (and continuing) recognition of the world beyond himself, whether a shard of flint or God. The "thing other" with which man is most involved is language itself, as words are as old as culture. Jones was alerted to his subject by his times. Archaeology (which Penguin Books kept track of) and anthropology made great leaps forward. The discovery and interpretation of prehistoric cave art was largely the work of French priests, and was thus, in a sense, an activity of the church. Psychoanalysis was Jewish and Protestant, but it came into being because of the kind of angst and insecurity of which World War I was a magnified example, but which was endemic to urban and unchurched life; it was no great step for David Jones to see two Jewish healers of wounded souls, Freud and Jesus, as in the same business. Art history had become vastly more sophisticated in Jones's time, aided by color reproductions and slides. Jones's imagination, for these and many other reasons, was acquisitively inclusive, capable of appropriating almost anything.

Joyce inspired him, as did Braque. He admired Picasso, calling him "our Hercules." He liked medieval Latin and Welsh poetry as enthusiastically as he liked bawdy marching songs of the infantry. His ear was tuned to the cockney locution as accurately as it was to

turns of phrase in the *Anglo-Saxon Chronicle*. The artist's eye no-
tices, studies, retains. In the composition of a work, details are
available that may have lain in waiting for years. In one of Jones's
engravings for *The Ancient Mariner* there is a figure seen from the
back who has his hand knuckles down on his hip, shoulder raised,
elbow bent but in the plane of his body. Jones, talking about this
print to Bill Blissett, said that it was a pose he had noticed in a sol-
dier on the western front. Two decades later, he found a use for it in
a composition. Clare Leighton once told me that Jones asked to do
a watercolor of her humble student's bed-sitter in Kensington
when they were both art students. The result was of "a room out of
the *Arabian Nights*, or some vision in Revelation, so colorful, light,
and airy he had painted it." Anyone who has walked along the Epte
at Giverny begins to wonder how such dull, featureless country-
side became the landscapes of Monet.

To see the Venus of Willendorf as a primitive fetish is one
thing. To see her as one of man's first premonitions of the Virgin,
as Jones does in *The Anathémata*, is wholly another. When Fry
turned us away from subject matter, he bound off the lifeblood of
art. Fry was correct in teaching that art encodes a new sensibility,
age after age, and with accumulative effect (so that Poussin is "in-
cluded in" Cézanne if one is coming to Cézanne ignorant of Pous-
sin, Velázquez in Whistler), but he was wicked to suppose that this
sensibility is not more in subject matter than in its treatment. Cé-
zanne does indeed show us a new way of looking at the world, but
he also decides what new world we are to see in his new way.
"There were no apples before Cézanne."

Both Spencer and Jones give us a new world. Spencer, the more
conservative of the two, rethought English art of the previous cen-
tury. It has been said (by Max Beerbohm, I think) that the Aes-
thetic movement made brick ugly. It is easy to believe that this is
true. Spencer was doubtless aware of this shift in aesthetic judg-
ment, and thus became the greatest poet of brick in all art. Brick.

Tedious to paint convincingly, a brick wall is nevertheless a pattern captivating to the eye, having something of the primitive love of reticulated patterns (all of France is covered with diamond networks, their equivalent of the Greek key fret, or West African zigzag lines), something of the regularity modernism imposed on industrial design. And yet bricks are biblical (especially when made without straw), Blakean, Joycean (the *Rosevean*, analogue of Odysseus's homing ship, is loaded with English brick). Look at the brick structures in Spencer. They are always demarcations, boundaries. Usually they divide a utopian space in which a world freed from guilt and sin indulges itself in *objets-petits-a* (a woman is made love to by a sunflower while her husband, exempt from jealousy, watches with approval). There are brick enclosures with some mystical meaning, like the one in *The Resurrection, Cookham*. A scholar can go a long way into whatever Spencer's passionate meaning may be by following the clue of bricks from painting to painting. A curving brick wall occupies a third of the background in the unfinished *Christ Preaching at Cookham Regatta*.

And bricks are but one example of a reticulated pattern in Spencer. This pattern has something to do with sexuality in its highest spiritual state, as witness *Angels of the Apocalypse* (plaids, polka dots, stripes). The dog a boy is kissing in *Sunflower and Dog Worship* is a dalmatian.

Patterned language is to Jones what visual patterns are to Spencer. From Joyce and Eliot, Jones had come to see that a text can be woven with words and phrases from other languages. He may even have seen, with Joyce's guidance, that these words and phrases are not, ultimately, foreign; not, anyway, to English. At the beginning of *The Anathémata*, the words of the first sentence describe simultaneously man (humankind) learning to make tools, utensils, and figurines like the Willendorf Venus ("this thing other") and a priest preparing the altar for Mass, where "this thing other" refers

to the transubstantiation of the host. Both prehistoric toolmaker and priest are making "an efficacious sign."

It was Joyce who returned fully the making of an efficacious sign to art. Art cannot, by its very nature, depart from making a sign. A still life by Chardin, *War and Peace*, a hat—all are signs rich in meaning. Meaning, however, inheres in the maker of the sign, which is why Tolstoy is a great writer, as we say, and Surtees a lesser one. (Jones would not agree, as Surtees is one of his *gens*, his folk, and can speak to him with a music and familiar sign absent in Tolstoy.) The meaning of a work of art is efficacious only insofar as its charm elicits a response. Thus a new kind of art, like Spencer's and Jones's, must educate an audience before it can communicate. It is significant that after *In Parenthesis*, in which Jones's art appeared mature and in full power (and baffled the readers of books), he turned to a work about the Mass, which historically was attended by catechumens (learners by ear, being instructed in a mystery). One learns to read *In Parenthesis* by reading *The Anathémata;* there is a sense in which *Finnegans Wake* has taught us how to see the symbolic structure of *Ulysses*, the *Portrait*, and *Dubliners*. The Middle Ages read the Old Testament through the New.

How, then, can we learn to see Spencer? His religious meditation is as rigorous as Jones's. Is he a visionary among the heaven-on-earth designers (Saint-Simon, Fourier, Mother Ann Lee) with a hope for political reformation? Clearly his sexual paintings constitute a critique of society as we know it, comically different from D. H. Lawrence's, Ibsen's, or the yeastier psychoanalysts with bees in their bonnets about a society without repressions. Not even Fourier, that most imaginative of utopians, considered orgies with sunflowers and dogs. A plausible answer might be that he is a disillusioned visionary. Apolitical, but a democrat in the philosophical sense, eccentrically religious, honest, a realist in matters of the flesh, Stanley Spencer was before all else a poet for whom the nat-

ural beauty of the world—meadows, gardens, trees in blossom, rivers—was the primary fact. That his gorgeous landscapes sold while his religious and domestic pictures did not must not tempt us into the cynicism of saying that he painted them for a quick pound. These handsome landscapes are as carefully and as lovingly wrought as anything he did.

The landscapes are the base of his statement about the world, for man is part of nature, God's creation. It is God as flesh that Spencer depicted with his most dramatic awe and reverence, Christ in the streets of Cookham, among children, animals, brick, flowers. These paintings are the ones most raked by brilliant light, designed in stunning symmetries.

The religious paintings are also the ones with freedom of movement, an orderly flow of running children or moving figures through a clarity of space. The domestic paintings, by contrast, are claustrophobic, full of people getting in each other's way. The military scenes are similarly congested, like the murals of men working, the resurrections. Even the baptism of Christ is in a crowded swimming pool. The domestic paintings are the most crowded of all, the most awkward. *Christ Preaching* was going to be a very crowded, Bosch-like tangle of people, picnicking, and punts. A great deal of eighteenth-century British humor comes from too many people in a space (Rowlandson, Hogarth, Smollett). This very British theme becomes for Spencer an *objet-petit-a*, an intimacy with gratuitous sensual content (*Domestic Scenes: At the Chest of Drawers, Christmas Stockings, The Dustman or the Lovers*). Carried into the inevitable absurdity of all obsessions, as in visionary paintings such as *Love Among the Nations* and *Bridesmaids at Cana*, Spencer's compressing of space reveals its real identity: a cancellation of emotional distance.

Spencer's roadways have neither automobiles nor people on them. There is the occasional vehicle (army trucks, distant boats, punts), but they are shown as having reached a destination. They

are arrivals, stationary. The foregrounds of the landscapes are oc-
cupied by large, interesting objects. Although his perspectives are
deep (the horizon in *The Resurrection, Cookham* is a good mile
away), Spencer's statement of space is intimate, convivial, sacra-
lized in his peculiar idiom, wherein a pack of dogs sniffing their
own and human genitalia is as spiritually charged as Saint Francis
among Cookham poultry. In *The Resurrection: The Hill of Zion* a
man is feeling his nose to see if it is still there, and an angel scratches
her thigh. That is Spencer's art: an insistence that the world (not a
world created ideally by a choice of attentions) is there.

David Jones in *The Anathémata* creates something like a Spen-
cerian unfolding and conflating of time. The Mass reiterates an
event, the Crucifixion, which itself was a repetition (with a new
and final victim) of an age-old sacrifice. Jones tells us that his insti-
gation for the poem was in realizing that a British soldier whom he
saw on duty in Palestine in the 1930s was in some sense identical to
a Roman soldier in the same place in the time of Christ. This kind
of historical rhyme is characteristic of modernist art. Pound and
Eliot (and Rudyard Kipling and Charles Doughty before them)
saw the two great empires, Roman and British, as a historical re-
currence. The idea is throughout Spengler, whom Jones read with
interest; and in his friend Christopher Dawson. Joyce's is the most
eloquent shaping of this idea.

Space, however, remains a geographical reality in David Jones.
If anything, he magnifies its slow distances, as the majestic pace of
The Anathémata must move Christianity and its enveloping cul-
tures, Greek, Roman, and Syrian, along certain routes, by land,
and most lyrically, by sea, to Britain. This poetic act is a redoing of
Doughty's *The Dawn in Britain*, for which *The Anathémata* serves
as a critique and as a successful rendering of a previous work whose
density and solemnity limited it to a small audience. The history
of art is rich in such repetitions.

Jones intended to be as British as Doughty, who intended to be

as British as Jonson, Chaucer, and Spenser. Traditions keep to their family trees. Jones, for instance, knows that he does not descend from Tennyson, Browning, Shakespeare. He is "matter of Britain" all the way: Welsh, cockney, Catholic, English farmer and shipwright, a northern European who came into a heritage from the Mediterranean (a heritage with religion for its lifeblood). His culture was old when William the Bastard landed at Hastings in 1066. The dialect of Latin that William spoke would overlay English, and English ways, thereafter. A fruitful reading of David Jones is to enter into his exploration of British ways, beliefs, thoughts, manners that eluded the Normans. In scholarly parlance, David Jones spent his career stripping away the Renaissance, the Age of Reason, and the romantic period to lay bare the England whose invader was not William but Caesar and Claudius, Danes and Norwegians, and the sweetest raptor of them all, the Christians with Greek gospels in their possession.

The distance traversed by Christianity to arrive in Britain was immense. That some Norman lords won a battle against a weary Harold becomes a trivial local event. *The Anathémata* is the great poem it is because of the historical configuration it invents. The past is both nightmare (as Joyce said) and a deposit of meaninglessly spent energies. Historian and artist give it its shape. When Jones was writing *In Parenthesis*, with *The Anathémata* in his head, H. G. Wells was presenting Neolithic man as a monster of unrestrained primal passions (and accounting for war by man's inability to civilize those passions). The Hearst Press in the United States was inventing the caveman, grunting brute. Known to a few only, knowledge of Neolithic times was carefully being sorted out by French, British, and German archaeologists. Jones was the first to take up what they had to teach. His Neolithic man has now displaced Wells's: the carver of Solutrean flint arrowheads, the painter of Lascaux and some four hundred other caves, a builder of villages, weaver, potter, and theologian.

Jones displaced Pound's periodic history (bursts of energy, "springtimes" in Provence, China, Egypt, Italy, Greece) with a slow, patient, vegetating history, one whose lines of force are all but invisible.

Jones's contemporary Fernand Braudel had the same understanding of history. The time for grass to become wheat eludes the imagination in its awesome length. History is "long durations" and where it seems to introduce a novelty, such as Christianity, or arithmetic in tens, or farming, or the Indo-Iranian languages, we have learned to look again and to recompose our ideas.

The genius of Jones's imagination is that he was willing to believe that Christianity is religion, seamlessly continuous from its beginning we know not when or where. It is a dialect of the one religion: the Catholicism of a Welshman is Catholic but it is also Welsh, very Welsh, and cannot be otherwise, and before it was either Catholic or Welsh it was Roman, Greek, Syrian, on back to the artist-poet-priest who shinnied up the chimney piercing a rock in southern France from an underground river to a cave overhead, and painted a dancing man wearing an elk hide, with elk horns, and with the genitalia of a panther. The painting (of what? tutelary spirit? god? shaman?) finished, the painter descended the rock chimney, and a band of children went up and danced in a circle in the clay of the cave floor on their heels. This sacred place was then sealed. It was next entered, some twenty thousand years later, when David Jones was on the Western Front. He knew about it, later, shell-shocked, surviving one depression after another, struggling to be one of these who depict the spirit in its search for form, order, truth, God. (He always said that the bear he drew as a child was his best drawing. The skill of that bear would have qualified him, twenty thousand years before, as the elect painter of Elk Man with Lion Sex deep inside caves.)

Modernism has been owned and operated by various groups with their own interests to look after. It is scarcely surprising that

two religious artists of the first order have taken far too long to assume their proper place in modern art history. Their seeming eccentricities and radical innovations soon turn out to be solidly within the deepest traditions of British and European poetry and painting. Their work constitutes an occasion for religious art to communicate with the world at large, in its ancient manner, and an occasion for religion to consider the visionary donations of Spencer and Jones. Christianity began as a renewal of the prophetic tradition of God working through man, each godly man closing the distance between God and man (as in Amos's vision), and can only proceed by constant renewal of this awareness and responsibility. That is what Spencer was doing. There is an unfocused confusion, except to a talented few, in trying to imagine the crucifixion on a hill in Judaea. To imagine it, in all its ugly cruelty, as happening in the familiarity of an English village, is both to renew one of the oldest strategies of European art and to effect what that strategy can accomplish: the vivid and periodically necessary reshaping of the narrative through which Christianity has its life.

David Jones refinds Christianity in history. With inevitable regularity history liquefies and needs rechanneling, while religions petrify, paralyzing their spirit in pedantry. The guardians of both must constantly keep history from meaninglessness and religion from the death of its symbols. David Jones's guardianship of both is great and beautiful.

Wheel Ruts

IT WAS JULES MICHELET who asked for a history of the unhistorical—of nature, of the poor, of women, of manners, of industries: all those human and everyday things that get into other kinds of history only if they're needed to explain diplomacy or wars or why this or that great man stood for parliament. In our time we have had, from Émile Durkheim to Fernand Braudel, a lively French analysis of history in fine detail. Nothing, ultimately, is unimportant once one's historical method has found what Braudel referred to as *long history*, such as the weather for five hundred years. Weather changes slowly and can be seen as a force in history only after you've done the research, plotted charts and correlated. European weather began the next ice age in the thirteenth century, for instance; the vine no longer grew in England, nor wheat in Scandinavia.

Turner's violent sunsets can be traced to a volcano in the Pacific, which loaded the air with dust and made chromatic changes in the sky. An element in romanticism can thus be traced to tectonic plates. From Turner, Ruskin; from Ruskin, Proust; from Proust, Beckett. Our sense of history can always be activated by such connections, whether they're dependable or not. Every age's past is a chosen one, and tells as much about the age as about the history it recovers.

A History of Private Life, Volume One: From Pagan Rome to By-

zantium (1987), an ambitious book, consists of five essays, nicely unharmonized (one, for instance, says that the Romans' delight in cruelty was Stoic education, not sadism; another says that it was sadism pure and simple). The editor, Paul Veyne, has contributed an introduction and a general overview of Roman society. Peter Brown's "Late Antiquity" (the best in the book) studies the transition from pagan to Christian in Italy. Yvon Thébert's "Private Life and Domestic Architecture in Roman Africa" focuses on a large family house in the Roman provinces and is illuminating about domestic space and the workings of a big place full of people. Michel Rouche's "The Early Middle Ages in the West" is the best account I've seen of how feudalism came about, and how the public civic sense of the Roman Empire melted under the northern European system of ruling families with private armies. Evelyne Patlagean's "Byzantium in the Tenth and Eleventh Centuries" has the most difficult subject to struggle with. Byzantium remains a strange and inexplicable time and place for an American with a normal, well-rounded education. We do not have a literature to go with it, as we do with Greece and Rome.

We know the past in many ways, responding to it according to the imaginative shape writers and artists have given it. The editor's claim that the ground this book covers "was untouched" is not quite right. For all the diligent facts in these essays, we will find ourselves still thinking of Roman soldiery as we know about it from Robert Graves, Rudyard Kipling, David Jones or others. And there will always be as many Romes and as many Athenses as there are imaginative reconstructions. These imaginary places have a peculiar way of coexisting in the mind without canceling each other. This is because the imagination operates like music, in a particular key and with a particular effect. Thus the London of Thackeray is not the London of Dickens, and I for one have quite

If there is an ongoing revolution for a responsible and creative freedom, we lose and we win, getting nowhere. What hampers us is a failure of history itself; namely, that advantage seems invariably to corrupt the ability that gained the advantage in the first place. Democracy came about in the modern world because of a critical discerning that depends on education, and on the public and pervasive critical sense that education provides. The uncritical mind is a prey to credulity, and without skepticism there can be no democracy.

We are astonishingly Roman all over again. We are half in love with fascism (the Godfather gets things done, doesn't he? He enjoys respect and loyalty, doesn't he? To succeed we have to know the right man in the right place, don't we?) and more than medievalized, as witness the press's daily staple of violence and sex, bogus psychology and bogus medical news; never mind the specialized press, the *National Enquirer* and its clones, with its medieval gossip about babies born with tattoos, about monsters in the mountains, aliens from space—all good fare from the twelfth century.

What we have added to human depravity is again a thoroughly Roman quality, perhaps even a Roman invention: vulgarity. That word means the mind of the herd, and specifically the herd in the city, the gutter, and the tavern. Our means of broadcasting vulgarity are so much greater than the Roman, however, and our critical defenses against it so enfeebled by a new ignorance and a rampant new superstition that it is easy for the pessimist to take the logical next step and predict a new dark age. We even have, in nuclear war, the ready means to duplicate the destruction of our civilization by the barbarian hordes.

So that what we learn from a close and detailed study of life in ancient times is that human nature is capable of practically anything. I would like for us to learn that we are an unspecialized animal of unexplored potential and flexibility. We can hold our gouty

foot to the TV screen while the Reverend Oral Roberts is practicing Old Stone Age medicine, or send our life savings to the Reverend Jim Bakker (medieval fund raiser), or watch a movie about chainsaw mutilation (the Roman circus). The ruts are well worn. The critical, sane mind wants to ask what wheels made those ruts.

Eros, His Intelligence

Stephen Dedalus, James Joyce's artist named for an artificer who wore wings, a symbol of transcendence, escape, and freedom, says in *A Portrait of the Artist as a Young Man* (1916), using words whose meanings were shaped by Aristotle, Scholasticism, and modern science,

> The instant wherein that supreme quality of beauty, the clear radiance of the aesthetic image, is apprehended luminously by the mind which has been arrested by its wholeness and fascinated by its harmony is the luminous silent stasis of aesthetic pleasure, a spiritual state very like that to the cardiac condition which the Italian physiologist Luigi Galvani, using a phrase almost as beautiful as Shelley's, called the enchantment of the heart.

Shelley's phrase, in *A Defence of Poetry* (1821), is "the mind in creation is as a fading coal." (Charcoal, Shelley means: radiant if blown upon, otherwise black but burning.) A fading coal, "which some invisible influence, like an inconstant wind, awakens to transitory brightness."

Galvani enchanted the hearts and legs of dead frogs by running an electrical current through their muscles. That's the word Galvani used: enchantment, *incantesimo*. Or, as we might say in English, he *besonged* it, he magicked it with a spell, a charm. Shaped words perhaps began as magic spells, *charms*. *Lovely sounds* is what

cearm means in Old English, and by Chaucer's time we were saying *bird charm* for birdsong, and were saying as well that church bells were charming the hour. That literacy was kin to casting spells with words can be seen in the fact that *glamor*, the power of beauty to enchant, is *grammar* misheard and mispronounced. Rhymes that bite and accuse—satire—were thought in ancient Rome to be so disruptive of social order that laws proscribed them.

Critics faced with talking about charm quickly find themselves at a loss. Mikhail Bakhtin liked to quote the Kantian Hermann Cohen in noting that there is nothing in us that needs a work of art, and nothing in a work of art that compels our presence before it. But he went on to say that art arranges for understanding and communication among us powerful enough to cancel the gaps of loneliness that divide us, and beguiling enough to bind us in social harmonies.

How, then, does art charm? That is the subject of the classicist Anne Carson's "essay" *Eros the Bittersweet* (1986), a work of great charm in itself, an intellectual exercise that dazzles (frequentative of *daze*) without stunning, flashes without blinding, and concludes, leaving us brighter and smarter. I've put "essay" in quotes to indicate both that the word is being used in its old sense of exploration and try-out and that the modern sense of the word is charmingly taxed: this is a book, and a long book compressed by elegance of style and a rigorous terseness.

Like a good teacher enticing us, Professor Carson begins with a fable from Kafka (the one about the philosopher who spun tops) to indicate that this book is about kinesis and balance, about things spinning, moving, fluttering (like Sappho's heart, Eros's wings, Dedalus's wings, vibrances of air that we call music, poetry, talk), colliding frequencies of meaning that sometimes dance together (as in metaphor and simile) after their collision, and sometimes remain opposed but joined, like Sappho's word *bittersweet*, or as the Greek has it, *sweetbitter*. What's bittersweet is Eros, the god

of falling in love (being in love is another matter, involving other, wiser gods). Gods and states of mind are contiguous in Greek thought; *eros* is the Greek for that giddy, happy, all too often frustrated conviction that another human being's returned affection and equal longing for you are all that's lacking to make life a perfect happiness. The word does not occur in the New Testament, which uses another Greek word instead, *agape*, which also means *love*. The tension between these two words has filled many books and caused much grief down through history, as well as much comedy.

Eros when we first see him (in Anacreon, I think) was a naked stripling with a red ball. The ball later became a bow with erotic arrows, and Eros acquired (or always had) a sister named Peitho, both children whose mother was Aphrodite.

Carson begins the real work of her essay by inspecting a poem of Sappho's, Fragment 31 as classicists know it, in which Eros has bagged a handsome man, a beautiful girl, and an onlooker who speaks the poem. Sappho, if you will, is the onlooker, though I like to deromanticize the matter and imagine that Sappho wrote songs for people to sing; that is, to give definitive words for universal emotions. Poetry is the voice of the commune.

The poem translates:

> The man sitting facing you looks like one of the gods listening carefully to what you're saying, and to your lovely laughter. [This sight] makes my heart beat its wings [like a fluttering bird], for every time I look I lose my breath, my tongue won't work, a fire burns under my skin, my eyes go out of focus, my ears ring, cold sweat breaks out, and I shake with fever. I'm greener than grass, and exist somewhere between living and dead.

We have the Greek text of this poem because an anonymous critic (once thought to be Longinus) thought it a masterpiece, though we would have had its sense in Catullus's translation. By-

ron, tongue in cheek, lists it among the classical works that abetted the corruption of Don Juan's morals ("Although Longinus tells us there is no hymn / Where the sublime soars forth on wings more ample"). Trust Byron to pick up the imagery of wings. What interests Anne Carson is the triangle: the geometry of the poem. She will build this triangle into the structure that concludes her work. Boy, girl, observing poet. In his late etchings of erotic subjects Picasso habitually includes what Freudians call a *voyeur*, who often looks like Picasso himself. Our century is nervous about the geometry of this poem because we are terrified of embodying Freudian sins, and have been taught by the popular broth of Freudian odds and ends that we should not watch, but do.

Yet Sappho is eloquently in the vulnerable angle of the figure, the Tonio Kröger embarrassed displacement of the artist. T. S. Eliot remarked (and demonstrated with the figure of Tiresias in *The Waste Land*) that in our time we know far too much about the erotic life of the opposite sex. Do we? And if we do, why is this poem of Sappho's so difficult for us to understand? Is it about jealousy? Is Sappho in love with the girl and suffering the bitterness of exclusion? Is Sappho happy for the lovers, in an ecstasy of observing, *feeling* that happiness? Let us say that she includes herself, visibly, in the business because all artists are there, at that point of observation, or the subject would not exist as a poem. No photographer, no photograph. Poe must send a visitor to the house of Usher, or that story would be George Berkeley's silent-movie tree falling without noise.

Later in the book Carson develops this theme of triangulation, using Plato's *Phaedrus*, the dialogue in which Socrates argues that desire (Eros) moves the mind to learn as well as to love. To get to Plato, Carson goes by way of the peculiar genius of the Greek language and its alphabet (the perfection of graphing sounds that had begun with the Phoenicians), Velázquez's *Las Meninas*, and the birth of the novel. *Las Meninas* is a trick painting; Foucault (whose

disciple Carson would seem to be) has made much of it. The painting is of Infanta Margarita with her maids and dwarfs in Velázquez's studio while her parents have their portraits done. The king's and queen's presence can be inferred from their dim reflection in a mirror deep in the picture's background. Velázquez, at his easel, gazes out at us; that is, at the king and queen, who are (in the logic of the thing) standing where we are—we, buttermilkfed backpacking Danes, Mr. and Mrs. Bridge from Kansas City, an Italian dentist and his brood—we must stand in the ghostly space also occupied by Felipe and Mariana.

This imaginary space, the presence of an absence, is desire's pivot, the lack that love aches to supply a presence for, the ache to know. As Carson disarmingly says halfway through her discourse, to prepare us for its conclusion, "There would seem to be some resemblance between the way Eros acts in the mind of a lover and the way knowing acts in the mind of a thinker." To possess in the act of love (and be possessed), to know. Deep in the prehistory of Greek there was a word root constructed of a *k* or *g*, an *n*, and a vowel. The words springing from this root all have to do with reproduction, both sexual and intellectual: *generate, gonad, know, ignorant,* and forty others. In the King James Bible a husband *knows* his wife and begets children.

Eros is a transient, irresponsible, mischievous god. He weakens our knees (said Archilochus), melts us, drives us mad. The acquisition of knowledge is without limit; there is always more to know. Both activities, loving and learning, gather momentum the more one pursues them. Their delights are exquisite; grasped, they melt in the hand like ice, freezing and burning all at once. Every lover knows that love is a sweet misery ("a form of madness," Aristotle said) that makes one feel completely alive; every scholar knows a kind of lechery in finding facts, in fitting them together. Which is the more sensual, Leonardo's notebooks or Hokusai's erotic drawings?

Socrates conflated seduction and education in a living meta-phor, and we are confused, we moderns, that he was a chaste family man who did not consummate his desire for the charming boys he delighted to teach. What Carson's book makes us understand is that Socrates' living metaphor used the imagery of Eros as Kafka's professor the spinning top. It is the kinetics of desire that creates the euphoria of loving and of learning, of being alive. We are largely ignorant of satisfied desire as the ancient Greeks under-stood it. Humanity is humanity; satisfied desire is a fulfillment of some kind and as a subject belongs to housekeeping, child rearing, reverie; that is, to the world of order. Desire and learning are by their nature disorderly, disruptive, agonizing: bittersweet.

It is no wonder that the Greek erotic imagination invented the ritual game in which it is shameful and unmanly for the beloved to submit to his lover. Greek pederasty was a courtship with no ensu-ing marriage. The beloved got educated in manners, military sci-ence, and the code of the tribe. His desirability ended when his beard appeared ("they are for Zeus to love," says a poem); he mar-ried, begat a family, fulfilled himself as scholar, statesman, or sol-dier, and chased boys. Modern liberals miss the whole Greek point; they want to legalize (in the name of freedom) what the Greeks thought slightly absurd and to repress wholly (in the name of psychology) the Greek erotic game of loving children. Re-fracted through western history's second erotic game, courtly love (where again the beloved must not give in to her suppliant), the spectrum of Greek desire has flip-flopped. They chose wives sanely and soberly, with a regard for tribal connections, while Eros spun them giddily in the gymnasium and marketplace.

Carson's subject is not Greek sexuality but Greek thought and poetry. One wishes she had folded in their graphic and plastic arts, where Eros is as vivid as in poetry and philosophy. The lesson she has to teach us is one of aesthetic geometry. Art happens in an act of attention (James's "point of view") that is to be transferred, af-

ter being made into an intelligible shape, to other minds. We forget that this is a miracle, a metaphysical unlikelihood. Poplars along the river Epte, Monet painting them, us seeing them a hundred years later. The process is always triangular, even if no work of art gets made. To remember those poplars, if one has seen them, requires a psychological triangulation all in one brain: event, memory storage, and curiously having to find for oneself a vantage in memory, to observe oneself remembering.

This nonexistent, impossible place and its definition form the invisible center of Carson's brilliant essay. She calls it the blind spot. It is where we are when we desire (in a state of lacking) and when we accrue knowledge by experiencing a page of a book. In doing both we are motivated by desire. We want to nibble our beloved's ear, to master the Pythagorean theorem; what we are really doing is defying entropy and moving into the mind's capacity for synergy. The lover's world is a new one to him; he sees whereas before he was blind; things long thought to be dull are suddenly interesting; a sense of wonder lost since childhood returns. Scholars, artists, craftspeople who love their work forget to eat. Their work is not labor. "A thinking mind," Carson writes, "is not swallowed up by what it comes to know."

Eros the god belonged to a world we can scarcely imagine. It becomes visible to us with the alphabet itself (hence a chapter dedicated to it, one of the most beautifully written in a beautiful book), which comes from the Greek sense of edges, limits, meticulous definition. Greek can delineate a word in another language, a leap forward: Egyptian hieroglyphs could not graph "Socrates"; Greek could graph "Osiris." Carson sees in the metallic beveling of Greek, its sharp edges and sinuous contours, a paradigm of Greek sensibilities. It is a Mozartian language. Sappho's poems were written for the barbitos, an instrument something like our zither or autoharp. Her meters are fast, decisive; some sound like Mother Goose, or Gerard Manley Hopkins at his most chiming.

Persuasive as Carson is, we still need an anthropology of senti-
ment and a grasp of history to appreciate the dramatic account she
gives of the Greek fusion of biological desire and intellectual
quest. Greek history in perspective seems to be an adolescence,
growing splendidly but never arriving at a maturity. The Romans
came and imposed one on them, not quite with success. Their
prose and their poetry remained youthful, relentlessly inquiring.
A page of Plutarch is somehow younger than a page of Herodotus.
Socrates with his daimon and his students, his bare feet and his
irony would not last a semester in an American university. The Ro-
man police would have scooped him up along with Musonius. On
the other hand, ancient Athenians would have liked Anne Carson.
Barbarian, yes, but she speaks our language.

We no longer teach Greek and Latin to university students as a
requirement for a bachelor of arts. What we do teach (in history
and survey and art classes) amounts to a feeble exposition. A book
like Carson's is all the more welcome in that it derives from Greek
ideas and has a measure of Greek wit (along with a measure of
French style). It is easy to toss about words like *Greek* and *Roman*
without giving (or having) any sense of what they imply, the charm
of the one, the plain goodness of the other. Plutarch, who had seen
the Roman senate (let's say that if you and I were to see it we might
describe it as the American Senate with garlic, uncomfortably se-
rious, its oratory windy and undulant), has occasion to describe
Alcibiades speaking to an Athenian council. Spoiled charge of Per-
icles, handsome favorite of Socrates, scapegrace, a Byron before
Byron, the fast sporting set's ideal of a real Athenian, he was never-
theless an aspirant statesman and man of affairs. He had brought
his pet partridge with him to stroke as he orated. The partridge
got loose. The Athenians were delighted. They leapt and fell over
each other to catch the partridge and return it to Alcibiades, who,
his pet secure under his arm, continued his speech, which con-
cerned the gravest civic matters. We cannot imagine this in the

Roman senate, nor a Roman historian recording it. It is, as we must say, "very Greek." Why, we can't say; just as we can't say why Sappho's song or Socrates' fusion of desire and philosophy is Greek: gone forever, nonrecurring.

Anne Carson asks us to imagine a city without desire, where philosophers do not run after tops, no poems are written, no novels. For without desire the imagination would atrophy. And without imagination, the mind itself would atrophy, preferring regularity to turbulence, habit to risk, prejudice to reason, sameness to variety. It would be a city that had ostracized Eros. No such city could exist (boredom is lethal); we need, however, a charmingly percipient philosopher like Anne Carson to teach us ancient verities in a bright new way.

A Letter to the Masterbuilder

ON CHRISTMAS DAY 1803, and the day after, Charles Fourier, the most thorough and imaginative of modern utopians, wrote his "Letter to a High Judge." He was at the time a cotton factor and unlicensed stockbroker in the industrial city of Lyons, where the Revolution had taken turns divergent from those of Paris and had been crushed and brought into line by Napoleon. Here was a thinker far more revolutionary than the Revolution, a provincial intellectual who had an elaborate plan for the reformation and happiness of humankind, who saw that a clean sweep and a new beginning had happened before his very eyes and that he could have a say in the political and social rebirth of an entire country. He had written a treatise with an uninformative title, *A Theory of the Four Movements and General Destinies: Prospectus and Announcement of Discovery,* published five years after the letter to the high judge, much as if he had thrown all copies into the sea.

The letter is, as we can now say, Kafkaesque, title and all. The high judge to whom it was written was Kafka's Klamm in the topmost room (if he existed) of The Castle. We have had so many analogues of this high judge that we do not need to labor the point. He is Hitler, Stalin, all the gaudy dictators of South America, Franco, Tito. They are all somehow the suit of empty armor that Philip II of Spain set up to review his troops, who thought the king was inside. The king was instead in his room in the Prado (hung with

nudes by Rubens, for his eyes only) studying minutely every diplomatic paper crisscrossing his vast empire, very much the spider at the center of his web, alert to every twitch. Every human life was in his hands but none had access to him except through intermediaries strung out along a maddening and labyrinthine remoteness. We now know that all of Fourier's communications to his government—letters to the Foreign Office, to high judges, to Napoleon himself—were intercepted by the police, investigated ("from a harmless idiot," one of them is marked), and filed, to be found by scholars of French intellectual history in the late twentieth century.

You and I know perfectly well, O Masterbuilder, that if we were to write a letter to the President of our Republic, the letter would never reach him. It would go directly to the FBI, with copies to the National Security Agency and the CIA. They would not read the letter for what we wanted to say, but for what clue it might contain as to what they should do about us: whether we are a harmless idiot, an assassin, a terrorist, or other threat to their hegemony. Our letter might well be a plan to reverse the entropy that is turning all our cities into slums, a plan to cancel the national debt as a black hole sucking all our taxes into it, a complaint that our food is poisoned by preservatives, or that our neighbor's power mower and leaf blower of a hundred decibels (the noise you hear and feel standing under the wing of a 747 as it guns for takeoff) are making life intolerable in our neighborhood. All of these would be of equal indifference to the jaded eyes of the interceptor. Fourier's last letter to Napoleon asked for four hundred orphans (of which there were tens of thousands, thanks to Napoleon and his wars), four hundred quaggas (zebras with stripes on the neck only, now extinct thanks to glovemakers), and an estate anywhere in the country (plenty of those, too, depopulated by the guillotine). These orphans, all of a tender age, and the quaggas (their mounts), were to be raised on the estate (the manor house a barracks) as Harmo-

nians, living according to the philosophical principles announced in *The Four Movements*. Such phalansteries were already in existence in the United States—the communities of the Shakers, Mennonites, Owenites, and many others. The experiment would have been, let us say, interesting, even picturesque. Such ideas were scarcely unfamiliar. Wordsworth and Coleridge had a vague plan to found a truly democratic community in Ohio. Marx and Lenin would later be inspired by some of Fourier's ideals. But Fourier's letter to Napoleon, like the earlier one to the high judge, were never read by the high judge or Napoleon. They were intercepted by the police.

So, O Masterbuilder, I do not expect the sentiments and ideas of this letter to be read by you, whoever you are. I call you Masterbuilder, Ibsen's name for his imaginary architect, who became so eloquent a symbol for Ibsen's disciple Joyce. The Finnegan of *Finnegans Wake* is a masterbuilder. He is the symbol for *homo faber*, Man the Maker. In our time the anthropologists and philosophers have tried to find the boundary line between wild and tame, nature and culture, the uncivilized and the civilized. The line is easily found for the other species. But we will have tamed ourselves, and how?

Some thinkers place the boundary at the beginning of speech, some at cooked food, some at clots of kin forming the embryonic family and state, some at a sense of justice, and so on. Ibsen and Joyce placed that line at architecture: the house, the temple, the village. Carl Sauer, that subtle geographer, had doubts about Louis Leakey and the origin of social humankind in the Olduvai plain, where the evidence of our beginning as social creatures would seem to be. No, said Sauer, that's hunting territory, without shelter or permanent campsites. The human animal is helpless in its infancy for longer than any other animal. It must be taught to walk, to speak, to protect itself, and it needs a good three years, and longer, to survive with the least measure of independence. So

Sauer guesses that humankind in Africa would have built huts on the coast, with the ocean to take to in boats in time of attack, and with food from the sea. The Olduvai Gorge would have been hunting territory.

We will probably never know how or when it came about, but we are at present, and have been for as far along the perspective of history as we can see, animals who build houses. A. M. Hocart and Lewis Mumford have written convincing theories about the origin of villages and communities, and Fustel de Coulange's description of an ancient Greek city is perfectly valid, Rodney Needham tells me, as a description of primitive villages in Southeast Asia and Africa. That is, the sense of boundaries, clans, the distribution of sacred and secular property is pretty much the same. From this I derive that the city is a concept shared by the human race, however the diffusion of this idea came about.

The old Greek *polis* was built around a hill (the acropolis, "hill-top"), which was both temple for the supernatural being imagined as the city's protector and a fort for the people to take refuge in during an attack—our word *sanctuary* still has this double meaning. A city was thought of as the origin of a particular kind of people, and when through overcrowding it sent out colonies, or daughter communities, it became a mother *(metro-)* city *(polis)*, metropolis. Rome was never what we call a country, only one city with many colonial cities constituting to our modern eyes an empire because we see it as a vast state. The state is an invention of the sixteenth century, not of the classical world. Neither Greece nor Rome had a name for itself as a political organization. Leagues and treaties bound them together.

What I want to say in this letter, O Masterbuilder, is that your civilizing art, that of building, has undergone, like everything else, changes of such a radical ("from the root") nature as to invite comment from a provincial intellectual who, like Fourier, can write a letter to the powers that be, but must write it in Kafka's

world, having no hope that what it has to say will ever be seen by the eyes that ought to see it. As early as that visionary Edgar Poe, writers have had the premonition that they are writing messages which will have to be put in bottles and thrown into the sea. Lucky the writer who knows for whom he or she is writing! Fourier is yet to be read by someone with the scope of a Napoleon (thank God, considering the time). Joyce wrote for he knew not whom. The writers most characteristic of their trade in our time are Antonio Gramsci in prison (kept there by Mussolini); Ezra Pound in prison and a madhouse (put there by Mussolini's enemies); Solzhenitsyn in his gulag; exile, prisoner, recluse, banned writer. I'm not certain what this pattern means, for most of my acquaintances who are writers suffer as much from being published and paid no attention to as from being unpublished for whatever reason. It all adds up to the high judge not getting his mail.

But we continue to write. Let me say, O Masterbuilder, that I think of you as civilization's practical genius, and prefer you to many other kinds of genius we can locate at the creative heart of civilization. When William Morris placed architecture as "the beginning and end of all the arts of life," he was, I think, speaking an absolute truth. I'm the kind of provincial intellectual who has concerned himself enough with architecture to have an opinion or two of substance. I know Le Corbusier's writing and his buildings (he is the significant continuation of Fourier into our time). I have sought out buildings in various places and studied them to the best of my uneducated abilities. I know a little something about architecture. And I have questions.

I live in Lexington, Kentucky (and have for thirty-one years). As in most American cities, downtown Lexington has been destroyed as effectively by commerce (well, commerce built it in the first place) as Dresden by the American and British air forces in World War II. I understand this: it is a process admitting of full ex-

planation. What destroyed downtown Lexington is of course the automobile, which had no place to park itself.

It is useful in talking about the automobile to think of it as a creature, like Samuel Butler's Erewhonians who saw machines evolving at a much faster rate than animals (Butler had read Darwin and Malthus in his own way) and solved their rivalry by revolting against them. Butler was right. The automobile is a bionic roach. It eats cities. Another principle in operation with the automobile was discerned by Diogenes in the fifth century B.C.: namely, that a man who owns a lion is also owned by a lion. We are all owned by automobiles, creatures whom we must feed gas and oil (a necessity so transcending political rhetoric that we continued to buy oil from Iran while it held our citizens hostage, and from Libya while we bombed it), shoe with rubber, wash, and lavish with other attentions, not the least of which are lifelong car payments. It is the most successful of parasites, far beyond the wildest hopes of microbes or rats. There is no system of slavery in history as rigorous as our enslavement by the automobile. But this complaint (and diatribe) is incidental only to the predicament of the architect in our time.

We have adjusted to the automobile. It has a room in our houses (the garage or carport, touching analogue of the room for the ox in an Italian peasant's house), we have turned it into a house (mobile home), and have pretty well relinquished the house itself in favor of living in the automobile. Fourier's prophetic eyes would note a reversion to barbarity, to the Golden Hordes on horseback. Well and good: we are the new barbarians, pioneers into the inhuman and into a new vacuum of knowledge. But we have not yet given up architecture. And it is precisely in the way buildings are being built that I (provincial intellectual writing futilely to the Masterbuilder) see a wrong direction that (I hope not) signals a totally wrong direction for all of civilization.

I had better get down to examples. Recently a new bank building went up in the urban wasteland of downtown Lexington. It is very tall: some thirty storeys. It is a steel skeleton with a glass skin. The top three storeys are beveled with a raking forty-five-degree angle (I suppose this must not be called the roof), so that the building seems to be modeled on a plastic kitchen trashcan. That's fine. What I want to ask about is the nature of this building's being. First, I have never looked at this building, which I must see daily, when there weren't workers on a plank suspended by ropes from the top washing it. To wash the second storey they must lower themselves twenty-eight storeys by rope and pulley. I presume this building is to be washed forever, much as the Golden Gate Bridge must be painted forever.

To comment on this astoundingly primitive idiocy (I mean the word), I must come at it from another angle. Whether from the inevitable disillusionment of middle age or from an accurate perception of reality, I began to notice a decade ago that the spirit of our times indulges in an inordinate amount of gratuitous meanness. Meanness: a withholding of generosity, a willingness to hurt, a perverse choice of the bad when the good is equally available. Journalism proceeds thus: the worst possible light is the one that sells newspapers and magazines. The blinding type we must read nowadays in books is another example: before computer-generated type the various sizes were designed individually, the proportions of smaller type being different from those of larger. Modern type designers draw one font and reduce and enlarge it photographically, not caring that the smaller reductions are anemic and an awful strain on eyes.

It is difficult to distinguish gratuitous meanness from greed. The thin wall that is not a boundary for noise, the rotten concrete that collapses on New Year's Eve, the plumbing inside walls that requires the destruction of a house to be repaired, the window that could so easily have been designed to swing around for inside

washing rather than requiring a ladder. You can think of a hundred more examples, but whether they are the result of indifference or stupidity is a nice question.

I'm asking about matters that I presume architects have thought about deeply. The office tower in which I work at the University of Kentucky is sealed. All of its air is dead, supplied by air-conditioning, a failure of which would suffocate the occupants. (In passing, we might note that the contemporary concern for breathing second-hand tobacco smoke is coincidental to all buildings' being air-conditioned, that is, with inert air trapped in a building, and the spokespeople for this problem seem oblivious to the fact that cigarette smoke is as a speck of dust to a boulder when compared to the emission—poison—from automobiles, an emission daily in the United States equal in volume to the volume of the Atlantic Ocean.)

With modernity in architecture there came, tied to it, the paradox of a technological retrogression. If a medieval candle went out, one person was in darkness; the failure of a power station plunges a whole city into darkness, halts elevators in their shafts, trains on their tracks. That's the principle. The actuality is far more subtle. The brunt of modernity is in a pervasive convenience and in technological "advances." I put that word in quotation marks because I have come to feel that modernity has marched into a great trap, that the once-balanced paradox has come to weigh more on the side of retrogression.

Is the destruction of cities by the automobile an advance? Decidedly and unarguably, no. Is the high-rise building an advance—full of inert air, with sealed windows, dependent on a power station to move its elevators, be lit, or even breathe? No. That the high-rise is a spiritual backwardness we all know well. There is no lonelier or more dangerous living space than the modern apartment or condominium complex. The inwardness of the modern house has made a desert of the yard and street. Conviviality (of the

Mediterranean kind Le Corbusier said should be the *sole* purpose of a city) does not any longer exist.

The decision to make the modern city a wasteland began with the transfer forty years ago of all police to squad cars; thus ended all protection of the citizen by the police. What the police do now is respond to a telephone call and review a crime that has already happened and from which the criminal has had plenty of time to escape.

What I think all this keeps adding up to, O Masterbuilder, is distance. With all the technological advances of modernity we made distance negligible, and now we are in a position to ask what was wrong with distance that we employed all our ingenuity to obliterate it?

One solid definition of a city is a number of people living close enough together to live well. What Fourier was writing about to the high judge was closeness. He asked that we be close, community after community, emotionally, conveniently, spiritually. Aristotle had said that a city in which the mayor did not know all of its people by name was too large to govern. Fourier was after the re-tribalization of humankind, the sort of group we all keep trying to re-create in church congregations, clubs, scout troops, little societies with common interests (gardening, politics, hobbies).

The spirit of modernity went the other way: into widening every distance. If, once, I wanted to talk about the bread I eat, there was the baker. Now all I can do is write a letter, if I can find where the bread comes from, and of course the letter will have no effect at all. Distance negates responsibility. I would like to ask the architects who built the office tower where I work if they were aware of the fierce currents of wind they created in putting their building on a hill with no walls to break the eddying of air, and if they knew what pressure this wind would put on the outward-opening doors that are the only access to their building. I would like to ask them why they didn't use revolving doors, invented (I believe) precisely

to alleviate this problem. I would like to ask a hundred such questions of architects, about space, windows, privacy, stairwells, lighting, noise, students' desks (the ones in my classrooms are the worst designed in the history of chairs), and many another thing.

As futility is the instigation of this letter, it is fitting that futility end it. What happened, O Masterbuilder? What was there in modernity that it went so wrong? Why did our dream of great mobility turn into a nightmare of paralysis? Could you not work around the bankers and their greed? Did gratuitous meanness wear the mask of revolutionary innovation? What was it that caused all of Le Corbusier's buildings to be betrayed, all his model cities unbuilt? Why is New York City more dangerous to live in than Dickens's London (itself more dangerous than medieval Paris)?

Unlike Fourier, I will keep my own vision to myself, as there is nothing practical in it. But I am writing to a practical person, for the architect is the very essence, along with the architect's twin the engineer, of practicality. As I see it, your task is to return the city to us, or to provide an alternative. This second route, you understand, amounts to rebeginning civilization, which has so far invented no alternative to the city. The home is long gone (it is a bed, a garage, and a TV screen), the city is destroyed, there are no neighborhoods, the quietest backstreet in the smallest town is now used as a freeway by interstate trucks and drunken drivers, all trees and parks have only a few more years before parking lots take them over. I keep seeing all this as a defeat of your great art, the basis and crown of civilization, and my provincial mind keeps coming back to the thirty-storey building of glass that must be washed forever by workers on a plank suspended by ropes and pulleys from its top, a predicament so gratuitously mean and backward and countermodern as to focus all of modern architecture into one question: why?

Two Notes on Wallace Stevens

I

BERNARD HERINGMAN in his contribution to Peter Brazeau's *Parts of a World: Wallace Stevens Remembered, An Oral Biography* (1985) records that when he asked Stevens about Picasso's Blue Period *Man with a Guitar* and "The Man with the Blue Guitar," he replied *"probably not THE Picasso painting* of the old guitarist was in his mind then, *hard to remember about many of these things."* (The italics are for Stevens's own words.) "He confirmed that the shearsman was a tailor and at the same time sitting in the cross-legged position, like the guitarist in that picture."

It is plausible, given Stevens's pervasive and lifelong engagement with George Santayana, that "The Man with the Blue Guitar" had its beginning in a passage in *The Realm of Essence* (1927), which would become volume 1 of the four-volume *Realms of Being* (1937). Santayana offers three examples, "one drawn from emotion, one from perception, and one from imagination," of "the living moment" when his *essences* can be detected and defined. On pages 147–48:

> Suppose that in a Spanish town I came upon an apparently blind old
> beggar sitting against a wall, thrumming his feeble guitar, and uttering
> an occasional hoarse wail by way of singing. It is a sight which I have
> passed a hundred times unnoticed; but now suddenly I am arrested and
> seized with a voluminous unreasoning sentiment—call it pity, for want

of a better name. An analytic psychologist (I myself, in that capacity) might regard my absurd feeling as a compound of the sordid aspect of this beggar and of some obscure bodily sensation in myself, due to lassitude or bile, to a disturbing letter received in the morning, or to the general habit of expecting too little and remembering too much; or if the psychologist was a Freudian, he might invoke some suppressed impression received at the most important period of life, before the age of two. But since that supposed impression is forgotten and those alleged causes are hypothetical, they are no part of what I feel now. What I feel is simply, as Othello says, "the pity of it." And if I stop to decipher what this *it* contains, I may no doubt be led, beyond my first feeling, to various images and romantic perspectives. My fancy might soon be ranging over my whole universe of discourse, over antiquity, over recent wars, over so many things ending in smoke; and my discursive imagery would terminate in dreary cold facts, the prose of history, from which my emotion would have wholly faded. The pity is not for them: it is not for the old man, perhaps a fraud and a dirty miser; it is pity simply, the pity of existence, suffusing, arresting, rendering visionary the spectacle of the moment and spreading blindly outwards, like a light in the dark, towards objects which it does not avail to render distinguishable. There is, then, in this emotion, no composition. There is pregnancy, a quality having affinity with certain ulterior things rather than with others; but these things are not given; they are not needed in the emotion, which arises absolutely in its full quality and in its strong simplicity. My life might have begun and ended there. Nothing is too complex to be primitive; nothing is too simple to stand alone.

II

American poetry in our century achieved a brilliance and a diversity rivaling that of the greatest epochs in world literature. In that phalanx of genius, Wallace Stevens (1879–1955) was one of the most original and distinguished. The measure of his distinction, however, is still under debate, and the meaning of his dense, sen-

sual, whimsical, philosophical poems has exercised the ingenuity of critics for some decades now. Beginning with the collection called *Harmonium* in 1923, Stevens's books, handsomely published by Alfred Knopf, had an authority and finish, a presence. In 1957 Samuel French Morse edited Stevens's uncollected poems, and some prose, under the title *Opus Posthumous*. In his 1989 edition Milton J. Bates adds to Morse's edition twenty-three poems, a short play, a rich selection from his notebooks, and nineteen prose pieces. He keeps Morse's macaronic title, which should be *Opus Posthumus*, or in even better Latin, *Opus Postumus*.

Stevens was a philosophical poet who was suspicious of both philosophy and poetry. He was a man of the world, an insurance executive, careful never to appear in public as a poet. When, at age forty-four, he published *Harmonium*, the event was very like the emergence of the gaudiest polychrome moth from its cocoon. Here was a poet with the verve of a Laforgue, the wit of an Apollinaire, and the obscurity of a Mallarmé, but with echoes of Blake and Whitman. Here was a poet who had listened to Santayana at Harvard, and had a Lucretian sense of the physicality of things.

It is easy to see Stevens as a religious poet. In all of his work he grieves that belief is impossible. Science collapsed the reality of biblical history; textual criticism shredded the New Testament. But poetry isn't religion, however much it might be its voice. Poetry is as well the voice of spirit, where religion resides, so we keep coming back around to the poet as a kind of theologian, not one with first principles and dogma but one searching for the source of spirit.

All of twentieth-century art participated in a navigational correction. It was the sense of our greatest creative minds that we had gone off course. Wittgenstein changed the direction of philosophy: we had, he said, wandered away from real philosophy. Picasso, Pound, Joyce, Gertrude Stein—all were resetters of courses. Wallace Stevens and Marianne Moore were especially concerned to re-

turn poetry to an authenticity it had been seduced away from by the very nature of poetry. Poetry, they felt, had much to do with order in the world and grace in the soul.

For Stevens the soul was a poetic invention, and he became infinitely speculative about how we see the world and what we make of it in our imagination. That was the quick of the matter—the imagination. The first poem in *Harmonium* is about a wildcat eating an antelope. It is a poem that rewrites Blake's "Tyger," focusing not on the *why* of the wildcat but on its place in nature. We human beings, however, are displaced, out of the harmony of nature. "Poetry is a means of redemption," says an entry in one of Stevens's notebooks. *A* means.

So to search for redemption in poetry Stevens constructed a kind of poem that is always strongly crafted, always wittily congenial, always gorgeously colored. Everything is plotted as well as it can be. It is clear that he knew the etymologies of every word he used; the archaeology of language was part of his poetics. In "The Comedian as the Letter C," the protagonist of that poem is precisely that, the letter *c*, which is a *k* or an *s* or a component of *ch*, and has a dubious claim to be in the alphabet at all. Its homonyms are *see* and *sea*, the key verb and noun in the poem. Mastery likes to play. Stevens was always a good-natured, frequently happy writer. He had the most lively sense of humor of any American poet; he stands out like a beacon in the inexplicable humorlessness of much modernist writing. (Hemingway was totally devoid of a sense of humor.)

"Poetry must be irrational" is another adage in Stevens's notebooks. Poetry has to appear as nonsense in a world of senseless violence. In insisting on poetry's irrationality, Stevens is really insisting on its separate order: the order of feeling and the imagination where, at our best, we seem to have our being and where our instincts seem to tell us that we belong.

Stevens, like Emily Dickinson, is a poet we need to read whole.

Individual poems display an obscurity that fades away in a knowledge of all the poems. Each poem has a way of being a commentary on the others. Bates's edition of fugitive poems and variants is the more welcome for that. It is, indeed, an extra volume of Stevens in its own right, and has enough good poems to outshine many a lesser poet's lifework.

Jack Sharpless

IN JACK SHARPLESS'S FIRST BOOK, *quantum* (1978), each poem defines a word. Diderot and d'Alembert's *Encyclopédie* defines Pumper Nickel (as they call it) as "the name in Westphalia of a very black rye bread the crust of which is so thick and hard that they cut it with a hatchet. It does not altogether lack taste, but is difficult to digest." Is an encyclopedist to deny his Parisian palate as a sacrifice to precision and objectivity? Who knows what encounter with pumpernickel is here being revenged? And why may we not have a lexicographer who is also a poet abandon himself to define choice words exactly as he wants to?

Affinities are more important to Jack Sharpless than definitions. His dictionary is one of exfoliation: shadows on the walls of the mind.

Then with *Inroads* (1980), his second book, Sharpless (1950–1988) turns to shadows on the mind of Elizabeth I. Some unlikely marriage of Japanese verse, or perhaps simply *imagisme*, and the historical anecdote has happened here. It is a happy marriage. It works. The essence and tone of an age rise up before us. The words are stacked so that we read them properly, one at a time.

Next, in *A Soldier in the Clouds* (1981), he turns to Thomas Edward Chapman alias Lawrence alias Shaw alias Ross, who, like Elizabeth, lived absolutely. What Jack Sharpless re-creates is the Laurentian energy, passion for detail, sardonic perception, and the

vast range of his interests: archaeology, statecraft, warfare, history, endurance, machines.

The last book, *The Fall of the X Dynasty* (1984), seems translated from the Chinese. More directly than in the other books, these poems weigh the civilized against the barbaric, life against death, justice against tyranny.

Jack Sharpless came to visit me some years ago, bringing with him a woman and her little daughter and the makings of a picnic. I was in the process of turning an old ramshackle house into a livable place. The backyard was still a jungle of bindweed and hedges gone wild; the inside of the house was all ladders and unpacked boxes. The only place we could have Jack's picnic was the front steps. It was quite clear that he thought this an ideal place. He exclaimed over the rightness of it, as if we had the use of a sunny meadow, and proceeded to feed us handsomely. With poets the imagination does not go a long way merely; it goes all the way.

To stack the words of a poem one above the other is both to make a list and to emulate Chinese poetry. Words in a stack also suggest addition: the poem as an arithmetic of images. The method has kinships with William Carlos Williams and E. E. Cummings but is an imitation of neither. The second poem of *Inroads* begins

> *In*
>
> *side*
>
> *on oaken*
>
> *board*

We can detect a cubist strategy, wherein fractal notations function as complete images (lines across a circle for a guitar, JOUR for LE JOURNAL). A *sideboard* is there.

> *a*
>
> *tabby*
>
> *cat*

Tabby: an old maid, Arabic silk, Tabitha, a good woman raised from the dead by Paul—all of these interact with the dying Elizabeth at Nonesuch, her fears and hopes.

> *sits*
>
> *beside*
>
> *a bronze*
>
> *vase*
>
> *counting*
>
> *squirrels*
>
> *through*
>
> *the oriel*
>
> *of leaded*
>
> *glass*

Bronze, lead, glass. Coffins are made of oak and lead. The cat becomes death idly contemplating its prey. In the previous poem Elizabeth is looking out this same window at the winter woods, and the poet makes us see that it is the winter of a world, the end of an epoch as well as of Elizabeth. Her tired old eyes had looked into those of Shakespeare and Raleigh. Death is never far from Jack Sharpless's attention.

These poems are a triumph over death. Cats will count squirrels as long as the world is fit to live in. People of rare and singular energies will die on a hillock of cushions or on a motorcycle going ninety miles an hour. In the rhythms of history, poets are both rare and singular. Jack Sharpless was the master of a pure talent that he nourished to something like perfection.

Thoreau and the Dispersion of Seeds

SINCE THOREAU'S DEATH in 1862 at age forty-five, those of his writings that were unpublished in his lifetime have found their way into print with a steady if widely spaced regularity. *Excursions* came out in 1863; *The Maine Woods* in 1864; *Cape Cod* in 1865; and *A Yankee in Canada* in 1866. These were all collections of magazine pieces and were books only in the sense that they were related texts brought together under a publisher's title. *Poems of Nature* appeared in 1895. A *Collected Poems*, edited by Carl Bode, came out in 1941, followed by a second, enlarged edition in 1965. The year 1906 saw the publication, in fourteen volumes, of his *Journal*, to which Perry Miller added a fifteenth volume in 1958. Alexander C. Kern published two more journal entries, newly discovered, in 1968.

There are thousands of unpublished pages of Thoreau in libraries around the country. *Faith in a Seed: The Dispersion of Seeds and Other Late Natural History Writings* (1993),* a "new book" by Thoreau, is a deciphering of a manuscript that was clearly meant to be the work that would follow *A Week on the Concord and Merrimac Rivers* (1849) and *Walden* (1854). Thoreau's method of composition was to draft passages daily in his journal, often at the point of observation, writing with an implement he and his father invented, the lead pencil exactly as we have it now (a stem of ground

*Edited by Bradley P. Dean, Foreword by Gary Paul Nabhan, Introduction by Robert D. Richardson, Jr., Illustrations by Abigail Rorer.

graphite and clay encased in a cedarwood tube). These journal entries then became the source of his books. There was an intermediary stage of redrafting, polishing, and elaborating—on any handy sheet of paper or on the backs of envelopes. *He* would know how to piece it all together for a fair copy, but it took Bradley P. Dean ten years to find the continuities and to come up with this text of "The Dispersion of Seeds," now printed for the first time together with three other fragments, "Wild Fruits," "Weeds and Grasses," and "Forest Trees." These studies, taken with others like them gathered by Robert Sattelmeyer in 1980 as *The Natural History Essays*, constitute a substantial body of scientific writing from a classic American author whose reputation as a prose stylist, an eloquently independent spirit, and a philosopher in the mode of the Greek Cynics and the Roman Stoics has not until now included scientific inquiry.

What "The Dispersion of Seeds" establishes is that Thoreau was inventing the study we now call ecology—how nature keeps house. At the same time that Thoreau was plotting how individual trees have their seeds distributed by squirrels, birds, wind, snow, rain, and a free ride on human trousers and skirts, in France Louis Pasteur was disproving the age-old belief in spontaneous generation.

Even though the introduction by Robert D. Richardson, Jr., places this text historically and biographically, showing how it reflects Thoreau's acceptance of *On the Origin of Species* (1859) over his allegiance to Louis Agassiz's theory of repeated cataclysms and geneses, there is a deeper dimension to Thoreau's text. At the center of his detective work is Thoreau's observation that pine seedlings thrive best in stands of oak, and vice versa: exactly the opposite of what one would expect. Thoreau sees in this a cunning arrangement whereby if an oak forest goes down to a forest fire or the axe, the beginnings of a pine forest will be there ready to replace it. But he does not have the knowledge of soil chemistry to

account for why pine seedlings fare better among oaks than near their parent trees. It was in the reforestation of Jutland that the Danes discovered that the mountain pine *(Pinus montana)* seemed to be dependent on the proximity of spruce *(Picea alba)*, neither of which grew into healthy trees without the other. A Colonel E. Delgar established this mutuality as a principle, and thus reforested large areas of a country that was being taken over by sand dunes. I suspect that Thoreau had discovered a similar interdependency far ahead of botany's ability to account for it.

The fascination this text holds for us is precisely Thoreau's detective work in finding out how squirrels disperse seeds by making their winter store, how birds drop part of their dinner, how winter wind sails seeds across snow, how "parachute seeds" ride the air. (The phrase is startling until we realize that we are in the age of ballooning, and thus of parachutes, long before the airplane.) Sherlock Holmes, we remember, invoked Thoreau in the matter of circumstantial evidence, "as when we find a trout in the milk." In the square mile around Walden Pond (on property belonging to Emerson) Thoreau set out to account for every plant, animal, and insect. He was a diligent scholar, able to read German, Italian, and French, and he knew the classical writers on nature in Greek and Latin. His "faith in a seed" is his constant wonder at nature's abundant fecundity and its seeming intelligence in providing for survival. Seeds are wily and determined. (In my own backyard in Kentucky I have a hardy stand of licorice that rode over from the Bois de Boulogne, its seed being designed to hook onto passing foxes, cats, and blue jeans.) The soles of shoes are rich in pollen and seeds. Botanists now know that the coconut palms of Central America derive from islands in the Indian Ocean: coconuts float. We see Thoreau running along roads to trace milkweed in the summer air to its source miles away. He digs up squirrel hoards (carefully replacing them) and maps out the route they were carried. He knows that inefficient digestive systems pass seeds

through birds and horses. An oak forest is the diligent work, always, of animals.

"Nature's design" is a recurring phrase. *On the Origin of Species* begins with the phenomenon of dispersal, Darwin's "distribution" that scientists like von Humboldt, Linneaus, Wallace, and many others had been studying for a century. Darwin, whom Thoreau had just discovered (a friend of Asa Gray's had brought a copy of *Origin* out to Concord), introduced the theme of struggle into natural history. Each species is programmed to take over the earth and has the fecundity to succeed, except that rival species check its omnidirectional radiance. Thoreau the transcendentalist, like Agassiz the special creationist, saw an "intelligence" in nature. Agassiz thought it was divine; Thoreau wasn't so sure. Accident, trial and error, and the stupidity of human beings played too large a part in the order, or disorder, of things. Samuel Butler's "luck and cunning" better states nature's strategies.

Inventor and manufacturer of the lead pencil (and of raisin bread), handyman to Emerson and Hawthorne, a pied piper to all the local children, Thoreau was by profession, when anybody could get him to work, the local land surveyor, defining boundaries, drawing up plats, knowing every inch of Concord real estate. Ironist that he was, he must have mused on the pun the title surveyor made. His real surveying of the processes of nature was at odds with what he saw as exploitation, bad soil management, and an unworthy husbandry of the land. The very modern note on which "The Dispersion of Seeds" ends (or pauses) is a plea for forest wardens and agronomists to control despoliation.

Walden was concerned with a pond in a wood and with the seasons; *A Week on the Concord and Merrimac Rivers*, written at the same time as *Walden*, is about rivers and water meadows. Both are meditations on what to do with our lives. "The Dispersion of Seeds" has none of the philosophical agenda of his other work. It is science. But it is also one of the most beautiful texts in American

writing, for Thoreau's eye is as lively as a squirrel and his descriptions are beautiful not because he is out to write poetic prose but because they are accurate and meticulously responsible as to information. Here is a typical passage:

> I remember years ago breaking through a thick oak wood east of the
> Great Fields and descending into a long, narrow, and winding blue-
> berry swamp which I did not know existed there. A deep, withdrawn
> meadow sunk low amid the forest, filled with green waving sedge three
> feet high, and low andromeda, and hardhack, for the most part dry to
> the feet then, though with a bottom of unfathomed mud, not penetra-
> ble except in midsummer or midwinter, and with no print of man or
> beast in it that I could detect.

I count sixteen distinct facts in this passage, and it goes on until we are looking at the god Pan surveying his realm.

Thoreau's own accomplished eye is supplemented by his scholarly research into many authors ancient and recent, giving the text the richness of Montaigne's in both the breadth of reference and the jump of wit. Early readers of Thoreau's journals complained that they become increasingly technical and dull, lacking the epigrammatic pronouncements that rivaled Emerson's and Carlyle's. He had become terribly serious about how a rise in the ground can cause pine seedlings to grow in a line along it and about the timing of florescences, migrations, and the seasons.

If this text had been published soon after Thoreau's death it would not have modified his reputation a great deal. He had published smaller studies like this one on wild apples and even on the succession of forest trees. John Burroughs and other naturalists who were working in the same direction are largely forgotten. Coming into print 125 years late, and as a masterful reconstruction from drafts that Bradley P. Dean spent a decade fitting together, *Faith in a Seed* is not only a timely reminder of Thoreau's genius but a vindication of his stature as a naturalist.

Life, Chance, and Charles Darwin

FATE REMAINS THE ENIGMA. Some chance event at the beginning of our lives keys in its plot. That this is so is the understanding of both folklore and the highest fiction. Dick Whittington's cat, the stone embedded in a snowball and thrown in random mischief, the kite that caught on fire. There is a scene in *Charles Darwin: A New Life* (1991), John Bowlby's abundantly detailed biography, in which we see Darwin relaxing on a sofa at Down House. He is reading George Eliot. Around him are his meticulously catalogued library, his notebooks, microscope, stacks of scientific journals. He is the preeminent scientist of his century and of ours. The great theory that he began to suspect as a young naturalist on the long voyage of *The Beagle* (1832–36) was one in which chance opened possibility after possibility over millions of years, so that the offspring of creatures now known only by fossils worked out a genetic fate. The bear, the wolf, and the dog are children of the same mother. Gratuitous modifications nudged each other toward divergent fates. George Eliot wrote about such things as they modified human lives in a few years; Darwin, as all of creation is modified over eons.

Darwin and his theory stand parallel to Marx and his. Their energies have radiated from the nineteenth century with something like the force of religious movements. They are theories with embattled histories. (Marx and Engels saw in Darwin a justi-

fication for their materialism, but a copy of *Das Kapital,* inscribed to Darwin by Marx, still sits in Darwin's library, its pages uncut.)

Even before the publication of *On the Origin of Species by Means of Natural Selection* (1859), the theory had become a collaboration. Alfred Russel Wallace, the British naturalist who had been up the Amazon with H. E. Bates and had in the Malay archipelago come to the conclusion that species transmute according to the advantages they have in their environment, proved to be not a rival but an ally. Thomas Henry Huxley in England and Ernst Haeckel in Germany took up the cause. The theory was born in some sense prematurely, for geology had not yet given Darwin the time needed and Gregor Mendel's work in genetics was as yet unknown. T. R. Malthus's studies of population growth and food supply fed into the theory, as did the accumulated information of pigeon and horse breeding that Darwin could consult at any English farm. We have come to misunderstand the latter part of Darwin's title, "by means of natural selection," by which he meant that nature has its way of selective breeding and that its purpose is the same as humankind's in evolving the domestic dog from the wolf, a sturdier horse, a faster pigeon.

In the century and a half since its inception, Darwin's theory has been under constant study toward its verification. It has no scientific rival. John Bowlby, in his biography, is careful to demonstrate that Darwin was researching and offering proof for a theory of evolution rather than initiating it. He channeled into an orderly flow tributaries that go back to his grandfather Erasmus Darwin, to Lamarck and Cuvier, to Goethe, to many geologists, and even to Lucretius and Ovid.

John Bowlby (who died soon after completing his biography) was a British psychiatrist who had a long and distinguished career as a doctor at the Tavistock Clinic, as a researcher in the United States (at the National Institute of Mental Health at Bethesda and at

Stanford), and as an author of several studies of parenting, juvenile delinquency, and of the role of affection in families. It was this latter interest that brought him to write a book about Darwin, who was born into a large family that for two generations had been scientists, engineers, industrialists, and well-to-do landowners, and yet who, despite his genius, was a sufferer of neuroses, constant illnesses (he vomited every afternoon at four), a kind of hysteria that took the form of gasping and palpitations, and seizures of depression in which he wept uncontrollably.

The *Encyclopaedia Britannica* says confidently that all this can be explained by a recent diagnosis of Chagas's disease, caught in Argentina. Darwin recorded the bite of the insect that could have given him the disease in his *Beagle* journal. But as Bowlby points out in an appendix, Darwin was already suffering from the gastro-intestinal nausea and cramps characteristic of the disease six months before the bite.

Bowlby's thesis is that Darwin's illness was psychosomatic, traceable to the loss of his mother when he was eight. The family was stoic (Grandpa Wedgwood, the famous potter, had a wonky knee obviated by the practical solution of amputating the offending leg) and treated death and grief by paying no attention to it.

Little Charles, Bowlby thinks, was deprived of the grief his mother's death required. Darwin's attacks tended to be more severe when members of his family died, and he once wrote a comforting letter to a friend who was grieving over a death in which he says that he himself had yet to suffer the death of a loved one—an obvious suppression of any memory of his mother's death.

Fortunately, Bowlby's account of Darwin's life is so thoroughly professional that the reason he came to write it (to solve the mystery of Darwin's chronic illness) does not obtrude. Genius pays for being genius. The biographies of intensely creative people are full of awful despondencies (as in the James family, in the lives of Beethoven, Nietzsche, and Melville) as well as of crippling illnesses.

There's Sir Walter Scott and Montaigne, both with excruciatingly painful kidney stones. There's Francis Parkman, whose mysterious illnesses resemble Darwin's.

And, confusingly, there are many artists who were orphaned early with no apparent harm, or who, like Brancusi, were turned out of the house to make their way in the world at age ten. It may well be that a deprivation of affection is psychologically ruinous, but it is also clearly true that prolonged and excessive parental care is smothering and has its own psychological disorders. Nature seems to be wonderfully flexible here. I have always thought it a spectacle for amusement that such exemplars of the French avant-garde in our time as Apollinaire, Cocteau, Laurencin, and Sartre all had to report to their mamas well into their thirties. General Wolfe, the conqueror of French Canada, dutifully wrote to his mother a daily letter. Mencius praises an emperor who made no decisions in war or peace before he had consulted his mother.

Would Darwin's mother, had she lived to a matriarchal age, have been distressed by her son's materialistic theory in which a hazarded variation causes the success or obliteration of a species? She was a woman descended from freethinkers who had known Franklin and Jefferson. Darwin's wife, Emma, loving companion that she was (her affectionate name for Charles was Nigger, and his for her Mammy), was anxious throughout their marriage about his indifference to religion. Though Darwin lists the concept of God among the "noble" ideas that separate man from the other animals, he had no talent himself for a belief in imaginary beings.

Darwin's illness has a special interest for Bowlby. What the reader will find far more interesting is Darwin's hale and lively mind. There are many accounts of Darwin's sharp intellect; Bowlby includes ample evidence of Darwin's unfailing wit (though he failed to appreciate Samuel Butler's) and the elastic jump of the man's curiosity. He was interested in practically every-

thing. When an idea came into focus, he took it and ran with it. Between the *Origin* and *The Descent of Man* (1871), his two masterpieces in science, there came the monumental *The Variation of Animals and Plants under Domestication* (1868). His later life was incredibly productive: the elegant treatise on the fertilization of orchids (still the authoritative work), his book on earthworms, the neglected work on the facial expressions of emotions, the autobiography (not published whole until 1958), and many botanical studies, botany having nudged zoology to one side in his old age. There was a day in June 1864 when Darwin wrote to the botanist Joseph Hooker: "I have a sudden access of furor about climbers. Do you grow *Adlumia cirrhosa*? Could you have a seedling dug up and potted? I want it fearfully, for it is a leaf climber and therefore sacred." This from a man who was writing three books at once, raising a family of geniuses who still grace the scientific world, carrying on an international correspondence, and upchucking every day at four. (There has been a Darwin in the Royal Society since 1761.)

And therefore sacred. Several students of Darwinian discourse have noted that Darwin, Spinoza-like and probably unintentionally, evolved a faith in the natural forces he found the mechanics of. In successive editions of the *Origin*, Nature acquires a capital and a gender (female). The *Origin* and the *Descent* are an Old Testament and a New. The structure of ideas easily wears a new mask while keeping its architecture unassailable.

There is no event without a past. Once geology began to uncover the fossil record, a rational account of it was inevitable. Darwin was an orchestrator of evidence and created a moment in knowledge when all the right questions began to find a plausible answer. The turbulence around Darwin is intellectual theater, still going strong. Not only theater but a kind of myth—the Victorian de-

bates between rhetorical giants, the almost instant abuse of the theory for ulterior motives, the invention of "social Darwinism" by Herbert Spencer, the Molièresque comedy in Dayton, Tennessee, the fundamentalist creationists and flat-earthers whose real motive is to keep their hapless children from knowing about sex until the marriage night, the embarrassment of both Protestants and Catholics, the *rifiuto* of Islam.

Bowlby's final chapter in this splendid biography is a coda in which he traces the careers of Darwin's associates and detractors beyond Darwin's death. It might well have been (especially as Bowlby seems to have come upon an incandescent energy at eighty) a sketch of Darwinism as it moved outward into the world. A moment still bright in Scandinavian intellectual history was the translation of Darwin by Jens Peter Jacobsen into Danish, coming hard on Georg Brandes's lectures (the first in Europe) on Nietzsche. There was the touching drama in the United States of Louis Agassiz's rejection of the theory while his colleague at Harvard Asa Gray accepted it. Darwinism rippled through literature in a rising tide. "The survival of the fittest" lost its scientific meaning of "most advantageously adapted to an environment" and became "might makes right." Oswald Spengler thought Darwinism a mere version of British middle-class faith in Progress, unworthy of the Faustian soul.

Darwin's first great good luck was to have been born into a family whose traditions were scientific and technological. The Darwins and Wedgwoods were broadminded and generous as well as industrious. The only cant word in Bowlby's biography is "workaholic," a coinage of the Rev. W. E. Oates in 1968, a yuppie babu word that is used in medical circles and that probably struck Dr. Bowlby as a nifty Americanism. Bowlby would seem to have been a workaholic, but Darwin wasn't. He was not a slave to work. He loved what he was doing and he did it out of pure curiosity. He

was not at a university and did not lecture. His childhood had been an adventure in collecting, an activity that put him in with good minds and loyal friends. His sailing on *The Beagle* was a stroke of fate. *The Beagle* had a naturalist (he abandoned ship in a snit at the first opportunity). Darwin was along for the very British reason that the captain was a gentleman who could only associate with other gentlemen, and on a four-year scientific journey one wants company. Captain FitzRoy (Bowlby spells him correctly, and is practically alone in so doing) might have been invented by Dickens. His mind was narrow, he had not a scrap of imagination, and he was a pompous ass. Though he rose to admiral and governed New Zealand and sat on many naval boards, he was driven mad by knowing that he had harbored and dined with an atheist. While Bishop Wilberforce debated Huxley at Oxford, FitzRoy paced with a Bible before the crowd outside, shouting, "The Book! The Book!" He later slit his own throat.

Bowlby notes that Darwin was unhappy and fretful if he wasn't working. Genius finds its rest and its refuge in its work, let the psychiatrists make of this what they will. England had invented the British family, one of the most harmonious societies in the world. Servants ran it: Darwin had a Jeeves all his life, even on *The Beagle*. In his daily round Darwin had the company of a loving and congenial wife, a houseful of children and eventually grandchildren. He corresponded with every scientist in the world. The old Alexander von Humboldt came to England to meet him. It is, I suppose, mysterious that so successful a man should be a mess of hot nerves and gasping anxiety. I respect Bowlby's diagnosis: hurt children can and do carry encrypted grief to the grave. That Darwin was extraordinarily sensitive can be seen in his notebooks where, as a very young man, he was already committing himself to an uncompromising materialism. He was careful to keep his aesthetic sense alive, and to work it into his theory, where it appears as

sexual attraction. All excess of this thrilling response to the giddiness of mating is the bonus that we call art. It is wonderful to think of *Die Zauberflöte* as the sublimated evolution of the booming of grouse.

What Darwin had taught himself to see was an invisible text written across nature. He read the Galápagos finches (a slightly varying kind on each of a group of islands); he read the fossil record; he brought all of creation into one grand plot of chance and adaptation. He must have known that he was changing the way every honest mind saw the world. He had no illusions, but the Victorians were a pious and idealistic people. He could not foresee how Freud would parody his theory by imagining evolutionary stages in human emotions, or how the social sciences would vulgarize it, or how it would all become a popular misconception; but he did know that he was dynamiting acres of theology and redirecting all studies of the past and of nature.

Though Darwin's easily recognized face can be found in all icons of Great Thinkers, he is not read. He was a competent writer but no stylist. *The Voyage of "The Beagle"* is readable; the notebooks are fascinating. The *Origin* and the *Descent* can be read by people who enjoy tedious arguments and copious examples. For those with a taste for such things, Darwin on the fertilization of orchids and on the earthworm is engaging reading.

The art of biography was evolved for precisely such intricate lives as Darwin's, which was lived mostly in the mind, and which has consequences and reverberations laterally in his own time and diachronically down to ours, and which far from running down is gaining momentum, attracting attention from many directions. Only now is the study of facial expressions coming into its own. Linguists are claiming Darwin as one of their pioneers. Paleontology, medicine, zoology, sociology, genetics all share a Darwinian heritage.

If Bowlby the clinician who specialized in grief wanted to write a biography of Darwin that emphasizes the enigmatic anguish of a great mind, he has succeeded. He has also written a thoroughly good biography in which Darwin is vividly present against the background of his distinguished family and his times.

Lenard Moore

COLLARDS COOKING in a farmhouse kitchen, crickets making a pinewood ring, misty tobacco fields at early morning—Lenard Moore's poems are as native to North Carolina as John Clare's are to Northamptonshire. A sensual truth of locality sustains both poets, and in first looking through Moore we realize that we are being shown a particular place by a poet whose soul lives there, as Alkman's Spartan birds and red-bean soup authenticate all else that he says, or Sappho's flowery meadows and starry nights. A poem's geography is, in both senses of the word, its ground. The Sicily of Theocritus, Wordsworth's Northumbria, Whitman's Long Island and New Jersey, Lorine Niedecker's Wisconsin: the poet must have his place that he feels he belongs to.

> *The far field red with sun.*
> *A dog, blacker than shadows, yaps and yaps,*
> *running long rows of tobacco*
> *as black men, and a mule (older*
> *than the men) walk slowly*
> *toward the barn.*
> *Dust rises, then falls. Somehow*
> *rises again, drifts here, there,*
> *coating speechless crows*
> *who glide from post to fence.*

Farther up the row now,
the unbridled mule's tail quivers,
striking a stalk gone limp
as sunlight fails.

And yet art comes from art, as it is a thing made with skill. I remember trying to paint South Carolina landscapes as a child, using Constable as my instigation. I now know that Constable showed me South Carolina woods and fields, just as Whistler showed me how to make drawings of city streets and houses. This is a wonderful paradox, and it is very much in operation with Lenard Moore's thoroughly realistic and tonally rich poems about the North Carolina tobacco country, which he learned to see through the eyes of the medieval Japanese poet Bashō. One thinks instantly of another artist with a beautiful world before his eyes, Claude Monet, who nevertheless looked at Hiroshige and Hokusai, with whose landscape prints all his walls were hung, before he took his canvas out to the banks of the Seine at Argenteuil or to the haystacks and rows of poplars at Giverny. It is a lesson in poetry, this kinship of artists that knows no boundaries of time or country: Picasso and the mask carvers of Benin, Walt Whitman and Millet ("Leaves of Grass," he said, "are simply Millet in words"), Bashō and Lenard Moore.

a black woman flashes across the cottonfield
like October winds —
and all you can see
is slanting rain
rushing rushing rushing
down the evening sky

But these alliances are beginnings only. Lenard Moore's ancestors would have spoken Twi or Ashanti, deeply imbedded locutions of which are still detectable by the linguist ("she be well" is

good African grammar, stubbornly remaining). As he notes in a poem, his people sang hymns and imbibed the locutions of the King James Bible as their earliest forms of poetic expression in their new land. Poetry by American blacks has had a slow history, and its ranks have been thin. Music claimed his people's genius. Our greatest composer is arguably Scott Joplin, and certainly our greatest opera comes out of the great fund of black folksong. And two of our indigenous musical styles, the blues and jazz, are known and loved the world over.

Poetry is the art of feeling, of allegiances and love, of memory. The whole value of Lenard Moore's verse in *Forever Home* (1992) is his attention to family, land, and seasons. Weather to the farmer is utterly different from the weather of others. Tobacco needs so much rain, so much sun, so many dry days, as much as it needs the care of hands and eyes. There's cricket chirping throughout these poems (as in Virgil and Theocritus), and it is not local color or decoration. It is one of the signs of weather.

> *A woman whose face wears a shaft of sun*
> *comes to the farm of a fastidious old black man*
> *where a peach tree still blooms,*
> *and sees in the pond clouds like feather beds*
> *until a bullfrog jumps and wrinkles them*

And there are grandparents. Farm children are more than likely raised by grandparents, as their parents are in the fields. And nothing is more valuable to a poet than long memories conveyed by grandparents around the fire in winter or on the porch in summer. Rural families constitute a clan, knit by loyalties and a common, isolated history. They know time as the seasons and as birth and death. Lenard Moore does not now live in this world of the aromas of collards and cornbread, but for this book he has zoned away the city, history itself, and even the political and sociological anxieties germane to his subject matter. He has chosen to keep to a

great purity of purpose, the native identity of the place on earth that shaped his mind and heart.

As with his master Bashō, what he seeks and what he finds in these poems is that inner stability—peace, if you will—which will not desert us no matter what outer fortune assails us.

The most composed and stalwart Romans looked back to the childhoods on Tuscan farms to explain the stability of their character; so Lincoln, so an American myth. What Moore finds in his past is an education of the senses, a validation of his world. This may be the most valuable act we can perform: to make peace with the only reality fate has given us. The power of poetry is demonstrated by Lenard Moore's learning from Bashō that the smell of honeysuckle and the prudent departure of quail from a field are experiences as charming, and as absolute, in Onslow County as in the prefecture of Kyoto. This, we might notice, is the opposite of romanticism. The romantic goes to SoHo and tries to participate in artistic modalities that were trivialized years ago in Europe. The realist finds all he needs where he is.

Guernica

ON APRIL 26, 1937, three squadrons of Fascist bombers (Junkers 52 trimotors, Heinkel 111 B bimotors, and Dornier 17s) of the Condor Legion, a German unit stationed in Spain, dropped high-explosive and incendiary bombs on Guernica, a Basque town near Bilbao on the northern coast. It was a Monday, and market day. The attack began at 4:30 in the afternoon; some accounts say that it lasted for three hours. The target was a bridge outside of town, the destruction of which would have cut off the retreat of Basque troops on their way to Bilbao. The first wave of bombers missed the bridge and dropped their bombs in the center of town. Successive waves used the smoke of the first as their target. Franco's headquarters reported to the world press that Guernica was dynamited by Communists, who invented the air attack. Berlin said that nothing at all had happened.

Four months before this cynical use of Guernica for the double purpose of trying out the effectiveness of German bombers while aiding Franco's struggle to place Spain under Fascist rule, Pablo Picasso had been approached by the embassy of the Spanish Republic in Paris, asking him to contribute a painting to their exhibit at the 1937 Paris World's Fair. What Picasso was planning for a subject is now a matter of conjecture. In his *Picasso's Guernica: History, Transformations, Meanings* (1988), Herschel Chipp argues

that it was to have been a grand working up of the theme of artist and model that dominated Picasso's imagination at this time. After the bombing of Guernica, he decided to paint an allegory (as he called it) of that event. His concern was to construct an unforgettable image of violence and terror.

The painting, which is twenty-five feet long and eleven feet high, was begun on May 11 and finished on June 4. It was painted at 7, rue des Grands-Augustin, a building in which an episode of Balzac's *Le chef d'oeuvre inconnu* is set.

Now, half a century after the painting of *Guernica*, the interpretation of its symbols and the origins of its iconography are still the cause of controversies. Rudolf Arnheim's *Picasso's Guernica: The Genesis of a Painting* (1962), still a useful study, was the pioneer investigation. With archival material about the bombing itself unavailable to Arnheim, and with newly discovered sketches for the proto-*Guernica*, Herschel Chipp has written a rich study far in advance of Arnheim's. Eberhard Fisch's *Guernica by Picasso: A Study of the Picture and Its Context* (1988) is not nearly so good, botched by pedantry and a strange visual obtuseness, but has some useful points. Ellen Oppler's compilation, *Picasso's Guernica: A Norton Critical Study in Art History* (1988), is designed for classes and seminars, and is what used to be called a casebook. It contains all the primary critical sources as well as interpretive essays, and is altogether an exemplary compilation for the study of a complex painting.

The test of these books is the extent to which they can help us understand Picasso's work. All three recognize the relevance of "The Dream and Lie of Picasso," the *Minotauromachy* etching, and the centrality of the corrida to the painting's meaning. Chipp offers an extensive analysis of the deep roots of *Guernica* in the ritual violence and blood of the bullring.

Picasso, for all his distortions and stylistic innovations, is always a very literal painter. When he graphs a broken statue, he

makes it clear that the severed head is bronze, not flesh. Yet Fisch sees decapitation rather than broken metal.

The power of *Guernica*'s energy, however, depends upon the extension of a very literal reading into symbolic meaning. The fallen horse is primarily the picador's horse. It has been gored and is dying in anguish. It is also any defenseless, helpless creature gratuitously (however ritually) killed: it is the town of Guernica. It is, as well, an eloquent symbol in which we can find a range of meanings. Nietzsche was very much in the air among the anarchists and poets of Barcelona, and Picasso would have known that Nietzsche's mind snapped when he saw an old horse fall in a street in Turin. It is also the hobby horse, symbol of the old year's demise, whose cult survives more persistently in Spain than elsewhere. And because Picasso has obviously alluded to writing, or printing, in the rows of dashes on the horse's body and legs, the horse also means Writing. Together with the statue of the warrior beneath it, the horse is something like History. Or Truth. Or Literature. It occupies a space that also contains an electric light (which, as many critics have pointed out, is also a sun) and a lamp.

The bull, variously interpreted over the years as Franco or Fascism or Spain itself, is first of all the bull of the bullring. In blind instinctual fury it has gored the horse. We cannot assign any guilt to it; we cannot call it cruel and bestial. It is a beast and acts like one. In the corrida the bull is provoked to an insane ferocity through pain and taunting. It is violence: the blunt fact of violence. If he had chosen another vocabulary of images, Picasso might have used lightning instead of the bull; earthquake, a mad dog, plague.

The corrida is the last survival (except perhaps boxing) of the Roman circus, which lasted longer in Spain than in the rest of the empire. All of his career Picasso meditated on the bullfight and built a private if articulate myth of its elements. He saw the Minotaur in the bull. He saw primal, instinctual power as yet unsubdued by civilization. He placed it in opposition to various symbols:

innocence, as in the *Minotauromachy* etching, human (as distinct from bestial) sexuality. In *Guernica* the bull is war, the horse peace. It is violence, and the horse is all that's vulnerable to its power to hurt.

The four women (one with a dead child in her arms) are repetitions of the horse. Iconographically, they are a pietà, a Demeter (with lamp) bewailing the rape of Persephone, and the two Marys at the crucifixion. Literally, they are the women of Guernica.

In none of these books is there any engaged consideration of the decisive element that makes the painting what it is; namely, its style. Its color—grisaille—is a symbol in itself, announcing its kinship with newspaper photographs. In halftone reproduction it would keep its color values. (The first picture postcard of a work of art, Millet's *Man with a Hoe*, lost very little in sepia reproduction, and Picasso is on record as saying that color is a distraction in a painting.) Monochrome also makes *Guernica* kin to Goya's "Disasters of War" etchings, and we remember that Henri Rousseau's one print was of his *War*, one of Picasso's iconographic sources.

The painting streams to the left like a Hebrew text. It is, like Courbet's *Studio*, both a room and an exterior. It is both night and day. There are visual puns: eyes are teardrops; the horse is a crumpled newspaper (or a destroyed book: Nazi bonfires of books were burning as Picasso painted). The warrior's lined hand is a popular graph of Fate. The bull's tail is a wisp of smoke. The deepest allusion may be to the painted cave at Altamira (at Santander, a few miles from Guernica), and to other prehistoric caves with their bulls and horses. We know that Picasso visited Altamira while Henri Breuil was copying its images in the early years of the century. (Lascaux was not discovered until 1940, so that the dying horse cannot be an allusion to the disemboweled bison there, transfixed by a spear, though the accuracy of Picasso's evocation of Magdalenian cave art is inescapable.)

The style is archaic in two ways: it has the naïve distortions of

children's drawing, and it reaches back to a theme native to both slopes of the Pyrenees—the majestic otherness of the animal. When the Spanish watch their bullfight, they are not only celebrating their love of seeing agony and death but also participating in a prehistoric awe of the feral. Marxist critics attacked *Guernica* early on for its failure to depict the actual bombing (as socialist realism required). Other critics have noted that Picasso is not at home with technology; he has never depicted an automobile or airplane or telephone. He has always inhabited a mythological world of his own devising. The lamp in *Guernica* keeps the painting from being dated earlier than mid-nineteenth century; the electric light places it in the twentieth. No other artist could possibly have painted it. Or drawn it, as it is technically a large drawing. Every graphic quality is that of a pencil drawing to which gray washes have been added.

Both Chipp and Oppler devote much attention to the history of the painting, from its dramatic first showing at the Paris World's Fair in 1937 (a Nazi guide to the fair noted that it was the work of a madman) to its installation in the Prado in 1981, where it is protected by the Guardia Civil and bulletproof glass. It was on loan to the Museum of Modern Art from 1939 until 1981, and before that it was exhibited in Scandinavia, San Francisco, and Chicago. ("BOLSHEVIST ART CONTROLLED BY THE HAND OF MOSCOW," said a headline in the *Chicago Herald and Examiner*.) It is galling to learn that American provincialism all but unanimously disapproved of its style, and American ignorance and innocence could not grasp its denunciation of a gratuitous bombing of a defenseless Spanish town.

What's welcome about these studies of a single painting by Picasso is that they open the way to seeing Picasso; that is, to reading him iconographically, to realizing that he is a painter deeply literary and traditional, for whom narrative and anecdote remained

important despite his protests against them. (There is a page of the "Human Comedy" drawings that depends on a knowledge of Alfred Jarry's *Le Surmâle* to be understood, and many of the "347 Gravures" allude to Spanish drama of the Siglo de Oro.) Picasso is our Ovid. His sensibilities have always been Roman; that is, realistic, masculine, spectacular. He would have been a comfortable Pompeiian. His best friends were poets; his influence on literature was always fructive (witness Apollinaire, Cocteau, Rilke, Gertrude Stein, even Eudora Welty, whose first story, "Acrobats in a Park," was inspired by *Family of Saltimbanques*). His influence on painters was disastrous, as witness Pollock, Dora Maar, Gorky. Gris, Tatlin, and Braque were more collaborators in invention than disciples.

"What a pity that he never painted a picture," the old Chagall said of him. Perhaps we have been looking for pictures where Picasso was painting something quite different. We can answer Chagall by saying that Picasso wrote many poems or that he was a maker of images. He insisted that he was a *peintre* (a profession that includes house and sign painters) rather than a *peintre-artiste*, that tacky French locution which suggests Bouguereau in a smock, with cravat.

Guernica may well not be "a painting." It is a Magdalenian glyph, a poster, a sign. It is, in every sense of the word, ugly. In Goya, Delacroix, and Munch, to choose three painters of terror, the subject is subsumed into the beauty, formal and sensual, of painting. Picasso refused that beauty. There are great harmonies in the design of *Guernica*, but they serve only to organize. Picasso, like the painters of Lascaux, suspended his images between reality and artifact. As Rilke says in the Fifth Duino Elegy, he could command the *thereness* of his subject. The implication is that art all too often brings its subject into the domestic *hereness* of Art. The rarest success of the artist is to leave his subject where he found it (like

Joyce, Goya, van Gogh) and take us to it. *Guernica* will, in time, be "a picture." Sixty years later, it is still an image of violence and terror as sharp as the photographs of Robert Capa or Margaret Bourke-White, and as timely as news reports from Bosnia and Northern Ireland.

Late Gertrude

ABOUT THREE YEARS AGO Gertrude Stein was at a Lexington, Kentucky, bookstore, promoting her latest. I learned this by overhearing one sorority sweetheart shouting to another on campus. "It was fab seeing her in person! I mean, you know, Gertrude Stein!"

It was Gloria Steinem at the bookstore, but what other American writer, fifty years dead, can claim a place in the sparse learning of the intrepidly illiterate? Gertrude Stein is firmly wedged in the American mind, together with Alice Babette Toklas. Her salon at 27, rue de Fleurus (between the Boulevard Raspail and the Luxembourg Gardens), is an echo of the eighteenth century. There, in a room as famous as any in our time, hung with Picassos, Cézannes, Matisses, and Derains, one might encounter Ernest Hemingway, Jacques Lipchitz, or Sherwood Anderson. Even Ezra Pound. (He broke a chair, and was never invited again.)

She is a vivid figure in the history of art, of writing, of the two world wars, of music, of popular culture and academic folklore. Yale printed all of her posthumous writings, six volumes of them. Periodically there are compendia, like *A Stein Reader* (1993, edited and with an introduction by Ulla E. Dydo), published in the thin hope that somebody will read her. Random House has kept a *Selected Writings* in print for decades. The general opinion is that *The Autobiography of Alice B. Toklas* (1933) is readable and charming,

that *Three Lives* (1908) is significant, that her operas (scored by Virgil Thomson) are great fun, but that the large part of her copious works is unreadable. It takes heroic effort to make one's way through the thousand pages of *The Making of Americans* (1925), and conscientious students who have read *A Long Gay Book* (1933) and *Stanzas in Meditation* (1933) and *How to Write* (1931) should be issued a medal by the American Academy.

The century will end with our having to admit that we have learned how to read some, but not all, of its writing. Joyce and Pound demanded a redefinition of the act of reading. It is still not clear what Gertrude Stein was trying to do. Where we can understand her, she repays attention in great measure. We can specify fairly accurately what of hers we can and can't read, and to what degree her pages make sense. At one extreme is the easy, flexible style of the *Autobiography*, and at the other the "cubist" nonsense of repetitions and agrammatical phrases of *A Long Gay Book* (whose title does not mean what you think). In between, we have the epic echolalia and logorrhea of *The Making of Americans*, and the plays and operas, which always make a kind of sense. We can understand "The Mother of Us All" (1947) in the same way that we understand Mother Goose and Edward Lear (and shall we add Wallace Stevens?).

Many children and even a dull professor or so can enjoy "Doctor Faustus Lights the Lights" (1938) if only to laugh at the little dog who says "Thank you!" to everything, and because we've heard of Faustus and Mephistopheles.

Ulla Dydo has put together a selection of Stein's writing quite different from previous ones (though Richard Kostelanetz had broken ground in this direction). It is all Difficult Gertrude Stein and very hard to read. Except for excerpts from *The Making of Americans* and *Stanzas in Meditation*, all the texts are complete.

Those who, like William Carlos Williams, saw Gertrude Stein as a revolutionary writer claimed that she was scrubbing words

clean so that we could see them anew. She was, to her own mind, being a cubist. That is, she was making a fractal sketch of things the way Picasso and Braque could paint a mandolin with a few suggestive lines. Her most successful technique was teasing, making us guess, alerting us to the traps in language that we normally avoid or can't be bothered to think about. Here Stein moves parallel to Wittgenstein, who saw that language is a game with agreed-upon rules.

If Gertrude and Ludwig had ever met, apparently they could have talked for hours about the sixth Act IV of *An Exercise in Analysis* (1917). The act in its entirety is: "Now I understand." This is the sort of statement that worried Wittgenstein for the last thirty years of his life. It involves the problem of other minds, of certainty, of epistemology, and the language game. We can supply many contexts for such a statement.

"Here is plenty of space" is another bit of dialogue in this play. I hear William James in his Harvard classroom with Miss Stein alone paying attention. There is the same amount of space everywhere, evenly distributed. But not, Samuel Beckett would say, in this world. Is the speaker arranging the furniture or arriving in California? "Can you see numbers?" "Call me Ellen." "Extra size plates."

Gertrude Stein was a great reader. In novels, Henry James's for instance, characters talk, and in their nuances lurk the subtlest intricacies of the author's web. Imagine a text of a novel, say James's *The Sacred Fount* (1901), from which everything has been extracted except the dialogue.

These difficult pieces have puzzled readers and stymied critics since they were known. What are they? The music of Philip Glass can help us, a little: repetition with slight variants can be mesmerizing or tedious, according to your nerves. The sheer cheekiness of it commands respect. We realize that we are in the presence of a sophisticated and cunning technique, of an achieved style. She is,

with her array of styles, asking to be put beside Picasso. *Stanzas in Meditation*, read aloud in a good voice, is eerily like Shakespeare's sonnets for sonority and majesty of line. They even *say* something—but what? It's like overhearing an actor two rooms away. You can feel the cadences and the power, but you can't hear it well enough to know if it's Donne, Milton, or Marlowe. It's like watching a photograph develop in the tray before it is recognizable.

If only we could make her texts come alive as they do in Virgil Thomson's music. We can get somewhere by suspecting comedy practically everywhere and laughing with Gertrude rather than at her. Her writing is always elate, spirited, good-humored.

James Laughlin, who was once Gertrude and Alice's errand boy, automobile mechanic, and typist (under injunction to bathe daily, as "men smell"), has described Gertrude at work. She wrote in an exercise book resting on her thigh, and the writing did not interfere with her carrying on a conversation (Laughlin timed her: two and a half minutes to fill a page). Alice was in the next room typing the previous exercise book. Do not be put off by the conversation; Dickens worked the same way. What we should see is the sureness of what she was doing. She trusted her style.

There were, however, agonies. Ulla Dydo's excellent headnotes to these pieces reveal unsuspected, extensive revisions in the earlier work. They also identify occasions and names, adding some critical observations. Citing an event in relation to a text is frustratingly unhelpful. What we need is a way to read Gertrude Stein. My experience has been that there's sense there. In one of Picasso's densest cubist works a scholar has recently been able to discern the figure of Arcimboldo's *Librarian*, so that we can now see the visual logic of what had seemed an abstract shingling of small, busy angles. This is not finding the bunny in a puzzle picture; it is recognition of aesthetic organization.

My sense is that Stein began with what in another writer would be an idea. She does not, however, propose to develop the idea into

a plot, a poem, or an essay, but to submit it to the chemistry of her considerable intellect. One day she must have heard, or herself re-marked, that Byron's life would make an interesting play. She would not write the play; she would think about the intricacies of historical figures in plays and about what a play is. So in 1933 she wrote *Byron A Play*, which seems to be about Byron, plays, and the problem of what we mean when we say a famous name. *Seems*. To read it we need to find a part of our brain that we have never used, where the synapses are differently designed. It is the very literate equivalent of children playing in a sandbox. They are happy, busy, purposeful in their own way, but only angels know what they think they're doing.

O. Henry

It was only toward the end of the first decade of this century that the shy and amiable North Carolinian who had published some three hundred stories under the pen name O. Henry consented to be photographed. He had, as we know, his reasons. Nor would he be interviewed. One of his editors at Doubleday, Page, and Co., Harry Steger, persuaded him to be photographed by William M. Van Der Weyde, whose portraits of O. Henry are some of the finest of any American writer. Steger remembered in after years that it took two hours to cajole O. Henry into getting dressed and walking two blocks from the Hotel Caledonia to Van Der Weyde's studio.

The unique interview, by George MacAdam, was also at the insistence of his publishers. But here O. Henry was in his element and had only to become one of his own characters (the master confidence man Jeff Peters) to bluff his way through it. He made himself a Texas newspaper man—true enough—to account for his knowledge of the West. Of his job as a teller in an Austin bank he said nothing.

"Then a friend of mine who had a little money (wonderful thing, that—isn't it?—a friend with a little money) suggested that I join him in a trip to Central America, whither he was going with the intention of entering the fruit business."

We can hear that *whither*. If you're speaking fiction, you might

as well make it literary. William Sidney Porter was in Honduras because he had been charged with embezzlement in Austin, and had jumped bail (married man that he was, with a daughter) and sailed to Central America from New Orleans. He could not have been in New Orleans for more than a few days, yet the stories he set there have the color and tone of a native's familiarity.

"The banana plantation faded into nothing; I drifted back to Texas." There had never been a banana plantation, and O. Henry returned to Texas after two years in Trujillo because he learned that his wife was very ill. She died on July 25, 1897, and O. Henry was tried in February of the next year—on the same day that Émile Zola stood before judges in a Parisian court (he jumped bail too and sat out his troubles in London) for accusing the army and government of falsely condemning Captain Dreyfus in that notorious *affaire*. O. Henry and Dreyfus were probably equally innocent. One of the charges against O. Henry was for a day when he wasn't in Austin, and the others may have been due to inept bookkeeping. There has always been a rumor that O. Henry was shielding someone else, and he wrote many stories about embezzlement, false charges, and one friend's taking the rap for another.

"I went to New Orleans and took up literary work in earnest."

He went to the Ohio State Penitentiary on April 25, 1898, to serve a five-year sentence. He was released, with time off for good behavior and exemplary deportment as a pharmacist in the infirmary, on July 24, 1901.

In prison he changed his middle name from Sidney to Sydney (a city that began as Botany Bay). Throughout his work we can find concealed references to his detention. The pseudonym that he began to write under in prison is constructed from the first two letters of *Ohio* and the second and last two of *penitentiary*. (He gives the code for this in the story "The Man Higher Up," in which a con man named Alfred E. Ricks is caught but returns to the game as A. L. Fredericks.)

In an age of triple names, when even P. G. Wodehouse had to be Pelham Grenville Wodehouse, the name O. Henry sounded puckishly plain and humble. It was an Odyssean *Nobody.* To every query about its choice, O. Henry gave a different answer. "O. is the easiest letter to write." Sometimes he said the O. was for Olivier, "the French for Oliver, you know."

From prison O. Henry made a stop in Pittsburgh, and almost immediately moved to New York, where his stories were beginning to be talked about and in demand. For the next ten years until his death (under the pseudonym Will S. Parker) in 1910, he kept magazines and newspapers supplied with short stories in a style unmistakably his own, a handful of which have always been staple selections in anthologies. He was one of the most popular American writers. The year of his death saw two collections, *Strictly Business* and *Whirligigs. Sixes and Sevens* came out in 1911, and stories were still being collected into books as late as 1917 (*Waifs and Strays*). His childhood playmate C. Alphonso Smith's biography was published in 1916, disclosing the truth of O. Henry's life and making him not so much a character from one of his own stories as one from Conrad. To those friends who knew his past, O. Henry always compared himself to Lord Jim.

His first book, the novel *Cabbages and Kings*, is strangely like *Nostromo*: both from 1904, they are both intricately plotted novels about the misappropriation of large sums of money in a Latin American republic.

The year of O. Henry's (and Tolstoy's and Mark Twain's) death, 1910, was also the year when, after a vigorous adolescence, modernism came to full maturity. Neither America nor Europe, however, was yet aware of it. Modernism was a secret enterprise. If O. Henry was unaware of Stieglitz's gallery 291, so was Ezra Pound.

O. Henry wrote with the frontier at his back. For him modernity was being able to buy a New York dress (only three years out

of date) in Houston, or to hear John Philip Sousa on a phonograph in Honduras. His modern architecture was not Wright's Robie House (1909) but the Flatiron Building (1902). He mentions Alberto Santos-Dumont twice, but not the brothers Wright. Yet for all his being, like Kipling, an avuncular presence in a new age of revolutionary nieces and nephews, he seemed to Europeans to be a radically new kind of American writer.

Cesare Pavese considered him to be an innovator and energizer of narrative English. "He ended sentences the way no one had ever before ended them, except Rabelais." Pavese credits him with opening a vein of new ore *del bizzarro e del cosmopolitico*, the finding of a strange beauty in the mundane business of a city. To the Russians of the Constructivist movement, he was a writer whose constant wit, terseness, and irony were the essence of American vitality, like ragtime, the automobile, and pragmatism. Ejxenbaum distinguished between the sentimental, sweet stories and those of harsh frontier and city life, which he preferred, and praised them for their vigorous comic spirit and sardonic detachment. The analogy to ragtime is not farfetched. If Washington Irving, whom O. Henry admired and thought of as an ancestor in the matter of writing about New Yorkers, wrote for the harpsichord, and Poe for the cello, then O. Henry was the Scott Joplin of prose stylists.

With two exceptions, O. Henry's stories display a remarkable family resemblance. These two, "Roads of Destiny" and "The Enchanted Kiss," are instructive in that they show how wayward O. Henry might have been far more often and how wise he was about keeping to what he could do best. "Roads of Destiny" is set in France (the only time he tried *that*), and in a romanticized past (or *that*) and is, not to put too fine a point on it, a plagiarism of Robert Louis Stevenson's "The Sire de Malétroit's Door." But it is a generous plagiarism, as O. Henry triples Stevenson's plot. It is a skillful story. When Stevenson's ground for O. Henry's variations

was first published, its title was "The Sire de Malétroit's Mouse-trap." O. Henry in a notable letter about a novel he never wrote, and in several stories, refers to the human condition as "a mouse-trap." And the collection of Stevenson's in which it appeared in 1882 is *New Arabian Night's Entertainment*. Eventually, O. Henry would evolve the metaphor of the writer as a Haroun al-Raschid moving in disguise among his subjects.

The other exception to "the O. Henry story" is a flirtation with Poe, the supernatural, and drugs. That he did not repudiate these cuckoos in the nest is evidence that he was ambitious to abandon his typical kind of story. The last, unfinished story was, consciously or unconsciously, an echo of Ambrose Bierce's "The Incident at Owl Creek," and thus an analogue of Borges's "The Secret Miracle"—in all three stories a man at the moment of death experiences a dilation of time in which he lives for a considerable while.

When O. Henry said that life is a mousetrap, he was thinking of the trap of habit and convention. He wrote several stories in which a person resolves to break free from his dull round and yet returns to it at the first opportunity.

A more apt image than the mousetrap would be a maze or laby-rinth, for O. Henry built some of his best stories ("The Higher Abdication" and "The Church with the Overshot Wheel" for example) around the possibility of finding a lost past in a maze. Luck and coincidence are very real, and credulity is taxed far more by reality than by fiction. Fiction, however, has to explain itself. The famous "O. Henry ending" is always plausible and logical. O. Henry's characters are never pawns of fate; they carry their des-tiny within themselves. Some—the tricksters—are aware of this and become masters in the art of making things happen. Others— the innocent and helpless—are usually lucky or wander around unharmed in the magic of their own unawareness of evil. Kidnap-

pers are defeated by the innocence of the kidnapped ("Hostages to Momus" and "The Ransom of Red Chief"), the biter is bit. The more elaborate the plot to deceive, the more hilarious the failure.

It is not, however, the plot that the reader who has come to like O. Henry reads him for; it is the charm of his comic eye, the accuracy of his ear, and the rude honesty of his moral sense. Bret Harte's "The Postmistress of Laurel Run" might well be by O. Henry. The style and plot are similar, but no one would mistake it for an O. Henry story: it is not in his idiom. It lacks the epigrams O. Henry (like Mark Twain) tucked into the narrative. Consider:

> Thrice in a lifetime may woman walk upon clouds—once when she trippeth to the altar, once when she first enters Bohemian halls [to dine with artists in Greenwich Village], the last when she marches back across her first garden with the dead hen of her neighbor in her hand.

> As for children, no one understands them except old maids, hunchbacks, and shepherd dogs.

> We may achieve climate, but weather is thrust upon us.

> The full moon is a witch.

> All of life, as we know it, moves in little, unavailing circles.

> Man is too thoroughly an egotist not to be also an egoist.

> All cities say the same thing. When they get through saying it there is an echo from Philadelphia.

> When a poor man finds a long-hidden silver dollar that has slipped through a rip in his vest-lining, he sounds the pleasure of life with a deeper plummet than any millionaire can hope to cast.

> But in time truth and science and nature will adapt themselves to art.

> When we begin to move in straight lines and turn sharp corners our natures begin to change. The consequence is that Nature, being more

adaptive than Art, tries to conform to its sterner regulations. The result is often a rather curious product—for instance: A prize chrysanthemum, wood alcohol whiskey, a Republican Missouri, cauliflower *au gratin*, and a New Yorker.

One of the few authors O. Henry mentions in his own voice is Montaigne. He also admired Lamb and Hazlitt, and the one successful writer among his characters is an essayist. When academia began to dismiss O. Henry as a scribbler of light fiction for the semiliterate, they complained that he wrote in slang, and hinted that he was vulgar. He was indeed a master of many vernaculars —of the cattle ranch, of Southerners black and white, of the Bowery—and his own prose sometimes ran to epidemics of puns (usually good, like "a peroxide Juno," which I would have to explain to my students, unless they had just read a translation of Homer with "ox-eyed Juno" in it) and to outrageous periphrasis. But look at a scene that's happening in O. Henry's own territory, written in the naturalist manner:

> A very little boy stood upon a heap of gravel for the honor of Rum Alley. He was throwing stones at howling urchins from Devil's Row who were circling madly about the heap and pelting at him.
>
> His infantile countenance was livid with fury. His small body was writhing in the delivery of great, crimson oaths.
>
> "Run, Jimmie, run! Dey'll get yehs," screamed a retreating Rum Alley child.
>
> "Naw," responded Jimmie with a valiant roar, "dese micks can't make me run."
>
> Howls of renewed wrath went up from Devil's Row throats. Tattered gamins on the right made a furious assault on the gravel heap.

That's the opening paragraphs of Stephen Crane's *Maggie: A Girl of the Streets* (1893).

O. Henry would have found a way around *circling madly, infan-*

tile countenance, livid with fury, crimson oaths, and *tattered gamins.*
And there are more dime-novel formulae than Crane would have
liked to see pointed out. Crane's style would evolve into the tense,
imagistic prose of *The Red Badge of Courage* (1895) and "The Open
Boat" (1898). The modernity of *Maggie* is in its beginning with a
scene of brisk action, as if it were a moving picture.

When the cinema began in the hands of the Lumières, Edison,
and Méliès, it had to return to the most archaic moment of theater:
the mime. O. Henry begins and ends his novel *Cabbages and Kings*
with silent images, the first to show us the plot of the novel by care-
fully misleading us as to what's actually going on; the second is of-
fered as "a vitagraphoscope," the kind of short film one saw at
Coney Island by leaning in to a viewer while turning a crank. The
classical mime appeared in Greece simultaneously with New
Comedy. Old Comedy, which may have developed from the rau-
cous and gloriously obscene satyr play, was harshly satiric and ad
hominem—Aristophanes' *The Clouds* is about Socrates and his
philosophy, caricatured in broadest humor and reduced to the ri-
diculous.

In New Comedy the characters are all types (the Old Grouch,
the Stupid Servant, the Young Lovers, the Athenian Cook, the
Miser). The Greek word *character* means trademark—a potter's
mark on the underside of a vase—and was used by Aristotle's stu-
dent Theophrastus in his study of psychological types. The fun of
types is that they are predictable, trapped, with mechanistic re-
sponses. This brilliant invention of the fifth century B.C. proved to
be the most durable of the arts. It must have existed in culture as
the folk art of the joke before Menander shaped it for the stage. Its
twin but lesser art, the mime, was a short skit acted at dinner par-
ties and in city squares by a single actor taking all the parts. The
actor had to establish in a matter of seconds that he was a rube
from the sticks, or a near-idiotic schoolteacher, or a portly matron
trying on all the shoes at the cobbler's. In our time, the mime be-

came the silent film (Laurel and Hardy, Buster Keaton, Chaplin) while New Comedy flourished both on the stage and in the short story. Miserable as our century is, we can still boast that for seventy-five years of it we had P. G. Wodehouse, the Menander of our time, and for ten years O. Henry. There have been many others, of course, but none, with the possible exception of the exotic and manic S. J. Perelman and the gentle, whimsical James Thurber, whose whole art was cast in the masterfully styled puppetry of New Comedy.

Yevgeny Zamyatin saw O. Henry's stories as the art of brevity and speed proper to America. It is democratic, optimistic, proletarian. O. Henry's stories were published in newspapers and magazines; they could be read on the subway, in restaurants, in any odd fifteen minutes.

To comedy alone is character in its original sense meaningful and necessary. Achilles is not a type, nor Hector; the weather of their minds, while rich in heroic sunlight and sweet with affections and loyalties, is unpredictable and infinitely variable. New Comedy was born as a psychological theory about minds of limited means: the young in love for the first time, people trapped by ideas and passions or in human bondage to prejudices and greed. O. Henry is fascinated by programmed minds. In "The Duplicity of Hargraves" the stock character is a proud, boastful old Alabama gentleman living in Washington and in near poverty with his daughter. Hargraves, a young actor, duplicates him in a play about just such a character. The old gentleman sees the play and is outraged. So far we have a story that in other prose and with different slants of light Henry James might have written, or Chekhov. O. Henry, however, has only laid his ground. The old Alabaman is distracted from his outrage by the wholly unexpected arrival of a faithful black retainer, a child when last seen. He has become a successful farmer in "Newbraska," where he is a citizen of some prominence, and is in Washington for a Baptist convention. He

has come to repay money the family gave him after the war, to start a new life in the West. The old gentleman, in tears, accepts the money; more importantly, his antique values, which Hargraves's play had ridiculed, are restored by the freed slave's loyalty and respect. But this black prodigy of Roman virtue is also the actor Hargraves, as only we and the daughter know. O. Henry has shown how versatility, a liberty of spirit, can dance any dance it wants to around rigidity: this mobility is the very essence of comedy.

Hence the large number of stories O. Henry wrote about confidence men, together with the high comedy of confidence men gulling and being gulled by other confidence men. A variant of this theme is that of humble people assuming, for an evening, the status of the rich (itself a variant of the Haroun al-Raschid theme of the rich and powerful disguised as nobodies). These stories are the richer for our knowing that O. Henry himself was a man in disguise, in more ways, I suspect, than the biographers have appreciated. He kept his past to himself, even his image. He refused to play the one role in which he was famous, that of writer. In the interview with MacAdam he said that he thought little of his stories, even when they had the dignity of the collected volumes. One wonders how honest he was with himself when he said that he wanted to be a serious writer, to abandon the elaborate jokes that an enormous public admired as lively and wise short stories.

The novel he planned and never wrote was to be about a perfectly ordinary man "caught in his mousetrap." He wanted to be as minutely realistic as a writer can be. Flaubert had the same ambition: "to write a book in which nothing happens."

Joyce fulfilled both projects in *Ulysses*. O. Henry's ideal novel remains among possibilities. Publishers call such books ghosts—projected works that never got written. (Milton's was a *Macbeth* with which he got no further than the title.) In a sense, all of O. Henry's stories add up to the unwritten novel. They cover American life at the turn of the century from the West to New

York, the South, and Central America — Teddy Roosevelt's geography, if you will. The Mississippi belonged to Mark Twain. In a perfect world with perfect books, we might have O. Henry's Western tales illustrated by Frederic Remington and the New York tales by John Sloan and George Bellows.

Is it humility or satire that has O. Henry mention a bargain lot in a junk shop that's "Henry James's works, six talking-machine records, one pair of tennis shoes, two bottles of horse radish, and a rubber plant," all for $1.89? We can imagine William James's chuckle. We know that O. Henry bridled at being compared to Maupassant ("smutty"), but we have no information as to how he thought of himself among writers. His New York is contiguous with that of Edith Wharton, who entered doors closed to William Sydney Porter. The truth is, literary history has forgotten O. Henry's world. There is a story, "The Snow Man," which O. Henry had one Harris Merton Lyon finish for him. Lyon is Theodore Dreiser's "De Maupassant, Junior" in *Twelve Men*, a bohemian failure "who sometimes wrote like O. Henry." Of the New York literary people with whom he worked — Robert H. Davis, Richard Duffy, William Johnston, Gilman Hall — only the name of Witter Bynner has survived the ocean of time. It was he who, fresh out of Harvard, showed O. Henry how various stories could be fitted together to make the novel *Cabbages and Kings*.

O. Henry's literary companions were ones he never met: Robert Louis Stevenson, Rudyard Kipling, Mark Twain, and the unknown writer of *The Thousand and One Nights*. The wonder is that their influence is so invisibly absorbed. From all of them (along with Omar Khayyam) he took the understanding that a story is a calculation of fate, independent of a philosophy or religion, and that the art of tale-telling is a high skill deriving from observation, experience, and insight into human character. He did not challenge any of the writers he admired on their own ground (except for the one Stevensonian homage). Nor did he ever write an auto-

biographical line. All of his work is a miracle of imaginative projection.

He probably never saw the many boardinghouse rooms of the working girls that he described so convincingly. He never met a South American dictator, a New York millionaire, or a Mexican bandit. He knew one confidence man (the original of Jeff Peters). His being a registered pharmacist turns up regularly when he shows off his expertise in *materia medica* and prescriptions.

His prose style is by now historical and can be compared in energy to that of Thomas Nash or Thomas Urquhart, or to other literary vernaculars, whether Artemus Ward or Damon Runyon. It is a narrative (and expository) style of wonderful flexibility, as useful for pathos as for satire. What's most admirable in it is its constant attention to telling specifics—to the comfort of a cool iron bedstead against which to press tired feet, to the furniture on a summer resort in the Blue Ridge Mountains, to the art of cooking for cowboys on a roundup. Real history, a wise historian has said, is in novels. The age encapsulated by O. Henry is an American cultural myth. There is no erasure of history in believing in his fresh-faced freckled girls or his frank, good-natured young men (Hemingway continued them, having deleted their sense of humor), or cowpunchers as tough as whang leather and gentle as a baby. Nature allows everything. That there is one prostitute in all of O. Henry, no clergy, and no odors can be explained by the genteel tradition that policed the arts not so much as a puritan interdiction (though there was that, too) as a code of well-bred manners, of which writing was considered to be an arbiter.

O. Henry's myth addressed itself to good nature, honesty, fair play, compassion, love, and friendship. His culture demanded these of him; he was heartily willing to comply. But one has not read far into him before one realizes that he is mischievously subversive, that he admires rascals and barefaced liars and those who have opted out of the rat race. It is the trickster who survives in a

world that is legally dishonest (governments, banks, lawyers). Virtue is *virtú*: outmaneuver or be stepped on.

Twice in O. Henry artists destroy very lucrative work with which they are dissatisfied. The hack writer is treated as a villain. Sharpshooters, safecrackers, successful revolutionaries, titled lords who can cook good grub for cowboys—skill is success in O. Henry. If he had a philosophy, it was that to be good you have to be good at something. And for something. He himself was very good at writing stories.

Gerald Barrax

THE TITLE OF GERALD BARRAX'S third book of poems, *The Deaths of Animals and Lesser Gods* (1984), assures us that we are in the presence of a poet. Animals as exemplars of the divine are familiar enough: the eagle as Zeus, the dove of Yahweh, the cat as Pasht. But that a god is a lesser being than an animal is a tricky idea we want to know more about. And how can a god die?

The very first poem, "The Conception of Goddeath," involves us in the same paradox that enlivens the title. To conceive of a god is a metaphor admitting that gods are our imaginative invention. Yet to conceive in a literal sense is to beget. Begetting is of life, not death. But, we then admit, to beget life is to beget death, for all living things die. One reason we have invented as to why things die is that a god cancels our being. These are philosophical questions we have wrestled with for thousands of years.

Poetry is not philosophy. It welcomes passion and feeling where philosophy banishes them. So in this first poem we are moved by a sensibility kin to Ovid's. The death of animals observed by man in some primal innocence brings the idea of death to human consciousness:

> *Sparrow Hawk dropped from the sky and stiffened*
> *On the ground. Blue Gill and Mud Minnow turned over,*
> *Bloated in the water. Great Reptiles rotted,*

Swelled in the sun. Tiger's yawn locked open,
Her serene eyes gone.

This is Adam learning about death. That great reptile, how-
ever, expands the meaning to a universality of human history. The
myth of science says that we were not here to see the dinosaurs
come to awesome extinction in a million years of dying. Science
has nevertheless allowed us to participate in the periodic catastro-
phes written in the fossil record. Our sense is that life is a majesti-
cally slow pulse of being in style after style. Prehistory has become
our Ovid's *Metamorphoses*. Creation—still ongoing—is a succes-
sion of epochs, some of which contain leviathans and behemoths in
swamps as large as continents, moving in forests of ferns. Others
contain the animal man extinguishing himself at places with the
poignantly human names of Jamestown and Jonestown. We can
add further examples: Johannesburg, Belsen, Beirut. It may well
be, Gerald Barrax says in these moving poems, that humankind
embraces death when it embraces any of its imaginary gods.

These thirty poems are meditations on death. About death we
are all confused. That is, logic deserts us, emotion blinds us, and
ideas as primeval as dinosaurs misguide us when we try to make
sense of death; that is, of life. Gerald Barrax can be wonderfully
simple, as in the poem "Barriers" where he dramatizes the illogic
of our being upset with the cat for killing a songbird when we have
a chicken in the pot for dinner. In that first poem, it was a raptor, a
sparrow hawk, that came to Adam's attention first.

History must have examples. It is never an abstraction. Gerald
Barrax is concerned in this book with the history of infamy: of
slavery, of death as economic advantage, of suffering itself in many
kinds of injustices, and of the suffering of trying to understand
why humankind is massively cruel.

Politics is the art of grievances, Robert Frost said; poetry is the
art of grief. For Gerald Barrax poetry is the art of understanding,

of being wholly aware of grief. What sets his poetry above philosophy and politics is the fusion of intelligence and feeling he achieves. His words occur with the rhythms of the voice, not in the rhythms of traditional poetic style. Listen:

> *Nothing on earth can make me believe them.*

And:

> *Very deadly serious, the religious white Christian*
> *lady on TV said God wanted this country*
> *to bomb the Devil out of whatever Yellow Evil*
> *disguises itself as old folks and children.*

Worth pausing at these lines. Mimesis of voice that's colloquial, ironic, critical is woven in with a poet's voice. "Very deadly serious" is human talk performing a putdown, but the "deadly" has a meaning reserved for the poet. "Religious white Christian lady on TV" is again a phrase one might find in a novel. The poet, however, wants us to assess these words in the pattern the casual voice has made for them. Does a religious white Christian lady (lady!—the sociological force that demands *lady* for *woman* is the same force that accommodates *religious white Christian*) differ from a religious black Christian lady? Yes. "On TV"—image and voice promiscuously disseminated with a power wholly unavailable to Saint Paul or Jesus himself. It is frighteningly random and gratuitous. To be on TV is both futile and a great advantage. The rabid voice (brutally misrepresenting Christianity, which teaches forgiveness, not the bombing, of enemies) projects the concept Devil onto something it cannot understand. The poet interprets: "old folks and children."

Barrax makes us see the white Christian lady on TV as the opposite of a poet. She embodies a principle from the electronic complex she can use but not understand: "garbage in, garbage out."

Which is another way of saying what the lady's teacher laid down:
you can't harvest what you didn't plant. Or to put it another way:
you fall the way you lean.

I do not want, however, to characterize these poems as a system
of ironies, or to reduce them to poems of protest. They are indeed
poems that begin in grief, and speak out against abuse and injus-
tice. Their value must remain in the power of their success as
works of art. A poem ultimately has only itself to offer: words
shaped in measure, words that make sense because of the skill with
which they have been built. Barrax has the gift of accurate and un-
forgettable phrasing: "the jury of my senses and I said No." He
finds the right pace for every poem. He is a man of great clarity,
great feeling. What makes the poems so good is the sweetness of
Barrax's large mind. His strength is tempered by compassion; his
anger, by music.

Calvino: Six Memos for the Next Millennium

WHEN ITALO CALVINO DIED in Siena on September 19, 1985, a month short of his sixty-second birthday, he had just finished writing five Charles Eliot Norton Lectures to be read in the translation of Patrick Creagh at Harvard. The sixth was to be called "Consistency," and he planned to write it at Harvard. In all, he had confided to his wife, he planned to write eight.

Such fecundity was typical of Calvino, who never used a literary form twice. Born into a scientific family (in Cuba), Calvino lived a life complex with multiplicities. Drafted into the Young Fascists, he bolted to the Resistance. He was a Communist for some years (the Italian Party looks down its nose at Moscow as an upstart latecomer) and worked with the brilliant group of leftists at the Turinese publishing house of Einaudi, which brought out his books.

These brilliant lectures or "memos" (he liked this English word and said it has charm) are at once an intellectual dance and a description of the qualities that make Calvino's fiction so readable and so satisfying.

These qualities are lightness, quickness, exactitude, visibility, and multiplicity. Calvino's style as a lecturer owes much to that of Borges, who approached his subjects with an intense deftness of observation and a saturation of examples. Their strongly poetical character also owes something to Joseph Brodsky and Milan

Kundera, writers who do not argue with sweet reason (in the British manner) or chew on their subject like a lucky dog with a beefsteak (in the American manner) but put their subject before us with triumphant confidence and surefooted subtlety.

The quality of lightness is peculiarly Calvino's in twentieth-century writing. He is in many senses our Voltaire. He says in the first lecture that language either can hover above its subject like a field of magnetic impulses or can give weight and concreteness to its subject. Lightness implies "precision and determination" in a writer. He quotes Valéry: "We must have the lightness of a bird, not that of a feather." Lightness also means analyzing the world into its finest components, like Lucretius and Emily Dickinson. Ultimately, Calvino means by *lightness* wit and elegance, the salient qualities of the eighteenth century. We recognize in this lecture his own *The Baron in the Trees* (1957), a novel in which a boy refuses to come down from a tree to supper, vows never to come down, and spends his life aloft, a Robinson Crusoe whose apartness is just above the world he might have inhabited rather than across an ocean. He is Rousseau's noble savage, a modern Diogenes, Aristophanes' philosopher in the clouds.

In all of these lectures there is the insistence that writing is a search for lightness (of spirit, of intellect) to free us from the weight of reality. The spirit that writing seeks is a necessary counterbalance to the dreary weight of our times. We have, Calvino says, brutalized our senses, and have abused language in its political and commercial enslavement. "In an age when other fantastically speedy, widespread media are triumphing, and running the risk of flattening all communication onto a single, homogeneous surface, the function of literature is communication between things that are different simply because they are different."

Differences are surprising, turbulent, informative; sameness is comforting, assuring, and unenlightening. All of Calvino's fiction explores unlikely spaces and hypothetical conditions (an empty

suit of armor that moves and speaks, a man divided into independently functioning halves); that is, he studies difference for the information it can generate. The great paradox of our time is that hordes of us choose to be different in the same way: hippies in the sixties all seemed to be the same person. Uniformity is its own caricature.

Although Calvino does not mention him in these lectures, the ghost of Antonio Gramsci hovers near. It was Gramsci who realized that all innovation is swallowed and digested by our glutting and glutted communication systems.

Calvino saw himself as a counterforce to this trivialization of all meaning. The opposite of television's endless flipping from image to image (children swilling Pepsi, rocket exploding, cute old man eating ersatz bacon, machine-gun bullets spraying up frost in Afghanistan) is the wisdom encoded in the folktale, a form he explored toward the end of his life. He explains that writing at its most imaginative takes one of two forms, the crystal or the flame. By crystal Calvino means writing like his own, with a logical and symmetrical structure, faceted and gleaming. By flame he means that art which holds turbulence inside a shape. Stillness and flow: the abstract and the concrete.

What we have in these lectures is a modern *Poetics* that crystallizes the strategies and achievements of Calvino and his aesthetic kinfolk: Jorge Luis Borges, Franz Kafka, Francis Ponge, Wallace Stevens, Primo Levi, and many others. It is certainly one of the most rigorously presented and beautifully illustrated (in five languages) critical testaments in all of literature. It will serve as a magic book of the arts for anyone aspiring to write.

If it achieves its purpose as a guidebook for the next millennium, it will return writing to the imagination and the writer to the chemistry and architecture of vision and feeling.

Toward the end of the fourth lecture Calvino evokes the figure of Leonardo as the archetypal creative mind, and shows us the

heroism we can detect in the *Notebooks*. Leonardo knew neither Greek nor Latin, a restricting disability in the Renaissance. But he could draw, and he could revise his writing in a vernacular Italian unsuited to all the sciences that Leonardo knew better than anyone else in his time. In this struggle with language Calvino sees the eternal problem of the writer. Nothing is out of reach to the art of words, yet only a few find the laws of the particular crystal to be shaped or the bounding envelope for the flame. For the immediate future Calvino offers two possibilities that always present themselves to the writer: to reshape the past in new contexts or to wipe the slate clean and start over from scratch. Calvino himself did both. His example of the clean slate is Samuel Beckett.

A plague has descended upon language, Calvino says, a plague that infects meaning, truth, responsibility. We remember that he grew up in Fascism and spent his life seeing language raped and mutilated, prostituted to propaganda and commerce, treated as noise. Where language has torn the world to pieces, the writer can put it back together. Calvino closes his study of the art of writing by summoning two ancient masters deep in his country's past: Ovid the storyteller, who wrote about the continuity of forms and their cyclical, logical renewal; and Lucretius, who saw nature as common to every being and every particle of creation. Difference and sameness: all is separate and inviolably unique, and yet everything is of one substance. In this interplay of difference and sameness Calvino invites us to create, renew, come together, imagination responding to imagination.

Such an articulateness of the spirit has happened before; these lectures may be read as one of the liveliest and most sensitive accounts ever written of that articulateness. And they may be read as a passionate recall of that articulateness. Our freedom and our humanity depend on it.

Journal 1

PROTAGORAS SOLD FIREWOOD. Democritus liked the way he bundled it for carrying and hired him to be his secretary. Mind is evident in the patterns it makes. Inner, outer. To discern these patterns is to be a philosopher.

❀

The caterpillar of the coddling moth feeds on the kernels of apples and pears.

❀

Greek time is in the eye, anxious about transitions (beard, loss of boyish beauty). Hebrew time is in the ear (Hear, O Israel!). What the Greek gods say does not make a body of quotations; they give no laws, no wisdom. But what they look like is of great and constant importance. Yahweh, invisible, is utterly different.

❀

The American's automobile is his body.

❀

Camillus had asked for pure youths and the adjutant without a blink aboutfaced, looking wildly for a warrant officer. Pure youths, said the warrant officer. Clean, said the adjutant, scrubbed. Young means they won't have had time to sin with any volume. Say recruits who aren't up to their eyes in debt, fresh of face, calf's eyes, good stock. Washed hair. Take them to the flamen, who'll get

white tunics on them, and clarify their minds for going into the *fanum* to bring the figure out, proper.

❀

To sit in the sun and read Columella on how to plant a thorn hedge is a pleasure I had to teach myself. No, I was teaching myself something else, and the thorn hedge came, wisely, to take its place. They're longer lasting than stone walls and have an ecology all their own. Birds nest in them and snails use them for a world. Hedgehogs, rabbits, snakes, spiders. Brier rose, dog thorn. There are some in England still standing from Roman times.

❀

Being ought to have a ground (the earth under our feet) and a source. It seems to have neither. The Big Bang theory is science fiction. It may be that the expanding universe is an illusion born in physics labs in Paris, Copenhagen, and Berkeley. It is also too eerily like Genesis (being in a millisecond) and other creation myths. It is partly medieval, partly Jules Verne. From a human point of view, it has no philosophical or ethical content. It is, as a vision, a devastation, an apocalypse at the wrong end of time. It is a drama in which matter and energy usurp roles that once belonged to gods and angels. It is without life: brutally mechanical. It is without even the seeds of life, or the likelihood.

❀

Store Valby: earliest record of agriculture in Denmark: naked barley, club wheat, einkorn, emmer wheat, and a seed of Galium.

❀

Gibbon turns an idea in his fingers.

❀

French regularity is kept alive as a spirit by turbulence and variation. Only a felt classicism knows novelty. Novelty in the United States is a wheel spinning in futility: it has no tangential ground to touch down and roll on.

❀

Je ne veux pas mourir idiot. French student demanding that Greek be put back in the curriculum.

❀

The circumcision of gentiles in the United States is a cruel and useless mutilation. Michel Tournier in *Le Vent paraclète* likens it to removing the eyelids. It is an ironic turn of events. The circumcision of the Old Testament was a slicing away of the merest tip of the foreskin, the *akroposthion* as the Greeks called it. In the Hellenizing period of the first century c.e. (see Maccabees) the rabbinate changed over to total removal of the prepuce, to make a more decisive symbol. Gentiles began to circumcize fairly recently: a Victorian attempt, one among many, to prevent masturbation. (A. E. Housman was circumcized at thirteen.) It is done nowadays by parents so ignorant that they don't know it doesn't need to be done, and doctors, always ready for another buck, recommend it on hygienic principles. It is difficult to think of another such institutionalized gratuitous meanness, the brutal insensitivity of which enjoys universal indifference. A Tiresian conundrum: a male who has never known the sensuality of a foreskin, both for masturbation and for making love, cannot know what he has been so criminally bereft of.

❀

If Jews returned to cutting away the wedding ring's worth of flesh (as with Michelangelo's David, who has almost all of a foreskin, and as with Abraham, Isaac, and Jacob)—a nicely revolutionary recovery of archaic truth—perhaps American parents would quit agreeing to the mutilation of their children's bodies. But as long as Ann Landers et Cie. continue to idiotize the populace with a rancid puritanism, maiming boys will continue.

❀

It is the saurian mind that has prevailed in our time. Apollo has been asleep for most of the century.

❀

Klee's *Twittering Machine* is a parody of Goya's people out along a
limb.

❀

What is the difference between learning as a child and as an adult?
There's such a thing as *re*learning. Nietzsche says that philosophy
might take as its task the reconciliation of what a child has to learn
and knowledge acquired, for whatever reason, in maturity. What's
happening when children watch TV? Consciousness is an ad hoc
response to a webwork of stimuli: intrusions, attractions, claims
on one's attention, hurts, disappointments, insults, fears. The crit-
ical mind tries to keep its balance in stoic indifference. But turbu-
lence aerates, renews a sense of balance.

❀

The impotence of Andrew Wyeth is that he asks us to see with his
eyes subjects about which he has made a decision and, with the
gratuitous meanness of his generation, isn't going to tell us what it
is. There is no drama of seeing, as in Picasso and John Sloan. Wy-
eth makes us into an adventitious onlooker at something he, and
only he, was privileged to see.

❀

What got Kipling a bad name among liberals is his intelligence,
humor, and affection. These they cannot tolerate in anybody.

❀

Sartre's idea of literature, the opposite of Pound's, is still within
the category that includes Pound. The word *political* has a wholly
different meaning in the United States than in France. Our politi-
cians have no interest whatever in changing society or in making
life more liberal. How can they, with a people who have to be sat on
and with criminal exploitation ready to corrupt any liberal explo-
ration of liberty? There is no reversal possible of American medi-
ocrity, which will worsen until we have total depravity of the idea
of freedom. There is no American business: only diddling the con-

sumer. The Congress is as incompetent and irresponsible a squanderer of our money as the most loutish tyrant in history.

❁

History is a matter of attention. Parkman was interested in the awful waste of energy in the (wholly unsuccessful) conversion of the Indian. Because he was so appalled by Catholic fanaticism in Canada, what he wrote is a history of reason in the New World.

❁

Denmark begins at the SAS ticket counter, JFK, behind a contingent from Lake Wobegon whose problem is made more complex by a computer that's down. Waiting, I solve a problem of my own. The second floor of SAS is, as its sign in Danish says, the *other* floor. For years I've wondered why in the English ordinals there's the Latin *secundus* between *first* and *third*, the only Mediterranean intrusion into a sequence that's otherwise archaically North Atlantic. But the Danes count *first, another, third, fourth*. Our *another* is *one other* and the repetition of the *one* must have crowded so useful a word out of the ordinals, to be replaced with monkish or military Latin.

❁

English is a Romance language the way a porpoise is a fish and a bat a bird. English is the second, or other, language of Denmark, used among themselves with a fluency that is well along toward making it a dialect. A little babu: "fried chickens" on a menu. We do not (thank goodness) have the first hotel we called in Copenhagen, because "the booking have gone to Easter."

❁

Danish, like Dutch, is English unmarried to French.

❁

On Swedish TV, a children's program with a robot who has a spigot for a penis. Another sign that the Danes are a highly moral people who are unembarrassed by the facts of life. Also some comic books and posters you'd go to jail for owning in Kentucky.

❁

Just as Denmark looks familiar, though we've not been here before, the Restaurant Cassiopeia on Nyhavn is wholly unthreatening, cozy, strangely familiar. I have the feeling that I've been trying all my life to get here. We have a table by an old-fashioned window of many small panes looking out on masts, rain, sixteenth-century buildings. We see that Danish cozy is our sense of cozy. Waitress very young, beautiful, friendly. Fish soup, terrine, veal, kidney. A pear and almond ice drenched in a liqueur. Bonnie Jean, the whiz at arithmetic, notes that our meal costs eighty dollars.

❁

I buy a blue denim cap, very Danish student of the last century, and call it my Nietzsche cap, remembering that he ordered a Danish student's uniform when he learned that Georg Brandes was lecturing on him at the university here. Bonnie Jean counters by buying a Lutheran housewife's dress, demure, practical, and quite becoming.

❁

The restaurants on Nyhavn are run by children. The cook at The Mary Rose, Ejnar, looks twelve, and the waiters are teenagers.

❁

A profoundly *northern* feel to the graveyard where Kierkegaard and Hans Christian Andersen lie. Pale sunlight, wet conifers.

❁

Sign in a barber shop: *Er taget til Spanien for at bekæmpe Fascismen. Kommer straks.* Gone for the day to Spain to fight fascism. Back soon.

❁

At the zoo, which Joyce and Nora once visited in the thirties, a little boy hugging a goat said to me (I was photographing him), "I am cute, am I not?"

❀

"Of course all young Danes are beautiful," Bonnie Jean says, "they drown the plain ones." It is apparently against the law to be plain, ill natured, or sober.

❀

The water birds we find in every pond are perhaps grebes. I name them "Bonnie's coot." They can run along the surface of water.

❀

Along the pedestrian street, a young man seated on a four-wheeled contrivance that several friends are pushing. His virile member is out through his fly (silly and bemused look on his face) and erect. One of the friends carrying a sign: *Ja, jeg skal gifte!* Oh boy, do I ever need a wife! They're all gloriously drunk. BJ is a bit disturbed by so much drunkenness: I point out that they're not drivers. They're wonderfully on foot. Earlier, two twelve-year-old boys so drunk that they have to walk hugging to keep from falling down.

❀

Music everywhere. Children playing Mozart and Telemann on the pedestrian streets. BJ gives all the change she has to a four-year-old tot who was making a hash of something baroque on her Suzuki fiddle.

❀

The Sweet Pan Steel Drum Band.

❀

Lunch at the train station in Roskilde, far superior to the best food and service to be had in Lexington. Roast pork, red cabbage, wine, potatoes, banana split.

❀

Bonnie Jean, of fellow Americans in Elsinore: "Travel is very narrowing."

❁

BJ insists that I buy a Danish scout manual, and a pair of important-looking straps, blue, lettered *Spejdersport.*

❁

BJ does not keep a journal but asks that I put in this one:
Honesty is the best deceiver.
Questions are a way of avoiding information.

❁

Rietveld's chair at the Louisiana Museet. It is much smaller than I'd thought and looks comfortable.

❁

Years ago I wrote in *Tatlin!* that the Baltic is pewter and silver in its lakes of glare. It is.

❁

Helsingør. Coffee and pastry shop, center of local social life. Suddenly all very Bergman: an accurately scaled midget across from me, nattily dressed and with a woman who seems to be made up for a Strindberg role, dress about 1880, but obviously not all there. Housewives talk about her behind their hands. Eventually a rough sailor type, red-bearded and in a pea jacket, comes and takes her away. She rolls her hips and eyes as she leaves. The midget continues his coffee. No sign of a circus in town.

❁

A long walk through the deer park at Klampenborg, sharing Granny Smith apples, children orienteering in all directions (a little boy greets us with "Oh, yes! Oh yes!"). The landscape is a Constable. Immense sense of peace, love, togetherness.

❁

Boy with mother, rich dark hair, pink scarf, nautical jacket, gray canvas trousers, big sneakers. Relation with mother wholly un-American: more like kids falling in love on a first date.

❀

Bonnie invents "holstein cat" for the bishop's Webster and Thorvaldsen, whom we speak to every day. The bishop of Copenhagen is also bishop of Greenland: part of his parish.

❀

The statue of Kierkegaard in the garden of the National Library is Lincolnesque, noble, grandiose (seated, with a Bible propped against his chair), writing. The newer, triumphant statue in the circle of theologians around the palace church is of Kierkegaard the dandy, in tight britches, foppish.

❀

Little Jack Horner, who sat in a corner. The *Horner* is the Danish *hjornet*, corner.

❀

Where it was, there must you begin to be. There are no depths, only distances. Memory shuffles, scans, forages. Freud's geological model implies that last year is deeper in memory than last week, which we all know to be untrue. The memories we value are those we have given the qualities of dream and narrative, and which we may have invented.

❀

An American evangelist on Swedish TV reminds me that kinship is one of the most primitive of tyrannies. Our real kin are those we have chosen.

❀

Desire is attention, not gratification of the self. The ego is the enemy of love. Happiness is always a return. It must have been out of itself to be anything at all.

❀

If timespace, then how does time move and space stand still? Time moves through us; we move through space.

❀

County as the satiric unit: Coconino, Bloom, Yoknapatawpha, Raintree, Tolkien's shire, "the provinces."
Tragedy: house, castle, room.
Romance: sea and open country.
Comedy: city.

❀

The hope of philosophy was to create a tranquillity so stable that the world could not assail it. This stability will always turn out to be a madness or obsession or brutal indifference to the world. Philosophy is rather the self-mastery that frees one enough—of laziness, selfishness, rage, jealousy, and such failures of spirit—to help others, write for others, draw for others, be friends.

❀

Athens (which could not tolerate Socrates) and Jerusalem (which could not tolerate Jesus) come down in history as the poles of the ancient world (for Proust, Arnold, Joyce, Zukofsky). If these two long traditions have fused, they have no genetic line. Judaism is closed, is itself exclusively; Athens is diffused and lost.

❀

This paradox: that where exact truth must be found the only guide thereto is intuition, the soul moving like the animal it is by a sixth sense, which Heraclitus called smell, thinking of the exquisite nose of his dog. All the senses must be opened and trained, exercised, clarified.

❀

Psychology is the policeman of the bourgeoisie, enforcing middle-class values with as bogus a science as alchemy or palm reading. Foucault was right on this point.

❀

In Kafka other people are too close and God is too far off.

Gibbon

"THERE IS JUST APPEARED a truly classic work," Horace Walpole wrote the Reverend William Mason in February 1776, "a history, not majestic like Livy, nor compressed like Tacitus; not stamped with character like Clarendon; perhaps not so deep as Robertson's *Scotland* . . . not pointed like Voltaire, but as accurate as he is inexact; modest as he is *tranchant* and sly as Montesquieu without being so *recherché*. The style is as smooth as a Flemish picture. . . ." Walpole's opinion has been the world's; *The History of the Decline and Fall of the Roman Empire*—the Augustan epic, filling the same space in its age as *The Faerie Queene* and *Paradise Lost* in theirs—is as "truly classic" as a work of literature can be.

W. B. Carnochan begins *Gibbon's Solitude: The Inward World of the Historian* (1987) by reminding us that we give the epoch to Johnson, not to Gibbon, perhaps because Johnson was a heroic figure and Gibbon is all but invisible. He was fat, timid, industrious; his genius flowed steadily into his great work. Johnson's, impeded by dilatoriness overcome by gigantic agonies of labor, seems to us to be more modern, closer to the literary center of gravity in English history, which still quivers around the Romantic and Victorian *cultus* of sentiment and self-expression.

As for history itself, it has long ago consigned Gibbon to historiography. He is as much an antique as his subject. The very effort

of reading Gibbon does not fit in with the laziness and habit of instant gratification of the way we teach now, or the way we read.

So Carnochan's first task is to find Gibbon for us. He conflates the interior and exterior Gibbon in a new and interesting way. Most of us are apt to have in our imaginations the roly-poly, self-confident, triumphantly skeptical Gibbon who was Lytton Strachey's hero. Displacing this caricature, Carnochan approaches Gibbon through his admiration for a Renaissance sculpture, Lorenzo Lotti's *Jonah* in the Chigi Chapel in Santa Maria del Popolo in Rome. Gibbon thought it "the finest modern statue I have seen." It is a handsome, curly-haired athlete astride a rather leathery and collapsed whale, an iconographic variant of Arion on his dolphin, or an Eros. The figure is nude except for a length of cloth the ends of which are in Jonah's hands and which flows from his left shoulder down his back and across his right thigh, making a stout bulge in its concealment of his genitals. Psychology has taught us that to hide is to display. Some interior symbol in Gibbon's imagination was responding to this Renaissance Jonah, whose fate was to be concealed before he could act, and whose ministry was to declare the fall of a city. But Gibbon had a monstrous swelling of the scrotum that tight eighteenth-century trousers defined for all to see, much as the rhetorical robe in Lotti's sculpture emphasizes that Jonah is young and male.

Carnochan's Gibbon is a writer wholly interior, a master spirit of his chosen art—history as richly expressed as a Renaissance work, firmly grounded in classical origins but shaped by a modern spirit. Gibbon began his career as a critic who hated nonsense and velleities. These he found around him: in William Warburton's bogus theories and in received histories of Christianity.

The chapters in this study devoted to Gibbon's preparation to be Rome's historian seem to me to be the best. We watch Gibbon in a series of Cartesian decisions, always making the right choice.

Would he write in French or English? Where would he begin, be-
fore or after Hadrian? Where would he stand? (The point of view
in so vast a panorama was crucial.) Gibbon chose to remain in
Rome, to unify the geography of his epic. (I've always felt that the
one personal moment of the epic, the only time the diligent chron-
icler looks up from his quill and paper and smiles at us eye to eye, is
when, late in the work, he himself realizes that he is one of the bar-
barians he is talking about in the mists of Britannia, remote from
the Italian sun. It is the moment of plenum, when the outlines and
eternal destiny of the empire are filled and fulfilled.)

Carnochan applies to his new Gibbon many recent skills of
criticism. He takes from Panofsky the fact that we see on the con-
cave surface of the retina; the farther back from the horizon we are,
the more it curves. Perspective is ultimately a rondure, not the
pinching in of a vanishing point. Gibbon knew this instinctively.
It was long ago noticed that his sentences grow longer as he moves
farther away from Rome. There is nothing indistinct in Gibbon;
or, rather, he keeps to the one epic focus of indistinction through-
out, so that the remoteness of great distance—Muhammad, the
East, the Rhineland—is as distinct as the streets of Rome.

Never has the imagination had such unity in literature as in
The Decline and Fall. It is a splendid unity and a tyrannical one:
much had to be sacrificed to it. The space Braudel would occupy
later, and the French *annalistes*, is never entered, so that an
eighteenth-century reader would have had to turn to other
sources to know the domestic life of the times. The reader would
have to supply that glorious history of the church which we know
as the history of art and architecture, of poetry and music. Gib-
bon's Christianity is all irony and outrage, a map of infamy and a
dissection of credulity, superstition, and cruelty.

His universe, as Carnochan says, was "open." He had neither
doctrine nor prejudice to be his guide. Like Hume, he doubted, he

tested, he thought for himself. His scalpel was irony; his antiseptic, contempt. His voice remains even, judicious, mild through six fat volumes. He was not writing a romance; he was writing truth.

Carnochan's real subject is the lonely integrity of this undertaking. The problems were immense: how to shape the actors as to character, how to sift through sources in Greek and Latin. At what pace was he to move through the centuries between us and the Antonines? How much of the story could be narrated sequentially? The plot is radial: Roman history was always a design of moving outward from a center. In the history Gibbon assumed we knew already the pattern of centrifugal diffusion that had been established: divide and conquer, rule as an administrator. The conquered were clients, not slaves. When Gibbon picked up this long history, the boundaries had just been fixed and the effort was to civilize the world within them. But this order was momentary. It would prove to have the fluctuations of an amoeba: gathering in, spreading out anew. And it would become fibrous, until the empire needed two emperors, four, six. Human nature itself would change over and over. Theodoric was a thousand psychological miles from Marcus Aurelius.

One can plausibly read Gibbon precisely for these character studies, letting the campaigns and councils, reorganizations and revolutions flow around. Gibbon's eye for character was as sharp as Voltaire's but more patient and more forgiving. He is at the opposite pole from Shakespeare and Plutarch. He is not interested in understanding human nature as tragic or comic. He is a moralist, and his scales weigh meanness and generosity, stamina and sloth, intelligence and stupidity. In the history of the church, it is the church's betrayal or concealment of its own ideals that he comes down upon hardest.

Carnochan's best achievement is to keep before us the fact that history is art, and that Gibbon had a double task to write accurate history and to make a work of art of it. It must be coherent, in one

style, from one point of view, unified in one music, so to speak: in the same key throughout. "I believe," Carnochan says, "that the ironist should be judged according to the human consequences of his art. Does he shut his world down to interpretation or open it up?" This question makes us see the deferential articulateness of Gibbon's art. He poises all on an ironic point, observation by observation, allowing compassion (if you are so talented) or contempt (you are welcome to that, too) to vibrate in response.

At this point in his analysis, Carnochan invokes Lucky's mad, incoherent speech in *Waiting for Godot*, a brilliant piece of theater the irony of which is congenial to us. We feel for and with Lucky's hysterical outburst, something between the braying of an ill-treated ass (he is in a harness) and the just expression of all frustrations in Christian belief. (*Was* Christ God incarnate? Will he return? When? Has not all this become, by this time, a maddening farce?) Gibbon is in some sense, in the highest value we can appreciate in his consummate art, a little like Lucky. He has traced a thousand years of human history in its configurations of famine and wealth, conquest and superstitions, balances and collapses, and what are we to make of it?

Carnochan might have added that Lucky is taken from the New Testament, where he is called Tychikos (meaning *fortunate* in Greek). He is Saint Paul's amanuensis, a writer by trade. His art is words, and their grammatical and spiritual order. Like Gibbon's.

Journal II

The wasp carries his wife from aster to pear.

❀

A Plymouth Brethren chapel, or hall as they say, on the Faeroes. William Sloan, Scots missionary of the Plymouth Brethren, converted the Faeroes in 1865. The Danes call them *Baptistar* or the *sekt*. They are abstemious. "Beer," they say, "is another man."

❀

A March laundry line of oystercatchers. Drifting acres of glare on the sea, clouds grazing the chimneys. Oystercatchers like wash lines in March.

❀

Randolph Bourne's idea, that critical discernment is in knowing why we like what we like, is intelligent and wise. He was disturbed that education in art is geared to an imposed canon. Our problem now is that nobody knows anything to begin with. A love of knowledge is gone, and with it curiosity and a critical eye. We have theory instead of perception, contentiousness instead of discussion, dogma instead of inquiry.

❀

Jaako Hintikka, philosopher and critic of Wittgenstein. In private life a reindeer.

❁

"Not ashamed to sin but ashamed to repent" (Defoe). A motto for Kentucky.

❁

Neither Kafka nor Donald Barthelme could have written an autobiography.

❁

Crusoe was on his island for the thirty-five years before the landing of William III at Torbay (which he mentions as the place of a shipwreck). Defoe was among William's soldiers. Friday was the empire.

❁

A life is a secret.

❁

Freudian analysis turned out to be insensitive to the very values that give art its identity, as deconstruction is a hostile cross-examination of a helpless witness.

❁

An American reading Lévi-Strauss is in the peculiar position of a person without a civilization reading a person from a highly civilized country writing about culture. In some sense we do not know what he means. "Hell is other people." But for the American the Other does not exist. We are solipsists. We are not individuals, as the individual does not exist except in a culture. No culture, no individual (who can only be an example of a culture). So we must read Lévi-Strauss as people he's writing about rather than for.

❁

The USA and the USSR have exhausted their inherited European culture.

❁

In our century the great event has been the destruction of the city, and therefore of public life, by the automobile. Next, the oblitera-

tion of the family by television. Thirdly, the negation of the university by its transformation into a social club for nonstudents. Fourthly, the abandonment of surveillance by the police, who act only upon request and arrive long after their presence could be of any use. All of this can be blamed on the stupidity, moral indifference, and ignorance of politicians and public alike.

❁

There's a Dutch philosopher in Groeningen who charges forty dollars an hour for Wittgensteinian solutions to problems. "They know the answers. It's their questions they aren't aware of."

❁

Jane Kramer says that the French prefer a common etiquette to a common ground. We all do, I think. It's Lévi-Strauss's table manners as a technique of culture. Boring and impossible people are primarily violators of etiquette, imposing a different sense of space, time, periodicity.

❁

High-minded principles and intolerance are twins. The word *liberal* has over the past fifty years come to mean *illiberal.* Not only illiberal: puritanical, narrow-minded, mean.

❁

Avoid the suave flow of prose that's the trademark of the glib writer. An easy and smooth style is all very well, but it takes no chances and has no seductive wrinkles, no pauses for thought.

❁

It was Bourdelle who advised Rodin to clothe his *Balzac.*

❁

The emptier a room the smaller it seems. This is true of minds as well.

❁

PHYTOLITH. *Nardus stricta* contains phytoliths that could not

be mistaken for those from any of the other grasses. Microscopic bits of crystal from the soil that get built into blades of grass.

❀

A sixty is a flower pot three and a half inches in diameter, so called from sixty of them being thrown from the one batch of clay.

❀

"Hibiscus!" said the lion. "Isaiah!" replied the owl. The moon was white, was round, was rising. Bartók, the cicadas.

❀

One road into Rimbaud is through his meadows.

❀

Michel was, as he figured it, happy. He was not certain what happy was, but his happiness had been noticed and specified. Once when he was smaller his class had gone to the Museum of Mankind to see Eskimo things, and he had, while their teacher was showing them a kayak, taken off his shoes and socks to count his toes, of which there were ten. Suzanne, the busybody and snoop, said: "O mère de . . . look at Michel!"

Teacher had said, placidly, "Michel is happy."

❀

Isak Dinesen's meadow at Rungsted. Beyond an apple orchard. Her grave is under a great beech.

❀

Forty finches in the thistles, in the high summer of time.

The road, always the road, through groves of olives, through fields yellow with wheat. Figs, melons.

Their walking made the silence creak. Flap of sandals. Thomas, the twin, talking.

—Rabbi, this tearing off of the foreskin, is it right?

Yeshua's answers were always quick, as if he knew what you were going to say. He looked at something else while you were talking, a woman with a jug of water balanced on her shoulder, a

sparrow hawk circling, cows in a wadi, and at you when he answered.

—If the Everlasting had wanted us to have no foreskin, we would be born without one. Nothing should be shorn that does not grow back.

Thomas looking around Yeshua's hat to study his eyes in the brim's shadow.

Yeshua's smiling irony.

—If our bodies are designed by the Everlasting for our souls, what a wonder!

Yeshua talking, talking with the sweet patience of the fellowship, to Thomas and Simon and John, and to someone else also. They had remarked on this among themselves, that their company sometimes included an unseen other.

—But if our souls are created for the body's sake, that would be the wonder of wonders. The Egyptians elongate the infant's skull while it is still soft, and there are people you know nothing about who bind their women's feet and picture their skins all over with needles and ink, and file their teeth to a point. Only the subtle Greeks, whose Heraclitus could parse the grammar of creation and whose Pythagoras discovered the harmony of numbers, leave the healthy body intact, as it was created.

A stonechat dipped and sailed sideways. Yeshua put out his hand and the stonechat came and sat on it, head cocked.

Yeshua speaking to the stonechat, in its Latin.

—Is the flesh then good? Thomas asked.

—Is there, Yeshua asked, perhaps of the stonechat, perhaps of Thomas, Simon, or John, any other way of being? The Everlasting's work is all one creation. Are we to say of the one creation there is that it is nasty?

Thomas looking at his fingernails, Simon at his feet.

❁

Horses buck, cocks crow. Cat dogs one's steps. Dog badgers. A subset of animal words. To squirrel away things, to cow one's enemy, to horse around, to ferret out, to weasel, to parrot, to canary, to ape.

❁

Many russet-clad children
Lurking in these broad meadows
With the bittern and the woodcock
Concealed by brake and hardhack.

❁

Samuel Palmer. Moss sopped in gold clotted on the thatch of a roof. Mr. Christian trudging by.

❁

"When angry, paint bamboo." — Wang Mien (1335–1415)

❁

The white frost that made the fire feel so good, and the quilt so comfortable, had also reddened the maples and mellowed the persimmons. Cloth shoes stink by the fire. Foxes bark in the deep of the wind.

❁

Opossum:persimmon::moth:mulberry. Christmas Island (South Pacific): imperial pigeon, noddy, glossy swiftlet, reef heron.

❁

To see a clock as a clock, Wittgenstein said, is the same as seeing Orion striding in the stars.

❁

Queneau on Fourier as a mathematician, making Marx more of a Fourierist than a Hegelian.

❁

No force however great
Can stretch a thread however fine
Into a horizontal line
That is absolutely straight.

(A prose sentence in a textbook, by sheer accident a Tennysonian stanza. There's a Yeatsian sonnet so disguised in *The Counterfeiters* of Hugh Kenner.)

❀

Hemingway's prose is like an animal talking. But what animal?

What Are Revolutions?

THE ROMAN GODDESS OF THE DAWN was also a goddess of battles, so that down through the infamous history of warfare the great battles have begun with sunrise: Shiloh began at 6:00 A.M. (April 6, 1862) with Confederates bayoneting Union soldiers in their bedrolls. The first Battle of the Somme, in which one million and 265 thousand men were killed or maimed for life, began at dawn. And at dawn on April 19, 1775, seventy men stood in a line on the commons at Lexington, Massachusetts, awaiting the British troops Paul Revere had told them were marching to Concord, seven hundred of them, under Lieutenant Colonel Francis Smith.

On this same common, sixty-two years later, Ralph Waldo Emerson's *Concord Hymn* was sung on the Fourth of July, 1837:

> *By the rude bridge that arched the flood,*
> *Their flag to April's breeze unfurled,*
> *Here once the embattled farmers stood*
> *And fired the shot heard round the world.*

This was our revolution. It lasted until 1781, when at Yorktown Cornwallis surrendered on October 19—the British, company by company, marching to a jaunty little tune called "The World Turned Upside Down," gave up their flags and stacked their arms before General le marquis de Lafayette and General George Washington.

"The revolution," John Adams remarked later, "was over before a single shot was fired." He meant that our independence had evolved as a historical process. In some sense the French Revolution was also over before it began. Both these revolutions happened in and were the result of a time called the Age of Reason. A French historian has recently argued that their revolution was unnecessary, a tragic waste of two million lives. A million is a thousand thousand. One of the horrors of facts is that they are abstract. "Wars," Melville said in a poem, "are fought by boys." Consider one young Frenchman, the son of a family, with brothers and sisters, with a girlfriend or wife. He is healthy, he is of a height, or he isn't eligible to die of gangrene at Jena or have his legs blown off at Austerlitz. Now multiply him by two and think of this second soldier with his face blown away at Waterloo. Now multiply him by three. If we stand here and count two million young Frenchmen—plain, handsome, curly-headed, lively, dull—one a second, it would take us twenty-three days and nights to count all two million of them.

What, then, is a revolution, that it should murder two million Frenchmen in the Age of Reason? The historian I mentioned feels that the real tragedy of the revolution was that it established the formula "If you want peace, make war." If you want fraternity, kill your brother; if you want equality, decapitate the nobility; if you want liberty, enslave the young in an army. Listen to a fervent revolutionary, Jean-Baptiste Carrier, "We shall turn all France into a cemetery rather than fail in her regeneration."

One of the battle hymns of the Bolshevik Revolution, which enslaved the Russian people with a power beyond the wildest desires of the cruelest czar, was "La Marseillaise."

A revolution, then, is a way of putting power in different hands.

They have happened over and over down through history. One is raging at the moment in Haiti, another in Nicaragua, another in Honduras, another in Ecuador, another in Chad. There has not

been a single minute of peace in the world since the Battle of Waterloo. Wars have gotten worse and worse, and will continue to get worse. We can even look back on battles that struck terror into the imagination and, by comparison with what we have done since, think them almost idyllic. The awesome battle of Lepanto, when Spain and Italy destroyed Turkish naval power for all time, lasted two hours. The battle of Lexington fifteen minutes or so. Greek, Roman, and biblical battles lasted a few hours only.

Is this, then, what revolutions are? Well, history is not wholly a Grand Guignol of blood and suffering. The British became a constitutional monarchy over years of evolution, with incidents of revolution thrown in. One should always think of Iceland, which lived more or less happily and successfully for five hundred years without any government at all. It has one now to be up with the times. The head of it is a tidy Lutheran woman with advanced ideas, and the big national concern is how strong beer should be. But no one has equaled the ultracivilized Danes in their revolution. This occurred with a petition to the king for a constitutional monarchy and an elected parliament. The king invited the revolutionaries to tea, where the matter was discussed favorably.

Revolution and evolution are perhaps like fire and rust, which are different speeds of oxidation. Heraclitus in the sixth century B.C. discovered that many different things are the same; the philosopher's task was to find what is too fast or too slow to see; too small and too large. Evolution and revolution are the same process, one very slow, the other fast.

Of the evolutionary clock we can say little—it is out of our hands. But of the revolutionary clock we can ask: Is it in our hands entirely? Is it controlled by our desires and passions, our hope and restlessness? Or do we want to ask if evolution and revolution must cooperate? The United States freed its black slaves in 1865 with revolutionary violence, but the evolution of their freedom is a very long way from being complete. The communist revolution hap-

pened, in Russia and elsewhere, and is still happening with the understanding that its evolutionary stage is a long process.

Our political problem now in the United States is that we are a long way from our revolution. Congress proves daily that it is incompetent. It collects our taxes and throws them into a bottomless pit of debt. The last project we have been able to pay for was the building of the Panama Canal—from that point forward we are still in debt, and the interest is compound. Our revolution was fought because of a penny tax on paper and a two-penny one on butter. We are now taxed for every movement we make, every exchange of a nickel from citizen to citizen. That tyrant against whom we rebelled would not have dared to tax his subjects' incomes and was innocent of the diabolical idea that one can collect taxes on income not yet earned, which all of us now pay.

We cannot communicate with our government; I asked the Internal Revenue Service a few years ago a very serious question and am still waiting for its answer. I know very well that I will never hear from them.

I do get messages from them, however, about other matters. My most recent one said: "Estimated Income Tax overpaid. Overpayment will be applied to next year's return. There is no penalty for this."

If there were a human mind behind that message I could join a revolution and express my displeasure, while hoping for the government I like, the one designed by Jefferson and Adams in 1789. But my message from the IRS was generated by a computer. That snide remark about no penalty for overpayment, which would have widened the eyes of Franz Kafka and George Orwell alike, is a phrase built into the machine. This machine has no manners, no wit, no heart.

When I am tempted to join whatever revolution holds out some hope to my and your condition, the temptation will come from my having, without doing a thing, managed to demote myself to sec-

ond-class citizen. I have no driver's license, which means that I have to use a different mode than drivers to get a passport. A driver's license *is* citizenship. It is our *carte d'identité.* I know this painfully when I try to write a check, or when I must give evidence that I am me. I am, in our society, incomplete. I do not have a body. My body, at this moment, should properly be in your parking lot, if permitted. The body of an American has four wheels, drinks gas and oil, and eats cities.

The strangest revolution of our century is this perverse and invisible evolution of the human body into the automobile. Which brings us to the real subject of these remarks—the Heraclitean discovery of a hidden process, and what to do about it.

Evolutions, with their revolutionary bursts of speed that we call invention and war and discovery, most often happen, as Heraclitus said, unseen and undetected until long afterward. Greek city-states, with no idea of ever congealing into what we call a country, one by one, to help themselves in their eternal wars with one another, became client cities of the Romans, who willingly took their sides in their petty forays and greed. Until one morning it dawned on the Greeks that they had become Romans and that they were a country, the province of Greece, with tax collectors and an emperor to rule them.

That's an example of the slow process. We know all about the fast. Ask people in the Czech Republic or in Hungary. But what we are interested in here is the slow and the invisible. When we wake up from our myths we will discover that we Americans do not live in Jefferson's republic but in a technological tyranny the likes of which has yet to be described by political scientists, who have slept through it all.

The prophets warned us. There were many of them: John Ruskin, Henry David Thoreau, Buckminster Fuller, Yevgeny Zamyatin, Booth Tarkington, Ezra Pound, William Morris. You will note that it is a strange list, these prophets. I want to take one of

them and look at his outrageous ideas. He is Samuel Butler, Butler the Second, as we must say, not his namesake whom Darwin read with interest, but Darwin's contemporary, the author of *The Way of All Flesh* (1903) and several cranky objections to Darwin, some delightful travel books, and an amazing satire called *Erewhon* (1872).

Butler's *Erewhon* is a satire about Victorians and what they really believed beneath their sophistication and official religion. They believed, Butler said with a wicked smile, that to be ugly is a sin, that to be sick is a crime, and that to be luckless is punishable by a prison sentence. Like us, they worshiped money, and their true church was the bank. To be rich and fortunate, good-looking and healthy was the state of grace the Bible was really alluding to, not all that soppy stuff about brotherly love, compassion, and salvation.

The satirist takes a man at his deed, not at his word. Bernard Shaw built a career on a few of Butler's ideas; he is an awfully good author to steal from. Ask Joyce. Butler's greatest satire, however, is in those two brilliant chapters of *Erewhon* called "Darwin and the Machines." Machines, a great Erewhonian philosopher discovered, have an evolutionary destiny precisely like that of organisms. In fact, they are organisms. They mate and beget offspring. We are shown how human pollinators, calipers and blueprint in hand, work at a factory to assist in a nursery of locomotives. As the bee assists in the propagation of plants, so the machinists assist at the lying-in of locomotives, the breed of which all of Butler's readers had seen improve in their lifetimes, from the archaic Puffing Billy and Tom Thumb to great eight-wheelers that could chug from London to Edinburgh overnight. The evolution of the pterodactyl to the robin took millions and millions of years; from eohippus to the Belgian draft horse, again, millions of years. But from Puffing Billy to the locomotives of the Great British Southern Railway, the process had taken scarcely fifty years. Wilbur Wright lived to see his wood-and-wire flyer of 1904 evolve into the jet airliner. I grew

up with people who liked to compare their first sight of an automobile. My grandmother, like Alexander Graham Bell, would not have a telephone in her house—she said it was a vulgar invention. (Bell, its inventor, did not have one because it was a damned nuisance.) I like better the objection of Edgar Degas, who did not have a phone because there was a great likelihood that the party calling might be someone to whom you had not been introduced.

The technological evolutionary scale, Butler's Erewhonians figured out, was so much swifter than the biological that it was clear that they would very soon be enslaved by machines. One would spend most of one's day behind the wheel of an automobile, taking it where it wanted to go. One would have to ransom it from a bank and work one's fingers to the bone to keep up the payments it demanded and to feed it petroleum. One would have to build roads for it and tear down cities for its parking lots. It might even become a treacherous master and turn on you and kill you, as it does more than forty thousand Americans annually, injuring at least two million more.

The Erewhonians had not gotten as far as the automobile when they staged a revolution and killed the machines before it was too late. They slaughtered the locomotives, the power stations, the bicycles, the power looms.

And they were free. Not of their prejudices, for they are a wonderfully silly people, the Erewhonians. They devote their freedom from machines to sending people with measles and influenza to jail, along with the poor and the ugly, the luckless and the dull.

When we Americans wake up, we will see that we are an Erewhon that did not have a revolution that killed the machines. The philosopher who can tell us what has happened has not yet written a word. We did not listen to the prophets and now we do not even have a diagnostician to specify the name and nature of our enslavement. Nor do we have the technologist of Darwin's genius to write the history of the evolution of the machine. Of all the creatures,

the fish is the one that cannot define water for you. It can only say, "It's what is. It is the way things are."

If we had this imaginary Darwinian technologist, he would say something like this: As in biological evolution, where the liver fluke learned over a million years to take over, cell by cell, a water snail that sheep like to eat, and thus enter the sheep; so the automobile, to take but one machine, got us to believe that it is our body. The principle was laid down by an astute street philosopher 2,500 years ago: "A man who owns a lion," Diogenes said, "is a man owned by a lion." He was talking about slavery and noting how clever slaves frequently seem to own their owners. "Masters!" he also said. "Obey your slaves, and all will be well."

Anybody can see that the automobile owns us, not we it. We are its slaves. It takes sharper eyes to see the more insidious process: the car swallowing up our soul in its metal-and-glass body. But it has happened and it is so.

This is an example of evolution as revolution and can be studied and demonstrated. The first place to look is at our bodies, which are now obsolete.

Never before since the Manichaeans raged have we so diligently criminalized all affection that involves the body. Our system of taboos is so charged with fear and suspicion that in the newspapers daily we have Ann Landers counseling parents to call the police because Uncle Jack has hugged his nephew upon entering the house. Will not the nephew grow up to be gay? Ann Landers always says yes. Is Uncle Jack normal? Obviously not. A normal Uncle Jack would explain his new car to his nephew and urge him to pet and caress it like a normal American male. Because, you see, the nephew cannot reach puberty and find a mate without an automobile. He cannot be thought of as masculine and properly American. It is, as Ann Landers has no way of knowing, his body and his destiny. He must, for instance, have one to go to high school; what is education without a car?

In Villiers de l'Île-Adam there is an arrogant but ultra-civilized aesthete who lives for the arts and their sensations only. He is accused of letting life pass him by. To which he replies, "Living? Our servants will do that for us." We can now say, since we failed to stage the Erewhonian revolution, "Living? Our machines do that for us. We have an automobile for a body, a TV set for our imagination, a CD player for our musical expression."

But these things, we can object, are labor-savers, and they are necessary. Necessity is the first argument of all tyrannies. Ask Hitler; ask all architects of totalitarianism.

Technology is our glory; it is the shape our brilliant civilization has taken. We are advanced in a miraculous way, and we will advance further and further. With technology the surgeon can laser away the cataract and restore our sight. We can enlist the artificial intelligence of the computer to perform engineering and mathematical exercises that would have taken Isaac Newton months of calculation.

And so on. We cannot, we do not want to turn back. An Erewhonian revolution makes no sense. There are, we know, romantic and quirky people who have declined TV and the automobile, the refrigerator and the personal computer. They are, in some strange sense, both advanced and retrogressive. The most strenuous prophet of the machine was R. Buckminster Fuller, who said that in the machine we have utopia (that's the Greek for Erewhon, which is "nowhere" spelled backward) in our hands. We will not need to work. All of our time will be leisure. And then what do we do? Why! said Fuller, we devote all our time to the delights of the mind. If he had not been a New England transcendentalist, he would have added the delights of the body.

Well, what if we lost the delights of the mind and the body when we constructed a wholly automatic technology? Fuller said of politicians that they are people who couldn't do anything else. We don't need them in a technological paradise. They'll go away

in a generation. Businesspeople? Bankers? Financiers? What about them? Pirates! said Fuller. They will have no place in the new world. Instead we will have poets and painters and novelists, philosophers and scientists.

Fuller had an answer for everything. To a question about overpopulation, Fuller once pointed out that the population of the world could forgather on the island of Manhattan. There's room there for all of them to stand—shoulder to shoulder, on every inch of floor and ground and underground space—but it can be done. So much for overpopulation. Fuller was not so much the only serious Erewhonian we had among us, in his own way—an Erewhonian who wanted to govern rather than obliterate the machine—as a 'Pataphysicist. This latter kind of scientific thinker, you remember, was imagined by Alfred Jarry, in the person of one Dr. Faustroll. His was the science of demonstrating that the opposite of all scientific truths is true. Water does not seek its own level. Gravity is grossly misunderstood. Time flows both backward and forward.

If, as I think, we must have an Erewhonian revolution, it will stem as much from 'Pataphysics as from Samuel Butler. We are decidedly not moving toward Fuller's utopia; we are moving toward a disaster that we can't even imagine. We have been trapped in the logic of the revolutions of the Age of Reason. If you want peace, make war. We must have an arms buildup to have the strength to negotiate an arms reduction. And so on.

Because I don't like theories and don't have the wisdom to design a revolution that I can incite you to start, I am going to fall back on reality. Let us go back to the people who had their revolution over cups of tea at the king's palace in Copenhagen. The Danes. They were once a people so terrifying that the English Book of Common Prayer asks God to protect us from them. In those days they were Vikings and it was wise to ask God to be protected from them. Then they heard the gospel preached and

mended their ways a little. They thought Christianity sounded pretty good, but only up to a point. They didn't like the part about having only one wife. A prudent church obliged them with the *lex danicum*, which allowed the Danes only to be polygamous Christians. They also wanted, as long as the church was passing out favors, to be baptized in warm water. That concession was given them also. Thereafter the Danes have followed what seems to me to be an exemplary path toward being successful and happy human beings. They have the highest standard of living in the world as measured by money and comfort. They are universally envied, except by Germany, which thinks them pushy and a touch immoral.

Danish history is a series of revolutions nicely balanced in an evolutionary frame. In the Age of Reason they had a charming writer and thinker named Ludwig Holberg. Denmark is a small country with few people, so Holberg had to be their all-purpose humanist: their importer of the Renaissance (a little late), the founder of their national theater, the inventor of many genres of literature, as well as a man of the church and government. So the Danes became model humanists after the pattern of Montaigne and Erasmus. Then came N. F. S. Grundtvig, who was a man of church and government also. He made them all literate, peasant and bourgeois alike, and wrote a thousand hymns and collected their folklore. Then came Søren Kierkegaard, who told them they were fat satisfied pigs and no sort of Christians at all, despite their exemplary Lutheran piety. So they all became philosophers and good Christians (limiting themselves somewhere along the way to one wife apiece). Then they had to hear the account of their shortcomings from Georg Brandes, who said they lacked sparkle and verve — Brandes was the first, anywhere, to lecture on Nietzsche. The conservatives were horrified by these lectures and fired him as a professor. Never mind: various people who did like his lectures passed the hat and made up his salary so that he was back in his classroom in no time. What we call modern Denmark — the coun-

try where everybody on one day under the Nazi occupation wore the yellow star of David, the king included, in compliance with the German order that all Jews identify themselves—is the creation of Brandes and his brother Edvard. "We are all Jews," they said. Just as today one can see a blond, blue-eyed Dane wearing a button saying that he is a black South African.

The process goes on. They sound like Erewhonians of the most dangerous sort. They sunbathe naked in their parks. They have decriminalized every affection they can think of. They have absolute freedom of the press. In Denmark you can, if you choose, beget your next baby in the middle of the street; the traffic is very gentle and polite and there would be no other objection.

But to observe them from an American point of view is confusing. Children can see a film about twelve-year-olds experimenting with sexual play but they cannot see Disney's *Snow White*, which is banned for its violence and spookiness. At the same referendum on which the Danes voted to legalize pornography they also voted to keep a state church, the Lutheran Evangelical. How, we ask, can they have so much freedom, with more to come, and be so quiet, well-run, charming, and clean a country?

They have TV and they read a hundred more books than we do. They speak at least three languages from the cradle up and yet adore their own language and have a rich and extensive literature in it.

Having legalized what we call pornography, they then lost all interest in it except for some rather spicy comic books that, I suppose, are educational in the long run. Illiteracy, poverty, and prejudice are unknown.

Their smallness can account for some of this—all excellence is local and specific to a culture. Their history, which is one of being lucky in their prophets and of a national propensity to heed their prophets, is another explanation. But I would like to argue that at

the center of their success (and I do not mean to praise them while slighting Canada, Switzerland, Norway, Sweden, or other foci of civilization such as quattrocento Florence or fifth-century Athens or Tokyo) is a matter of culture, of good breeding family by family, and that this is the result of a long historical process. There are two kinds of geniuses: those whom God drops anywhere—a Mark Twain in Florida, Missouri—and those who are the products of their culture. An Isak Dinesen or a Jens Peter Jacobsen appeared in Danish culture as palm trees grow in the Seychelles; they are native to it; the seeds were there. And that is how the Danish constitutional monarchy happened in reason and civility rather than with a million deaths and the ravagement of the country.

England and her American colonies were as civilized as Denmark, yet we resorted to musket and bayonet for our revolution.

I think we need a revolution, here, now. I want us to be a free, happy, wise people. But how this is to be achieved I do not know. I do know that the real revolution must be a ripeness of evolution. What scares me is that for the past fifty years we have been moving backward while we have dreamed, or fooled ourselves, that we were moving forward. Every one of our cities became more dangerous to live in; we all became little more than consumers and taxpayers as far as our government was concerned. Rascality in government has become the norm rather than the exception. Wars have gotten longer, more demoralizing, more devastating and irrational.

Perhaps there is a process here that we do not understand—though it looks awfully as if we have begun to accept rot for ripeness, illusion for reality, credulity for skepticism, stupidity for intelligence.

Because I have no rational revolution to offer you, I suggest, for the fun of it, that you try the Erewhonian. Take back your body from its possession by the automobile; take back your imagination

from the TV set; take back your wealth from Congress's bottomless pit and maniac spending; take back your skills as homemakers from the manufacturers; take back your minds from the arguments from necessity and the merchants of fear and prejudice. Take back peace from perpetual war. Take back your lives; they are yours.

Walt Whitman and Ronald Johnson

CHARLES IVES ENDS HIS SONG "Walt Whitman" (lines 1–5 of Section 20, "Song of Myself") with a playful splash of dismissive notes, an Ivesian "Hey! Did you get that?" This little song is all that he reclaimed from a projected *Walt Whitman Overture*, which, we can speculate, might have been as magnificent as *The Robert Browning Overture* or as beautiful as the four literary meditations on Emerson, Thoreau, Hawthorne, and the Alcotts of the second piano sonata, "The Concord."

> *All I mark as my own you shall offset it with your own,*
> *Else it were time lost listening to me.*

In closing his song with these lines Ives is responding to Whitman's sense that *Leaves of Grass* is a democratic text to be appropriated by its readers. His "myself" is any self, *the* self. It was Whitman's good guess that his readers hadn't been born yet. Though James A. Garfield could quote the opening of "Song of the Exposition" and the *Leaves* had many coteries of readers that included Emerson, Thoreau, the Rossettis, Victor Hugo, Oscar Wilde, and a band of young disciples like Edward Carpenter, Horace Traubel, and John Burroughs, Whitman's text was subject to the fate of all poems, to be permanently significant or to be forgotten.

Whitman himself has always been as substantial in history as

his poetry, and it is not unusual to find distinctions between them. Edith Wharton's story "The Spark" is about a man who had known Whitman in the war. He is a man prominent in New York society who forgives his wife's adulteries, cannot abide cruelty to animals, looks after an impossible, trying, and drunken father-in-law, and is, in short, a decent and kindly old soldier remarkable for stoic self-control. Edith Wharton hints that his strong and compassionate character comes from a male nurse in the field hospitals. He can't quite remember his name but recognizes his picture in a book he picks up idly in a young friend's library. The young friend reads him several of the most moving poems from "Drum Taps." The old soldier is appalled that Whitman wrote "all that rubbish."

The Whitman that he remembered can be seen in John Burroughs's *Whitman: A Study* (1896):

> An army surgeon, who at the time watched with curiosity Mr. Whitman's movements among the soldiers in the hospitals, has since told me that his principles of operation, effective as they were, seemed strangely few, simple, and on a low key,—to act upon the appetite, to cheer by a healthy appearance and demeanor; and to fill and satisfy in certain cases the affectional longings of the patients, was about all. He carried among them no sentimentalism nor moralizing; spoke not to any man of his "sins" but gave something good to eat, a buoying word, or a trifling gift and a look. He appeared with ruddy face, clean dress, with a flower or green sprig in the lapel of his coat. Crossing the fields in summer, he would gather a great bunch of dandelion blossoms, and red and white clover, to bring and scatter on the cots, as reminders of out-door air and sunshine.
>
> When practicable, he came to the long and crowded wards of the maimed, the feeble, and the dying, only after preparations as for a festival,—strengthened by a good meal, rest, the bath, and fresh underclothes. He entered with a huge haversack slung over his shoulders, full of appropriate articles, with parcels under his arms, and protuberant

pockets. He would sometimes come in summer with a good-sized basket filled with oranges, and would go around for hours paring and dividing them among the feverish and thirsty.

From cot to cot they called him, often in tremulous tones or in whispers; they embraced him; they touched his hand; they gazed at him. To one he gave a few words of cheer; for another he wrote a letter home; to others he gave an orange, a few comfits, a cigar, a pipe and tobacco, a sheet of paper or a postage stamp, all of which and many other things were in his capacious haversack. From another he would receive a dying message for mother, wife, or sweetheart; for another he would promise to go an errand.

And yet Burroughs, whose real response to Whitman are the twenty-three books he wrote about birds, animals, and forests, gives an inadequate account of the poetry. He tries hard, drawing lines around categories, listing virtues and felicities, but ends up gasping out, over and over, that Whitman is a cosmic poet writing for the universe. Overpraise is a feeble way of commending anything.

Literature looks after itself. Whitman thrives best in allusion and obliquities (as Edith Wharton knew). He strides across a Long Island beach in *The Bridge*, "your lone patrol," and figures as a ghost in deep perspective in Pound, Eliot, and Stevens. His true disciples arrived late and with a mind of their own: William Carlos Williams and Gerard Manley Hopkins, Jonathan Williams and Allen Ginsberg. Theodore Roethke includes him as a fat white spider at a ghostly supper with Vachel Lindsay.

He walked on the Boston Common with Emerson, exchanged greetings with Lincoln on Washington streets, heard Agassiz lecture on geology, attended Poe's reburial in Baltimore, and held a kind of salon in Camden in his old age, eating doughnuts with a circle of young men, sitting for a portrait by Eakins. His last words were all too human: "Help me up, Horace, I've got to

shit." Horace Traubel's three volumes of Whitman's talk is good reading.

If Whitman's life fulfilled what de Tocqueville predicted for that of an American poet (unrooted in tradition, eccentric, wildly original, populist and effusive), *Leaves of Grass* has its troublesome, wobbly history. There have been sane and levelheaded critics like John Jay Chapman who thought Whitman was an irresponsible tramp and egotistical monster wholly out of touch with the American common man. Academic critics have largely been embarrassed by him, as much for his subject matter as for the radical originality and difficulty of his form. The liberal mind defers to Freud before giving an honest ear to Whitman, though that priority precludes an honest ear.

While the thirty-six-year-old Walter Whitman was printing *Leaves of Grass* in Brooklyn on a friend's press, having set a considerable portion of the text himself, a wool merchant in Moravia named Jakob Freud and his twenty-year-old second wife Amalie (née Nathanson) were engendering a son whom, in due course, they named Shlomo, after his grandfather. The world knows him as Sigmund. He would become a doctor inquiring into the nature of the human imagination, and his theories would insinuate themselves like an entangling vine into Whitman's poetry.

The year 1855, having given us *Leaves of Grass* and Freud, also saw one James Harlan (1820–1899), of Clark County, Illinois, elected to the Senate. A decade later he was Secretary of the Interior in Lincoln's cabinet. He had so little to occupy his time that he liked to riffle through his clerks' desks. In the desk of his clerk Whitman he not only found a book of smutty poems but the exciting fact that Whitman had scribbled them. He fired him the next morning. (It was a busybody from the Postal Service who showed a shocked Eisenhower juicy passages from *Lady Chatterley's Lover*, and Jesse Helms's spies are still on the prowl.)

Innovation monotonously collides with censorship, which is

just as monotonously embarrassed by its own scandal of hypocrisy. Public taste is public taste, and Whitman was writing just when the genteel tradition was hiding the body under more layers of clothing (always excepting the Inuits) than in all of human culture and was purging English of all words even obliquely suggestive to the polite mind of procreation, anatomy south of the chin, and digestion. It is no accident in a lively imagination that "Song of Myself" is rich in animals—oxen whose eyes express "more than all the print I have read in my life," a bay mare whose look "shames silliness out of me." Animal grace and animal faith in the world were essential to Whitman's ideal natural human being.

We need to make curious adjustments in chronology with Whitman. Some of his most moving war poetry—such as the lines Mary Colum singled out in 1937 as proof of Whitman's greatness and of the scandal of our lack of appreciation, "I am the man, I suffer'd, I was there," and "Agonies are one of my changes of garments"—were written ten years before the war. It looks throughout "Song of Myself" as though Whitman had studied Darwin and found rich veins of poetry in *The Origin of Species*, except that it wasn't published until four years later. When we read of "the threads that connect the stars" ("Song of Myself," 24) and that "there is no object so soft but it makes a hub for the wheel'd universe" (48) we feel their modernity, as well as that of the startling passage in which generated Being is traced with a neat swirl from the primal dilation to ourselves in the womb—

> *Before I was born out of my mother generations guided me,*
> *My embryo has never been torpid, nothing could overlay it.*
>
> *For it the nebula cohered to an orb,*
> *The long slow strata piled to rest it on,*
> *Vast vegetables gave it sustenance,*
> *Monstrous sauroids transported it in their mouths and deposited it with*
> *care.*

That great green dinosaur carrying its egg in its mouth, lumbering toward evolution into other species, and yet others in unimaginable numbers of years, until the species *Homo sapiens* gives birth to Walt Whitman, has been edited out of our accounts of *Leaves of Grass*.

One of Whitman's characteristic ways of designing a line is to build a cunning nest of assonance and consonance at the start, and to unfold it in a lash to complete the line.

> *I believe a leaf of grass is no less [there's the nest] than the journey-work of the stars*
> *And the pismire is equally perfect [nest] and a grain of sand, and the egg of the wren*

Look at the harmonies: believe / leaf, grass / less, pismire / perfect. "A leaf of grass" encodes the title. Ants live in grass; grain is another name for a species of grass; wrens build their nests of grass.

Journeywork is work done by a master craftsman in a day. Plants grow at night, in starlight, though the photosynthesis by which they live happened in sunlight—but then daylight *is* starlight. A leaf of grass is precisely a processing of starlight; so is all life.

The commentator of this metaphysical Whitman, the poet Ronald Johnson, has never written a line of prose about him, his response being in two poems, "Letters to Walt Whitman" (in *Valley of the Many-Colored Grasses*) and the long and complex poem *Ark* (1996). It is modeled on Simon Rodilla's Watts Tower in Los Angeles, as well as on Ferdinand Cheval's Palais Idéal in Hauterives, both of which are masterpieces of folk architecture and structures of no apparent use.

Ark: the title alludes to the great ship built by the non-shipwright Noah that floated all of creation for forty days; to the rainbow (French *arc-en-ciel*), and the bow itself; to a segment of a

circle; and by whimsical extension of the abbreviation Ark. into *Arkansas* (which started out as *arc-en-ciel*), to Kansas, where the poet was born.

In Johnson's *The Book of the Green Man* (1967), the poem "Emanations" begins the commentary on Whitman that continues into *Ark*. The poem begins with two quotations. The first is from Edith Sitwell: "I am a walking fire, I am all leaves." The second is from "Song of Myself":

> *I find I incorporate gneiss, coal, long-threaded moss,*
> *fruits, grains, esculent roots,*
> *And am stucco'd with quadrupeds & birds all over.*

All of Being is, as Heraclitus and Democritus had intuited, of one substance arranged organically and inorganically. Whitman invented an imagery of puzzle pictures: his "root of wash'd sweet flag! timorous pond-snipe! nest of guarded duplicate eggs!" is both what it says and male genitalia. To be stucco'd with quadrupeds and birds all over is to be aware of the unbroken descent of man through the stages of evolution. Johnson's "green man" is in European folklore a figure transitional between vegetable and animal, fused here (by Johnson interpreting Whitman) with the Polynesian creator god Tangaroa (the wooden figure of him to which some thirty froglike little humanoids adhere in the British Museum can be seen in Hewicker and Tischner's *Oceanic Art*, 1954, plate 84), an image that influenced Melville's description of Queequeg's tattooed body. (Whitman reviewed *Typee* and *Omoo*.)

In this poem Johnson establishes two perceptions in Whitman: that wind through grass or grain is the spirit of life in matter ("Winds whose soft-tickling genitals rub against me," as Whitman says) and that light and matter in cooperation form the nucleus of Being.

Johnson's "Letters to Walt Whitman" is a prelude to *Ark*, and is one of the readings Whitman counted on future generations to

come up with, a reading that is aware of the nineteenth-century science (Darwin, Agassiz, Lyell) that Whitman saw as a dawn of new knowledge about the physical world, aware of Einstein's universe—where Whitman is, through Johnson's eyes, triumphantly at home.

Though Whitman wanted language to be the twin of reality, he depended on the image he could precipitate with a chemistry of words. It is this imaginative strategy that becomes Johnson's way of making a poem. The first "Letter" is a Kansas cornfield. Each of the letters begins with a passage from "Song of Myself," much as a correspondent might quote from the letter before him in his reply.

> I hear you whispering there O stars of heaven,
> O suns—O grass of graves . . .
> If you do not say anything how can I say anything?

Let us tunnel

the air
(as a mole's green galleries)
toward the ultimate

cornfield
— the square of gold, & green, & of tassle

that rustles back at us —

What the stars whisper now is information about the extremities of the universe, the Big Bang of creation still chirping light years away. The world sings, stars and starlings. It is a closed, self-cycling energy system. Grass on a grave (corpses in Whitman's day were in pine coffins) is one energy system (carbohydrate processing) converting to another (photosynthesis), both in response to light. The poem is arranged on the page according to the axis and left-right symmetry of the human body. Note that astronomers are moles tunneling through air.

The second letter considers replication through seeds and through seeing. The world that we know is an upside-down image on the retina (the eye is therefore a kind of seed, containing information that "uncrumples" into discourse, poetry, science).

> Unseen buds, infinite, hidden well,
> Under the snow and ice, under the darkness,
> in every square or cubic inch,
> Germinal, exquisite, in delicate lace, microscopic . . .
>
> *Slant sheen / wrinkled silver.*
>
> *Foxtail & lace-fly out of the vast organic slough*
> *of the earth,*
> *& the exquisite eye*
> *— as myriad upon myriad of dandelions —*
>
> *seeding itself on the air.*

The third letter is about Whitman's sexuality. Note that the quotation sounds like Ariel, dispenser of illusions. Sex in humans is an imaginative act (we do not know whether it is in animals). Nature is prodigal and protean. The pond grass calamus (sweet flag) was Whitman's symbol for the penis.

> These I compass'd around by a thick cloud of spirits . . .
>
> Solitary, smelling the earthy smell
> . . . a handful of sage.
>
> Here, out of my pocket—
> *twigs of maple & currant-stems,*
> *copious bunches of wild orange, chestnut, lilac!*

The fourth letter is a Fullerian hymn to interstices, networks, and spin. Things twirling tend to englobe, whether galaxies of stars or of gnats. Nature is a system of engaging events: the cockle-

bur is designed to be carried far away from its parent and thus fill
the world with cockleburs.

> The press of my foot to the earth
> springs a hundred affections,
> They scorn the best I can do to relate them . . .

> (The moth and the fish-eggs are in their place, The bright
> suns I see and the dark suns I cannot see
> are in their place . . .)

> *I see a galaxy of gnats,*
> *close-knit, & whirling through the air,*
> *apparently for the pure joy of the circle, the jocund*
> *inter-twinement.*

For all its simplicity, the fifth letter serves in its candor as a
mirror of Whitman's friendly openness.

> Earth, my likeness
>
> . . .
>
> *I, too, have plucked a stalk of grass*
>
> *from your ample prairie, Walt,*
> *& have savored whole fields of a summer's hay in it —*

The sixth letter makes a Whitmanian puzzle picture of clouds
over meadows and of sexual desire. This is pastoral; cricket song
was the correlative of hankering in Theocritus.

> Hefts of the moving world
>
> at innocent gambols silently rising, freshly exuding,
> Scooting obliquely high and low.
> *Dappled concave pulsing to the cricket's scrape:*
>
> *the scud & mottle of sudden*
> *dilations, divigations & night-jars.*
> *CHURR, CHURR.*

A computation of large rhythmic movements in our planetary system would include the earth's tides and continental drift, the weather and seasons. These are local and vital. Other forces— gravity, momentum, solar winds, the spin of our galaxy—figure in the miracle (as Whitman saw it) of Being.

The transparent base (and bass) of the seventh letter is sound: the persisting reverberation of the Big Bang, the white noise that we always hear, the noise of silence. This is a music massively un- heard: the roar of the sun's fire, the crunch of soil nudged aside by growing roots, whale song, the sliding of tectonic plates. The sounds we hear—cowbells, traffic, owls, the refrigerator's hum— are local swells in the infinite ocean of sound. Ancient tradition posited a music of the spheres that only angels heard. But if there is a "circulatory music" it is the sound of flux, perhaps of chaos.

A transparent base

shuddering . . .
under and through the universe

rides the brows of the sounding whales

& swells in the thousand
cow-bells.

The quotation that begins the eighth letter is, in full, "This grass is very dark to be from the white heads of mothers." The Val- ley of The Many-Colored Grass[es] is the setting of Poe's story "Eleanora," a fantasy about pure love in an imaginary land of great beauty. In its warmth and lushness it is an opposite to the frozen dawn of the aurora borealis. Both, however, are a kind of mirage, the one natural, the other psychological.

This grass is dark
. . . to come from under the faint red roofs of mouths.
Dark as heat-lightning —

mirage of flesh!
— purifying the air electric.

The intimate kernel putting forth final leaf

from The Valley Of The Many-Colored Grasses.
An Aurora Borealis

'dawning'
incorporeal.

All day the figures continued to move
about
& to bend over the green mounds

in the warm air.

Shades limned exact in the prismatic spheres
of death.

O SPEARS! TRANSPARENCIES!

The ninth letter, like the eighth, opens a debate about reality and the imagination. For Whitman poetry was a spirit transforming reality and providing it with a penetrating significance. *Eidolon* (Greek for image, work of art) is a favorite word of Whitman's. Is the world a cinder heap onto which we project our dreams, as imaginary as Oz, or is it Whitman's "miracle" that our dullness keeps us from seeing?

Landscapes projected masculine,
full-sized and golden . . .
With floods of the yellow gold of the gorgeous, indolent,

sinking sun, burning, expanding the air.

But are these landscapes to be imagined,
or an actual
Kansas — the central, earthy, prosaic core of us?

The tenth letter is amorous and erotic, whispered from lover to lover.

> The smoke of my own breath,
> Echoes, ripples,
> buzz'd whispers, love-root, silk-thread,
> crotch and vine.

> *I have put my ear close & close to these lips, heard them*
> *to the last syllable*
> *spun out —*
> *respirations of an encircling night*
> *— a cat-bird's ventriloquil*
> *'whisper-song'*

Johnson's visionary response to Whitman's harmonic universe in which passionate friendship is an example of its harmony is, by its nature, a meditation on the depths rather than out to the horizons. Criticism finds itself lost between the vastness of Whitman's subjects and the concise beauties of his phrases. He may be, after all, not the people's poet but a poet's poet (by which we usually mean the perfect reader's poet). His credentials for a place beside Horace are impeccable.

> *and from time to time,*
> *Look'd up in perfect silence at the stars.*

> *Through patches of citrons and cucumbers with silver-wired leaves*

> *That hell unpent and raid of blood, fit for wild tigers or for lop-tongued*
> *wolves, not reasoning men*

But he fits as well beside other poets and we have yet to take his measure.

Grant Wood's The Good Influence

GRANT WOOD'S *The Good Influence*, drawn with charcoal pencil on brown wrapping paper, is one of a suite of drawings executed from 1936 to 1937 for the Limited Editions Club reprint of Sinclair Lewis's *Main Street*. It depicts the character Mrs. Bogart, moralist, prude, and bully. The model, James M. Dennis tells us in his *Grant Wood: A Study in American Art and Culture* (1975), was Mrs. Mollie Green, "hostess at an Iowa City hotel restaurant." That's the Baptist church behind her. Architecture is one of Wood's constant metaphors for character, as we see in *American Gothic*, where the title refers equally to a building style and the farmer and his wife.

Grant Wood belonged to a period of American art when satire was a norm: the age of Sinclair Lewis, H. L. Mencken, James Thurber. It was a searchingly psychological satire, gentle by today's standards, civilized and yet keenly observant.

Wood was the subtlest of American painters. All of his major works contain witty displacements of natural fact: Revere is on a child's rocking horse in Iowa in *Paul Revere's Ride*; Washington's head in the Parson Weems picture (see page 92) is Gilbert Stuart's portrait, familiar to everybody as the image of Washington from a three-cent postage stamp.

There are many displacements in *The Good Influence*. At first glance, we see a nun, who gives way to Chaucer's Wife of Bath.

Grant Wood, *The Good Influence*, 1936. Black carbon pencil, india ink, and white gouache on tan wove paper, 20½ × 16¼ inches. Courtesy of the Museum of American Art of the Pennsylvania Academy of the Fine Arts, Philadelphia. Academy Purchase, Collections Fund. 1952.6.2

There is also a sly allusion to Leonardo's Mona Lisa. Once we have the iconographic information that this all too typical Midwestern American woman is a specific character in a satirical novel (she is a widow and has spoiled her son, who is a lout), we see her for what she is: a gossip, a hypocrite, a self-righteous critic of other people.

As in a Renaissance portrait, she authenticates her power by standing in front of the institution with which she wants to be identified. She is pulling on a glove—a moral knight donning armor. She wears her widowhood with religious propriety and sacramental grace. Her eyes are perfectly ambiguous. They are mean and generous, innocent and worldly wise, mocking and kind. Their puzzling look is complicated by her smile. She has just said, "I'll get even with you, never you doubt I won't" or "I've been in love with you for years."

Her look is the kind that terrifies little children, who have things they'd rather their parents didn't know about, and this woman is a snitch. She is master of moral blackmail. She will tell you that she understands, and grieves for, this husband, this wife, this somebody we'd better not mention, but you know who I mean.

Wood's technique as a graphic artist is uncompromisingly true to textures, volume, and space. See how her fingers going into her glove are defined, how the drawing here is meticulously tactile. The same can be said of her veil's transparency, of the dimpling flesh at the corners of her mouth, and of her incipient mustache. The composition, as usual with Wood, is a system of rhyming lines: the slant of the church roof on the right rhyming with her left hand. Downslanting lines to the left, of roof, of veil, of her right hand, all enforce the eyelash-line of her right eye. There is a wonderful harmony of hard angles and soft underslung curves.

"American Matriarch" might be another title for this exquisite drawing. Holbein and Goya would have admired it. There is an unhappy irony in knowing that it came along in the history of American art just when we were not yet prepared to appreciate a

classic satirist of Wood's stature, and just when Abstract Expressionism was about to claim practically the whole territory of serious art. Neither of the other two of the so-called regionalist triumvirate—John Steuart Curry or Thomas Hart Benton—was capable of so trenchant and understanding a portrait as *The Good Influence*. For its equal in delineating the mystery of human character one has to turn to the poets, to *Spoon River Anthology*, for instance, or to Willa Cather's women. I have called her the Wife of Bath, and I think Chaucer would say, "Yes, that's her." And Flaubert would recognize his typical small-town bossy householder, Madame Aubain, of "A Simple Heart."

Writing Untied
and Retied as Drawing

THE LACONIC PREFACE to Jean Cocteau's *Clair-obscur: Poèmes* (1954) is, in full: "Poetry is a language all to itself which poets can speak without fear of being understood, as people are in the habit of using that language for other purposes." Cocteau in all the arts he practiced for fifty-five years—poetry, fiction, essays, plays, films, painting, drawing—never lets us forget that it is the familiar world on which he works his magic.

The myth of Orpheus, which Cocteau made into a film in 1950, requires an oracle, a disembodied voice. An automobile radio serves Cocteau's purpose, and when it isn't being oracular it gives stock-market reports. Death is a surgeon. The Furies are a motorcycle gang. In his play about Orpheus, there is an angel who is an old-fashioned glazier who carries a rack of windowpanes on his back, resembling an angel with folded wings. One of Cocteau's films begins with an eighteenth-century philosophe assembling a daisy. This was achieved by filming a daisy being pulled to pieces petal by petal and running the film backward.

"J'eus une main de gloire," Cocteau said, "et la main était fée." How we translate that *fée* makes all the difference in how we see Cocteau. Enchanted? A supernatural gift? But also pixilated, touched by a dark genius. If a poet can "speak without fear of being understood" (this seems to subvert communication) he has something he wants to reserve, to hide.

Cocteau worked at a time when it was understood that art always has something to hide. Creation feeds on deep reservoirs of the unconscious. Freud was not the sole authority for this belief. The arts themselves undertook an exploration of the archaic (Stravinsky's primitive Russian rituals in *The Rite of Spring*, a pivotal event in Cocteau's career) in the world of dreams and visions (surrealism) and in the raw energy of primitive art (Picasso's *Les Demoiselles d'Avignon*). Cocteau, in a poem about Stravinsky, said that we must listen to the drums of the jungle to invigorate civilization.

Cocteau's habit of drawing doubtless began, as with all of us, in childhood. His output, as Edouard Dermit (his adopted son and heir) says in an introduction to the 1971 reissue of *Dessins* (1923), was enormous, practically a daily activity. The first mature drawings constitute an oeuvre in themselves—Cocteau's caricatures of the Ballets Russes. These could be printed, with minimal commentary, as a history of that brilliant period when, overnight in 1909, Paris was suddenly aware of a whole new theatrical world containing Diaghilev, Stravinsky, Karsavina, and Nijinsky. Cocteau, an aspirant poet at the time, drew posters for Diaghilev, designed costumes, wrote ballets. The residue of this creative blossoming (ballet is the most ephemeral of the arts, each performance being unique, unrepeatable) is in the drawings of Bakst and Cocteau.

Even if these drawings were not in one of the wittiest and suavest styles of the century, they would still have the primal value of historical documents. The camera did not record Nijinsky being toweled after dancing *The Spectre of the Rose*; Cocteau did. Or Stravinsky at the piano. Or Bakst drawing with his toes (a skill otherwise unrecorded).

Caricature has an authority far beyond that of the portrait or the photograph. A portrait may become symbolic, like Gilbert Stuart's Washington or Mathew Brady's Lincoln, but it is born innocent and must wait to be a cultural sign. A caricature begins as a

sign, determined and shaped, ready to flow in a currency of images. Richard Nixon came to look like David Levine's caricatures of him. Kierkegaard is helplessly a caricature; there are no portraits and no photograph. Cocteau's Georges Auric, Francis Poulenc, Igor Stravinsky, Erik Satie, even his Picasso and Diaghilev, have a cultural authority their photographs lack. We trust the comic spirit.

In John Singer Sargent's portrait of Nijinsky we see a young Slavic face, insipidly charming. There is, however, no information either psychological or somatic. Cocteau with a few deft lines gives us a real knowledge of Nijinsky: how he stood, how tall he was (not very), how the slanted eyes, high cheekbones, and flat nose gave his face its character. In all the drawings of Diaghilev and Nijinsky, Diaghilev looms, his elephant's eyes are possessive and jealous. In one drawing he *is* an elephant in a top hat, mournfully watchful over the gazelle's grace of Nijinsky beside him—a psychological perception years before the tragic rupture of the two. Tragedy, as Shakespeare knew, uses the comic spirit as its spy.

Cocteau was always congenial in his caricatures, with a sense of fun rather than malice. They are done with the freedom and familiarity an indulged nephew enjoys with a fond uncle.

Cocteau's style at that time would make a revealing study. It is based on a thoroughly original line and sense of pictorial space, and yet one can say that he has looked admiringly at Georges Barbier, Erté, the German humor magazine *Simplicissimus*, the French magazine *Assiette au Beurre*, at Picasso and Modigliani. At the heart of his style is a genius for caricature. His likenesses are exact, needing no captions.

Caricature was a French art that had flourished for a century when Cocteau was born. Daumier, Gavarni, Doré, Grandville and many others had shaped caricature into one of the most articulate and versatile of graphic arts, inspiring the founding of *Punch* in

Jean Cocteau, *Les Vacances*,
from *Drawings*, 1923

London, and laying the ground for the political cartoon and the comic strip.

It is tempting to claim for Cocteau the status of a great comic artist. His sense of humor is frequently delicious, as when he titles a drawing of a bald academician *Nude* or draws Monsieur et Madame Pierre Loti as romantic *flâneurs*, just close enough to Loti's own idea of himself to seem sympathetic, and wickedly witty enough to poke gentle fun at a popular, shallow writer.

That Cocteau's genius was in caricature can be easily seen by comparing his serious drawings with the comic ones. Here his enchanted hand became banal and dull. The erotic drawings, for instance, are badly drawn; drawings of his boyfriends are amateurish. The erotic drawings I refer to are explicit and obvious. There are erotic drawings that are mysteriously subtle. *Les Vacances* is one of these. Its components are a palm tree, a large rose, a lizard, an aardvark, a fish, two naked swimming boys, two winged flying boys (presumably angels), a ship under full sail, and a volcano on the horizon. Tropical bliss daydreamed, a world at play; even the smoking volcano seems placid. If we know Cocteau's poetry, we are aware that the rose, especially a rosebud, is a constant way Cocteau talks about the glans penis. Greek poets record that *lizard* was a playful word for penis. In Cocteau's drawing the lizard is climbing onto the rose. I suspect that an iconographer who has learned Cocteau's code could explain the drawing as a coherent fantasy rich in erotic lyricism.

My guess is that Cocteau drew best when he was daydreaming; that is, when he was technically doodling and the drawings drew themselves.

Cocteau has said of his drawing that it is writing untied and "knotted up again in a different way." He has also identified all his arts as poetry: cinema poetry, drawing poetry, and so on. We then notice how much of Cocteau's drawing depends on titles, or on an organic cooperation of word and image. A drawing of two hand-

Jean Cocteau, *Les rimes riches*, from *Drawings*, 1923

some draft horses is titled *Les rimes riches* (a rich rhyme is one of two words with the same sound but spelled differently). We *feel* the wit of this before we can see any sense in it. Rhymes double sounds; identical horses are somehow one horse doubled. What draft horses do in French is *tirage*; duplicating by printing is *tirage*. (For an English-speaking audience we have a drawing of horses that draw carts—this would have pleased Cocteau.)

There is such a thing as metaphysical humor; René Magritte was a master of it, as was de Chirico. It is the mode of humor inherent in the French surrealist movement of which Cocteau was a brilliant part while remaining officially outside. To draw two graceful soccer players and call the drawing *Foot-ball Annonciation* is to be metaphysically witty. "Soccer" is British schoolboy slang

Jean Cocteau, *Foot-ball Annonciation*, from *Drawings*, 1923

for Association Football. By substituting *annociation* for *association*, Cocteau, who admired young athletes, constructs a complex visual-verbal pun. "Not Angles [Latin for *English*] but angels," Saint Gregory said on first seeing English boys. Cocteau's *footballeurs* have raised arms, like the angel Gabriel at the Annunciation. We begin to understand Cocteau's saying that poets speak a language of their own "without fear of being understood."

There are many drawings of Cocteau's with very reserved meanings, some having to do with private allusions to his love of his own sex (another *rime riche*), with his addiction to opium, with the lively tension in his life between bourgeois propriety and his dedication to revolt and innovation in the arts.

His drawings of cabarets (effeminate young men, dirty old men, masculine women all in the Isis Bar, about which you can learn more in the pages of Colette) are drawn with satiric disapproval while wittily disapproving of *our* disapproval. Cocteau disturbed tradition in order to renovate it, not to destroy it.

A French newspaper began its obituary of Cocteau with "There died yesterday, after a prolonged adolescence . . ." Of his drawings we would not be far wrong in saying that they are work from a prolonged childhood. Capable of very stylish sophistication (as witness his design for a French postage stamp, his posters and theatrical designs), Cocteau got some of his best effects by drawing like a six-year-old. Look at *Memories of Toulon: M. Millerand Leaves Toulon*—the automobile is kindergarten homework, the politicians are a child's idea of pompous adults; only Thurber and Steinberg have got anywhere near such inspired charting of human folly.

The Tchelitchevian distortions (*Sailor Telling Tall Stories, 1900*), the deliberately labored copying of photographs (*Psychoanalysis*), the Klee-like reduction of the figure to a naïve scheme of absolutely necessary lines (*The Bicycle Lesson*) can be seen as child-

ish drawing. What we're looking at is the masterful work of an artist who has kept, or recovered, the privileged genius of all children.

Of many drawings by children, parents have tactfully to ask, "What is it, dear?" And we are often surprised by the answer, as in the case of Saint-Exupéry's "hat" that turned out to be a cobra that had swallowed a pig. Cocteau's eighteenth-century gentleman with his hat propped in his elbow is enigmatic without the title, *Thermidor.* The eyes then become stupid with authority. A revolutionary of the period when the revolution began to devour itself. Is this a doodle saved from the lycée history class? A covert commentary on some political event in France of the 1920s? The only cartoonist today who might have drawn *Thermidor* is William Steig.

Drawing after drawing, we can say of Cocteau that here he anticipates Steinberg or Thurber; here he echoes Beerbohm or Klee. His range of styles is prodigiously fertile. There are also paintings in oil and watercolors, and drawings in crayon and pastel. William A. Emboden's *The Visual Art of Jean Cocteau* (1989) is largely about Cocteau's work in color, best thought of critically as an oeuvre parallel to that of the drawings, which must remain in a category to themselves. The effortless grace and spontaneity are lost in the paintings (not all, but most), and there are obvious derivative subjects and techniques from Picasso and Matisse.

The drawings remain an achievement of all but absolute originality. If Cocteau's plays, poems, films, novels, essays have a center, it is probably in the masterful poetry that he wrote all of his life, and especially in the hauntingly beautiful and mysterious poem "Léone" (at once his masterpiece in writing and a defense of his imagination). But very near his poetry we must place the line drawings in all their wit and freedom. Drawing is the oldest of our arts of which we have any record, and it remains the most free, most intimate, and most lively of the graphic arts.

The Drawings of Paul Cadmus

A PAINTER'S DRAWINGS — or a sculptor's, or a writer's (the day-dreaming sketches of Shelley on his manuscripts or the dancing stick figures Kafka doodled in his notebooks) — have the privileged interest of rehearsals and first drafts. We are seeing process, revision, the artist's first attention in all its energy. "The process of drawing is before all else the process of putting the visual intelligence into action, the very mechanics of taking visual thought," Michael Ayrton says in his remarkable essay "The Act of Drawing" (in his book *Golden Sections*, 1957). Ayrton's observation is a meditation on Baudelaire, who had asked himself in one of his exhibition reviews if Ingres's draftsmanship "is absolutely intelligent." Baudelaire was participating in the nineteenth-century connoisseur's preference for the sketch over the finished work as a more transparent and immediate way of studying creativity and sensibility. "Drawing," as Ayrton says, "makes more precise and delicate demands on the intellect than does the physically more generous art of painting."

In Impressionism the freshness of the sketch was maintained in the finished picture. A late Cézanne is both; or, to say this another way, the sketch is the painting. Hence in cubism we have a systematic integration of annotations for a painting as the painting itself, much as a page of Gertrude Stein is a text developing (in the pho-

tographic sense of "coming up"), arrested, or left in a perpetual state of becoming.

In the eighteenth century the decision was made by collectors and museums that the artist's preliminary drawings were works of art in themselves. Sketching became an accomplishment for the educated of all classes. And drawing became a distinct art, as witness Seurat, van Gogh, and Degas.

The drawings of Paul Cadmus are both finished works and studies for paintings. As with Ingres, we have two parallel oeuvres (or three, if we want to count Cadmus's translation of his paintings into engravings, following the practice of Hogarth). So the paintings are the middle term of three media: drawing, painting, engraving. Quite early in Cadmus's career, the distinction between the graphic and the painted began to disappear. His meticulous and painstaking brushwork in tempera became more and more a method of drawing with paint. *Bar Italia*, for instance, is technically a large colored drawing executed with the same crosshatching as in his studies of models.

After we had Lincoln Kirstein's authoritative monograph on Cadmus (1986), the drawings needed a book to themselves (1989), not only for their beauty but for their distinct achievement in modern art. Cadmus's neglect by critics is notorious. He has been a true rebel in a revolution trivialized by fashionable rebelliousness that long ago forgot (and sometimes never knew) what the revolution was about. In a wonderful irony of history, he is the *enfant terrible* who turned out to be, after all, the keeper of the flame in a time of confusion and darkness. Whatever our allegiances or our taste, we cannot deny that having a draftsman among us who can draw like Pisanello is a miracle, and one that the Age of Andy Warhol scarcely deserves.

An artist's style is at once a graphing of spirit and an imparting of information. Because drawing is an art, even mechanical drawings of machine parts or Auguste Sonrel's meticulously accurate

lithographs of jellyfish and turtle embryos (for Agassiz's *Natural History of the United States*) have great beauty despite their being wholly informational. There is an easy suspicion that they are beautiful because they are saturated with information. A Jackson Pollock of the late period is all spirit, with no information whatever. So is a Piet Mondrian. In Cadmus, as in the best of Renaissance styles, we have a perfect balance of spirit and information.

The realism of a Mantegna or a Bellini was a solidification of things imaginary, of subjects posited by faith and tradition that no eye had hitherto seen. If the Word was made flesh, then its realization in paint had to be visually authentic, convincing, and rich in information. Faith is one thing; painting Christ's sandaled feet quite another. Our eyes read the world at all times; the greater our curiosity and sensitivity, the more we search for signs and symbols. In the matter of Christ's feet we want much information, as they must carry immense meaning in their being washed and dried, in their walking, in their being nailed to a cross. They bespeak humility, humanity, suffering.

Cadmus is as rich and accurate in his information as Piero della Francesca and Hogarth, as Flaubert and Joyce. We live in a swamp of predigested information, such as the *Encyclopaedia Britannica*, *Time* magazine, and television, and have forgotten the arts as a prime source of our knowledge of the world. In just a few more years we will be in a position to recognize in Cadmus his humblest virtue, the age-old duty of painting to depict. His subway and tourist's Italy and Coney Island and New York playground will become historical records. As basic and obvious a truth as this is, it is crucial, for Cadmus is also a psychologist and a moralist. His sensibility has two sharp cutting edges—one is satiric, the other visionary. The two are complementary: if satire says that we live in insane confusion, it must have an ideal of sane order from which to make its accusation.

Cadmus's ideal is not easy to discover. If his satiric statements

are clarity itself (we are in no doubt as to the meaning of *Seeing the New Year In* or *Bar Italia* or *Playground*), his visions of the orderly and graceful are sometimes straightforward, such as *The Bath*, *Mallorcan Fishermen*, or *The Shower*, and sometimes enigmatic to the degree of being puzzles.

How, for instance, are we to read *Night in Bologna*? In the soaring perspective of a colonnade, a rabbity young American male with the air of being newly arrived is gazing at a soldier, who is gazing at a chic Italian woman, who is gazing at the rabbity American. Are we looking at a moment in the perennial comedy, begun by Hawthorne and James, of American innocence and European experience? Cadmus is intrepidly a narrative painter. Anecdote, story, and moral statement dominate throughout his work. This can be said of Grant Wood, Ben Shahn, John Sloan, Reginald Marsh; the American painter works in a long tradition of exacting meaning from experience. American painting has also distinguished itself in having strong opinions, in philosophizing with various degrees of subtlety, from homemade vagaries like those of Thomas Hart Benton to exquisite symbolism and the achievement of intensely imaginative worlds of the mind—Georgia O'Keeffe, Charles Burchfield, Joseph Cornell. We have scant critical skills, however, in conflating a painter's thought with our literature and philosophy, and we shy away from the kind of speculation that might ask what Cadmus's *Seven Deadly Sins* series has to do with its historical moment, with literary parallels, with American painting in general. The result is that we talk aesthetics and the politics of fashion and remain in dismal ignorance of meaning in some of the most interesting painting in all of history.

Cadmus is his own interpreter at crucial moments. *Night in Bologna*, for instance, has a pendant work that comments on it. This is a still life, *Studio Stuff*: a T square on end, a roll of adhesive tape of the kind that used to be called *gum strip*, a forty-five-degree artist's triangle, and two snippets of gum strip that make a visual pun

on the number 69. The gum strip is unwound enough to form a loop (secured to the wall by a thumbtack) around the shaft of the T square. On first realizing that we are looking at an abstract diagram of *Night in Bologna,* our sense is of a comic obscenity: The T square is the soldier and the phallic tower that seems to rise above him as a symbol of his masculinity. The gum strip is the woman (adhesive when wet, clinging, binding). The triangle is the geometry of desire, and the 69—residual or vagrom femininity in the male—names the velleity generating the drama of the painting.

Proust once defined a homosexual as a man who wanted a soldier for his best friend. Cadmus's thought in *Night in Bologna* and *Studio Stuff* (the one a short story, the other an essay interpreting it) rhymes with Proust's uncomplicated remark, while penetrating it with psychological insight and investing it with American values. In an imaginary space explored by E. M. Forster and celebrated by Cadmus in other paintings and drawings, the soldier, his shy admirer, and the woman might cooperate in a triangular sexual pattern just as the artist's implements cooperate in the business of the studio. The T square and triangle rectify; the tape holds things in place. The two snippets of it either have been cut for a particular purpose or are leftovers. One meaning of this still life is: maleness is dry, firm, straight; femaleness is wet, floppy, serpentine.

But the crosspiece of the T square is secured to the shaft by a quincunx of screws, and it has a circular opening at its other end. The thumbtack is both masculine and feminine. Indeed, we are looking at a meditation on the ambiguities of gender and sexuality. Cadmus's questing soldier is a potential best friend, as amoral as Hawthorne's faun, as much as he is the potential lover or customer of the woman. Cadmus is a wonderfully literary painter, knowing that the quincunx is a symbol of Eden and of paradisiacal gardens in general. He invites our thinking of Pythagorean geometry and numbers, of interpenetrating signs (femaleness in maleness, maleness in femaleness), of flexible subtleties and witty configurations.

Once we are alert to this metaphysical wit, we discover that there are other paintings with commentaries (*The Tower* and *Apple Peeler*, for example).

There is a strenuous articulation of symbols throughout Cadmus's work. Lincoln Kirstein's study, good and sensitive as it is, is still an exploration of a ground far too rich and complex to be disclosed all at once. Realism for Cadmus is first of all accurate delineation. However ugly he finds the world, he skimps no detail. His respect for the truth of things remains the same whether he's drawing a splendid physique or a body deformed by gluttony and sloth. This "magic realism" (as it was once called) is always integral with an iconography that speaks in various styles, sometimes allegorically (*The Seven Deadly Sins*), sometimes symbolically (an example of which would be setting erotically charged but biologically sterile subjects in sand), sometimes satirically, sometimes dramatically.

It is in the dramatic paintings that we can find a principle of Cadmus's sociology. Moral chaos is always shown in crowds: Coney Island, drunken parties, hordes of people in Italian piazze, the Manhattan subway. These people, moreover, are too close together. Modern satire is a direct offspring of English satire of the eighteenth century. Crowded areas with no elbow space are symbols of chaos in Hogarth, Smollett, and Rowlandson. In fact, a sensible approach to Cadmus would be through his restatement of Hogarthian themes: *Subway Symphony* is a perfect rhyme with Hogarth, and we can see Hogarthian strategies in *Playground, Bar Italia*, and *The Fleet's In!*

Space for Cadmus must not be crowded. Correct distance is a symbol of both order and love. In most of the erotic paintings, desire happens across a distance to be traversed. This space is empty. Look at *Finistère, The Bath, Night in Bologna*, and Cadmus's most eloquent statement of erotic friendship, *Two Heads*. We can use this perception about distance to solve a problem: why, in Cadmus,

do we have an acidly satirical condemnation (the word is not inaccurate) of male homosexuality (as witness *Bar Italia* and *Fantasia on a Theme by Dr. S.*) in concurrence with a lyrically charming approval of it (as in *The Bath, Point O'View*, and *What I Believe*)? Part of the answer is in the psychology of personal distance, and in the deployment of desire in a given space. The answer applies as well to all sexuality, although Cadmus's attention is toward males. People are most comfortable in Cadmus when they are alone: his ideal is primarily monastic. Next, where there are two figures, they create their own space, having quite literally room for each other only. Once sexuality of any kind becomes a herd activity, Cadmus sees it as vice, chaos, a failure of order and self-control.

Notice how Cadmus changes character into caricature when he satirizes crowds, and how character intensifies and individuates in his paintings of craftsmen. His drawings of male nudes are of bodies, but of achieved, perfected bodies that serve as symbols, as in ancient Greece, of a perfect unity of spirit and flesh, mind and body. For Cadmus the body *is* the person, not a vehicle of flesh or Manichaean shell.

Cadmus has drawn from the nude male model almost daily for many years. Such discipline and humility is more native to the musician; Casals practiced his cello daily for the better part of a century. Between those artists who draw from nature—Cézanne, Cassatt, Eakins—and those who draw from their imagination—Picasso, Chagall, Klee—we can make a radical distinction. The latter tend to become calligraphers of hieroglyphs in a language of their own invention. Picasso began as early as the thirties to make graphs (and to redraw the holdings of museums). Klee became a metaphysical poet.

Cadmus is an artist for whom the human body is infinitely interesting. Just as Odilon Redon was pleased to be praised as a botanist, so Cadmus might take pride in being an anatomist. One of the first things that strikes us about his drawings of the male nude is

the variety of angles, the foreshortening, the triumphant illusion of mass on a flat surface: these all happen together and are one act of drawing. Archaic art knew nothing of this skill, or made an awkward failure of it when it was required, as in horses seen from the front.

Primitive art prefers the standing body seen whole, as did Egypt, Greece, and Rome for centuries. Not until the Renaissance did the body seen from an angle come in. Signorelli and Raphael move toward Baroque mastery, and Hans Baldung's bewitched groom opens a door on a wholly new visual world.

Cadmus's early nudes stand, stretch, dive, sit. Over the years they are more and more folded in on themselves, crowded into boxlike spaces, problematically foreshortened, returned to child-like, huddled, sleeping postures. Consciously or not, Cadmus has been posing his models closer and closer to the athletes or daimons of the Sistine Chapel, those gratuitous (and imaginary) quotations from the classical that the Renaissance mind found to be compatible with Christian and Hebraic iconography.

From Camille Pissarro to the death of Georges Braque, the strategies and successes of Western painting, sculpture, and architecture came from innovations in the service of a vast renewal. Impressionism was an intensification, a brightening of tradition, not a departure from it. Cubism was a fractal dialect of Impressionism, standing in relation to a late Cézanne the same way a page of *The Cantos* or *Paterson* stands in relation to a page of Apollinaire. And somewhere along the way in this brilliant and vigorous revolution—sometime around Jackson Pollock's dripped designs—innovation became disengaged from renovation: the revolution began to devour itself. It forgot what it was doing. It trivialized its intelligence and debauched its soul.

Lockstep, however, has never been the arts' order of march. Picasso was painting *The Three Musicians* while Monet was at work on the oval mural of his Giverny lily pond for the Orangerie. The

official histories of our time would have it that painting branched out into a bewildering divergence of styles before it collapsed into chaos. The perspective of time will show something quite different; just what, it is still too soon to prophesy. But the persistence of a tradition surviving from the Renaissance will claim its importance. In retracing our history we will see that as much innovation happened inside the tradition as in the revolution against it. And in this tradition we will see that one of its masters was Paul Cadmus.

What happened? We don't yet know. Vulgarity, always eminently marketable, has taken over. Vulgarity in, taste out; that's what vulgarity is all about: a defeat of the critical faculties by mindlessness. Cadmus's *Subway Symphony* is a picture of the last five minutes of the Roman Empire, and it asks "How did we come to this?" Ben Jonson had asked the same question in *Volpone* and *Bartholomew Fair*, Swift in *Gulliver's Travels*, Hogarth in *The Progress of Cruelty*, Voltaire in *Candide*.

There are awful times—ours is the worst—when satire loses its power to correct and to civilize. Goya failed, and his failure marked the beginning of the brutalities of our time. We can say that, despite Goya, we forgot with the convulsion of inhumanity from Guernica to Buchenwald every strategy humankind had evolved to make life worth living.

Satire differs from all other genres in depending on a place to stand. With so much to carp at, it needs something to love. The most radically revolutionary of the arts, it is also the most conservative. It must know what is right in order to say what is wrong. Aristophanes stood on old-fashioned Greek morals and manners (those of self-control, prudence, courage, and common sense) when he made fun of career warriors, idealist philosophers, gassy playwrights, and politicians. *Odi et amo*, as Catullus said. I hate and I love.

Cadmus the satirist—Auden once remarked that Cadmus's ge-

netic blend (part Dutch, part Spanish) was the perfect combination for accuracy of perception and moral indignation—has always balanced his critique of the world with a lyric expression of what he finds to be beautiful.

We look at Cadmus's *Seven Deadly Sins* (1945–49), to which he added an eighth in 1983, *Jealousy*. All the bodies of these allegorical figures are hermaphroditic, a confusion of natural design. Lust's body is all penis; Pride's, a balloon but with mailed hands; Sloth's, a gelatinous subtance; Anger's, armadillo hide; Envy's, a gaunt skeleton with cheeselike flesh that harbors a hydra of snakes; Avarice's, a spider; Gluttony's, a splitting sausage, or gut, eating itself; Jealousy's, a monster of too many eyes and ears (torturing itself and eating its own heart). We then look at Cadmus's drawings of beautiful bodies. We have moved from one world to another.

The world's meaning belongs to the spirit. The saint sees one world and the satirist another when they are looking at the same thing. Art is a perfection of attention and the opposite of indifference. In one sense we need Cadmus's recording of physical beauty to understand his satirical work. Tacitly we all read bodies with a deeply cultural, prejudiced set of ideas. We interpret bad posture as bad character, obesity as gluttony, a vapid expression as dullness. We need a great deal of experience before we learn that real beauty is inward. And yet the body accommodates itself to that inwardness and is beautiful despite the widest variations from a culture's canon of handsomeness. Most of the people in *Bar Italia* are ugly because their souls are ugly.

In any age other than ours, Paul Cadmus's satiric paintings would have status and authority, would generate lively dialogue, and would have imitators, much as Hogarth's did in the eighteenth century and Goya's and Daumier's in the nineteenth. But after the controversy stirred up by *The Fleet's In!* and the objections to the WPA murals, some organic change in public and critical taste allowed *Bar Italia* to be received in numb indifference, and *Play-*

ground, The Seven Deadly Sins, and *Subway Symphony* to be as unnoticed as if they were painted on the moon.

When Cadmus began to paint, satire was as vigorous and articulate an art in the United States as it had been in ancient Greece and Rome, when it established itself as the way in which Western civilization criticizes itself. Indeed, it was understood to be the last court of appeal in the debate between ruler and ruled, authority and dissent, humbug and common sense. It has always cheeked tyranny, hooted at pretense, objected to all hegemonies, and spit in the bully's eye. But its great power has been to criticize in finest detail the sanity of a society.

American democracy accepted satire from its beginning as the way it would prevent the sleep of reason (in Goya's eloquent phrase) from becoming madness. Mark Twain remains the distinctively American voice in our literature. His spirit and verve were alive in H. L. Mencken when Cadmus began to paint. We can locate this American satiric genius in Sinclair Lewis, E. E. Cummings, Joel Chandler Harris, Grant Wood, W. C. Fields, James Thurber, S. J. Perelman, George Herriman (creator of Krazy Kat), Buster Keaton. In the history of satire, the first half of our century and the latter half of the nineteenth figure as a renaissance.

It is all but impossible to calculate specifically the success of satire. We know that it makes a difference, an enormous difference. The human spirit was changed by Dickens, by Twain, by Swift, by Rabelais. The satiric voice has a human rightness about it that we recognize as ultimately more congenial than philosophy, religion, politics, or sweet reason. Periclean Athens, with Socrates and Aristophanes to listen to, knew which spoke for them, which to them. What would the French mind be without Rabelais, Voltaire, and Molière? The Spanish mind without Cervantes?

In the second half of our century satire began to lose its battle. Practically everything that Mencken damned and berated, for instance, has now had its way. We now accept and have institution-

alized and allowed ourselves to be bamboozled by all the loutish evangelists, snake-oil salesmen, mongers of fear and superstition that he berated with his hair-raising gift of contumely. Despite every attempt of satire to keep us sane, we have put Dwight Eisenhower, Richard Nixon, Ronald Reagan, and George Bush in the White House. It is not so much that we betrayed ourselves in putting them there (we began doing that when the ink was still wet on the Declaration of Independence) but that we betrayed the critical sense, which satire exists to educate, that would have kept us from electing the wrongest people to the executive chair of the republic.

Cadmus draws on toned paper. With graphite he records the image before him in quick, short, parallel strokes. He is drawing shadows, technically, the areas on the surface of an oak leaf, or creases in a shirt or chin, that are not facing the source of light. If the shadow is deep, Cadmus crosses the first courses of short parallel lines with a second course at an angle, variously narrow or open, to the first. Despite its being only a graph, the drawing is accurate, masterfully sensitive to the surface of the object drawn, and moves toward a wholly convincing simulacrum of a leaf, a shirt, a chin. Then, using a brush charged with white watercolor, he works in the highlights with the same meticulous calligraphy of crosshatching. Light and shadow on a ground: three tones and their graduations, and the whole world can thus be accounted for.

Seurat drew with smudged crayon on rough paper with a fibrous surface; his intermediate tones are a woolly tangle, his whites the virgin paper. Leonardo drew outlines (visual fictions, as nature has no outlines), shading with a rain of lines. These shadings are a kind of handwriting. Picasso's became increasingly fractal, impatient, brilliant in their suggestiveness. Cézanne's became local notations of overlapping scribble, varying from square to ob-

long. Cadmus developed his exquisitely articulate graphing to be eloquent about the muscles, tendons, and bones beneath skin, informing us about firmness, elasticity, tautness, tactility.

The body's shape is a cultural decision. Victorian aristocrats were thin, Victorian gentry fat. Rude and blooming health indicated upper or lower class; the former for riding a horse well, the latter for hard labor. The young of the aristocracy made lively sports out of the backbreaking labor of the lower classes. Rowing, once the task of slaves, became a university entertainment; football began as a murderous game for country bumpkins on holidays. A complex convergence of decisions in the nineteenth century reinvented the Greco-Roman male body. Among these were sports in English public schools to discourage masturbation (which medicine criminalized as part of the middle class's moral code, a code that Foucault argues was its equivalent of social status, offering to the world a metaphor that changed *good breeding* from its sense of bloodline to impeccable manners and morals). English sports crossed the Channel to inspire Baron Coubertin to refound the Olympic games. In Germany and Scandinavia a concurrent interest in the healthy body arose under the banner of hygiene, eugenics, and an openly erotic appreciation of nudity. The athletic body in our century can be accounted for by militarism, several liberal rebellions against one stodginess or another (the German *Wandervögel*, Scandinavian sunbathing cults), fashion, and a new sense of the body that owes something to all of the foregoing.

Cadmus's male nudes are fusions of Renaissance nudity and what we might call modern domestic nudity. About half of them seem to be studies for religious or mythological paintings (traditions take forever to go away); practically all of his female nudes make us think of Boucher and Fragonard.

The beautiful body entered American aesthetics elegiacally and heroically in Melville, Whitman, and Eakins. Critics were

Paul Cadmus, *Male Nude #NM 32*, 1967. Colored crayons on hand-toned paper, 19½ × 16⅛ inches. Private collection, courtesy of DC Moore Gallery, New York

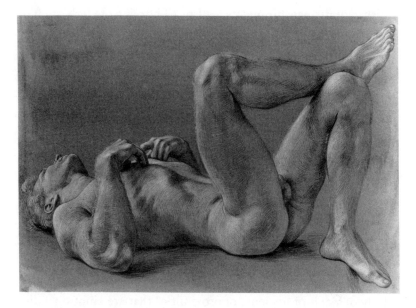

Paul Cadmus, *Male Nude #NM 39*, 1966. Crayon on hand-toned paper, 13⅞ × 19¼ inches.
New Jersey State Museum, Trenton, New Jersey

prudently silent; perhaps no one would notice and it would all go
away. Native to sculpture, nudity in statuary had a legitimacy de-
nied it in painting, poetry, and narrative. Sheer innocence permit-
ted Mark Twain some lovely nude scenes of boys and men in
Huckleberry Finn and *Tom Sawyer Abroad*. By the time Cadmus
came to paint, in the 1930s, the United States was undergoing a
strange process of criminalizing affection except that necessary for
procreation inside marriage, while banning all the arts that a pru-
rient suspiciousness considered obscene. The first painting of
Cadmus's career, *Jerry* (1931), is a portrait of Jared French,
decently nude but nude, reading *Ulysses*, which at the time was a
banned book. An obsessive prurience was quite willing to con-
demn everything in the painting—its nudity, the manner of af-
fection implied by a male nude in bed—and fashion could join
prurience in condemning the style of painting, both for its accom-

plished draftsmanship and its realism. (The reign of Herbert Hoover was far too genteel not to be offended by hair in armpits.)

Cadmus got into instant trouble with public opinion by setting out to explore the habits of sailors on shore leave, the comic ambiguities of YMCA locker rooms, sunbathers at Coney Island, and the denizens of Greenwich Village. What he had to say about these things was that we are a sexually clumsy and emotionally messy people. Also that we are cruel, prejudiced, and small-minded. As his friend E. M. Forster contrasted England and Italy, so Cadmus looked for a wiser, nonpuritanical world in Mallorca, Italy, and France. Put his *Mallorcan Fishermen* beside his *Y.M.C.A. Locker Room.* The one is a warm frolic of male camaraderie surviving from a deep Roman past. Its dozen males exist in an idyll, bound by a common, comfortable culture. The other is a comic study of a cult of hygiene, of proximities that are emotional distances. The roughhouse tumble of the Mallorcans would be impossible here and the little boy excluded. The Mallorcans are friends, a community; the Americans are strangers in a labyrinth of taboos.

For all his individuality, we must not see Cadmus as a lone figure. He is preceded by John Sloan and George Bellows, and by Reginald Marsh, whose influence and guidance he is quick to acknowledge. In George Tooker and Jared French he has allies. These three constitute a distinct school, with Tooker's Kafkaesque enigmas and French's surreal psychology as extensions of Cadmus's realism. And yet it is misleading to say that Cadmus is a realist. He is a realist as Ben Jonson and Cervantes were realists, to choose two masters of the imagination engaged rigorously with the real world. Satire demands exaggeration but exaggerates logically, keeping both feet on the ground. Cadmus's *Seven Deadly Sins*, which both Jonson and Cervantes would have admired, seems at first to belong to the world of Bosch or perhaps even Dalí. It belongs rather to an uncompromisingly realist tradition in which we

can account for all its monstrosity. Cadmus's imagination inter-
prets reality; it does not supplant it with fantasy.

We can see the principles and range of his imagination most
clearly in his still lifes, where his sense of humor is keenest and
where he permits himself liberties of great invention. Still life is
the sonnet of painters, the string quartet, the short story. It is the
minor form by which artists try out styles or refresh themselves, or
which they reserve (like Shakespeare and Milton) for privacies and
playfulnesses. Cadmus's still lifes are full of puns and jokes made of
egg cartons and Kleenex boxes, curls of bark and leaves. Anyone
wanting to explore the particulars of Cadmus's ideas and opinions
should study the still lifes, paying attention to books, visual meta-
phors, cunning and sly meanings encoded in shapes and conjunc-
tions. If Cadmus's large compositions tend to be satiric dramas and
his genre painting prose narratives, his still lifes are poems. Large
paintings, such as the triumphant *Study for a David and Goliath*
(1971) include still-life passages that establish their richly poetic
complexities.

Visually independent as they are, Cadmus's paintings are in
many ways literary, engaged in symbiotic relationships with texts.
The Seven Deadly Sins has its origin in Spenser; *What I Believe* in an
essay of Forster's; *Fantasia on a Theme by Dr. S.* in William H. Shel-
don's *Varieties of Human Temperament; Manikins* in the books that
Cadmus included in this still life (Groddeck, Gide, Shakespeare,
Michelangelo). *The Four Seasons* follows an ancient literary form.
That people read (and that Cadmus himself reads) is everywhere in
the presence of books and newspapers throughout the paintings.
The many references to texts are a tactical nudge: Cadmus's paint-
ings must be read, much as a Mantegna and a Botticelli must be
read. We say in the vernacular that we "look at" a painting. From
Impressionism forward, paintings were indeed made more to be
looked at than read. A Monet is a visual event. We can only look at
the paintings of animals in the caves of Lascaux; the means for

reading them are utterly lost. We look at an African mask, seeing nothing of its legible content. Over the years Cadmus has made us read as well as look at his paintings. *Subway Symphony* harmonizes the two acts: it is impossible to look at it responsively without also reading it. The reading of *Study for a David and Goliath* demands the kind of attention we give to a page of *Ulysses* or a poem by Eliot. It is a magnificent statement about mortality, heroism, stoicism, painting itself, the goodness of life and the place of myth and art in it, as deeply complex as Donne at his most metaphysical and as tragically joyful as Yeats or Sophocles.

In Cadmus we have a rare balance that few artists achieve in any medium: compassion and contempt. For satiric acid Cadmus has few equals: *Bar Italia* and *The Seven Deadly Sins* exercise the full power of satire to bite and sting. They place their painter with Hogarth, Swift, and Goya. And yet the same sensibility has given us *Playground*, with its articulate pity and regret for wasted lives, and *Herrin Massacre*. The erotic paintings (*Finistère, Night in Bologna*) and what, in all honesty, we should include among the erotic paintings—paintings of lyrically portrayed young men, like *Aviator*, *The Shower*, and *Sleeping Nude*—mediate between Cadmus's contempt and grief. They are, after all, the positive and negative responses of a moral unity.

Morality in the arts is in the whole fabric of the thing made, not an appendage or a specious gesture. The morality of a painter begins in his skill and its fidelity, in its humility in the service of our vision. The care and honesty with which Cadmus draws a hand are moral acts.

From the most archaic moment of Western civilization the naked body has been a symbol. The trim, athletic, symmetrical body of Cadmus's paintings and drawings was invented by the Hellenic people of the Greek mainland and Aegean islands at least by the ninth century B.C. This body is an invention in that it was in no way mutilated or distorted, tattooed or ritually scarred. In practi-

cally all other cultures we find elongations of the skull (as in Egypt and the Olmecs), the binding of feet (China), circumcision, lopping off of fingers, filing of teeth. Further, the Greeks eroticized the body as a unit, distributing its sexual attraction evenly rather than emphasizing local characteristics. The body could then move in and out of clothes without a sense of privileged revealing or modest concealment.

The Italic peoples adopted, with some shyness and disapproval, the Greek body. Christianity canceled it except as a symbol of innocence or poverty. The Renaissance revived it in its rediscovery of classical art.

The male nude has had a special symbolic value in the twentieth century. Joyce, whose employment of symbols is the most articulate of our time, places a scene of naked young men bathing in the sea immediately before the central epiphany of *A Portrait of the Artist as a Young Man* (Stephen Dedalus's sighting of a girl wading, a girl who represents all "mortal beauty" and who encodes Stephen's daimon, Aphrodite, the gods of writing Thoth and Hermes, a guardian angel). The naked young men, who will be repeated in the first chapter of *Ulysses,* are Joycean symbols of the Greek cultural springtime that preceded their great age of philosophy, drama, and art—an age in which the male nude was the prime symbol of the Greek spirit. Joyce would have been aware of the expression of a new openness in Scandinavian thought and art, from Thorvaldsen to Vigeland, as "a keen wind, a spirit of wayward boyish beauty"—the phrase is specifically for "the spirit of Ibsen," but it applies as well to Jens Peter Jacobsen and Georg Brandes.

We can see a similar placing of the male nude as an archaic sign of regeneration in Picasso, in Brancusi. Cadmus's lineage can be traced as well to the moment early in the century when there was a quietly parochial venture into the vague but hopeful notion of "a new age" heralded by Walt Whitman and Edward Carpenter in which love among males would be allowed to flourish as it had in

Greece, medieval Japan, Persia, Arabia, and other cultures that had tolerated and encouraged what has always existed furtively, or as privileged cults (in the Italian and English Renaissances, among the British aristocracy, among French intellectuals) or as a guarded but poignant theme in art and literature (Housman, Hopkins, Montherlant, Mann).

Part of Cadmus's critical neglect may be the mistaken assumption that his work is inside this parochial expression of male love, that he is a painter like Henry Scott Tuke, Michael Leonard, and Cornelius McCarthy, all of whom are very fine genre painters. Their subject matter, however, collides with our taste (as we like to imagine). What it collides with is a hedge of prejudice and ignorant fear. This hedge is invisible, of cultural manufacture, and is as unmapped as it is unspecifiable except as it obtrudes as a local interdiction or as an affront. As a matter of fact, we have no taste anymore; our critical aptitudes as regards art are sound asleep, narcotized and numbed by the trivialization of the modernist revolution and by a failure of nerve, a blindness and feebleness in the critical dialogue that art ought to enjoy and profit from in an alert society.

Our study of painting lags far behind. The achievement of Charles Burchfield and Grant Wood, of Stuart Davis and Charles Sheeler, lies all but uncommented on when we compare the attention they have had with the attention accorded comparable figures in literature. The ratio must be something like one study of Grant Wood to every fifty of Faulkner. It is as if we had been struck dumb and blind in the first two decades of the century. If we had a culture sensitive to good painting, we would still have the placing of Cadmus, with critical accuracy, in contemporary American painting and in the history of American painting. He is, I would argue, a master among contemporaries. But to say this we must characterize modern American painting as an unseen historical event. We have not yet taken the trouble to bring such a diversity of styles to-

gether. This will undoubtedly happen. What we need to do first is ask *what* got painted in the United States from 1900 forward; that is, we need an iconographic generalization. Iconography will lead to interpretation at a basic level. If we can say of the Italian Renaissance that it was painting the mythos of Christianity and coordinating that mythos with the classical past as worked out by both humanism and the Church, and if we can say of the age of Hokusai and Hiroshige that the visual arts constructed an exquisite aesthetic of everyday existence in Japan, and that Dutch painting in its golden age was a moral enforcement of a wealthy, industrious, and comfortable mercantile class, we should be able to say something equally inclusive about American painting.

We can locate several options: anxiety, discontent, nostalgia for an agrarian past, loneliness, a nervous vitality, private and eccentric visions. A brave irony has pervaded the century: Grant Wood's *Daughters of Revolution*, Cadmus's *Coney Island*, R. B. Kitaj's *The Ohio Gang*. Elegy and genre, a suspiciously energetic use of still life (Joseph Cornell, Aaron Bohrod, Georgia O'Keeffe). Our task would be one of enormous richness to work with. We have had practically no religious or historical painters. It may turn out that our time will be known as one in which painting focused on something like Joyce's epiphanies, symbolic enigmas that can only be understood by calculating the focus of forces the painter has brought together. We are not quite certain what *American Gothic* means but we can feel its staring energy (it accuses us of something), or what Georgia O'Keeffe was saying with her flowers and bleached bones, or why the vivid shapes of Stuart Davis express something very American and in an idiom peculiar to our time. Nor are we certain what Cadmus's *Bar Italia* and *Seven Deadly Sins* show about us: something, in any case, we ought to know. Practically all of Cadmus has an air of saying *"This, too, can be shown."*

The past of art is much deeper than history itself. From the

caves of Altamira to the invention of writing is a long, very long time. Art has always had the habit of being in a dialogue with itself over epochs longer than those belonging to any other human continuum. Cadmus is, in one sense, a painter who spiritually lives in the 1500s, when the world would have cut out his work for him, commission after commission. (Grant Wood's proper home was the Germany of Memling; Burchfield should have worked with William Blake and Samuel Palmer.) These imaginary displacements work the other way as well. It is one of art's means of constant renewal to place a sensibility native to one age in quite another. The advantage to us is incalculable. In Joyce we have a contemporary of Dante. In Cadmus we have a contemporary of Piero della Francesca who has painted our time—our confused, violent world—with an awareness of human values that has survived, integral with his skill as a painter, for half a millennium of Western culture.

Micrographs

Once, years ago, on a Trailways bus from Greenville, South Carolina, to Knoxville, Tennessee, toward late afternoon on a late summer day, the sleepy quiet of the passengers was butted asunder by the loud voice of a dignified black woman:

"Crazy old white man back here sticking his fingers in my hair!"

The bus rolled to a halt on the side of a country road. The driver, a man of paunch and deliberateness, slowly rose from his seat and walked back in his best *High Noon* stride. He did not speak until he was standing with considerable authority in the aisle beside the black woman's seat.

By this time the rest of us were trying to see all that was happening. I observed that the woman's hair was beautifully dressed, graying, parted in the center and drawn into a bun at the nape, and secured with a silver comb.

Behind her was a redneck of middle years whose watery eyes said drink.

The driver said to him: "Look here. Ever passenger is entitled to ride this bus without being pestered. Do you understand that?"

"I understand hit," said the redneck, with a foolish grin.

The driver walked back to his seat with meaningful slowness. Our journey recommenced.

Less than five minutes later, the loud voice sounded again. "Crazy old white man sticking his fingers in my hair again!"

The bus stopped. The driver walked back in awesome silence, his face expressionless.

"Up," he said to the redneck. "You're walking the rest of the way."

"Aw, shit," the redneck said.

"You got two minutes to get your ass off this bus," the driver said, "before I throw it off."

The redneck got up in an ecstasy of confusion and embarrassment, looking around for someone who would surely come to his defense. The bus was wholly silent. He was scrawny; the driver had the build of an ox. So the redneck shuffled his way off the bus and stood on the shoulder of the road with his back to us.

Our journey started up again. As soon as we had reached cruising speed and a buzz of conversation had arisen, a man walked down the aisle to the driver.

"Now what?" the driver said, a slight touchiness to his voice.

"My companions and I," the man said, "are delegates to the annual conventicle of the Church of Christ, in Knoxville, where we're on our way to, and we want to say that we will not stand for the unchristian language we're having to listen to on this bus."

"Well," the driver replied in an even voice, "you can stuff it, or you can walk to Knoxville, too. Don't make no difference to me."

FRAGMENT

Silence, with crickets. A throbbing owl call in the night.

—Talk about spooky, Hans said.

—Like doves, Erasmus said. They swivel their heads all the way around. The little Athenian owl was the *strix*, compact as a jug,

mewed from olives, flew sideways, wings as blurry as a hummingbird's.

Candlelight in the tent.

—O boy, Hans said, do we ever stink. The thing is to be honest and brave about it.

Fact was, we didn't stink. And I asked in my best offhanded voice why we weren't bathing.

—Ha! said Hans. It's part of getting away. At home we wash. Socks and underwear and shirts get snatched away from you and put in the laundry basket as soon as you take them off, no matter how much good wear is left in them.

—Truly, Erasmus said. The Dutch have been laundering their souls for five hundred or so years, and everything else they can get hold of.

❈

—Good coffee, Erasmus said. Now Adriaan will be himself.

—Unshaven, dressed like Adam, hair a nice mess, Hans said, he is still (and I quote) in sleep's old kingdom of unreason and sloth. Coffee, black and sugared, brings him into the realm of sweetness and light (in the words of Pastor Duckfoot).

—I'm getting there, I said.

—I have a feeling, Erasmus said, that Adriaan is going to call a halt to this barbarian abstinence from soap and water.

—Why? I asked.

—Because you are a clean person.

—And would I be obeyed?

—Of course. You have authority. Nephews obey uncles, guests defer to hosts.

—But, Hans said, we want to find out, don't we, what being dirty is, *ja*? We won't get any dirtier than people who go naked in the Celebes or Tahiti. Really dirty, anyway, is clothes. This meadow can't be dirty.

—Dump city trash in it, Erasmus said, atomic waste, indus-
trial crud.

—OK, Hans said, understood. But are not we, sweaty and
dusty as we are, clean in the same way as the meadow? What if we
hadn't brought toilet paper?

—The sea, Erasmus said. Even dust. We could powder, like
birds. A culture is clean in its own way and dirty in its own way.
Dirt has a different definition from section to section of a city,
even. Right down to individual decisions. It's fun to wear socks or
a shirt that extra day beyond their technical cleanliness. Dust on
shelves can wait until we need the spiritual uplift of dusting. Dirt,
after all, is anything we feel ought not to be where it is.

<div align="center">❁</div>

Erasmus with a handful of Norwegian daisies said that he didn't
like picking flowers, but that they are good to look at close, and
make a place.

He put them in his coffee cup. They fell out. Then into the
thermos.

—Make a place? Hans asked.

—Yes. Flowers make a place.

—My hair is nasty for the first time in my life. Dirt makes you
shine, Rasmus. It's wonderful. Have you ever seen anybody who's
circumcised? Adriaan looks shipwrecked, a beachcomber, walking
home from the Thirty Years' War.

—My nose, I say, is not as offended as my fingers. I'm not cer-
tain I can get used to being oily, gritty, dusty. What's different, of
course, is our finicky attention. If we had to be dirty, like soldiers
in a war, or miners, we would feel quite different about it all.

—Talk ruins everything, Hans said.

NOTEBOOK

Poetic knowledge is polythetic: it needs only a representative ex-
ample to make its case. But to talk about poetic knowledge in prose

we need the full set. Art is timeless; we are not. We must ask about the family to know the individual.

GARE DU NORD

An Irish passenger, seeing that the train was leaving on time, remarked, "The French are a very particular people."

FRAGMENT

The first appearance of the werewolf in Anderson, South Carolina, was on a spring night soon after the beginning of the Second World War. He drove at a great rate of speed down Main Street, going through all the traffic lights, slowing only to accelerate and make his tires screech. At Market and Main he hit a deaf typesetter who had just got off work at the newspaper, which was downtown in those days (it is now, like everything else, outside the city limits, and Main Street is as desolate and forsaken as Dresden after its two nights of being bombed alternately with phosphorus and TNT), knocking his shoes from his feet and killing him, one hopes, instantly. It was when the werewolf slowed in order to make his tires squall after hitting the deaf typesetter that a pedestrian saw him. Pedestrians are people who used to walk from one place to another before everybody owned at least two automobiles. The pedestrian described him as a wolf with a long feral snout. His eyes were yellow, small, and mean. He was wearing a cap pulled low over his forehead. The hood and front fenders of the car were splashed with blood.

The paws on the steering wheel were quite distinct.

Thereafter he was seen buying gas at country filling stations. He looked into windows. He frightened a carload of people from Georgia so bad that they drove into the lake.

The clergy were pleased. Evidence of evil played into their hands.

The war in Europe was never mentioned in school: our teachers did not know what it was about.

NOTEBOOK

The realm of art is not a subreality, with the inferiority of such a relationship; it is a superfluous reality invented by the imagination. There is a theory that the painted animals in neolithic caves are replacements for animals slain by hunters. Picasso, the most archaic of hunters, did several still lifes of meals prepared for him by his wife Jacqueline, inscribing them with the date and words of gratitude.

FRAGMENT

Yeshua (freckled nose peeling from walking bareheaded for two days, sitting in a fig grove by a well, smiling the convincing smile that puzzled some, delighted others), said:

—The seeker must not give up until he has found, because when he has found he will be surprised. You can expect the unexpected, as Heraclitus says in his book, but you cannot know what it is going to be. The finding is therefore a perplexity and always will be, but in perplexity is wonder, the child's response, the response of the child in us, and this wonder makes the finder nobler in his knowledge than the nobility of kings and those whose nobility is in family names and silver and property. Some day a searcher after truth will find out how this fig begets. Its flower is inside the fruit. This is a perplexity and a wonder even in our ignorance. The date palm is male and female; the naaman lily, more beautiful than Shulaman in his finery, blooms for a day only. Creation is cunning work, the ground of life, and beyond our knowing.

JANUS

Mr. Facing Bothways bought a batch of matchboxes depicting boxing matches between well matched boxers, a book about light

housekeeping for lighthouse keepers, and some Polish polish. I needed, he said, a max of botches.

POSTMODERN

The bomb, you see, has already dropped. Nobody noticed. The young, born dead, could move, breathe through their mouths, and watch the soaps and commercials on TV, having a good time. The bomb has dropped. All the pigs are trotters up, all the trees charcoal. Never wanting a change, only more of the same but better, we were of no mind to notice. It takes attention to notice things. Attention takes brains.

ICELAND

A china of peonies to the hocks of ponies and mops of roses.

THINKING ABOUT THE MINOTAUR

If we look to nature we see nothing human, and if to the human, nothing natural. We are not lions or trees; the wind is nothing like spirit. We have, to our credit and to our shame, become something wholly different. We are still becoming. The lion has become. It is plausible that we are retrogressing: giving in to the incomplete and inconclusive knowledge we call science, giving in to social and political violence. For a century we have acted as if nothing could be done about anything, reluctant to act because where action has been taken it was the rage of a madman against imagined wrongs. We have, as a species, always been afraid of ourselves, and with good reason: humanity has not yet organized into a people. We remain peoples, more distinct than wolf and mouse. Our imaginations are at war, Islam against Israel, Protestant against Catholic, even when we are at peace.

A BUGATTI IN FRONT OF THE INSTITUTE

To our left the botanical gardens, to our right the Museo Nazionale, a bicyclist passing in front of us. Inside the Institute, in a seminar room, a professor says:

— Of the French Jesuits' clock the Algonquins asked, *What does it eat?*

And in another seminar room:

— If we imagine the two brides of the fishnet as flanking figures, we can see the continuation of a reticulation as a field between twins, the field of stars between Castor and Pollux, in Gemini, the fishnet between the fish in Pisces. Recall that the zodiac shows traces of every sign once having been of twins, or perhaps of twins only at the four corners, the solstices and equinoxes.

In the courtyard, a statue of a general on horseback. In the shade of a lemon tree.

From the window of a lecture hall:

— The Japanese are animists with a lively interest in the correspondence between well-being and certain arrangements of rocks and sticks.

— Coherent light and articulate light.

The Bugatti dreams of the mists of Scotland, of twisting roads that give you, suddenly, around a curve, the shine of the sea.

Mr. Hawthorne, of Salem

A BIOGRAPHER, HAVING CHOSEN A SUBJECT, must then put it back into the dense fabric of time and place where its distinction was quite different from what the biographer is drawing for us. The time in which the subject existed interacts in a new way with the time of the biography. In Edwin Haviland Miller's *Salem Is My Dwelling Place* (1991), the twenty-second retelling of Hawthorne's shy and furtive life, his late maturity as a writer and the early loss of his narrative genius foreshadow a pattern in American writing: a brilliant period of creativity minimally fostered by a culture only marginally interested in good writing. His indifference to the abolitionist movement that so passionately concerned his neighbors— he lived across the road from Emerson, and Thoreau was his gardener—is puzzling to us, but is somehow not as surprising or disturbing as his flat refusal to be examined by a doctor or his demand that he be buried in his clothes without anyone's seeing his naked body. When, a month before he died, Hawthorne was ill with a disease still undiagnosed, the best his wife, Sophia, could do by way of a doctor's consultation was to have Oliver Wendell Holmes take a walk with him. It is as if a scarlet letter or emblematic birthmark must remain forever unseen.

Equally strange was his apparent narrow interest in books and ideas. He knew the eighteenth-century writers from whom he took his gracious, infinitely variable style. He knew Salem's guilty

past. Bowdoin College had given him a genteel education of sorts. He knew his Ovid. He was not, however, a reader.

Edwin Haviland Miller's biography of Hawthorne was ten years being researched and written, and will remain for some time the authoritative source. It is admirably conservative and diligent, finding no closeted neuroses, no incest, no figures in the carpet.

Hawthorne's childhood was that of a gentle, introspective boy raised in a household of women. His father, a ship captain, died of yellow fever in Surinam when Nathaniel was four. His only male friend was his uncle Robert, with whom he had some measure of outdoor life and boyish fun. He was tutored by the lexicographer Joseph Emerson Worcester. His favorite author was Bunyan. Quite early he learned to live in his imagination, although he also had the rare gift of living sanely and evenly in the practical world, taking his time with a patient diffidence. At Bowdoin he was more young gentleman than scholar, making friends he would be loyal to throughout his life, notably Franklin Pierce, whose biography he would write, and Longfellow. He wrote a Gothic novel, *Fanshawe* (1828), in which we can just make out his future genius, but he was ashamed of it almost instantly. His wife did not know of its existence until after his death.

He took his time with everything. Among the Peabody sisters he eventually chose Sophia (though it was Elizabeth, the intellectual, who had her bonnet cocked for him), whom he married after some doubts and an erotic flurry in another direction and after a very long engagement in which he dawdled at Brook Farm, that Fourierist experiment that seems to have been the golden moment of transcendentalism, a Victorian pastoral. The busy Margaret Fuller came and went; Emerson and Thoreau, who might have been the making of it, declined to milk cows and hoe vegetables in the name of philosophy and political justice. It provided Hawthorne with good copy, *The Blithedale Romance* (1852).

For all his powers of the imagination, Hawthorne derived his

romances (his word for novel) from realities. He turned Bunyan around, finding the symbol in things, whereas Bunyan had made things of symbols. *The Scarlet Letter* (1850) and *The House of the Seven Gables* (1851) are made of the Salem past; *The Marble Faun* (1860) from his culturally obligatory visit to Rome, with family, after his ambassadorial stint in Liverpool. Paul Pry he called himself, as if being a novelist were not quite a respectable occupation.

His stories, many of which are masterpieces in the art of short fiction, are never quite fantasies: they dabble in fantasy. Hawthorne is the most passive of narrators, almost as helpless as Kafka, to whom Borges compared him in a lecture in Argentina in 1949, one of the most skillful and searching comments on Hawthorne. Printed in 1952 as "Nathaniel Hawthorne" in *Other Inquisitions* *(1937–1952)*, this is the essay in which Borges discovers that writers invent their own precursors, whether they are influenced by them or not.

Poe stares into our eyes and mesmerizes us. Melville puts his confidential arm around our shoulders. Cowper displays his subject with the wave of an arm. Balzac is like a voice from another room, which perhaps we ought not to be overhearing. But Hawthorne idles into all his stories, nonchalant and without guile.

The story "Wakefield," which Borges found so interesting and so Kafkaesque, is blurted out in the first paragraph, breaking every rule by which Poe built a plot. Hawthorne then discusses the story, with some hope on our part that he will surprise us yet. He doesn't. He ruminates, and shows us how human a thing absurd and obstinate actions are, and how common.

Hawthorne was fascinated by the logic of absurdity, the inescapable contingences of necessity, the "blackness," as Harry Levin calls it, on the other side of light. *The Scarlet Letter* is a symmetry of rigidities, of morals, of doctrine, of character and hypocrisy. Hawthorne, who might have insisted at every turn that these double-binding symmetries are ridiculously inconsistent with a

religion teaching forgiveness and absolution, is interested instead
to play with light and shadow as if he has no ideas of his own. It is,
to quote Harry Levin again, opera. The plot is subservient to the
music of the narrative.

Miller as biographer is up with the times, has read contempo-
rary criticism but remains unseduced by it. He keeps account of
Hawthorne's reception among his peers—Melville's enthusiasm
and friendship; Emerson's inability to follow Hawthorne's dark
probings of human meanness, treachery, and moral blackmail; his
Victorian reputation as a charming storyteller who made forays
into the serious novel. Unfortunately, Miller stops short at what
might have been a brilliant adjunct to this biography, a tracing of
Hawthorne's standing, up through our time.

For our Hawthorne is the product of several reevaluations:
F. O. Matthiessen's in his *American Renaissance* (1941), Harry Lev-
in's in *The Power of Blackness* (1958), critical editions for college use,
European criticism, his readership abroad. Henry James in 1879
wrote the first astute and balanced study of Hawthorne, in which
he says that conscience is Hawthorne's ultimate subject. After
Freud, we might want to add guilt and obsession.

There was a period in which Hawthorne was a kind of harmless
founding father of the American novel, associated with black-clad
Puritans crossing New England snow on the way to the meeting-
house, with a whiff of the quaintness of witches. Leslie Stephen
tried hard in a speculative essay to decide if Hawthorne was a gen-
tleman (Americans frequently aren't), if "Wakefield" was a plagia-
rism, and if there was enough culture in New England to give rise
to a literature not derivative from Britain. A French critic begins
his essay by explaining that Salem is a suburb of Boston. And
there's Q. D. Leavis's excited discovery of him (she does not make
Miller's bibliography) and D. H. Lawrence's chatter.

Whitman found him dull but liked the gossip he'd picked up
that Hawthorne strolled along the Salem docks and talked with

sailors. In fact, it is worth knowing that Hawthorne was a gregarious creature when he left his Concord parlor and his hermit's attic. He knew Washington, through Pierce and others, and even talked with Lincoln, noting that he did not comb his hair. He was an efficient and hardworking ambassador. To his three children (of various fates) he was a good father. His marriage was a kind of idyll.

His imagination grew darker and stranger as he tried to write the fragmentary novels at the end of his career. I have a suspicion that his influence is greater than we have yet seen. Surely we can find his narrative hand and ironic eye in Isak Dinesen's fantasies? Henry James bears his stamp, and the priest Don Ippolito in William Dean Howells's *A Foregone Conclusion* (1875) wears the trademark *Hawthorne fecit*. Borges is right to see Kafka as a continuation. He is also a kind of doubling back to Hawthorne's beginnings in German romanticism. There are Hawthornian touches and lights in Calvino. We can imagine a *Baron in the Trees* (1959) by Hawthorne; it is, after all, a kind of "Wakefield"—a moment's caprice stubbornly adhered to until it opens a window into the radical absurdity of the human will. There's Charles Ives's "Hawthorne" movement of the Concord Sonata, addressing itself to the tension between reason and superstition, order and chaos. Are there not Hawthornian tactics in Cynthia Ozick? And Eudora Welty's old Mr. Marblehall, who is he but another Wakefield?

Hawthorne's demands on himself were such that some stories that we consider to be essential to his work were withheld for years until he was sure of them. He was a genius who, if not perfect in all he wrote, came as close to perfection as a writer can. There are no repetitions, no botches.

The Comic Muse

We trust seriousness to be the firm ground beneath our feet while knowing full well that it is ultimately dull and probably inhuman. The phrases "Protestant bombing," "Christian militia," and "abstract expressionism" make no sense. We have had Swifts and Juvenals who could hack at the stupidities seriousness thrives on. Their weapon or tool is satire, which at its best is actionable and not always protected by the First Amendment. The Romans outlawed it, and several talented satirists found themselves living beyond the Oxus.

But satire's little sister, comedy, was civilized quite early and given the run of the house. Our understanding is that satire is sneaky, unfair, and takes no prisoners. He knows right from wrong; he has stern morals and leaves bruises. Comedy is a free spirit, full of fun, and has no intention of explaining herself. In fact, much of her charm is in her mystery, in eluding the serious as successfully as a kitten that doesn't wish to be caught.

She loved it a few years ago when Dan Quayle spelled *potatoe*, as spelling and vice presidents are equally boring, and part of her fun (as she is coeval with civilization) was in knowing—but she wasn't about to tell—that Samuels Johnson and Beckett both wrote *potatoe* (Shakespeare got it right).

Why is this humble verse, poet unknown, comic?

> *Carnation milk is the best in the land.*
> *I've got a can of it here in my hand —*
> *No teats to pull, no hay to pitch:*
> *You just punch a hole in the son of a bitch.*

Elizabeth the first would have laughed; Victoria wouldn't. Comedy defines its audience and may be the most intelligent reach of the mind. And yet it does nothing but play:

> *We shall all go to heaven when we die*
> *And many of us stand on the head of a pin,*
> *Four or five of us, if we try;*
> *Six or seven, if we all squeeze in.*

That's Ian Hamilton Finlay, whose sense of humor has upset several European governments and whose *Glasgow Beasts, an a Burd, Haw, an Inseks, an, a Fush* (1961, written in Glaswegian) might have furnished *The Oxford Book of Comic Verse* (1994) with some puckish epigrams. But any anthology of English comic verse is a feast from an overflowing pantry, for English writing and art are different in having cast practically all of their masterpieces in the comic mode. There's Chaucer (represented here for his humor of perception rather than his slapstick bawdy or parody), Shakespeare, Ben Jonson, Smollett, Dickens, Thackeray, and on out to Joyce.

France has Rabelais, Molière, and Daudet; Spain, Cervantes; Russia, Gogol—all people have something in the comic mode, even Denmark and Arkansas. But the English, along with their outriding cousins the Americans, Irish, Scottish, and Welsh, have a world monopoly on the comic. They are the Greeks of our day.

So whereas it's bad manners to natter at an anthologist's choices, it is a tribute to his subject to ask: Where's Samuel Butler II's "A Psalm of Montreal," one of the funniest poems in the language (with its refrain of "O God! O Montreal!" ending each

stanza)? Or that master of the vernacular windfall Jonathan Williams? Or those latter-day masters of the classical epigram, J. V. Cunningham and James Laughlin?

John Gross, theater critic and from 1974 to 1981 editor of the *Times Literary Supplement*, has compiled a wonderfully rich compendium. Nobody reads an anthology; that's not what it's for. It is a book for the bedside table. It is a definition and illustration of its subject. The *Oxford Books of* (*Dreams, Literary Anecdotes*, presumably, in time, of everything under the sun—one on *Money* is in the works) are medieval (or Victorian) in their enterprise: a diligent editor's selection ("anthology" means in Greek a bouquet, or garland, of flowers) of what many writers have most sharply said about a topic. *The Oxford Book of Sunsets* would not greatly surprise me, though it might indicate that they are getting near the bottom of the barrel.

There are many *trouvailles* in Gross's anthology. It is innovative and fresh; in fact, it has an air about it of being rebelliously original. Anthologies are the most strategic means at the critic's disposal. They are the true academies, in the old sense, establishing reputations by inclusion or exclusion. Donald Allen's *The New American Poetry* (1961) added a new wing to the house of literature. Ezra Pound's early revolutionary activism was in specific rebellion against Francis Palgrave's *Golden Treasury*. Any museum on new principles gives us a new art.

An anthologist can therefore respond to all criticism with "Go make your own anthology." There is middle ground, however, for rational discussion, wherein ideas might be traded. I would have put in Marianne Moore's "Marriage" as one of the wittiest and most comically argued apologias for spinsterhood. And Wallace Stevens, for whom comedy was always the wind in the sails of his philosophical ship. Gross has rightly left out the bawdy and the coarse, which belong more properly to satire.

On the grounds that comedy is at its best when it makes fun

of the serious, I would have included Kipling's "McAndrew's Hymn," and for comedy's ability to mock the mocker, Ralph Hodgson's "Eve." This wickedly merry poem is about Enid Bagnold's seduction by Frank Harris (as Miss Bagnold disclosed in her autobiography), an event deplored by Hodgson and eventually by the seduced. It is a poem that shows how the comic spirit is most articulate when it has a rich culture at its disposal: a prosody surviving from the Middle Ages, a religious myth, a naughty novel by Aubrey Beardsley, a dark phrase from William Blake, and a personal animus against seducers. And yet it is, as the critics say, light verse, practically a nursery rhyme.

> *Eve, with her basket was*
> *Deep in the bells and grass,*
> *Wading in bells and grass*
> *Up to her knees,*
> *Picking a dish of sweet*
> *Berries and plums to eat,*
> *Down in the bells and grass*
> *Under the trees.*

The Oxford Book of Literary Anecdotes (1975), edited by James Sutherland, is largely a compilation of occasions on which authors were gratuitously mean to a victim of their wit. There is no such theme in Gross's collection, unless it is the British discomfiture with muddle (P. G. Wodehouse on proofreaders) and sham (Max Beerbohm parodying Hilaire Belloc). A critic looking for a theory to bring this bountiful anthology together might muse that comedy is a weapon employed by sweetness and light to tease, guy, torment, sass, bedevil, and spit on stupidity and vice. But that is too glumly moral an agenda for comic verse, the genius of which, as John Gross's anthology proves, is its delight in the playfulness of language and its wild freedom when it encounters any convention whatever.

Travel Reconsidered

WE USED TO BE ON THE MOVE all of our lives when we were hunters in the Ice Age, like Lapps and Eskimo today, following herds of the juicier animals. No sooner had we settled down on farms and in cities than the old roving instinct began to assert itself one way or another. We invented commerce, and merchants moved about in ships, in caravans. They brought back tales of far places, exciting the curious to travel for no other reason than to see the remote. Travel, the adage said, broadens the mind. It is also a wonderful measure of its narrowness.

Let us go at this subject by backtracking. This past summer I was cooling my heels outside the Musée du Louvre, a shrine not to be missed by the passionate pilgrim (Henry James's phrase for the American absorbing culture in Europe). Two such pilgrims with whom I was on vacation had wanted to see the Mona Lisa, and I, having shown them what I wanted them to see, had declined to try to see Leonardo's painting over the heads of five Lutheran Sunday School classes from Oslo, two busloads of Japanese businessmen, and a contingent of Mexican Rotarians. Two of my compatriots, husband and wife, kindly folk, retired Americans to the teeth, came and joined me on my bench, eager to exchange pleasurable observations about the beautiful city of Paris. I explained that I was waiting for friends who were inside trying to see the Mona Lisa.

"But," said they, "that's in the Louver. We were there yesterday."

"This," I said, with a sweep of arm, "is the Louvre."

"Oh no," said they, "this is the old king's palace. We've just been through it. We did the Louver yesterday. It's clean on the other side of town."

These good people were obeying a cultural imperative. They had come to see Europe. Their prototypes a century before prepared for the pilgrimage with long evenings of study and had lists of things to see: museums and palaces, cities and mountains. They read travel books that instructed them in tone and significance.

Nowadays all that's left of this ritual is the mileage. As best I can ascertain from casual research, the typical American trip to, say, Paris, has been standardized into four events as mandatory as the stages of a religious progress from shrine to shrine. These are an evening at the Moo Land Rouge (which ceased to exist years ago, but the crafty French have built a place so called), the Lido, and Mont Mart Tree, where you can see Impressionist painters at their canvases hard by Sacker Curr, and a tour by bus of "the old parts of the city."

All this began in the seventeenth century when young English gentlemen were taken to France and Italy by tutors of professorial rank (Hobbes, Ben Jonson, Addison, for example) with an eye to making Foreign Office material of them, to improve their accents, and to store up marvelous experiences (Milton looked through Galileo's telescope). By the eighteenth century the Grand Tour, as it was called, took many forms. Crowds of Englishmen fancying themselves dilettanti went to see paintings, architecture, and statuary, bringing a considerable amount of stuff back to England (Rokeby carting home Velázquez's *Venus at her Mirror*; Elgin, great chunks of the Parthenon), and writing about their experiences in delightful accounts that evolved into an art form all to itself.

Swiss and French travelers made ruins fashionable and invented Shelley. Wordsworth invented the Alps and taught us that waterfalls are grand. Byron organized these new feelings about travel into so many romantic thrills ("Childe Harold's Pilgrimage," 1812) and Samuel "Breakfast" Rogers organized them (in his poem "Italy," 1822) for the less strenuous. The greatest Grand Tourist of them all, John Ruskin, was invented by Rogers's "Italy," which he read as a child. It would be a nice exercise in scholarship to trace the agenda of tourists today who, all unknowing (and caught up in the genius of their own perceptions—"Arlene, they have French fries just like ours!"), go to Spain because of Washington Irving, to Venice because of Ruskin (where Byron *named* the Bridge of Sighs), and so on.

Anthropologists have, quite rightly, begun to study tourists. From a Martian's point of view, it is ultimately a damned strange activity for tens of thousands of people to make benign invasions into other countries, simply to gawk. A dedicated tourist myself, I have heard, on the return flights, what fellow tourists have made of their trips. I have heard of a visit to Elsinore in Denmark, "where Shakespeare wrote *Hamlet*." (I've also heard a father, in Washington, showing his children "the White House" while pointing to the Capitol.) In the Musée Marmottan I have enlightened a young American who thought she was in the Louvre.

The general impression, indeed, of Americans abroad is that they are lost in a fog. You can hear them debating if the city yesterday was Athens or Florence, and an undergraduate once informed me that in his summer travels he had looked in on Vienna, Italy.

The art of being a tourist—as we know from Goethe's account of Italy and Montaigne's journal of a progress by stagecoach from Paris to Rome, by way of Switzerland—is precisely that, an art. It is the art of paying attention, of learning, of taking another world into one's fund of experience.

But what has happened? I've seen a busload of American high

school kids pour out in Bordeaux, that beautiful city. They arrived at our hotel late in the afternoon. They all washed their hair, for hours, and squealed. They ate dinner. There is no nightlife in Bordeaux, at least none fitting for American high school students (the choice is between gossip, ranging from soccer scores to structuralism, in the cafés of the Place Gambetta, and the docks, which I cannot describe in a family magazine), so they went to bed and left next morning at eight. Thus Bordeaux, where they might have profited from a visit to Montaigne's tomb, the squares and vistas that influenced the design of Paris, and from being told that they were in the city of Odilon Redon and Rosa Bonheur, that John Adams received here our first salute by another country. The museum of prehistory—but let's stop there and say that the Grand Tour of yore still sends thousands of people thousands of miles, and that they don't know from moment to moment where they are or what they're seeing. But they take pictures. I've been shown them. "That was our bus," a tourist informed me, handing over a snapshot. "And here's the bus we had in the country of Scandinavia."

Grand Tourists still exist. Modern conveniences allow us to parcel out the experience over years and years. For me, thirty so far. We blend in with the Moo Land Rouge crowd on the Boeing 747, but our hand is tipped in the ritual exchanges of questions about how many countries one did in how many days. Had I seen Mont Mart Tree? a lady from Atlanta wanted to know, when I said I'd spent all my vacation in France. I was obliged to tell her that I visited the graves of van Gogh and Rin Tin Tin, and had successfully ascertained where Karl Marx spent some days in Argenteuil in 1883.

Keeping Time

BORGES Y *Yo*, WHICH SEEMS TO OBSERVE with Borgesian gloom that the coin outlasts the emperor, is also a Borgesian conundrum, for Borges the writer necessarily wrote it, not the *yo* of its title. Wittgenstein worried about who the *my* is when we say "My foot hurts." We say "I am writing," not "My hand is writing." How much of us has the ego colonized? When was Shakespeare a playwright—all the time? Proust said that we are not ourselves all the time, and not all of ourselves at any time.

A philosopher has suggested that there is no such thing as a mind; we have instead various ganglia of consciousness in communication with one another. This would account for Socrates' belief in a daimon (the Greek for *genius*). The daimon seems a good explanation of the writer's (and the world's) sense that there was something more to the limber-legged Irishman than the wayward citizen James Joyce. The Borges duet was an Argentine librarian and his daimon.

Daimons, Plutarch tells us, are laundered and polished souls of the dead sent back to guide those who will give them heed. My daimon (we're great pals) was a minor poet in the autumn of Roman time, polite, bashful, and pensive. *His* daimon, however, had been a charming lout too comfortable with himself to amount to anything but a joy to his enemies and a nuisance to his friends. So

when I write I am disorganized by my daimon's daimon, but kept in order by my daimon himself.

Socrates' daimon was an inheritance from the Pythagoreans. All of our daimons are personifications of the past, which is the ground beneath our feet. The more diligent the writer, the deeper into the past he can reach. The old Tolstoy became a contemporary of the prophet Amos. Joyce in *Finnegans Wake* speaks from the bogs, through mists. Centuries intervened between the war in Troy and the daimon of Homer.

My daimon is both a pest and an obliging teacher. His language is Latin, though he admires Greek. Tidy your sentences. If you're going to write English, write it idiomatically. Be as plain as you can but don't leave anything out. Of English writers he is forever holding up John Bunyan, Ben Jonson, and Samuel Butler. Sugar the biscuit if you must, he says, but make certain that you have a biscuit to sugar.

He holds his Roman nose at the idea of writing as self-expression. Writing is our finest implement of inquiry, and the inquirer inquiring into himself is a mirror held up to a mirror. The business of a writer is to show others how you see the world so that they will then have two views of it, theirs and yours. We are all of us trapped in our minds. We can get out through the imaginative alchemy of reading, a skill complementary to writing but psychologically more mysterious. How writing is written is a process far more straightforward than how it is read. Leave that to them, my daimon says, when I doubt a sentence.

My daimon likes to say that only I can write my stories, and has refused to have anything to do with this miniature essay on "the authorial I." It has no weather in it, no apples in a silver bowl, no goats with oblong eyes. *Taedium taurique stercus*, he says. So I have had to write this all by myself.

The Sage of Slabsides

John Burroughs (1837–1921), an essayist who wrote about the Catskills, where he was born and spent almost all of his life, is about as forgotten as a writer can be and still elicit a coffee-table book, lavishly illustrated, about his life and times. He is thoroughly presentable. He knew Walt Whitman (and supplied the hermit thrush in "When Lilacs Last in the Dooryard Bloom'd"). His friends included Teddy Roosevelt, Thomas Edison, John Muir, Henry Ford (who gave him two T-models), Harvey Firestone, and Ralph Waldo Emerson. Contemporary critical opinion preferred him to Thoreau. He became a venerable sage who took children and Vassar girls on nature walks. Randolph Bourne introduced him to Henri Bergson at Columbia—as incongruous a trio of intellect as the randomness of fate might assemble.

He was a writer of much charm and substance. I bought his complete works (the Wake-Robin edition, in twenty-four volumes) forty years ago with all of its pages uncut. Whether I have yet read all of him I can't say, as he is a writer one can read as the whim arises. His prose is easy and congenial, and is always interesting, as it is derived from observation of birds (he was a better ornithologist than Thoreau), squirrels, chipmunks, insects, and the seasons. Any page of Burroughs is almost as good as a walk in the woods. It was Whitman who suggested that he devote his life to exact observation and to writing in plain prose.

His one messy book was his *Walt Whitman* (1867), a work with some worthwhile information in it but which repeats, like a stuck phonograph record, that Whitman was a cosmic poet. Much as Burroughs admired Whitman, he was nevertheless embarrassed by him ("he kissed me like a girl") and was utterly unprepared to discuss the poetry critically or the ideas analytically.

Burroughs had an intellect of the middle order, neither brilliant nor dull. His defense of evolution as a kind of religion holds up as an argument, and his search for an intelligence in nature (the cunning of a tendril, the ability of a leaning tree to right itself with strategic roots, the migration of birds and butterflies) transcends amateurishness. He is never a crank, and rarely a scold. It is because he sounds today like an ecological prophet that he is worth resuscitating. He has always been worth reading. Writing for magazines taught him how to shape an essay, and he never forgot Whitman's rule that a fact accurately observed is worth any amount of opinion.

Edward Kanze's biography *The World of John Burroughs* (1993) is a well-intentioned effort of a fairly competent writer. It flows in and around photographs that vie for our attention, both old black-and-white ones (the heartbreaking portrait of the unhappy Ursula Burroughs and the picture facing it, of the patriarchal Burroughs with two dogs, are images that no writer could hope to compete with) and splendid new color ones. Most of the latter are by Kanze himself, and perhaps we should graciously accept this very attractive book as an album of his beautiful pictures of animals, birds, flowers, and places.

Kanze gives an engaging account of Burroughs's childhood on a dairy farm, his sparse schooling, his early marriage, his arrival in Washington, D.C. And then everything seems to go haywire. The narrative begins to display awkward gaps. It is not explained how Burroughs, who has been a one-room schoolteacher in rural areas,

is suddenly qualified to be a clerk in the U.S. Treasury. Even more mysterious is Burroughs's taking a job as "receiver of a failed bank in Middletown, New York." What this job is, and what it entailed in office hours and expertise, we are not told.

Moreover, Burroughs spent a dozen years at "bank-receiving," building a lovely house named Riverby out from West Park, traveling to England, writing four books. During these years he wrote the essays collected in *Winter Sunshine* (1875) and made a baby on the serving girl. This child—his son, Julian—he then adopted from an orphanage in a kind of scam. Ursula Burroughs, who seems to have been unhappy throughout the marriage, did not learn of this deceit until years later and was plunged into misery by the revelation. Only toward the end of their lives were Burroughs and his wife reconciled. But by then he had struck up a companionship with Dr. Clara Barrus, a psychiatrist. He was crossing the continent with her when he died in his Pullman berth. His last words were, "How near home are we?"

This biography will be read (and reviewed) by people who are ignorant of Burroughs's writing. His books are in some libraries, and Penguin is to bring out a selection in their nature series. Were Burroughs a writer I had not encountered before, I'm certain I would be grateful for this biography, my curiosity aroused. But he is a writer whom I count as an old friend, one who, like Montaigne, Burton, or Stevenson, is reliably interesting on any page I open to.

A biography, and especially a literary biography, has the distressing power to displace and confuse its subject's significance. The words "John Burroughs" refer both to a body of essays (in which ample biographical information is included) and to the man who wrote them. Each is at the mercy of different perspectives. The man in Clara Barrus's *Life and Letters* (1925) is not Kanze's Burroughs. A life is mutable in a way the work is not. It would take an Edith Wharton to trace Burroughs's emotional life, which

seems to be as dark as Ethan Frome's, and another kind of writer altogether to see into Burroughs's friendship with Walt Whitman. What we have, despite Kanze's honest efforts, is a tangle of anecdote and rumor. Kanze is himself a naturalist, trained as a geographer, whose initial, mild interest in Burroughs grew into a lively enthusiasm. He has given us a delightful picture book (printed in Japan and botched in places by computer technology—the beginning of the rump of a sentence on page 135, "began to fail," is still on a floppy disc in Kyoto). His photograph of Burroughs's studio Slabsides is a far more welcome and meaningful interpretation of Burroughs's prose than anything in his text.

When we have a general overview of American writing about nature, both scientific and literary—an overview including Sereno Watson, Clarence King, Louis Agassiz, John Muir, and all the others (our best living practitioner being Edward Hoagland)—we will have a context in which to see Burroughs. He is a very different kind of writer from Thoreau; he was, as he himself said, closer to Gilbert White of Selborne. In his writing we find that miracle of a true culture, the minor talent shaped to all the perfection it is capable of and therefore radically original. At his most engaging, Burroughs is a little like John Clare in England, spiky and rough but entirely himself.

John Cheever in Paradise

A STEADY CROW FLYING north by northeast across Boston Bay
for twenty miles from Quincy on the south shore to Salem on the
north moves along a line that criticism must inevitably draw be-
tween John Cheever, who was born in Quincy in 1912, and Na-
thaniel Hawthorne, who was born in Salem in 1804. Cheever, who
died on June 17, 1982, shared with Hawthorne a mastery of the
short story, a fascination for the slippery tussle between human
nature and moral codes, and a fine, forgiving sense that grace can
emerge out of the most wayward darkness of the heart.

The resemblances between these two scions of New England
puritanism are seductive. They both put Italian paganism and
American innocence in an ironic and heartbreaking contrast.
They shared symbolic vocabularies of light and dark, old and new,
spiritual deprivation and fulfillment, nature and civilization, man
and woman. Cheever saw life as a process of impulses whose power
to shape our destiny becomes apparent only when we can no
longer extricate ourselves from them. The world is beautiful and
fun; what we don't know in our joy of it is that what feels so good is
addictive and the hangover bitter. All Cheever plots are about
good intentions plunging with energy and verve into a trap. The
older he got, the more he liked to think that the trap is purgatorial,
is, in fact, good for us. Life has no other shape.

Unlike Hawthorne, he had the ability to see how gloriously ri-

diculous the fly is on its way into the spider's parlor. Cheever was one of the funniest of American writers. In an early story he brings a preternaturally innocent Midwestern couple to Manhattan, where they live up to every sophisticate's ideal of country bumpkins. They are so incredibly gauche that we are told that their clownishness at a party caused the guests to walk in circles beating each other on the back. (This perfect economy of description is maintained in the last novella, *Oh What a Paradise It Seems*, where a mafioso is given us deftly: "one of those small, old Italians who always wear their hats tipped forward over their brows as if they were, even in the rain, enduring the glare of an equinoctial sun. These same old men walk with their knees quite high in the air as if they were forever climbing those hills on the summits of which so much of Italy stands.") It is not until we have finished the story about the rubes and city folk that we realize where Cheever's sympathy was. It was, as always, with the hapless fools.

Fool is the right word. Cheever was—like Flannery O'Connor and Eudora Welty—interested in human nature at its most vulnerable, because he was convinced that it could not be defeated, that this world is its home, that in our worst ineptitude at living, we are, if only we can see it, somehow thriving and being a success.

In *Oh What a Paradise It Seems*, Cheever's protagonist is an old man whose sensual life is guarded like a match struck in a high wind. He has no intention of giving in, giving up, or giving an inch. He is well-to-do, he has been a skillful man all his life in business, in love, in savoir-faire. Cheever slips him neatly into a plot where greed fouls a lake, murders an honest man, intimidates a village; in short, into our world, which can be seen as a disintegrating fabric rotten in every seam.

This is the essential Cheever plot: a pattern of characters embroiled in self-perpetuating disaster, with a Dostoyevskian horror of the suffering of the innocent. There is an instructive contrast to be made between that other master of urban life, John O'Hara, and

Cheever. Their stories begin the same way and move into the same kind of misunderstandings and accidents. O'Hara the pessimist drives on into bleakness, scruffy tragedies, dark lessons for us of moral gangrene. Cheever the optimist with a wicked smile and sheer joy at the shamelessness of his incurable brightness insists that things right themselves and turn out all right, or as all right as we can expect, given the nature of our folly.

So this last work, for all its charming (and unapologetically bawdy) realism, its unfooled view of nastiness, and its opportunity to be despairing, is a triumphant statement about the human condition and its regenerative resources. The fouled pond is cleansed and its pollutors put out of business. The old protagonist keeps discovering surprises in his determination to squeeze all the juice out of life. But Cheever knows that these local victories are precisely that: applicable only to this place, these lives. Squalor worsens elsewhere; that's a problem somewhere else. I doubt if Cheever would have generalized any of his particularities (one would have gotten that wicked smile for an answer if one had dared ask). He was not interested in framing laws of nature, only in describing with lasting authority special cases of human nature.

In one of the stories there is a rakish dog (it looks like a cavalier at the court of Charles II) who works a rich suburban neighborhood on evenings when cooking is done on backyard grills. He can nip over a hedge and make off with a rare steak before you've noticed a dog anywhere about. He smiles a lot, this dog, and has beautiful manners. He perhaps knows with great accuracy that three martinis induce inattention in bipeds, and that their minds, these nice people with such toothsome steaks, are on adultery and the stock market and gossip from the country club. Of morality the dog knows nothing, except that it is a highly moral skill to steal with such style and grace.

Dogs were created hunters and carnivores. In Cheever's novel

Bullet Park (1969) a teen-aged boy with a luxurious house to live in, well-to-do parents, every opportunity for success, curls up in his bed and refuses to respond to any entreaty. He has rejected every-thing, for no reason anyone can discover. I think in all of Cheever's brilliant writing we are meant to see that boy who has given up in sharpest contrast to the elate, thieving dog. Some slip from grace that Hawthorne brooded on all his life keeps most of us from the lively successes of the dog, and some slip from what we have re-gained of that lost grace curls some of us up in defeat. Between these two states Cheever's characters move, foolish, anguished, most lost when they imagine they have arrived, happiest when they are wise enough to know that to be alive and free for a few hours is all there is.

Stephen Crane

In 1925 Thomas Beer's *Stephen Crane*, along with Wilson Follett's twelve-volume *The Work* [sic] *of Stephen Crane* (1925–26) fixed Crane securely in the American canon. There had been a biography in 1923 by Thomas L. Raymond. Follett's collected works had prefaces to individual volumes by Willa Cather, who met the young Crane in a Nebraska newspaper office, Carl Van Doren, Amy Lowell, and H. L. Mencken. Beer's charming biography had for an introduction a thirty-three-page essay by Joseph Conrad. Crane figures in the reminiscences of H. G. Wells and Ford Madox Ford, among others. No American student can get through high school or college without being assigned *The Red Badge of Courage* at least twice; "The Open Boat," "The Bride Comes to Yellow Sky," and "The Blue Hotel" are standard stories in anthologies. The Library of America *Stephen Crane: Prose and Poetry* (1984), edited by J. C. Levenson, contains just over a hundred pieces. Crane was twenty-nine when he died in the Black Forest in Germany, in 1900, of tuberculosis.

Thomas Beer's biography, a companion to his *Mauve Decade*, is as readable as Lytton Strachey—the influence of whose style, sense of fun, and irony is obvious—and as lively as Mencken. Beer's Crane is a kind of Penrod who evolves into one of O. Henry's fly young men who have come to New York from the sticks eager for the romance of real life. And with an O. Henryish flair for doing

the unexpected, he wrote *Maggie: A Girl of the Streets* in a Syracuse frat house before he had ever seen the Bowery. He wrote *The Red Badge* with such convincing detail that a veteran of the war bragged of knowing him at Antietam. (Several of Whitman's most graphic poems about soldiers and their suffering were written a decade before the war, and neither Beer nor Benfey recalls Daniel Defoe, the arch counterfeiter, whose way with fiction is exactly Crane's.) Benfey is good at spotting these reflections of life in art: "The Bride Comes to Yellow Sky" encodes the awkwardness of Crane's mistress (passing as his wife) Cora, formerly madam of the Hotel de Dream whorehouse in Jacksonville, Florida, being introduced to her new neighbors in England, among whom was Henry James (who liked her).

But as soon as we open Christopher Benfey's 1992 biography, *The Double Life of Stephen Crane*, we are told that Beer's is a work of fiction based on forged letters and coming from a hyperactive imagination. Scholarship has recently snatched away from us the friendship of Picasso and Alfred Jarry (it turns out that they never met). Beer's biography, to my eye, is not all that inaccurate or misleading. If biography is a literary art (as Plutarch, at its inception, thought it was, and has suffered damnably at the hands of nitpicking German pedants), then I still prefer Beer's biography as reading matter, while giving Benfey fullest credit for his diligence in research and interpretation of the texts.

It's best to think of Beer as an early biographer who did not have Benfey's advantages. He might have known that the young reporter who covered Crane's burial service in New Jersey was named Wallace Stevens, but then the name would have meant nothing to him in 1925. What Benfey has done is fill in large blanks in Beer.

Even so, Benfey has hard going of it in finding Crane and establishing a plot for his life. Lives do not have plots, only biographies do. And practically all of Crane's wildly active life — on

battlefields in Greece and Cuba, in New York courtrooms and Greenwich Village studios—has only Crane as its witness. What novelist would have his hero leave the Spanish-American War, nip up to a sanatorium in Tennessee, and then nip back to Cuba? Only a comic novelist—an Alphonse Daudet—would have his hero set out for Cuba in the first place, end up in Greece, and then, after a frantic afternoon in London with Conrad trying to raise travel funds, get to Cuba after all. Who but the most confused and impractical of people would set out from England (Cora thought it was the thing to do) when Crane was more than half dead to cross the Channel in raging weather and proceed on a litter to Germany, where Crane died almost immediately?

The "double life" of Benfey's title refers to the fact that Crane's writing anticipated so much of what he later did: the reality came after the fiction. He wanted to see if "he got it right." He authenticated the battle scenes in *The Red Badge* by observing Greeks and Turks. He authenticated Henry Fleming's experience in battle at San Juan Hill.

Perhaps biography is, after all, a nuisance. A writer's life must have *something* to do with what he wrote. Shakespeare is an absolute denial of this. Edgar Johnson's two magnificent volumes of Walter Scott's life add nothing whatever to our understanding or enjoyment of Scott's poetry or fiction. Richard Ellmann was so determined to get Joyce and his writing in sync that he concocted a curiously inaccurate biography as well as an imaginary work by Joyce (which he called *Giacomo Joyce*—it's simply one of Joyce's many notebooks on the front of which he whimsically wrote his name in Italian).

Curiosity is curiosity, and biography is a cultural ritual. Plutarch wrote his exemplary lives as a moralist and philosopher. Biographies are now written by journalists, professors, and surviving kin. Psychology has replaced philosophy, and the achievement (or sins) of the subject is the reason a biography gets written.

Benfey makes a great deal of Crane's childhood despite a paucity of information. Beer adequately treats the parents—a Methodist minister the father, a YMCA temperance tract writer and orator the mother. Benfey reads their Methodist treatises and makes a convincing case for Crane's becoming a writer because he grew up in a family that wrote. But the toddler Crane who played at writing (he was the fourteenth child and had seen lots of homework) and asked "How do you spell O?" sounds like a more plausible beginning: writing is a thing to do.

Stephen Crane is an intractable subject because so much of his emotional life is an impenetrable surface. Benfey has hard weather of it with the love affairs, and even with Cora, who remains a blur. Only Conrad's account of knowing Crane (the preface to Beer's biography) gives us any sense of what the man was like, and Conrad's words are so finely nuanced, so ironically reserved, and so obviously shaped for effect as to be a Conrad story, a kind of "Secret Sharer" in a different key. One hopes that Max Beerbohm was tempted to make a drawing of Conrad telling Crane, all of a long evening, Balzac's *Comédie humaine*. What other writer would have asked to have it told, and what other writer would have obligingly told it?

Crane's writing is more than we are aware of, and very uneven. The poems are disconcertingly mystical, the stories about babies are an imaginative truancy. Genius is sometimes very strange. Crane's best works were bolts of genius, unplanned and quickly written, never revised. In a sense, he did not live beyond his adolescence as a writer. His identity was invented and shaped by Conrad and Ford, for whom he was "The Impressionist." This metaphor from painting obscures the fact that Crane's painterly analogues are Winslow Homer and John Sloan. We had a real Impressionist in Lafcadio Hearn, of whom Conrad and Crane may have been vaguely aware. What they were really admiring was a perfection of narrative skill. Crane and Conrad together changed

the act of reading. We *experience* "The Open Boat." We experience *The Nigger of the "Narcissus"*. Tolstoy we watch; Balzac we listen to; Joyce we follow. But Crane at his best gets under our skin and stays there. We go through his imagined experiences with him. How he does it we have no science of knowing.

There's nothing extraordinary about Crane's prose in itself. His words are simple. His images have been praised for their startling originality. O. Henry had a better ear for dialogue. The clue, I think, is in his attack. "None of them knew the color of the sky" became for Conrad and his circle as magic a sentence as the last one of Flaubert's "Hérodias." *Maggie* begins with a rock fight among children, *The Red Badge* with lifting fog that discloses a bivouac. This abruptness is the first step in a masterful timing. It is Crane's pace that distinguishes him. It varies from an amble to quickstep but it is always brisk. He was a superb director of action. He is never retrograde like Conrad or diffuse like James. He has the clarity of a comic strip, and a comic strip's coloring (red, yellow, blue, black, white—his palette is as distinctive as his narrative pace).

Benfey's Crane is hard won from new research and from a great deal of original insight, especially observing patterns (things in a row, psychological undercurrents). The biography is a worthy and welcome contribution to Crane studies, yet Crane as a person is at a greater distance from us in these pages than in Beer, who in turn places Crane at a greater distance than Conrad's thirty pages. The essence of Crane may be in a few lines of Ford, who says (probably lying) that Crane once demonstrated precision in writing by pinning an ace of spades to his study wall and, from the opposite doorway, putting a bullet from his revolver through the center of it.

Ruskin According to Proust

FLAUBERT'S *Trois contes* (1877) is a medieval stained-glass window in a cathedral depicting the legend of St. Julian the Hospitaller flanked by a modern saint whose virtue exemplifies that of Julian, and by John the Baptist, whose martyrdom is the archaic fact generating Julian and Félicité. The design of this work allows for resonances among the three stories of such a symbolic and aesthetic richness that the reading of them helplessly becomes a meditation. We see that the three stories are somehow one story. The whole art of narrative is before us, inviting but not demanding attention. The perspective leads us to the cathedral window: it is a text for the illiterate, to be interpreted in sermons and religious instruction, as Flaubert shows us in the scene of Virginie's first communion in the first story, "Un coeur simple," and as he himself translates one window into narrative in "St.-Julien." Another window supplies the matter of the third story, "Hérodias."

The triumph of these three stories is in each of them being shaped by a different power of the imagination, requiring a different style and tone. Flaubert was preparing the ground for Joyce's polyphony as well as for Proust's harmonizing of diverse narrative tactics into one magnificent maneuver.

Flaubert's three styles are: a painterly realism for which we can find an analogue in Pissarro or Courbet (sharing their preoccupation with roads, villages, and farms); the style used for saints' lives

in the *Legenda Aurea* (from which the modern short story develops, as we can see happening in Boccaccio), supplemented by color and drawing derived from medieval illuminated books such as *Les très riches heures*; and the archeological style for bringing the deep past into immediate and tactile reality that Flaubert invented for *Salammbô*.

We cannot trace Proust to these Flaubertian instigations without an intervening stage. Proust took nothing raw from any source. His syntheses are complex and with an interacting geometry. Flaubert's three transparences depend for their success on the central stained-glass window. The implications of that window for an artist were, as Flaubert demonstrated, immense and exciting. It was the rendering of a biblical text into another medium and at a particular time so that we have to look at it understanding two forces at once, one from the first century, another from the twelfth, both present in the nineteenth and both acting simultaneously in the onwardness and the stillness of time.

The writer who had studied the Gothic painted window most imaginatively was John Ruskin. In 1900 the twenty-nine-year-old Proust published his translation of Ruskin's *The Bible of Amiens*, a genre-defying, Shandying work, typically late Ruskin. Its mercurial center, now here, now there, is its exposition of the Gothic cathedral of Amiens as a Bible in stone, its elaborate sculptures and windows being an equivalent of a text. Ruskin assumed, as Proust would assume in *A la recherche du temps perdu*, an audience that was sometimes a congregation hearing moral instruction (allowing him to refer to a work of art, much as a priest might keep pointing to a particular window in his church), sometimes a group of travelers in need of a guide, sometimes simply fellow human beings who enjoy gossip and confidences. Ruskin quite early began to use the digression as a major device of style, and later saw in his infinitely branching digressions (*Fors Clavigera* is a long work of nothing but) "Gothic generosity"—the polar opposite of classical restraint.

Ruskin the fundamentalist Christian obviously saw Gothic generosity as a quality kin to Hebraic narrative art. The Bible has as firm and geometric a structure as Chartres, but it is a structure of cross-references and epic repetitions, of many genres—psalm, national history, philosophy, drama, letters, exhortations—serving a common purpose. Proust would meditate on the polar opposition of Jerusalem and Athens, a tension in which he would suspend many of his themes, but would elect Ruskin's mode of Gothic generosity. He frequently called *A la recherche* "his cathedral."

The young Proust, dandy and *snob* (best translated as "connoisseur"), fell under the spell of Ruskin. His English was shaky (he worked from trots made by his mother and consulted a veritable committee of friends to keep his text accurate), but his fervor got him through all of Ruskin. The notes he provides are amplifications of *The Bible of Amiens* and *Sesame and Lilies*, connecting these books to relevant passages in Ruskin's larger works.

Richard Macksey has written a scholarly and sensitive introduction to a volume of new translations of Proust's two prefaces to Ruskin (together with a selection of Proust's notes), *On Reading Ruskin* (translated and edited by Jean Autret, William Burford, and Phillip J. Wolfe, 1987). Macksey accounts for how Proust came to do the translations, how he did them, and of what significance they are to our understanding and appreciation of Proust.

The two prefaces are quite different. The one to *The Bible of Amiens* is a declaration of love for Ruskin as well as a critical and cautious assessment in which Proust shows that he does not subscribe wholly to all of Ruskin's ideas, and does not consider Ruskin a high priest of a religion of Beauty. The second preface, to *Sesame and Lilies*, is the more engaging, the more "Proustian," as we can now say. In it he becomes the author of *A la recherche*. Taking Ruskin's method of meditating on anything and everything, he describes his room in Illiers (Combray), muses on reading, on the

spirituality of things. Ruskin is the philosopher of clutter (in his house at Brantwood, in the foreground of Turner's landscapes, in Gothic detail); Proust becomes one, too. With Ruskinian squirrelity he traces a lithograph of a general from its appearance in the house, brought by his grandfather, to its exile in his room, where all clutter was welcome, to its reincarnation as an image on a commercial poster in the dining room of the station hotel (only recognition is true knowledge). Proust, the poet of the gratuitously tangential and of essences as spiritual signs, would not want me to omit here that when I had lunch in this same station hotel a few years ago, which, like the large part of Illiers-Combray (it wears its fictional name hyphenated with its real one), is little changed, the dining room was still decorated with posters, one of which was of Proust, replacing, I would like to think, the military personage of his youth. Except that part of this preface is lifted from the abandoned *Jean Santeuil*, we could say we are witnessing the birth of Proust from a rich and well-laid Ruskinian mulch.

Macksey gives an eloquent account of how Proust absorbed and digested Ruskin, how Ruskin forms a donation into Proust's genius. It is a large donation indeed. Ruskin's interpretation of Giotto's frescoes bleeds through Proust, a detectable underdrawing (once we know about it) in which Giotto's allegorical Vices and Virtues become characters; a working title for a section of *Le temps retrouvé* was *Les vices et les vertus de Padoue et de Combray*.

When he had read Proust, Santayana wrote several friends to admit, with some astonishment, that his whole doctrine of essences, evolved in *Skepticism and Animal Faith* and in *The Realms of Being*, had been anticipated and worked out by Proust, according him the status of a philosopher and involving him in a simultaneous discovery. Bergson was in a position to do the same, though the parallelism of their treatment of time is a commonplace observation.

Proust's synthesis of his age transcended Ruskin's, and continues to synthesize as his work takes its place at the center of his epoch. Roger Shattuck has written cunningly about Proust and optics. Proust is greatly involved in the recovery of Vermeer. The worlds of Monet and Proust have merged. César Franck and Fantin-Latour, Haussmann's boulevards and Art Nouveau fall within Proust's artistic territory. We must revise Gothic Generosity to mean Gothic Acquisitiveness.

To Macksey's extensive analysis of Proust's schooling at Ruskin's knees we ought to add the *culte des jeunes filles* that Ruskin (in one of those feints which Proust detected in him as intellectual dishonesty) elaborated as a sustained sublimation of his arrested sexuality. The *culte* is extensive, and has its origins in Rousselian romanticism, in Wordsworth, in Blake, in Philipp Otto Runge, in Francis Jammes, in Whistler, in Henry James, to name but a few adepts. But even here Proust will use nothing he has not processed in the labyrinthine system of correspondences of his alchemy. Proust's frieze (his word) of girls in white dresses (Joycean transmutation of the flowering hawthorne, which Proust takes from *The Bible of Amiens*, Ruskin's raptures and all) with Albertine as their leader is introduced as so many Artemids, vessels of virginity and innocence. This is the way Ruskin wanted us to think of the children he adored. But Proust takes them over in a doubled acquisition, along with the Little Bands of girls and sissies from Fourier's utopian Harmony (*Petite Bande* is Fourier's phrase). To them Proust can then add their corresponding Fourierist Little Hordes, which was of boys and tomboys, and place them on Boudin's Normandy sands. Over the years they will grow old and vicious, and Proust's slow and unforgiving revelations will open before us in a moral vision of which Ruskin had no notion.

Proust and Ruskin are an example of pupil and teacher wherein

the pupil took, with splendid comprehension, everything the teacher knew, paid the teacher the highest gratitude, and then re-made all that he had learned into a matter wholly his own. One good of this edition (the first in English) of Proust's writings about Ruskin is to remind ourselves of Proust's scholarly talents: a scholar of many talents, we should say. He is a rival of Montaigne as a humanist scholar; he is a great critic of literature and art; a psychologist; a geographer; a historian. (He liked to arrange his household staff around his bed and give them lectures on French history.) And Ruskin may have also shown Proust, by bad example, how to write an enormous book into which everything he knew could be put. Ruskin's books are all like provincial museums with a long-winded guide. No matter how carefully he worked them out, as with *The Stones of Venice* and *Modern Painters*, they tended to-ward the grand and wonderful clutter of *The Bible of Amiens* and *Fors Clavigera*. (Ruskin once began an Oxford lecture on Michel-angelo, slid into a digression on shoes, then into one on the feet of little girls, and then into little girls altogether. In *Fors* he was capa-ble of moving from the Elgin marbles to plum pudding.) It was this exhaustible fund of essences and events that became Proust's inspi-ration: his liberation. He had at first considered translating Emer-son (who turns up in *A la recherche* as the favorite author of one of St. Loup's stage-door girlfriends), and Proust's spiritual tutor would have been even more unlikely than the one we have to con-template. Macksey shows us that we can discern Ruskin in Elstir, Vinteuil, Bergotte, and the narrator himself. Especially himself.

Both Ruskin and Proust chose to place their erotic experience in impossibilities involving permanently deferred consummation; both declined, after awhile, to inhabit the societies to which they belonged, and became hermits in surroundings totally under their own control. Neither was completely aware that he was the chron-icler of the death of the western city as our only unit of civilization, though both were aware that they were chronicling the death of a

culture into which they had been born. If Ruskin could have had Proust's sense of humor, the world could not have driven him mad from time to time; if Proust had had Ruskin's stamina and restless mobility, he could have lived to finish *A la recherche* with the degree of polish and completeness he longed for.

This small book is not a little one. It is, in Ruskin's phrase, a king's treasure; it contains a world. Neither Ruskin nor Proust can be read up; they are best when read a second or third time, when the resonances become richer and richer. And for those who have not had Amiens explained to them by Ruskin, or Ruskin by Proust, it is a book promising great adventures of the imagination.

"The Hunter Gracchus" originally appeared in *The New Criterion*; "On Reading" in *Antaeus*; "Tom and Gene" in *Father Louie: Photographs of Thomas Merton by Ralph Eugene Meatyard*, Barry Magid, ed. (Timken Publishers, 1991); "Taking Up Serpents" in *The Yale Review*; "Shaker Light" in *House & Garden*; "Joyce the Reader" in *James Joyce: The Critical Writings*, Ellsworth Mason and Richard Ellmann, eds. (Cornell University Press, 1989); "II Timothy" in *Incarnation: Contemporary Writers on the New Testament*, Alfred Corn, ed. (Viking, 1990); "Civilization and Its Opposite in the 1940s" in *Art of the Forties*, Riva Castleman, ed. (Museum of Modern Art, dist. by Abrams, 1991); "Style as Protagonist in Donald Barthelme" in *Review of Contemporary Fiction*; "Stanley Spencer and David Jones" in *Craft and Tradition: Essays in Honour of William Blissett*, H. B. de Groot and A. Leggatt, eds. (University of Calgary Press, 1990); "Wheel Ruts" in *Grand Street*; "Eros, His Intelligence" in *Grand Street*; "A Letter to the Masterbuilder" in *AIA: Journal of the American Institute of Architects*; "Jack Sharpless" in *Presences of Mind: The Collected Books of Jack Sharpless*, Ronald Johnson, ed. (Gnomon, 1989); "Thoreau and the Dispersion of Seeds" in *The New Criterion*; "Life, Chance, and Charles Darwin" in *The New Criterion*; "Lenard Moore" in *Forever Home*, by Lenard Moore (St. Andrews Press, Laurinburg, North Carolina, 1992); "Guernica" in *Art News*; "Late Gertrude" in *The New Criterion*; "O. Henry" in *Selected Stories of O. Henry* (Penguin, 1993); "Gerald Barrax" in *Loblolly*; "Calvino: Six Memos for the Next Millennium" in *The Boston Globe*; "Journal I" in *Antaeus*; "Gibbon" in *The American Scholar*; "Journal II" in *Taking Note: From Poets' Notebooks* / The Seneca Review; "Walt Whitman and Ronald Johnson" in *The Yale Review*; "Grant Wood's *The Good Influence*" in *Drawing*; "Writing Untied and Retied as Drawing" in *Drawing*; "The Drawings of Paul Cadmus" in *The Drawings of Paul Cadmus* (Rizzoli, 1989); "Micrographs" in *Limestone*; "Mr. Hawthorne, of Salem" in *The New Criterion*; "The Comic Muse" in *The New Criterion*; "Keeping Time" in *Who's Writing This?*, Daniel Halpern, ed. (Ecco, 1995); "The Sage of Slabsides" in *The New Criterion*; "John Cheever in Paradise" in *Inquiry*; "Stephen Crane" in *The New Criterion*; "Ruskin According to Proust" in *The New Criterion*.